Telling Stories

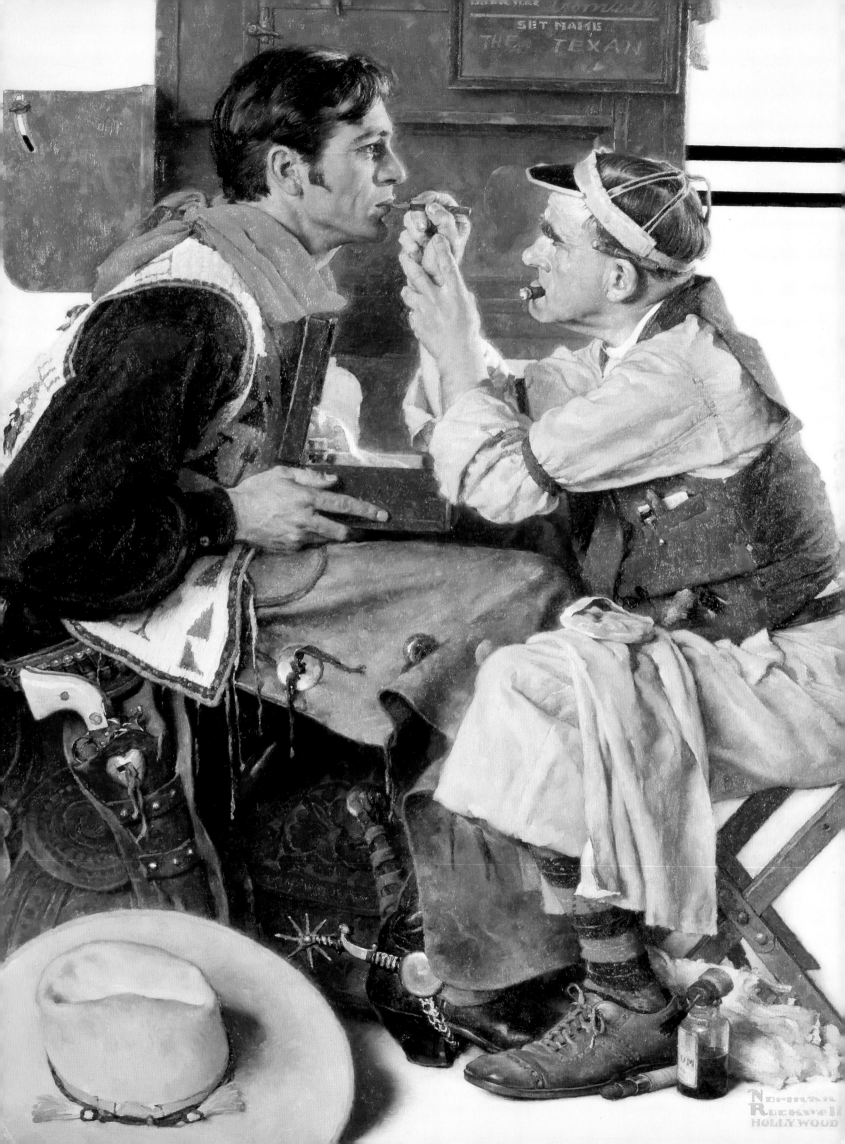

Telling Stories

Virginia M. Mecklenburg

with a contribution by Todd McCarthy

Abrams, New York, in association with the
Smithsonian American Art Museum

Norman ROCKWELL

from the collections of GEORGE LUCAS and STEVEN SPIELBERG

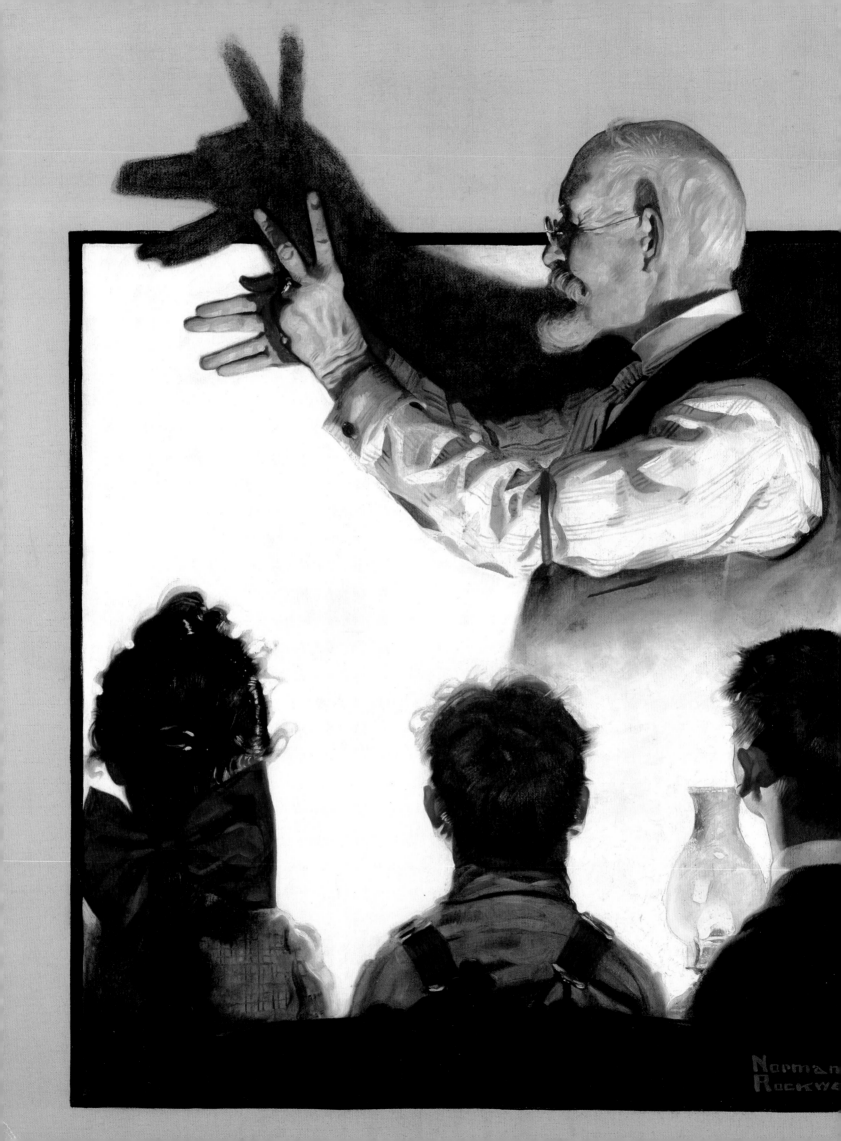

Telling Stories: Norman Rockwell from the Collections of George Lucas and Steven Spielberg is organized by the Smithsonian American Art Museum.

Booz Allen Hamilton has provided generous support as the corporate sponsor of the exhibition.

The Museum also gratefully acknowledges the contributions of George Lucas and Steven Spielberg.

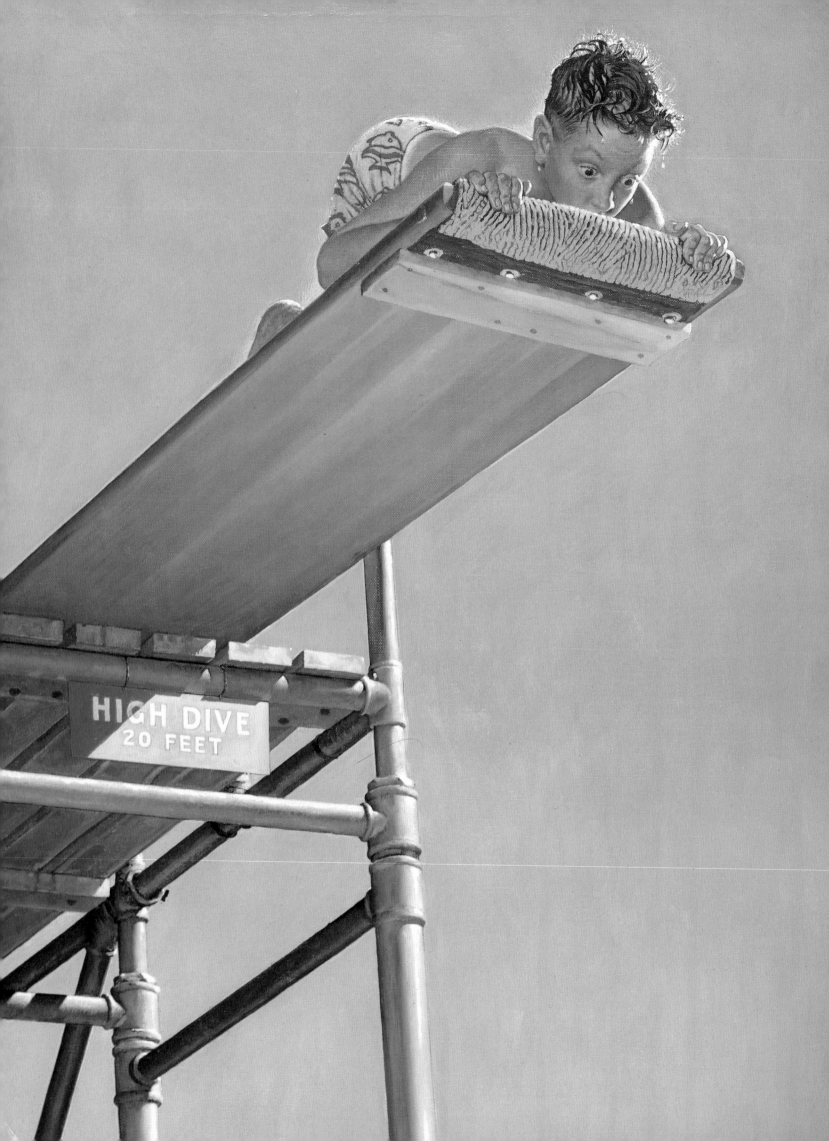

HIGH DIVE
20 FEET

Contents

Foreword

Norman Rockwell's art is loved in a way that transcends simple analysis of his subjects and style. The affection people have for his paintings was unshaken by decades of neglect from museums and disdain from art critics, and it endures today mostly unchanged by the new attention paid by these art professionals. To understand why, we need to look outside the usual frame of reference for art. We need to consider how stories have found their ways into our hearts over centuries.

For instance, traditional boys' adventures followed a hardy formula, with an unlikely hero facing seemingly impossible obstacles and finding some way to survive and outwit all challengers. Jack London's hit, *The Call of the Wild,* first published in the *Saturday Evening Post* in 1903, tells how a sled dog named Buck tapped his inner wolf to survive harrowing adventures. The story so resonates with kids and grown-ups alike that it has been remade for every generation. *The Call of the Wild* movies were released in 1935 (with Clark Gable), 1972 (Charlton Heston), 1993 (Rick Schroder), 1997 (Rutger Hauer), and in 3-D in 2009 (Christopher Lloyd); the novel was adapted in a 1978 cartoon spoof featuring Snoopy as Buck, a television series in 2000, and a Japanese *anime* series. It seems we need this story.

Rockwell was a genius at finding and visualizing the stories that endure, and this book suggests how the greatest storytellers, regardless of the medium in which they speak, recognize each other and draw inspiration from those kinships. The discovery presented in this exhibition is that today's greatest storytellers found Rockwell long ago and drew inspiration from him. We're grateful to George Lucas and Steven Spielberg for sharing their Rockwell passion.

Rockwell's pictures populate our minds and are mapped back to personal experiences in a loose way that is delightful, reassuring, fun, and meaningful. We all carry around certain images in our heads—images that freeze frames of our experience so that we can easily recall them. We call these frames "memories," but scientists tell us that they rarely reflect what actually happened in accurate detail. Rather, they distill life into myth by simplifying, connecting dots, creating story lines, and allowing us to find useful meaning in events that are often random, disconnected, or without moral perspective.

Finding deep meaning is the essential work of fairy tales, and it is possible to see them lurking behind the most successful and enduring stories. In *The Uses of Enchantment: The Meaning and Importance of Fairy Tales* (1989), Bruno Bettelheim characterizes them this way: "The fairy tale simplifies all situations. Its figures are clearly drawn; and details, unless very important, are eliminated. All characters are typical rather than unique.... The figures in fairy tales are not ambivalent—not good and bad at the same time, as we all are in reality." He says that the fairy tale takes "existential anxieties and dilemmas very seriously and addresses itself directly to them: the need to be loved and the fear that one is thought worthless; the love of life, and the fear of death.... Only by going out into the world can the fairy-tale hero (child) find himself there."

Whether it's Buck surviving in the wild, Rockwell's runaway boy with his belongings in a bundle, Indiana Jones embarked on perilous adventures, Nemo lost in the ocean, or Hansel and Gretel abandoned in the forest, we find ourselves in these stories. We're all facing the same "existential anxieties and dilemmas" as our favorite characters, and we love the geniuses who relay stories the best, in whatever medium they choose. The three geniuses featured in this exhibition—Norman Rockwell, George Lucas, Steven Spielberg—are heroes to us all for their rare ability to tell us the stories we love the most.

Elizabeth Broun
The Margaret and Terry Stent Director
Smithsonian American Art Museum

Preface

With the 2007 show *American Chronicles: The Art of Norman Rockwell,* organized by the Norman Rockwell Museum, and the 1999 exhibition *Norman Rockwell: Pictures for the American People,* which the Rockwell Museum co-organized with the High Museum of Art in Atlanta, public attention has focused again on the work of one of the country's best-known illustrators. In the catalogues published for these shows and in professional journal articles and new books, scholars have begun to reexamine Rockwell's pictures through a lens that disregards the deferential perspective of earlier publications to see what, besides sight gags, is embedded in his often complex scenarios. Building on Laurie Norton Moffatt's *Norman Rockwell: A Definitive Catalogue,* art historians Karal Ann Marling, Alexander Nemerov, Jennifer Greenhill, Eric Segal, Andrew Mendelson, and others have decoded meanings in Rockwell's work that were not acknowledged during his lifetime.

One of the reasons Rockwell has not received the close study accorded to other painters of his generation is that, until recently, scholarship in the field of American art has more often focused on painters who took the mainstream, fine-art path than on illustrators, many of whom, like Rockwell, made small fortunes creating pictures for mass audiences. Interviews Rockwell gave during his lifetime and his 1960 autobiography, *My Adventures as an Illustrator,* are anecdotal. Biographical information is interspersed with stories—about people he knew, models who posed, and

memories he recalled—that illuminate a genial personality but rarely offer insight into why he chose to paint particular subjects with particular points of view. As a result, although thousands of pages have been written about Rockwell, a surprising amount remains to be done to understand this man's place in twentieth-century art and culture. Where, for example, does Rockwell fit within the larger field of mid-twentieth-century American illustration? What was the interplay between his images and boys' literature during his early years? How do his pictures connect with the movies, television, best-selling novels, and the huge volume of popular fiction that filled the pages of middle-class magazines during the first half of the "American Century"? Highly regarded writers, some of them Pulitzer Prize winners, wrote many of the stories and, like Rockwell, had an indelible impact on readers of mass-market magazines. Among his colleagues appearing in the *Saturday Evening Post* were Irvin S. Cobb and P. G. Wodehouse, humorists who accomplished with words what Rockwell did with pictures; they mirrored things we all see and experience with a twist that allows us to realize the absurdity, and sometimes the pathos, that is embedded in the lives of ordinary people. These writers, along with Rockwell, and others among their contemporaries spoke about universal, sometimes even philosophical, ideas in microcosmic terms, and they did so plainly, using a vernacular that was, and is, easy to understand for those willing to look and listen.

The artworks featured in *Telling Stories* are drawn from the collections of George Lucas and Steven Spielberg. Both filmmakers are major collectors of Rockwell's work. Both have long appreciated the cinematic aspects of Rockwell's practice and see the painter as a kindred spirit. Combined, Lucas and Spielberg's holdings trace the full trajectory of Rockwell's career, from magazine covers of the late 1910s and early 1920s through commercial work of the 1970s, when he was almost eighty years old. Together the collections reflect most of the themes Rockwell explored and demonstrate the processes he used to create his pictorial narratives. The charcoal and pencil sketches featured here reveal Rockwell's almost obsessive preoccupation with perfecting the details of character, gesture, props, and set; oil "roughs" show us the way he blocked out color and form as he crafted images that could be apprehended in a flash. On close examination the paintings reveal the nuances and subtleties that allowed his viewers to identify his pictures with their lives and claim Rockwell as a virtual member of their families.

Many of Rockwell's themes and the character types he chose as protagonists of his visual stories were familiar fare; they appeared in movies and television programs as well as popular novels and magazine stories. Reflecting on images in the Lucas and Spielberg collections, *Telling Stories* suggests historical, biographical, and cinematic connections in hopes of refreshing some of the rich context in which Rockwell's illustrations were first created.

VMM

Acknowledgments

I am deeply grateful to George Lucas and Steven Spielberg for the opportunity to work with their remarkable collections of paintings and drawings by Norman Rockwell. Their reflections about the artist and their insights about the cinematic and cultural aspects of his pictures bring new dimensions to our understanding of one of the country's favorite painters. I would also like to thank art consultant Barbara Guggenheim, who nurtured the Museum's relationship with these two important collectors.

Bringing these collections to the American public would not have been possible without the generous support of Booz Allen Hamilton and the vision of Dr. Ralph W. Shrader, Chairman and Chief Executive Officer. I am especially grateful for the friendship and leadership of the team at Booz Allen Hamilton—Marie Lerch, Vice President, Marketing and Communications; Joseph Suarez, Director, Community Relations; and Christine Hoisington, Community Relations Manager—who have made it a delight to bring this project to fruition.

It has been a special pleasure to work with Lynne Hale, Jane Bay, Sarita Patel, Laela French, Lynne Bartsch, and Laura Muhlhammer at Lucasfilm and with Elizabeth Nye, Michelle Fandetti, and Marvin Levy at DreamWorks in this exciting endeavor. Thanks also go to filmmaker Laurent Bouzereau for capturing the words and thoughts of the collectors in a beautiful interview film and to Todd McCarthy for his insights on Rockwell's connections with the movies.

Director Laurie Norton Moffatt and her colleagues at the Norman Rockwell Museum in Stockbridge, Massachusetts, have been generous with their time and

expertise. Chief Curator and Deputy Director Stephanie Plunkett offered helpful comments on the manuscript; archivists Corry Kanzenberg and Jessika Drmacich steered me through the extensive collection of documents and photographs; and Rob Doane in the registrar's office responded with constant good humor to multiple requests for photographs and credit lines.

The copyright holders of Rockwell's images have been highly responsive to our requests. Special thanks go to John Rockwell, President of the Norman Rockwell Family Agency; to Joan Servaas, CEO of the *Saturday Evening Post,* and Cris Piquinela at Curtis Publishing; Mary Seitz-Pagano at the Norman Rockwell Licensing Company; and Craig Smith at Brown & Bigelow.

Attorneys Barbara Silberbusch, Rachelle Brown, Yolanda Riley, and Jennifer Kroan guided us through the agreements necessary to exhibit and publish the work in the Lucas and Spielberg collections. American Art Museum Director Elizabeth Broun and Deputy Director Rachel Allen provided constant support and advice. Development Officer Elaine Webster forged the partnership with Booz Allen Hamilton that has been instrumental in bringing the exhibition to the public.

As with each exhibition, everyone at the Smithsonian American Art Museum has contributed significantly and deserves thanks. I am especially grateful to the core project team. Deborah Earle negotiated and tracked photographs, permissions, and a thousand other details necessary to bring a project of this scope to life; research assistant Ann Prentice Wagner, interns Sarah Leventer and Kamal Zargar, and research librarian Douglas Litts helped dig out connections between Rockwell's pictures, popular culture, and the movie industry. I am grateful to Smithsonian American Art Museum volunteer Jack Rachlin, National Portrait Gallery historian Amy Henderson, and several anonymous peer reviewers who read the manuscript in draft and offered suggestions that greatly improved the text. Editor Tiffany Farrell, Graphic Designer Karen Siatras, and Publications Chief Theresa Slowik collaborated in turning a typescript and several folders of pictures into a beautiful book. As project coordinator, Amy Hutchins kept us all on track with meetings and schedules; Exhibition Designer David Gleeson envisioned a spacious and graceful installation plan; and educators and program planners—Carol Wilson, Suzannah Niepold, Susan Nichols, Nona Martin, and Laurel Fehrenbach—have scheduled family activities, film series, lectures, and other public events that promise to entice people of all ages to explore the nuances of Rockwell's pictures. Nancy Proctor, Carlos Parada, and Michael Mansfield in the new media office have conceived Web and podcast programs that will allow people all over the world entrée to the exhibition and ideas it presents. As always, I am grateful to my colleagues in the registrar's office who ensure that the artworks are properly handled and arrive safely. Thanks also to Laura Baptiste, Jo Ann Gillula, Emily Chamberlain, Chavon James, Allie Jessing, Janet Walker, and their colleagues in the external affairs department for ensuring that the press and the public know where and when to come. To Eleanor Harvey, George Gurney, and the staff of the curatorial office, thanks for your feedback and encouragement.

VMM

Mythmakers

Norman Rockwell was a mythmaker. In paintings that graced the covers of the *Saturday Evening Post*, children's magazines, and hundreds of ads he created for commercial products from the 1910s through the 1970s, Rockwell crystallized the hopes, memories, and wishful constructions of millions of Americans. His pictures tell stories—of biddies gossiping, of children growing up, and of couples growing old— that make us laugh with warmhearted recognition. Rockwell drew his images from American life during the first half of the twentieth century, but they cast a long shadow—in the grip his visual stories have on Americans more than thirty years after his death and in a legacy that values the foibles and fantasies of ordinary people that endures in the work of George Lucas and Steven Spielberg.

Lucas and Spielberg are Hollywood giants whose films have touched people of all ages since they first appeared in the 1970s. Both filmmakers felt the power of the Rockwell magazine covers they encountered as boys. *American Graffiti, Star Wars, E.T.: The Extraterrestrial,* the "Indiana Jones" series, *Saving Private Ryan,* and dozens of other movies and animated cartoons for children echo subtexts—about love of country, personal honor, and the value of family—found in Rockwell's pictures. Whether creating characters that seek the lost Ark of the Covenant or simply face the challenges of growing up, Lucas, Spielberg, and Rockwell have built myths that continue to shape our lives.

Lucas grew up in Modesto, in central California, Spielberg in Scottsdale, Arizona, during the heyday of the *Post.* Both families subscribed to the magazine; as boys, both pored over the covers. Lucas, in fact, claimed Rockwell as his introduction to art. He loves Rockwell's pictures for what they say about the times

in which they were painted. Like anthropological arti-facts, he said, Rockwell's pictures offer "a sense of what America was thinking, what [Americans'] ideals were, and what was in their hearts."[1] Spielberg, too, looked forward to the magazine's arrival every week, not to read the articles inside but to examine the stories told on the covers.

Lucas studied anthropology and art history in community college, then enrolled in the film school at the University of Southern California. Several short films he produced there won him an internship at Warner Brothers, where director Francis Ford Coppola helped him learn scriptwriting for movies with broad appeal.[2] Spielberg caught the filmmaking "virus" when he made an 8-mm movie for a Boy Scout merit badge. During weekends at California State University, Long Beach, he made a twenty-three-minute film that he called *Amblin'.* The movie landed him a job in the tele-vision branch at Universal, where he was soon directing episodes for *Night Gallery, Columbo,* and *Marcus Welby, M.D.*[3]

The two first met at a student film festival at UCLA in 1967, but became friends in the early 1970s when Spielberg was working on the script for *Sugarland Express* and Lucas was casting *American Graffiti* in Los Angeles. In 1977, Spielberg joined Lucas in Hawaii,

where he had holed up to wait for press and public reaction to the first of the "Star Wars" movies. There Lucas pitched the idea for his next movie, *Raiders of the Lost Ark,* to Spielberg, who immediately signed on to direct.[4] *Raiders* had all the ingredients of a Rockwell picture and more. The hero was a respectable college professor by day. Away from class, he was a whip-cracking adventurer who challenged the forces of evil to reclaim an object that symbolized the best of man-kind's aspirations. Lucas described Indiana Jones: "He's everyman. He's us."[5] With Lucas as writer and Spielberg as director, the two crafted a character that appealed to our "fantasy side" and our belief that we, too, would look and behave like Jones if the opportu-nity ever arose. This sense of everyman, and of the viewer's identification with an ordinary individual whose vision prompts him to overcome impossible odds and perform feats of impossible heroism, is part of what links Lucas and Spielberg's characters with the ordinary people in Rockwell's art. As types, they perhaps reflect an unrealistic sense of ourselves, but they allow us to believe that, were we to find ourselves thrust into comparable situations, we, too, would assume the status of hero. As *Washington Post* critic Ann Hornaday remarked, the films of Lucas and Spielberg have "tapped into the mass audience's

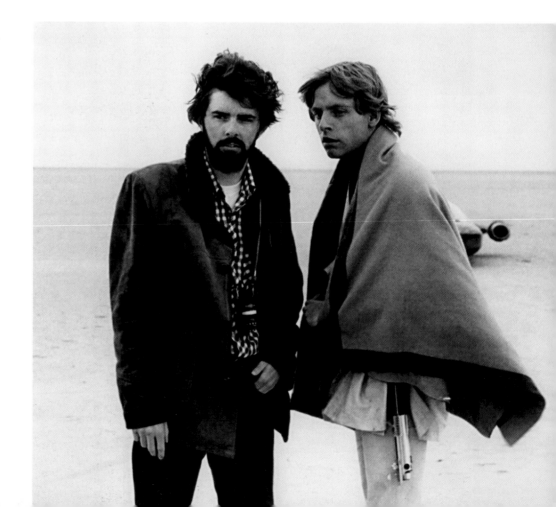

George Lucas with Mark Hamill
Star Wars: A New Hope location
shoot, 1976. Photograph courtesy
George Lucas

Steven Spielberg
on location for *Saving Private Ryan,*
1997. Photograph courtesy
Steven Spielberg

most fundamental hunger for archetype and myth."[6] Rockwell's pictures—whether of children watching a shadow artist create images on a wall, boys imagining themselves as heroic knights of yore, or a teacher being honored by her young students on her birthday— capture moments that our memories turn into myth.

Throughout his life Rockwell maintained that he painted the world as he would like it to be. This strain was echoed by Lucas. "When we were in film school, we would say, we're not making movies about the way things are; we're making films about the way things should be. The power you have as an artist is to be able to put your spin on reality, whether it's darker or more optimistic. Rockwell did this to relate to people [of his own day] but at the same time…to show generations to come what it was like in those years."

Both filmmakers recognize that Rockwell's world was a mythic construction. "At the core of Americans is a wish to have an innocent and naive life," Lucas remarked. "Even though [Rockwell's] images may be dated," he said, "the content is not." Rockwell looked into people and saw their souls; his pictures "symbolized…what America held most dear.…He really captured society's ambitions and emotions, and, as corny as they are, that's what America is." Spielberg noted that Rockwell "pushed a benign but important

agenda of a kind of community…a kind of civic responsibility to patriotism—understanding our nation by embracing our neighbor—tolerance of the community, of each other, of parents, of Presidents, of Boy Scouts of America, of our veterans and soldiers fighting abroad.… He was really one of the greatest Americans that this country has produced."[7]

Spielberg admitted that his creative vision is, at least in part, inspired by the artist. "Rockwell saw an America of such pride and self-worth. My vision is very similar to his."[8] He underscored Rockwell's idealized version of life that values patriotism, decency, and integrity. "He was a moralist. All of us have a sense of morality that now makes us wistful for Rockwell and for that little glimpse at the America that probably never was, except in pockets." Rockwell showed us the American dream, Spielberg explained, "and when we start to lose it, [he] shows it to us in another way to give us the ambition to reacquire it."

Rockwell's images have a strong nostalgic pull for Lucas. He grew up, he said, "in the Norman Rockwell world of burning leaves on Saturday morning. All the things that are in Rockwell paintings, I grew up doing, and it was a part of my life." Lucas aimed to capture a Rockwellian sense of nostalgia in his first hit movie, the coming-of-age film *American Graffiti.*

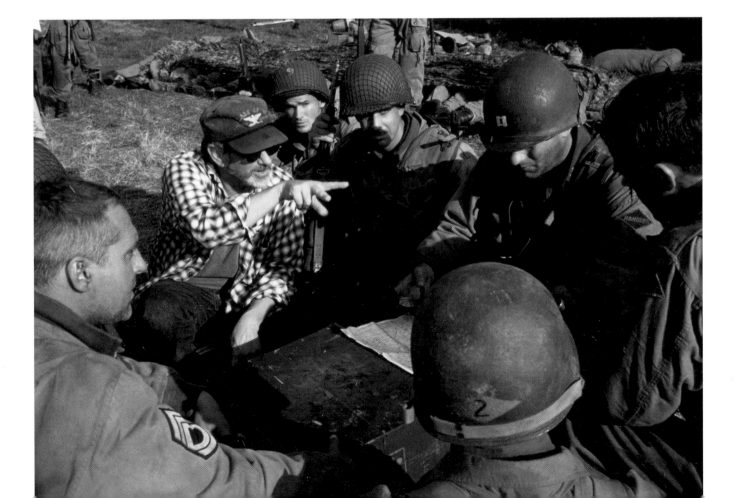

The "particular kind of social culture" it showed was a "direct descendent of Rockwell." He also acknowledged that "growing up on Rockwell was probably a very big influence on why I felt so comfortable when I got into the movie business because I understood how you develop character and tell stories using the visual medium."

All three storytellers are committed to entertaining their audiences, but they also give them something more. Spielberg has made unabashedly populist movies and finds it affirming when he directs films like *Jaws* and *Jurassic Park,* which everybody goes to see. He also made *Amistad* and *Schindler's List,* which probe deeper human emotions. Lucas recognized that audiences want movies that are "not only entertaining, but also... insightful into the way they live their lives....It doesn't have to be an incredibly deep, intellectual idea," he said. "It just has to be a little something that touches the emotional side of a human being." Rockwell knew this very well, he continued, adding "I make movies that way. Steven makes movies that way. A lot of people think it should be a cerebral exercise. We don't. We believe that it's an emotional connection between the viewer and the artist."

Spielberg described Rockwell as "the great American storyteller" who told stories "in a flash; he did this with a single image. He invites you to explore the image... and to question why." Lucas agreed. Rockwell was like a movie director, he said, who used cinematic devices to tell his stories. "Every picture [shows] either the middle or the end of the story, and you can already see the beginning even though it's not there. You can see all the missing parts...because that one frame tells everything you need to know. And, of course, in filmmaking we strive for that. We strive to get images that convey visually a lot of information....Norman Rockwell was a master at that,...at telling a story in one frame."

Rockwell worked on canvas; his pictures are single scenes in which curiosity, excitement, and humorous character quirks are conveyed through facial expression and body language. Unlike their quick-take impact, the films of Lucas and Spielberg are time contingent; their stories unfold in the hermetic spaces of darkened theaters. The witty dialogue, thunderous special effects, evocative music, and dramatic lighting they use to compel anticipation, tension, and emotional connectedness are more complex than the paint and canvas that Rockwell employed. Yet he, too, constructs alternative realities that nurture our love for fantasy, our sense that goodness can exist in the world, and that ordinary people with ordinary failings can overcome the forces

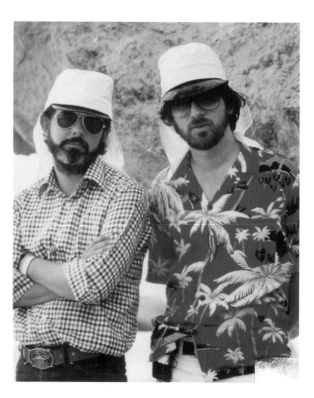

George Lucas and Steven Spielberg

Raiders of the Lost Ark location shoot, Tozeur, Tunisia, 1980. Photograph courtesy Steven Spielberg

of darkness that threaten the principles of our individual and collective lives.

The audiences of Spielberg, Lucas, and Rockwell come from different generations. The two filmmakers began their work in the 1970s as Rockwell's career was coming to a close. Rockwell had seen the nation through the prosperous years of the 1920s, the depression, World War II, and the growth of suburbia in the 1950s by idealizing individuals and celebrating families. In the 1960s, in paintings of astronauts, Peace Corps volunteers, and civil rights workers, he frankly acknowledged a changed and changing society. Spielberg, who owns several Rockwell paintings of the 1960s, observed, "It must have been heartbreaking for Norman Rockwell to watch the American dream start to evaporate, as it did…because the American dream in one iteration must change to become the next generation's dream…. When we had the free speech movement in the 1960s, and the trial of the Chicago Seven, and we had Kent State, and the Vietnam War, and the whole revolution—the second American Revolution, that great civil upheaval—I think that affected Rockwell's work very, very much…. The torch was being passed from the idealizing of the American dream with the Thanksgiving turkey and the entire family together, to something with a little more stridency in its voice."

Lucas noted a different order of change since Rockwell began working. "We are now going through a visual metamorphosis with digital technology," he said, that affects "the way kids grow up…. [Today] kids' experiences are so much different than the kids of the 1920s and 1930s in terms of the way they play. But," he said, speaking of paintings in his collection, "the simple awe of watching a toy being made, or playing baseball and somebody arguing—those things are eternal."

The painter's stories, and the ideals they reflect, fascinated these two friends and sometime collaborators and drew them to value, and collect, the work of Norman Rockwell. In *E.T.: The Extraterrestrial, Saving Private Ryan,* and dozens of other films Spielberg has produced or directed; in *American Graffiti,* the "Star Wars" series, *The Land Before Time,* and more than a hundred other films Lucas has written, produced, or directed; and in the "Indiana Jones" movies on which they collaborated, there is a Rockwellian sense of rightness and goodness that reflects a desire, in Lucas's words, "to make everybody whole again."[9] With humor and pathos, these three mythmakers have transformed ordinary people and quotidian incidents into stories that show us not only our better selves, but also the aspirations and ideals that have sustained Americans through good times and bad for more than three hundred years.

**Norman Rockwell
with Anne Morgan**
preliminary photo for *The Checkup,*
1957. Norman Rockwell Archives,
Norman Rockwell Museum,
Stockbridge, MA

1 Unless otherwise cited, this statement by George Lucas and those that follow were made during an interview with Laurent Bouzereau and Virginia Mecklenburg commissioned by the Smithsonian American Art Museum that took place at Skywalker Ranch on September 12, 2008.

2 Jim Windolf, "Keys to the Kingdom," *Vanity Fair,* February 2008, 120. The information about the early years of Spielberg and Lucas's lives and careers is drawn from this article. See also, Jim Windolf, "Q & A: George Lucas," *Vanity Fair* Web exclusive, January 2, 2008, www.vanityfair. com/culture/features/2008/02/lucas_ quanda200802, accessed July 17, 2008; and Jim Windolf, "Q & A: Steven Spielberg," *Vanity Fair* Web exclusive, January 2, 2008, www.vanityfair. com/culture/features/2008/02/spielberg_ quanda200802. Accessed July 17, 2008.

3 Windolf, "Keys to the Kingdom," 120.

4 Ibid.

5 Ibid., 123.

6 Ann Hornaday, "The Lord of the Light Side," *Washington Post,* Aug. 10, 2008, M5. Although Hornaday was writing specifically about *Star Wars: The Clone Wars,* her words ring true for the "Indiana Jones" series and Lucas's other movies as well.

7 Unless otherwise cited, this statement by Steven Spielberg and those that follow were made during an interview with Laurent Bouzereau commissioned by the Smithsonian American Art Museum that took place at the Amblin Entertainment offices on August 6, 2008.

8 Quoted in Allison Adato, "The People in the Pictures," *Life,* July 1993, 84.

9 Quoted in Lisa Vincenzi, "A Short Time Ago, on a Ranch Not So Far Away," in *George Lucas Interviews,* ed. Sally Kline, 163 (Jackson: University Press of Mississippi, 1999).

Norman Rockwell
on the set for *Little Girl Looking Downstairs at Christmas Party,* 1964. Norman Rockwell Archives, Norman Rockwell Museum, Stockbridge, MA

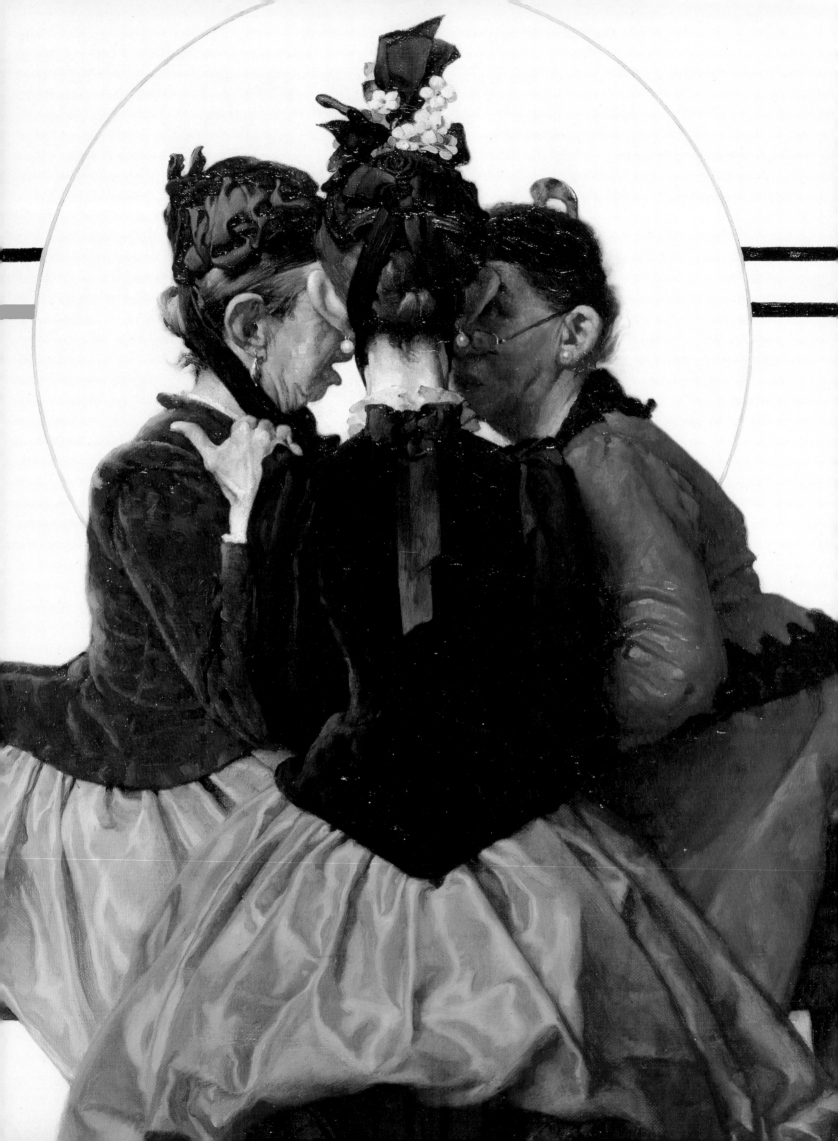

DADS PUZZLING OVER THEIR SONS' HOMEWORK, A TERRIFIED BOY clinging to the edge of a twenty-foot-high diving board, a little girl's first trip to the beauty shop—Norman Rockwell (1894–1978) conjures moments of delight, discovery, and the memory of youthful realizations that mark the transition from childhood to adult life. Rockwell was a keen observer of the world who captured the realities of individual lives as well as the mores that society held dear. And he did so in personal terms. His motifs—children, families, a truck driver winking at a pretty girl—were and are facts of ordinary life. But his pictures are much more than quick vignettes of fleeting memories or constructions that project the ideal onto the quotidian. Within them he embedded ideas about responsibility, heroism, patriotism, gender equity, and, later, racial integration, that tapped into the foundations of American culture as well as the evanescent beliefs of an ever-changing society. As filmmaker and art collector George Lucas remarked, Rockwell recorded our fantasies and ideals and gave us a sense of what was in our heads and hearts.[1]

Rockwell was also a master humorist with an infallible sense of the dramatic moment. Like a movie director, he determined the pose and facial expression of each character, positioned each prop, and lighted his sets for maximum scenic effect. His early magazine covers resemble frames from silent movies, in which sight gags, pratfalls, and stereotypes prompt the laughter of sudden recognition. But, as Lucas aptly recognizes, Rockwell's work was constantly evolving. His pictures from the 1910s and 1920s are simpler than those of the 1940s and 1950s in the depth and breadth of their emotional content as well as in the complexity of their compositions and the nature of their narratives. By the 1940s, his single-image stories represented climactic episodes in ongoing plots that implied prior and succeeding moments and played out in increasingly elaborate scenarios.

A magazine cover—Rockwell is best known for the *Saturday Evening Post* covers he painted from 1916 until 1963—had only a split second to reach its audience. When lined up on a newsstand, *Collier's, Cosmopolitan,*

Virginia M. Mecklenburg

Telling Stories

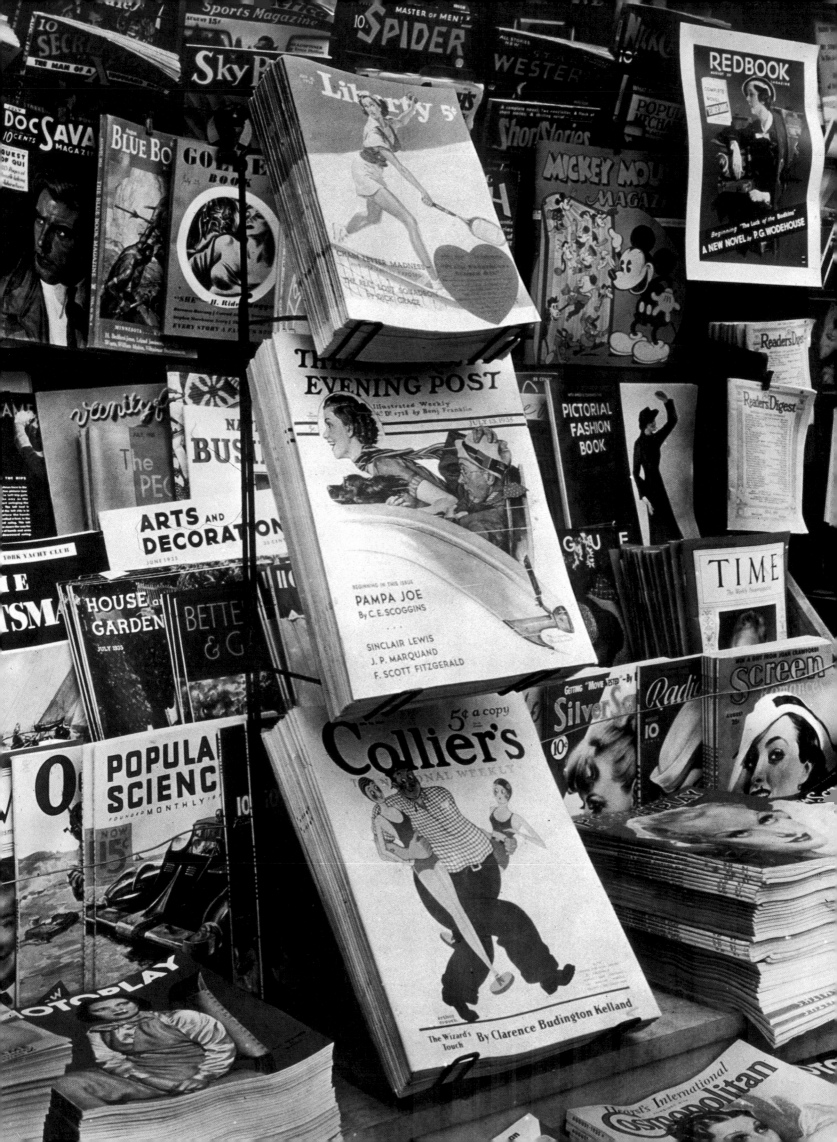

Good Housekeeping, Ladies' Home Journal, McClure's, Redbook, the *Saturday Evening Post,* and, beginning in the 1930s, *Life* and *Look,* competed for attention. (fig. 1) The most successful covers grabbed the reader through sheer visual impact.

Rockwell is one of many artists whose magazine covers, advertisements, and book and story illustrations flooded the American print media during the early and middle years of the twentieth century. J. C. Leyendecker, Howard Pyle, and N. C. Wyeth were famous by the turn of the twentieth century; John Falter, Mead Schaeffer, Steven Dohanos, and many others became well known in the 1940s and 1950s. Among them Rockwell stands out. His name became synonymous with the *Saturday Evening Post* and is now a household word, familiar to baby boomers who, as children, rushed home from school to pore over the cover of the latest issue, as well as to people born long after he left the magazine. The adjective "Rockwellian" is now part of the popular jargon, used to describe movies, pictures, and stories that depict traditional values, simple pleasures, and ordinary people with wit and warmth.

Rockwell has been called a painter of nostalgia, a Pollyanna who avoided dealing with the hardships of the depression in the 1930s, the anxieties of the cold war years in the 1950s, and the trauma of racial conflict during the civil rights era.[2] In fact, unlike the paintings of early-twentieth-century reformists John Sloan and George Bellows or social realists Ben Shahn and William Gropper in the 1930s, Rockwell rarely used art as a social instrument until he began working for *Look* magazine in 1963. Subtly yet adroitly, however, his pictures acknowledged that values associated with rural versus uban life—prompted by the huge migration of individuals from farm to city in the 1910s and 1920s and from city to suburb in the 1950s—were changing, as were concepts of childhood and family. His 1933 *Post* cover *Child Psychology,* for example, offered a quick chuckle for parents confused by competing theories about discipline and reassured them that others shared their dilemma. (fig. 2) He reported on life in the 1930s not by reminding us of the traumas of Hoovervilles and breadlines, but rather by showing us the glamour of the golden age of Hollywood and the quiet satisfaction of a good book. And his themes are universal. Images of scampish boys playing childhood pranks, little girls determined to outdo little boys, or the emotional bonds between grandparents and grandchildren not only speak to the middle-class, mostly white people depicted in his work, but also embody memories and emotions that people the world over share.

Many writers on Rockwell have taken him at face value, accepting his description of himself as an artist who lived an uncomplicated life in small-town America. Even early interviewers reported the self-image he projected of a modest artist with a wry sense of humor who painted life as he would like it to be. This hermetic view focuses on the painter and his pictures without considering the broader context of editorial policies at the magazines he worked for, issues that caught the public

1

Unidentified Photographer
Newsstand Magazines
July 1935
Hulton Archive/Getty Images

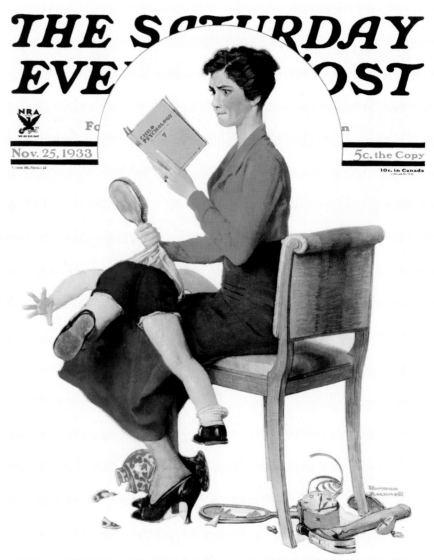

2

Child Psychology
The Saturday Evening Post,
November 25, 1933

psyche at a given moment, or his personal growth as an artist and individual. Rockwell may have led a simple lifestyle, but he was not a simple man. Across more than five decades, he carefully constructed images to create the appearance of simplicity and to convey narratives that had widespread appeal. As an illustrator for commercial publications, he constantly juggled the demands of editors, art directors, and shifting editorial policies, and he accommodated advertising agencies charged with satisfying client requirements. He was also acutely aware of the need to stay current. He captured passing fancies and momentous events—the jazz craze and the stock market crash in 1929, the one-hundredth anniversary of baseball in 1939, and the vogue for hitchhiking in 1940—as well as larger social issues faced by a country negotiating the changing circumstances of twentieth-century life.[3] It is a tribute to, not a criticism of, his highly developed intellect and social sensibilities to acknowledge that Rockwell calculated his pictures for maximum and particular impact.

Initially for children's magazines, in ads for products sold by more than 150 companies, and on the covers of the *Saturday Evening Post* from 1916 through the early 1960s, Rockwell's images touched millions of Americans. His pictures, like the writings of Sinclair Lewis, the poetry of Robert Frost, and the movies of Frank Capra and William Wyler in the 1930s and 1940s—and those of George Lucas and Steven Spielberg since the 1970s—captured the hopes and dreams, and also the anxieties, of life in twentieth-century America.

Boys' Life

Rockwell started out as an illustrator of magazine stories and books for children. At age eighteen he was an ideal choice to become the first art director when, in 1912, the Boy Scouts of America launched *Boys' Life,* the national magazine the newly formed organization would send to tens of thousands of members. In his illustrations of Boy Scouts in action, Rockwell rehearsed the values of the masculine, outdoor life promoted by former President Theodore Roosevelt and played out fantasies of hero-ism and athletic prowess that escaped him as a skinny, pigeon-toed youth with big ears and knobby knees.[4]

A gangly boy who constantly compared his own scrawny frame with that of his athletic, older brother, Jarvis, Rockwell avoided sports and instead incessantly drew. "Art," remarked one commentator, "was Rockwell's path to self-esteem."[5] By the time he was fourteen, he had determined to become an illustrator. He dropped out of high school after his sophomore year and traveled daily into New York City to study art, first at the National Academy of Design and then with George Bridgman and Thomas Fogarty at the Art Students League.[6] When Robert McBride & Company needed illustrations for a new volume in a series of children's books—the "Tell Me Why" Stories by Carl Harry Claudy—Fogarty sug-gested Rockwell, who crafted a dozen illustrations for which he was paid a total of $150.[7] In the fall of 1912, Fogarty heard that the new Boy Scout organization—the U.S. branch was founded in the summer of 1910—had recently bought a struggling magazine to serve as its official publication, and he suggested that Rockwell check to see if they needed an illustrator. The pen-and-ink pictures Rockwell drew for a story by popular writer Stanley Snow pleased *Boys' Life* editor Edward Cave, who published them in the January 1913 issue of the scouting magazine and also asked Rockwell to illustrate Cave's forthcoming book about hiking. When Cave saw the more than one hundred illustrations Rockwell com-pleted for the *Boy Scout's Hike Book,* Cave offered Rockwell a job doing a *Boys' Life* cover and illustrations for a story each month at a salary of $50. Rockwell was thrilled and accepted on the condition that he could also work for other magazines and book publishers. Within the year, he had been promoted to art director. He continued to do monthly covers and story illustrations for *Boys' Life* and parceled out the remaining work to other illustrators.[8]

Steven Spielberg, an Eagle Scout who made his first film for a merit badge, once remarked that "aside from being an astonishingly good story-teller, Rockwell spoke volumes about a certain kind of American morality."[9] Strength of character, consideration for others, love of country—all were values that Rockwell captured in the magazine covers and story illustrations he did for *Boys' Life* and in the Boy Scout calendar images he painted almost every year from 1924 through 1976.[10] They also recur in his most famous paintings—the 1943 renditions of Franklin Roosevelt's Four Freedoms that reminded Americans of the guiding principles on which the country was founded and helped rally the nation to the cause during World War II.

Rockwell's earliest images for *Boys' Life* featured predictable themes of heroism and selflessness. Scouts at the helm of a ship, on a raft rescuing an injured sailor in dangerously rough seas, helping an elderly man cross a snowy street—the pictures reflected the oath each Boy Scout took to do his duty to God and country, to help others, and to keep "physically

3

Tail End of a Dive
Boys' Life, August 1915

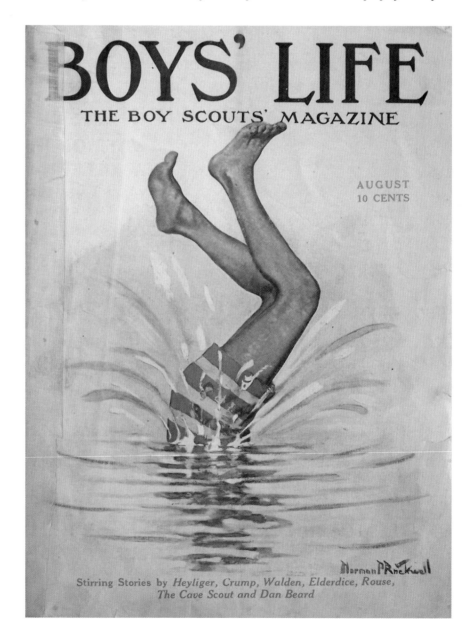

strong, mentally awake, and morally straight."[11] The outdoor life that President Theodore Roosevelt promoted during Rockwell's youth found expression in scenes of boys hiking, hunting, camping, and playing football. But Rockwell understood that not all boys could identify with the rugged images of strong, physically fit youth who epitomized the Scout ideal and that too heavy a dose of duty misrepresented the life of the ordinary American boy. So he interjected some fun. For the August 1915 cover, the flailing legs of a diver protrude upward from a splash; his head and torso have disappeared under water. (fig. 3) Although Rockwell risked rejection by an editor looking to publish heroic images, *Tail End of a Dive* introduced the boyish sense of humor that made the young illustrator famous when he began doing covers for the *Saturday Evening Post.*

Rockwell was soon in demand to illustrate stories and articles for many of the country's major juvenile magazines. In 1913 he had begun drawing illustrations for *Everyland,* and by 1915 his work was appearing in *St. Nicholas* and *Youth's Companion.* Book publishers sought him out as well. By the time he was twenty-six, his illustrations had appeared in at least fifteen volumes, and he was touted as "one of the best and most popular of the great magazine artists today."[12]

Two Million Walls

Pictorial calendars had been big business since the late 1880s when two struggling journalists in Red Oak, Iowa, needed to give a boost to their flagging newspaper. They printed a picture on poster-weight paper, attached a calendar pad, and sold the product to local businesses. Their quick success soon spawned competitors, among them Brown & Bigelow of St. Paul, Minnesota. By 1904 the firm circulated promotional materials assuring customers that the cheapest method of advertising was to print the names of their firms on calendars that clients checked every day.

In 1923, Brown & Bigelow approached the Boy Scouts about producing a promotional calendar. It was a brilliant marketing scheme. The calendar featured an appropriately themed artwork above a calendar pad with tear-off sheets for each month of the year and was purchased by firms that distributed them free of charge to customers. The local companies, whose names were printed on the calendars, were thereby connected with the values associated with scouting, and images of Boy Scouts doing good deeds reached hundreds of thousands of people all over the country. It was an excellent way to recruit Scouts; Boy Scout headquarters received royalties; and Brown & Bigelow expanded its already huge market.

The first calendar, which appeared in 1925, featured *A Good Scout,* a picture of a boy in uniform bandaging a puppy's paw while the worried mother dog looks on, a painting that Rockwell had made for a 1918 issue of the *Red Cross Magazine.* Its success prompted the Boy Scouts to approach Rockwell about painting an image for the 1926 calendar. He agreed to do a picture that would also be featured on the cover of the February issue of *Boys' Life* magazine that year, an arrangement that continued almost

every year until 1976, when he painted his last calendar in honor of the country's bicentennial anniversary. To support the Boy Scout cause and thank the organization for having given him his start, Rockwell offered to do the 1926 calendar pro bono.[13] The Scout calendars caught on fast. Soon some two million copies with signed Rockwell images bearing the names of department stores, insurance agencies, gas stations, drug stores, real estate firms, bowling alleys, and grocery stores were tacked to walls throughout the country.[14]

Spirit of America, the Boy Scout calendar art for 1929, is an iconic image that links youth with tradition, present events with past greatness. (fig. 4) Behind a full-color profile of a mature Scout in uniform hover faces of notable Americans painted in blue grisaille. George Washington, Abraham Lincoln, Theodore Roosevelt, Benjamin Franklin, a pioneer, an American Indian, and Charles Lindbergh—all symbols of America—convey the heroism and sacrifice that defined Boy Scout, and national, character. Like heads on ancient coins, Rockwell's profiles are emblems, symbolizing strength, power, or universal truth. Spielberg, in fact, calls Rockwell one of the greatest profile artists in history.[15]

Rockwell had included the head of a conquistador in a preliminary charcoal sketch for the painting, but when news arrived that Lindbergh had landed his Ryan monoplane, *The Spirit of St. Louis,* in Paris on May 22, 1927, the artist replaced the conquistador with the head of the flyer (who looks remarkably like the Scout), linking the Boy Scouts to a legacy that extended from America's founding fathers to its latest national hero and affirming that even ordinary boys could achieve greatness.[16]

Lindbergh's success was big news in 1927. An unassuming American youth had triumphed in a daring venture and won the coveted Orteig Prize for the first person to fly nonstop between New York and Paris. In addition to the $25,000 award, the winner would go down in history. Famous pilots in the United States and Europe planned their routes and calculated the amount of fuel required for the 3,600-mile flight, but it was Lindbergh, a twenty-five-year-old airmail pilot from the Midwest who made the dangerous trip. The day he took off from Roosevelt Field in New Jersey, the *New York Times* reported that Lloyd's of London refused to issue odds on Lindbergh's success and that many in government circles considered the mission suicidal.[17]

Not since the Armistice in 1918 had the country rallied with such wild enthusiasm. Newspapers reported Lindbergh's life story and canvassed friends and colleagues for anecdotes about the young aviator. The *New York Times* called him the "Scion of Viking Forbears," who hoped to emulate the daring exploits of his ancestors.[18] News photographers and Movie-Tone cameramen broadcast images of the six-foot-tall, blue-eyed, sandy-haired Lindbergh to audiences around the world. Best of all, he was an ordinary guy. Friends based at the flying field in St. Louis where he had worked as a mail pilot recounted Lindbergh's love of practical jokes, and one Mr. Knight, a backer of the transatlantic venture, reported

4

Spirit of America
Boy Scouts of America Calendar, 1929. Oil on canvas, 20 × 16 in. Collection of Steven Spielberg

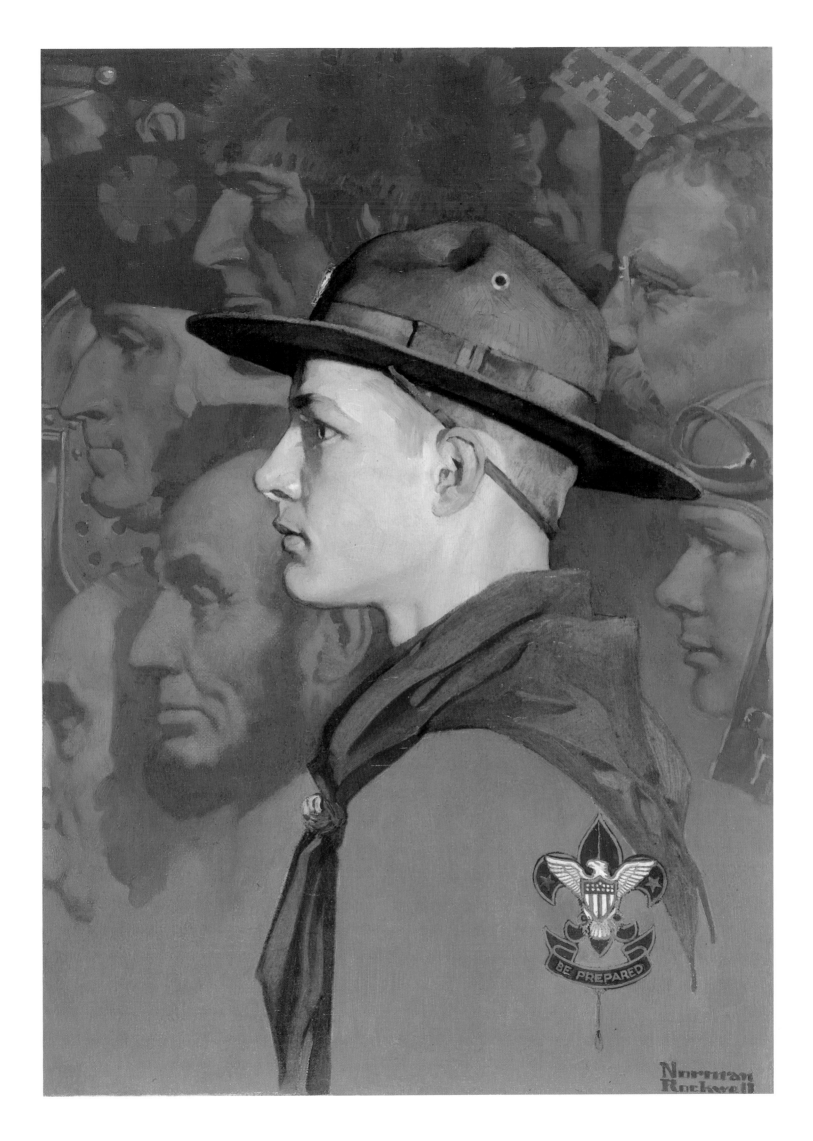

that Lindbergh would rather "sleep on the floor than in a bed" and that
he "does not smoke, drink, even coffee, chew or like the movies. He does
not like to stay up late at night and hasn't much use for girls or dancing."[19]
Lindbergh's mother, who went to her job as a high school chemistry
teacher in Detroit the day he took off, described him as "just an ordinary
every day boy."[20]

Well-wishers at Roosevelt Field held their breath as the fuel-laden *Spirit
of St. Louis* skimmed over telephone lines and a parked tractor at the end
of the runway. Throughout the day and night, newspapers tracked his
progress. An ocean liner, the steamship *President Roosevelt,* altered course
and aimed powerful spotlights into the sky, hoping that Lindbergh would
see the ship through fog and sleet and know he was on course. The
French government banned all other night flights and turned on the new
Mont Valérien beacon, which could be seen as far away as London, to
help guide him in.[21]

When he landed in Paris, at 10:24 pm on May 22, after thirty-three-and-
a-half hours in the air, airfield workers had to pull the exhausted Lindbergh
from his plane to prevent his being overwhelmed by cheering crowds.
Three weeks later, hundreds of thousands of New Yorkers thronged
Broadway and Fifth Avenue for the new hero's welcome-home parade. The
city was awash in likenesses of Lindbergh and his plane. Lapel buttons,
neckties, painted watermelons, French pastries, soap carvings, and
crocheted items were available to the "multitude which was five miles
long, two blocks wide and five hundred feet high."[22]

The reception in St. Louis was equally enthusiastic. A half-million
people lined the streets, hoping for a glance of "Lucky Lindy." St. Louis Boy
Scouts, many of whom helped police with crowd control, cheered when a
young Scout of the Flying Eagle Patrol presented Lindbergh with a certificate
honoring him as an official Scout. In a formal address U.S. Secretary of
War Dwight F. Davis called Lindbergh a "modern [Christopher] Columbus,"
and compared him to Lewis and Clark, who had left St. Louis more than
a hundred years earlier to "explore the unknown reaches of the West."[23]

The message of *Spirit of America*—the integrity and courage of the
nation's youth—reflects Rockwell's sensitivity to the values the Boy Scout
organization has instilled in multiple generations of American boys.
Spielberg, in fact, credits scouting with the discovery of his life's work. He
got the moviemaking "virus" when the Scouts of Troop 294 in Scottsdale,
Arizona, laughed and clapped at an 8-mm movie he made for a merit badge.
He also loves the Boy Scouts, he said, "because they created a great sense
of independence." Scouts, he continued, "give you a real chance to grow
up outside the family." Working for the Boy Scouts put special demands
on Rockwell. Chief Scout Executive James West routinely solicited ideas
from the organization's staff and presented their suggestions to Rockwell.
Only after agreement was reached on a theme did Rockwell begin work.
But West, ever vigilant that the paintings be accurate as to uniform,
badges, and insignia and also represent scouting's high ideals, often sent

5

Pioneer of the Air
The Saturday Evening Post,
July 23, 1927.
Oil on canvas, 22 ½ × 18 ½ in.
Collection of Steven Spielberg

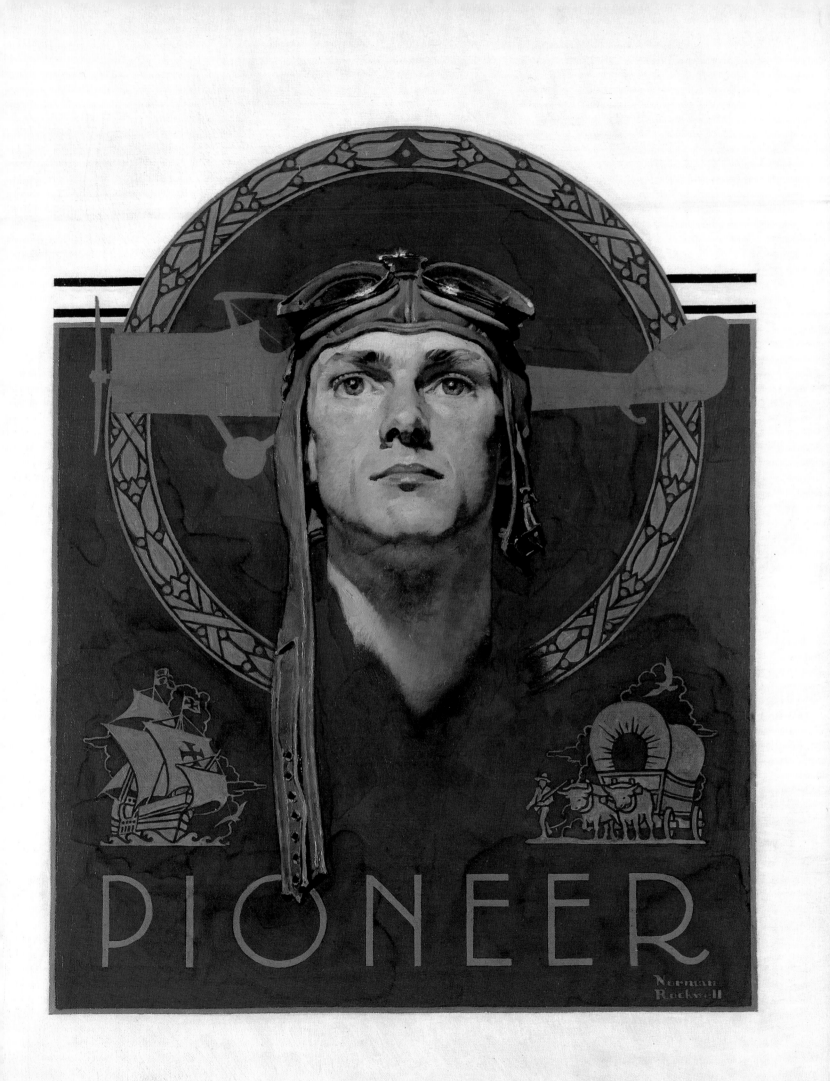

a representative to Rockwell's studio to check on his progress.[24] Rockwell later remarked that the Boy Scouts were the most exacting of the hundreds of clients he worked for in his sixty-five-year career.

On hearing of Lindbergh's success, Rockwell dropped everything else and painted for twenty-six hours straight to finish a portrait of Lindbergh in time for the July 23, 1927, issue of the *Saturday Evening Post.*[25] The cover featured *Pioneer of the Air,* a frontal portrait of Lindbergh wearing his flying helmet and goggles atop his head against a sky-blue field. (fig. 5) Rockwell drew on Secretary of War Davis's words for the heraldic image of the determined young mail pilot by showing Columbus's *Santa Maria* and a Conestoga wagon to represent the arduous trek of Lewis and Clark and thousands of unnamed pioneers who had settled the western lands. Lindberg's own *Spirit of St. Louis* appears in silhouette in the background.

This was not the first time, nor would it be the last, that a Rockwell image reflected the national imagination. He was sensitive to contemporary events, but the lag time between completing a painting and its appearance as a *Post* cover was usually several months, so instead of capturing breaking news, Rockwell interpreted the impact of current events and changing social trends on the ordinary American citizen. Like Frank Capra, whose enormously popular movies of the 1930s and 1940s celebrated the common man, Rockwell developed a visual iconography that cast the little guy as hero.

Creating a National Constituency

The decade of the 1910s was a golden age for magazine publishing in the United States, and especially for the three publications owned by Cyrus H. K. Curtis. A brilliant businessman, Curtis had launched the *Ladies' Home Journal* in 1883, and in August 1897 he purchased the failing *Saturday Evening Post.*[26] With a circulation of just sixteen thousand, it was poorly printed and ranked near the bottom in the list of magazines aimed at a middle-class audience. In 1898, Curtis hired George Horace Lorimer, a young reporter for the *Boston Herald* who had graduated from Yale, worked as a junior executive with the Armour meatpacking company in Chicago, and then gone into newspaper work. After Lorimer read wire reports that Curtis had bought the *Post,* Lorimer telegraphed him for a job. Curtis hired Lorimer as literary editor and within a year promoted him to full editorship of the magazine. Lorimer came to his job believing that he could create a national voice that embodied the values of the average American. Hundreds of newspapers and magazines around the country targeted local or specialized markets, but few aimed at the broad American middle class that Lorimer hoped to reach.

The *Post* had two counterparts within Curtis Publishing: the enormously successful *Ladies' Home Journal,* edited by Lorimer's friendly rival Edward Bok, which appealed primarily to homemakers, and the *Country Gentleman,* directed at people who lived on farms and in rural communities. As editor of the *Post,* Lorimer looked for a format and content that would attract

their constituencies as well as his own. He determined to create a vehicle that would package the best informative articles, fiction, and illustration into an inexpensive weekly—it cost five cents—that would appeal to almost everyone and along the way create a sense of national identity.[27] In a two-page editorial in December 1899, Lorimer announced "*Post* Plans for 1900."[28] The *Post* would appeal to the "average American" and carry fiction aimed at the wholesome tastes of that individual.[29] In the year that followed, the magazine published stories by Rebecca Harding Davis, Paul Laurence Dunbar, Joel Chandler Harris, Bret Harte, Hamlin Garland, and dozens of other popular writers. Articles, serialized novels, and cover illustrations were aimed primarily at men in their twenties and thirties. Stories like "The Serene Duck Hunter" by Grover Cleveland, "The Fire Fighters" by Herbert E. Hamblen, Frank Norris's "The Pit," and Jack London's "The Call of the Wild," along with covers showing frontiersmen, outdoorsmen, and languorous young beauties were strategically selected to appeal to this target audience.[30] To help the enterprising young businessman, Lorimer also featured articles about getting ahead through hard work, modest investments, and the values of diligence and common sense in the commercial world.

To link urban and rural readers within a single moral framework, Lorimer published in 1902 a series of letters that an erstwhile merchant with the unlikely name of Gorgon Graham had written to his college-bound son. Horatio Alger–like, Graham had become a successful businessman and wanted to pass on lessons he had learned in his long career. Despite inauspicious beginnings, Graham had succeeded in business through pluck and hard work. His message to his son warned against presuming that he would reap the benefits of his father's thrift and industry without demonstrating similar initiative himself. Graham's letters were kindly, loving, and funny, but within them Lorimer wove a tapestry of optimistic and cautionary values. The message of the letters was straight out of Benjamin Franklin's *Poor Richard's Almanac,* written in the untutored language of a Huckleberry Finn. The letters, which appeared in serial form in 1901 and 1902, were strategically crafted for an audience of young and old, rural and urban, who hoped to get ahead in life—in other words, every-one. Although Lorimer skated close to the edge of editorial propriety in printing correspondence he had written that purported to be the authentic work of a wise if unschooled author, the series struck a powerful chord with readers. Some five thousand letters deluged the offices of Curtis Publishing, and when the series was repackaged as a book, *Letters from a Self-Made Merchant to His Son* became an international best-seller.[31] With them Lorimer established the moral compass that the *Post* would follow for the duration of his long career and that would make Rockwell a perfect fit with Lorimer's editorial views.

Magazine success was measured in terms of readership, and under Lorimer's deft control the *Post* was, by all accounts, making huge strides. By 1903, just four years after he became editor, the magazine had grown

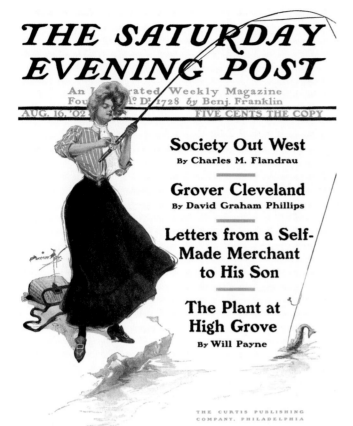

THE SATURDAY EVENING POST

An Illustrated Weekly Magazine
Founded A° D' 1728 by Benj. Franklin

AUG. 16, '02 FIVE CENTS THE COPY

Society Out West
By Charles M. Flandrau

Grover Cleveland
By David Graham Phillips

Letters from a Self-Made Merchant to His Son

The Plant at High Grove
By Will Payne

THE CURTIS PUBLISHING
COMPANY, PHILADELPHIA

6

Harrison Fisher
Girl Fishing
The Saturday Evening Post,
August 16, 1902

to a circulation of more than one-half million, which meant that probably five times that number read each issue.[32] Wide circulation attracted advertisers, the primary source of magazine revenues. Lorimer soon realized that he could significantly increase advertising income by expanding into the women's market and capturing ads for goods they were likely to buy.

In June 1908, the *Post* announced that it was "Not for Men Only," and over the next several years, Lorimer extended the magazine's reach to women in terms of readership and advertising draw.[33] The first two articles designed to appeal to female readers, on complexions and jewels, now seem paternalistic and irrelevant to middle-class women who worked hard at raising children and tending house. But Lorimer's gamble succeeded. Advertisers were smart about committing their promotional dollars to publications aimed at potential purchasers of their products. By extending the *Post*'s purview to homemakers, the magazine acknowledged that women were the primary shoppers for families, and it began attracting ads for packaged food, appliances, products for children, and goods for the home, as well as for automobiles and office furniture, the primary purchasers of which had traditionally been men.[34]

The tactic paid off. The proportion of advertising increased substantially and by October 1909 accounted for more than half of the magazine's total page count. Two of the five full-page ads that month, the most expensive and desirable from a publisher's point of view, were for Ivory Soap and Hoover Electrical Suction Sweepers, products designed to appeal to wives and mothers who wanted to bathe their babies in a soap that was pure (Ivory Soap's tagline promised it was "99 and $^{44}/_{100}$ percent pure") and spend less time doing housework.[35]

Having expanded content to attract women raising children, by 1910, the ever-practical Lorimer began reaching beyond decorating and home economics to appeal to the country's rapidly growing number of working women. "Banking Don'ts for Women," for example, explained how to endorse a check. Firsthand accounts of the careers of successful businesswomen followed. In a series called "Petticoat Professions," Maude Radford Warren wrote engagingly of women in law, education, and the arts, and in 1911 the *Post* published interviews she conducted with women who had purchased land and were farming in the West.[36]

By the spring of 1916, when Rockwell's first cover was published, the *Post* was almost as well known for the quality of its cover illustrations as for the reading material inside. In its first decade, cover illustrations were usually linked to articles or fictional stories inside each issue or, when independent of content, featured patriotic renderings by J. C. Leyendecker,

the illustration giant now best remembered for the elegant, square-jawed Arrow Collar Man he developed for the shirt manufacturer; images of pretty women in lovely bonnets by Henry Hutt; or pictures of graceful girls pursuing athletic pastimes of golf, shooting, and fishing by Harrison Fisher.[37] (fig. 6) With few exceptions, images of children were absent when the magazine was directed at men. But in the fall of 1908, after having announced that the magazine had expanded its purview, covers showing little boys surrounded by toys at Christmas or digging into huge servings of Thanksgiving turkey began to appear.[38] Mothers cuddling beautiful babies became a staple, as did nostalgic pictures of the elderly, conscious changes that grew out of Lorimer's decision to expand the magazine's audience.

Not until August 1911, with a Leyendecker picture of little boys skinny-dipping in a lake, did Lorimer introduce humor to the otherwise elegant format. By 1912, amusing covers featuring children appeared eight or ten times a year. Pictures of a little boy whose head is trapped in a clamp to hold him still for a portrait photographer, a teacher holding a schoolboy by the ear while a schoolmate laughs, and an adolescent pitcher in a baseball uniform balancing on a chair in front of a mirror practicing his windup were designed to capture the hearts and minds of the *Post*'s maternal readers, as well as the paternal and adolescent male population.[39]

A *Post* Man

Rockwell's oft-told tale about his first visit to the *Saturday Evening Post* in 1916 is a biographical staple. Encouraged by his friend Clyde Forsythe, a cartoonist and painter of western landscapes with whom he shared a studio, Rockwell screwed up his courage, took the train from New York to Philadelphia, and presented himself along with two fully realized paintings and several idea sketches at the editorial suite in the impressive new offices Curtis had built overlooking Independence Square. Rockwell was shocked and thrilled that the two paintings were accepted on the spot and that he was asked to work up the sketches into cover illustrations. More startling, he walked away with a check.[40] Flush with success, he proposed to Irene O'Connor, a pretty schoolteacher who lived in the boarding house where Rockwell resided with his parents.

The immediate response to Rockwell's pictures partially explains Lorimer's early and quick success in attracting high-quality and big-name contributors to the magazine. He promised writers and artists a yes-or-no response within seventy-two hours of receiving their submissions and payment on acceptance. With the *Post,* they no longer had to wait weeks or months for an answer before being able to submit rejected work to more receptive editors.

When Rockwell turned up on Lorimer's doorstep, he brought images that dovetailed with the *Post*'s new visual preferences. Rockwell repeatedly credited Forsythe with encouraging him to "try for the *Post*." Following the more experienced artist's advice, he immediately set to work on his version of the "beautiful woman" cover that had made Howard Chandler

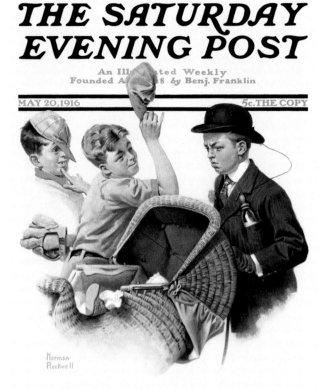

THE EMPIRE BUILDERS—By Mary Roberts Rinehart

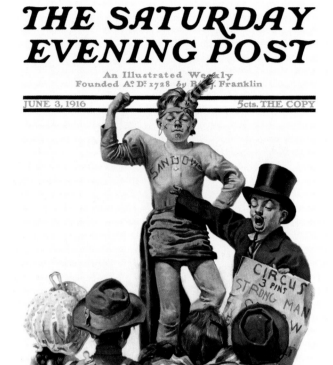

FRANCE AND THE NEW AGE—By Will Irwin

7

Boy with Baby Carriage
The Saturday Evening Post,
May 20, 1916

8

The Circus Barker
The Saturday Evening Post,
June 3, 1916

Christy, Harrison Fisher, and Charles Dana Gibson household names. On seeing the results, Forsythe advised Rockwell to go back to doing images of children: "Do what you are best at. Kids."[41]

Rockwell's first *Post* cover appeared on the May 20, 1916, edition. (fig. 7) Its story—of a well-dressed adolescent boy pushing a baby carriage to the amusement of two "real boys" wearing baseball uniforms—reprised, with a twist, a 1913 cover by Charles A. MacLellan, which showed a sullen boy pushing a baby carriage.[42] The MacLellan picture was amusing, but it lacked the extra spark of humor that Rockwell achieved by including a baby bottle in the boy's breast pocket and a couple of snickering friends, whose gestures resemble the exaggerated postures of actors in silent films. In *Boy with Baby Carriage,* Rockwell introduced the device of implied narrative that characterized his work for much of his life. The interplay among the figures encodes a story line that is enhanced by his choice of costume and props. Rockwell was particularly proud of the baby bottle. More than any other single element in the picture, the prop clinches the emotional tenor of the image.

Two weeks after *Boy with Baby Carriage* appeared, the *Post* published Rockwell's image of a boy dressed as circus barker and wearing a painted mustache who points to the "strong man" in a sideshow. (fig. 8) Five children constitute the audience. The strong man in Rockwell's rendition is a skinny adolescent whose wrinkly shirt sleeves have been stuffed with artificial "muscles." The shirt also bears the crudely lettered name Sandow, after

the pioneering bodybuilder Eugen Sandow, who had flexed his muscles to the delight of crowds at the 1893 World's Columbian Exposition and continued to be news in physical-fitness circles for several decades. (He made headlines in England and the United States in 1911, when he was appointed "Professor of Scientific and Physical Culture" to King George.) Putting on circuses was a popular pastime for children during the summer months. Rockwell's young strong man is reminiscent of the scamp protagonist of Booth Tarkington's 1914 novel *Penrod,* in which Penrod and several friends "get up" a show in the hayloft of the family barn to pass the time on hot summer day. For a September cover, Rockwell pictured a ragged, carrot-topped boy standing with clenched fist in front of a fence on which is scrawled "Redhead Loves Hatty Perkins."[43]

In these three *Post* covers, Rockwell marked the seasons—the arrival of spring baseball, the summer circus, and back to school—by implying both the temporal and psychological realities that each moment represented. They were also personal for Rockwell. Although the ideas and the details of their subjects may not have come directly from his own childhood experiences, the changing sense of identity felt by adolescent boys as they move from childhood to adult life is both a universal motif and a reflection of Rockwell's early sense of inadequacy as a skinny, awkward kid. The images also poke fun at the obsession with the masculine ideal as a strong, virile type. It was not a new theme. Fear of being considered a sissy was the topic of stories and illustrations that filled the pages of juvenile magazines as well as publications for adult readers in the early years of the twentieth century and was found in the work of artists such as George Bellows, whose 1913 illustration *Business Men's Class* caricatured the quest for physical fitness. (fig. 9) Rockwell's images of boys pushing

9

George Bellows
Business Men's Class
The Masses, April 1913. Monoprint with graphite, crayon, pen and ink, and scratchwork, 15 ¹³/₁₆ × 25 ⅛ in. Courtesy of the Boston Public Library, Print Department, Gift of Albert H. Wiggin

10

People in a Theatre Balcony

The Saturday Evening Post,
October 14, 1916

strollers, flexing muscles, or accused of being sweet on a girl fit squarely into the popular discussions of the day and reappeared in the "Our Gang/ Little Rascals" movies of the 1930s, some of which were written by Frank Capra, a director whose plots and characters in the 1930s and 1940s paralleled themes Rockwell explored.

Although Rockwell does not seem to have mentioned Bellows, John Sloan, or the other artist-illustrators known as the Ashcan painters, he mimicked their eye-level perspective and their preference for depicting people they observed while strolling through the city. Growing up in New York, Rockwell and his brother, Jarvis, could not have missed seeing the cameramen of early silent movies shooting actuality films of incidents and odd characters encountered on city streets. Rockwell's images, like actuality shorts, presented what Sloan called "bits of human drama," capturing vignettes that he—and the *Post*'s readers—might have seen in the course of their daily lives.[44] Rockwell had little interest in the urban imagery that

compelled the Ashcan artists, but their focus on the interactions of ordinary people and their often humorous tone bear a remarkable kinship with the covers Rockwell crafted for the *Post* and the *Country Gentleman.*[45]

The next Rockwell cover to be published in 1916, *People in a Theatre Balcony,* introduced a subject that Sloan also explored. (fig. 10) It confirms Rockwell's early fascination with an industry that captured the imaginations of throngs flocking to storefront theaters and movie palaces throughout the country. The *Post* was just one of many magazines that capitalized on the national craze for movies, although Rockwell's image shows not the film itself. Instead, the delighted faces of parents, grandparents, and children are illuminated by the flickering light of the silent screen. Two of the watchers hold playbills featuring the face of Charlie Chaplin, whose outrageous antics made him the most popular comedic actor in the country, to ensure that readers would understand they were in a theater that showed movies rather than stage plays.[46] By focusing on the family, Rockwell acknowledged changing attitudes about the pernicious moral effects silent films were believed to have on children and simultaneously suggests that going to the movies was an appropriate leisure activity for all generations. He also signals an appreciation for Chaplin, whose oversized shoes and exaggerated gestures Rockwell used as humorous devices in magazine covers throughout the late 1910s and 1920s.[47]

A Navy Man

In April 1917, a year after Rockwell's first picture appeared on a *Post* cover, the United States officially entered World War I. American magazines and newspapers, including the *Post,* had sent reporters to Europe when the conflict broke out in 1914. Stories and articles told of action at the front and atrocities committed against civilian women and children in Belgium, but at least initially, few pictorial accounts published in the American press hinted at the horrors faced by young men in the trenches.

President Woodrow Wilson had been reelected on a platform pledged to keep America out of the war, but as hostilities escalated, the country was increasingly divided. Former president Roosevelt agitated for active U.S. intervention after a German submarine sank the British ocean liner *Lusitania* in 1915, causing the loss of 128 American lives. Diplomatic protests from Wilson prompted the Germans to back away from submarine warfare for a time, but in January 1917 attacks on the seas began again. Prowar sentiment in the States further intensified when President Wilson released the Zimmermann Telegram to the press. The message from the German Foreign Minister urged the Mexican government to join the German war effort in exchange for assistance in reclaiming Texas, New Mexico, and Arizona as Mexican territory. The telegram's publication, coupled with the sinking of seven U.S. merchant ships, convinced Congress to declare war on April 6, 1917. Some fourteen thousand American troops arrived in Europe in June, and the American Expeditionary Force fired its first shells on October 23. Two days later Americans suffered their first

11

James Montgomery Flagg
I Want You for U.S Army
World War I poster, 1917.
Chromolithograph, 39 ½ × 29 in.
Smithsonian American Art Museum,
Gift of Barry and Melissa Vilkin

12

J. C. Leyendecker
Great War Victory Illustration
1918. Oil on canvas, 27 × 17 ⅞ in.
Smithsonian American Art Museum,
Gift of Thomas Whital Stern

13

Polley Voos Fransay?
Life, November 22, 1917.
Oil on canvas, 30 × 23 in.
Collection of George Lucas

casualties. By the end of the year, the impact of the war was felt on the home front as well. Railroads were snarled as food, fuel, munitions, and passengers competed for priority.[48]

Within weeks of the declaration, President Wilson launched the U.S. Committee on Public Information to generate a massive propaganda campaign to develop support for the war. Noted illustrator Charles Dana Gibson headed up the Pictorial Publicity Division and enlisted many of the country's best-known magazine cover artists to donate images to the cause. James Montgomery Flagg, whose Uncle Sam poster (*I Want You for U.S. Army*) is probably the best remembered today, and others, including *Post* cover artists Harrison Fisher and J. C. Leyendecker, also contributed. (figs. 11 & 12) In an eighteen-month period, the Pictorial Publicity unit produced more than fourteen hundred posters seen by millions in shop windows and on billboards across the country. Hollywood also participated, obligingly turning out anti-German films. *The Claws of the Hun, The Prussian Cur,* and *The Kaiser, the Beast of Berlin* were just a few. Some of the movies and posters appealed to the public's patriotic side; others used virulent anti-German imagery to exploit Americans' fear and hatred of the "Hun."[49]

Although Rockwell did not work for the Committee on Public Information, he wanted to do his part. Uncomfortable with inflammatory themes, he turned to the concerns of ordinary people and found potential material everywhere. "In 1917," he remarked, "I couldn't read a newspaper without finding an idea for a cover."[50] That year and in the first half of 1918,

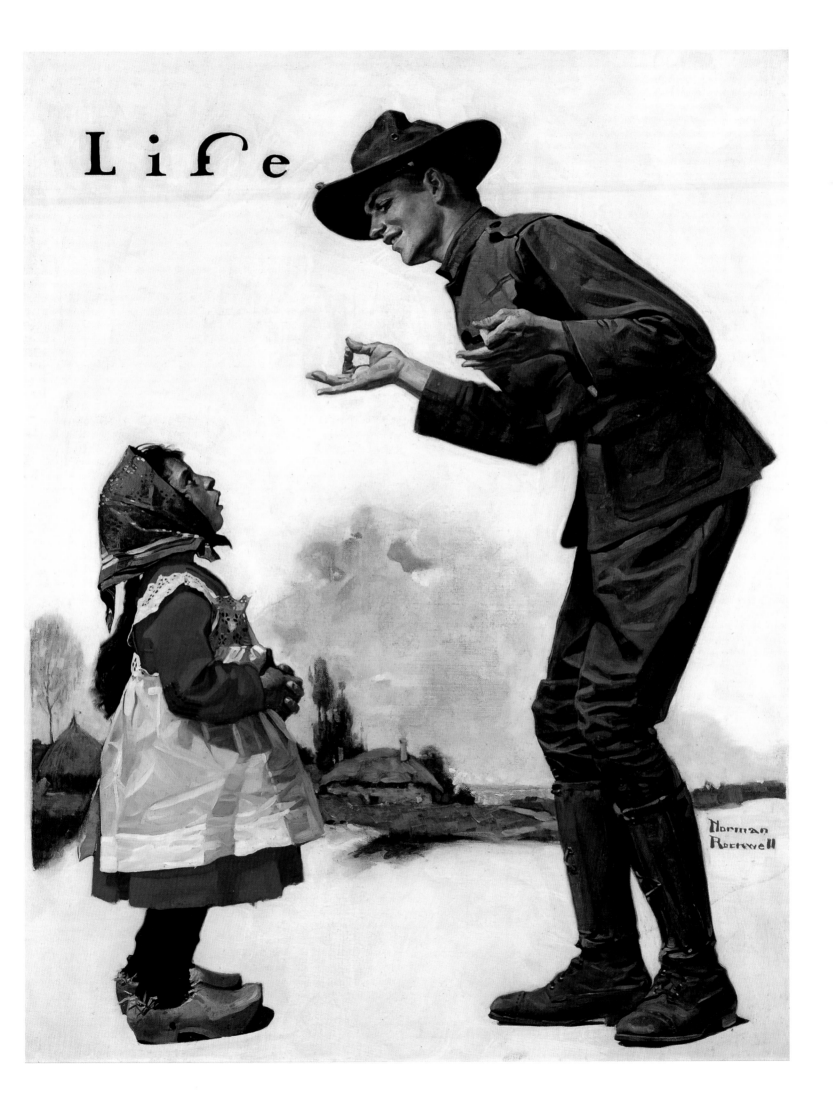

he did more than twenty covers for *Life,* a popular humor magazine, *Literary Digest, Judge, Leslie's,* and several other magazines that featured soldiers in settings designed to erase worry lines from a mother's brow.[51] *Polley Voos Fransay?,* which appeared on a *Life* cover in November 1917, shows a tall, angular soldier making friends with a puzzled little girl in wooden clogs by asking if she speaks French. (fig. 13) Rather than a heroic image of a strong, manly soldier, the cover emphasizes the youth and naïveté typical of the many recruits who had been drafted into service from America's farms and small towns. The boy has learned a few words in French, even if his pronunciation is poor, and he has the open countenance of one not yet scarred by battle. It is an image calculated to assuage parental concern about the psychological effects their sons might suffer fighting in the trenches. Astute viewers may also have read it as an allegory of national identity in which a young America, in the guise of the awkward soldier, emerges from isolation to assume a towering role on the world stage.

14

The Haircut

The Saturday Evening Post,
August 10, 1918

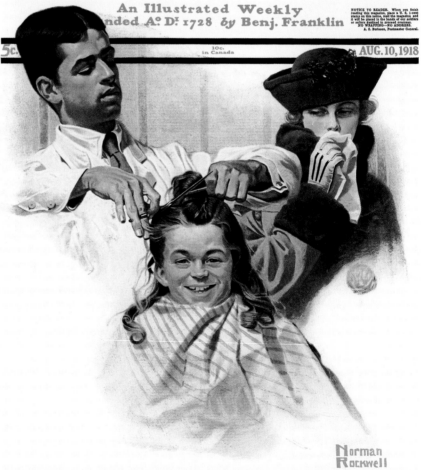

Rockwell also tacitly acknowledged that during wartime, boys grow up fast, and his work during this period reflects a wistfulness not apparent in earlier images. Even nonmilitary pictures show a changed attitude. In a May 1918 *Post* cover, a ragged boy sees a clown relaxing with a newspaper and realizes for the first time that the person inhabiting the clown suit is a real man. An August 1918 *Post* cover shows a boy getting his first haircut, his shoulder-length locks falling to the floor as his mother sniffles in the background. (fig. 14) The scene portrays both the boy's excitement and the mother's reservations as, like the gangly youth in *Polley Voos Fransay?*, he leaves childhood behind.

By July 1918, Rockwell was no longer content to sit on the sidelines. Although exempt from the draft because he had financial responsibilities to his family, he joined the U.S. Navy and was sent to Charleston, South Carolina.[52] After a day spent digging out tree stumps, he was assigned to the base magazine, *Afloat and Ashore*, to design layouts and draw morale-boosting cartoons. At night he went to the movies, he wrote in his autobiography,

> either at the YMCA (which we didn't like because they wouldn't let you in unless you answered a questionnaire and because there was a small admission charge) or the Knights of Columbus (which we liked because they let anyone in and it was free) or at the camp theater (which was even better because after the movie amateur theatricals were held). Once, I remember, *Poor Little Rich Girl* starring Mary Pickford was shown and as she refused one plate of scrumptious food after another (the poor little rich girl—she didn't want peach melbas or six-inch steaks, she wanted love), the audience got wilder and wilder. 'Try her on navy beans,' we yelled, 'try her on navy beans. That'll fix her precious stomach.'[53]

Navy duties occupied only two days a week; Rockwell spent the rest of his time drawing portraits of officers and enlisted men, and he convinced his superiors to let him continue doing magazine and story illustrations, many of which had patriotic themes. For a September 1918 *Post* cover, Rockwell depicted a little girl holding up a Red Cross collection box to an elderly gentleman who fumbles in his pocket for change. In another cover, published three months later in *Life*, a neatly combed soldier shows a picture of his mother to a sympathetic French woman.[54]

The Home Front

For Rockwell, it was important that normalcy at home not be overwhelmed by the turmoil of war, and he painted images showing the foibles of ordinary life and incidents that offered relief from tension at a time when war was escalating for U.S. troops abroad.[55] Boy-girl themes were special favorites. *Pardon Me,* which appeared on a January 1918 *Post* cover, is a classic narrative of adolescent embarrassment. (fig. 15) A young man has stepped on his partner's foot as they dance. Her party hat on the floor, she recoils in

15

Pardon Me

The Saturday Evening Post,
January 26, 1918.
Oil on canvas, 23 × 19 in.
Collection of Steven Spielberg

16

The Wishbone

The Country Gentleman,
November 19, 1921.
Oil on canvas, 18 ¼ × 16 ½ in.
Collection of George Lucas

pain and annoyance, while their friends snicker in the background. The toes of the boy's patent-leather shoes turn up with chagrin, and he holds his hands out, palms up, as he stutters an apology. In *Pardon Me* the multiple moments of an entire story play out in a single frame. Rockwell created dramatic tension by casting mismatched characters—a pretty girl and a clumsy boy—and developing a plot whose outcome has an inevitable conclusion that began in a prior moment, when the boy asked his partner to dance. Apart from their clothing—the boy wears a dress suit, the girl a fashionable white party frock—the incident might well have taken place fifty years earlier or later. As Steven Spielberg remarked, "It is a scene of innocent humor—something we've all done when we were younger and we still do when we're grown. Rockwell was extolling the virtues of simple values and simple moments."

Rockwell also recognized that readers emotionally adopted recurring characters as long as they did not appear too frequently. An erstwhile companion to *Pardon Me, The Wishbone,* which appeared in the November 19, 1921, issue of the *Country Gentleman,* features a plumpish young man excitedly making a wish as his taller, dreamy-eyed partner gazes into the distance.[56] (fig. 16) As in *Pardon Me,* the couple is mismatched.

THE SATURDAY EVENING POST

An I____ Weekly
Founded ____ Benj. Franklin

MARCH 27, 1920

5c. THE COPY

Hugh Wiley — Herschel S. Hall — Kenneth L. Roberts — Frederick Orin Bartlett
Lucia Chamberlain — Nina Wilcox Putnam — Will Irwin

Rockwell extended his range in the late 1910s and 1920s. In addition to humorous images of children, he introduced adults into his cast of characters and played on both the pretensions of the well-to-do and, increasingly, romance and the battle of the sexes. A buxom woman takes on the affectations of her employers, for example, in *The Departing Maid*. (fig. 17) She daintily extends her pinkie as she walks past a heraldic-type crest that features a kettle, rolling pin, and money bags marked with dollar signs. In October 1920, just months after passage of the Nineteenth Amendment gave women the right to vote in the upcoming national elections, Rockwell painted his first overtly political image—a couple on a settee, backs turned to each other, holding newspapers. A Republican logo occupies wall space beside her; a Democratic symbol describes his views.[57] With this image, Rockwell went beyond childhood pranks, embarrassed youth, and human foible to address a broader social issue that remained contentious, despite passage of the Nineteenth Amendment. He presented the woman as an intelligent, confident individual unwilling to relinquish her convictions, a motif he revisited in 1959 in *The Jury* (see p. 170).

17

The Departing Maid
The Saturday Evening Post,
March 27, 1920

18

**The Stuff of Which
Memories Are Made**
Edison Mazda Lampworks
advertisement, 1922.
Oil on canvas, 39 ½ × 27 ¾ in.
Collection of George Lucas

Growing Sophistication

In 1920, Rockwell received a commission from the General Electric Company's Edison Mazda Lamp division to paint images for an ad campaign. Rockwell's first advertisement—in 1912 for Heinz foods—had shown boys sitting at a campfire heating a pot beside a pile of empty baked bean cans. Except for its placement as an ad, it is indistinguishable from his *Boys' Life* illustrations. During the war years he had done ads for a number of other products—Fisk bicycle tires, Black Cat Reinforced Hosiery, Del Monte canned foods, and Best-Ever Suits—that also drew in theme and style on his Boy Scout work.

The 1920 Edison Mazda project marks a growing sophistication in his conception of image making. *The Stuff of Which Memories Are Made,* in which a mother watches over her children's prayers by the warm glow of an Edison Mazda lamp, is a contemplative scene that reinforces ideas of home, family, and the ritual of evening prayer in the quiet space of a darkened parlor. (fig. 18) Its emotional tone is significantly different from the comic edge of his magazine covers and most of his previous ad work. The nuanced concern with the way light strikes surfaces and casts shadows demonstrates Rockwell's skill in creating a traditional fine art picture and his versatility in developing visual strategies and themes that dovetailed with the requirements of his clients.

Rockwell took great care with the details of the painting. A doll and teddy bear rest beside the little girl on the floor, and an elf toy sits on the table. The contrast between the shadowy room and the warm light on the faces of mother and son and on the hand she rests on her daughter's head gives the scene an aura of serenity. Over a seven-year period, Rockwell painted at least twenty ads for Edison Mazda that appeared in the *Saturday Evening Post, Ladies' Home Journal,* and at least once in *Good Housekeeping.* These ads were also used as display cards in stores that carried the products.[58]

Whether or not the work for Edison Mazda was the spark, Rockwell's newfound interest in light and family scenes was well suited to advertising clients who wished to connect their products with cozy depictions of home, and it extended into magazine cover work for the *Post* and the *Country Gentleman. Shadow Artist* is an image of light and magic, reminiscent of the proto-cinematic pantomime shows that appeared in vaudeville programs during Rockwell's youth. (fig. 19) We observe the scene from the point of view of the children who watch in awe as the shadow artist, using only the light of an oil lamp, creates the image of an animal head. As Lucas noted, "Just by the tilt of the heads, just by their body language, you can tell that they are completely fascinated by what they're watching, and you can see the pride... on the part of the shadow maker." The glow dematerializes the lower body of the old man who emerges, genie-like, into an enchanted space. Unlike his usual crisp realism, Rockwell rendered wisps of hair and atmospheric space with soft strokes of brushy paint, and he constructed the picture so that the shadow artist's magic extends beyond the frame.

Like *Shadow Artist, The Toy Maker* captures a moment of wonder. (fig. 20) The kindly old man with a white beard and wisps of thin hair who puts the finishing touches on a whirligig doll is a holdover from the past. With the tools of his craft at hand on a table and wood chips littering the floor, he demonstrates his creation to the delight of a little girl who blows to make the red and white paddles spin. Her little brother holds a can of paint, unmindful that red drips will ruin his pale blue suit and ruffled white collar. Light from a small window casts Vermeer-like highlights on the toy maker's laughing face and the faded tattoo on his arm and provides enough illumination that we clearly see the model ship Rockwell added as a prop on the shelf behind his head. He may well be a sailor who learned to carve during long voyages, but now, too old to go to sea, makes his living creating toys for little children. George Lucas, who owns the painting, said that it appealed to him partly because he, too, built things when he was young. As an adult, he is intrigued with the idea of awakening children's imaginations.

The painting's format is distinctly Victorian. It occupies an oval shape within a rectangular frame, with corner spandrels decorated with foliate scrolling and little elves. The impression is of bygone days, as though it had been painted not in the flapper era of the 1920s but in some indeterminate

19

Shadow Artist

The Country Gentleman,
February 7, 1920.
Oil on canvas, 25 × 25 in.
Collection of George Lucas

moment of the past. The painting has the soft, painterly surface associated with Arthur J. Elsley (1860–1952), a hugely popular English genre painter whose scenes of childhood were reproduced as prints on calendars and in ads and book and magazine illustrations in Britain and America. The affect of Elsley's paintings of children with dogs and an occasional kitten is considerably more sentimental than is Rockwell's toy maker, but, as in Elsley's work, the children's Victorian clothes evoke nostalgia for a bygone era.

Toys and their makers were oft-discussed themes in the American press in the first decades of the twentieth century and also a topic of interest within Rockwell's own family—his brother, Jarvis, worked for a toy firm. Plays with titles like *The Toymaker* opened during Christmastime in Washington, Los Angeles, and other cities around the country, some performed by professional actors, others by amateur theatrical troupes.[59] The holiday appeal is obvious, but the fascination with old-time toy making also reflected a shift as industrial manufacturing began to replace hand-crafted children's toys.[60] American companies were particularly adept at devising metal toys that incorporated modern technology. Airplanes, dirigibles, small typewriters, trains, and other items that made noise and could be manipulated depended "largely for their success on the ingenuity of the inventor," and were "the forte of the American mechanic."[61] Although good for U.S. commerce, a *Los Angeles Times* reporter lamented that the wooden toys he had prized as a child had gone out of fashion in the United States.[62] His sentiment was echoed in a Chicago newspaper article that describes a picture much like Rockwell's *Toy Maker.*

There was a lot of romance attached to the old way of making toys and especially dolls, but alas! it is fast departing. Touching stories used to be told of how dolls were born of the love of the old German toy maker for his creations; of the intimacy between the creator and his children. The dingy old shops used to be as quaint a sight as the eye was like to light upon; the old white haired fellow grown gray in the service of his mighty family was a charming figure, a sweet fairy book sort of man, a first cousin to Santa Claus.[63]

In the early years of the century U.S. newspapers proudly announced that the proportion of imported to exported toys between Europe and America was rapidly reversing in favor of the U.S. toy business. With the beginning of World War I in 1914, the supply of German imports dropped precipitously, and in 1916 the U.S. exported some $2 million worth of toys, mostly made of metal, which was more than double the figure for toys sent abroad in 1911.[64] By the late 1910s, however, a revival of toy making by skilled woodworkers in New England reflected the growing desire among parents and educators for simpler toys that encouraged children to invent and imagine. Hingham, Massachusetts, became an active center for traditional toy makers, many of them retired seafarers, who developed individual styles or types of wood toys associated with their names. One Edward G. McCandlish, for example, made figures with contemporary themes such as the "new woman."[65] George A. Holmes of Duxbury, Massachusetts, specialized in whirligigs that he made in "his peaceful little old workshop under spreading apple trees."[66] Rockwell's red and white whirligig might well indicate that its creator was one of these American woodcrafters.

The appeal of traditional toys is also apparent in *Christmas: Santa with Elves,* a predictable holiday image of an exhausted Santa nodding off as harried elves rush to finish handmade toys. (fig. 21) Apart from their

20

The Toy Maker
The Literary Digest,
November 20, 1920.
Oil on canvas, 28 × 24 in.
Collection of George Lucas

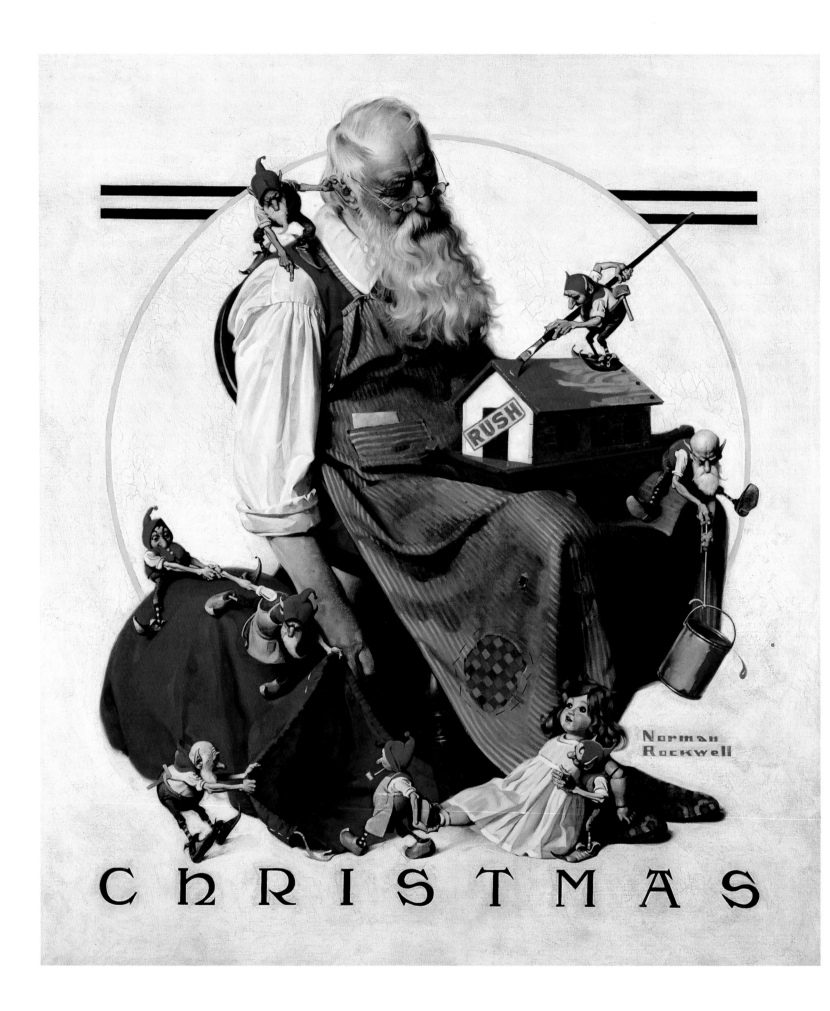

demonic expressions, the little creatures resemble the elves and pixies that were a staple of children's literature during Rockwell's childhood—particular favorites were the Brothers Grimm fairy tales like *The Elves and the Shoemaker,* Carlo Collodi's *Pinocchio,* and the Brownies created by Canadian illustrator Palmer Cox. Cox drew on Scottish folklore for stories, comic strips, and books pairing illustrations with verse that were widely distributed between 1887 and 1918. The similarity between Cox's Brownies and Rockwell's elves would have resonated with children and parents alike.[67]

The Magic of Fantasy

A challenge for all illustrators was the constant struggle to come up with fresh subjects. Rockwell worked in the studio ten to twelve hours each day, six days a week, and often sneaked away from the family on Sundays to put in a little more time. He usually spent two or three nights a week coming up with ideas. He and other illustrators borrowed freely from themselves, each other, and illustrations in art books. *—And Daniel Boone Comes to Life on the Underwood Portable* introduces a format that Rockwell used a number of times for ads and magazine covers. (fig. 22) Here a young man works at a typewriter with the vision of a story playing out above his head. As Steven Spielberg remarked, it shows a writer trying to find words to tell his story. Spread across the upper reaches of the canvas, the writer envisions an epic tale about a legend of American history whose courage and strength are writ large. Shortly before the image appeared as an ad in the *Post,* Rockwell had admired an illustration that F. R. Gruger, another *Post* illustrator, had painted for a serialized story. He wrote to Gruger on August 31, 1923, just two weeks before the Underwood ad came out, "I... would like very much to buy one of your originals for my wall. I was particularly struck by a picture you made for a POST serial entitled 'Barbry.' It showed a young girl dreaming in an attic beside an old trunk. Above was a vision of classic heroes. This is one of my favorites."[68]

—And Daniel Boone Comes to Life was the first Rockwell painting Spielberg acquired. It reminded him, he said, of his own work writing films. "I would sit down in front of my typewriter to try to write a story for a movie... waiting for that little thought bubble to appear over my head [with] an image that would get my fingers dancing on the keys. [It] was very evocative for me that [Rockwell's writer] was imagining Daniel Boone before he actually began to write about him." The work of a writer is laborious, Spielberg continued, "and the most frustrating is the work of the imagination of the writer as he pulls these disparate visual elements out of the sky and finds a way to express them in words." The same could be said of Rockwell and others who struggle with the act of creating.

Boone (1734–1820) had come to symbolize America's pioneering spirit by the time Rockwell chose him as the subject of the writer's panoramic vision. Boone was a legend during his lifetime, and his fame continued to grow.[69] Timothy Flint's 1833 *Biographical Memoir of Daniel Boone, The First Settler of Kentucky* was one of the best-selling biographies of the

21

Christmas: Santa with Elves
The Saturday Evening Post,
December 2, 1922.
Oil on canvas, 30 ¾ × 28 ¾ in.
Collection of George Lucas

nineteenth century, and by the early twentieth century Boone had become an American myth. People dressed up in leather clothing and coonskin caps for costume parties, and the *Los Angeles Times* stated that Boone's "adventures in opening up the wilderness to the white man prove that real life is more glamorous than fiction."[70]

The image of Boone in the 1923 painting *—And Daniel Boone Comes to Life* is very different from the portrayal of the hero Rockwell drew for "The Great Daniel Boone Contest," a story published in *Boys' Life* in 1914. (fig. 23) In the illustration, Rockwell showed Boone as an ordinary man. He carries his famous long rifle and is dressed in his preferred clothing—fringed hunting shirt, leggings, and moccasins—but, in a nod to historical accuracy, he wears the broad-brimmed felt hat of the men in the Quaker community of Berks County, Pennsylvania, where Boone grew up.[71]

In 1923, when he painted the typewriter ad, Rockwell updated this image by adding a coonskin cap.[72] In doing so, he reflected the identity of Boone that had visually coalesced around the turn of the century and was reiterated in a now-lost film serial called *In the Days of Daniel Boone,* which was produced for the Saturday morning children's market the year Rockwell painted the picture.[73] Boone had been shown with a coonskin cap in earlier depictions, but with the movie, the cap became the normative attribute that identified the frontiersman in the public consciousness solely and uniquely as Boone. In choosing the frontiersman for the Underwood ad, Rockwell crafted an image that looked like a movie screen, was epic in impact, and appealed to potential buyers not for the quality or price of the typewriter but through its association with a legendary figure.

The idea of the imagination at work is also the leitmotif of *Boy Reading Adventure Story,* which came out as a *Post* cover two months after *Daniel Boone* appeared as the Underwood ad. (fig. 24) Rockwell adjusted the panoramic configuration of the Daniel Boone vision to conform to the design format of the *Post* by using a thought bubble reminiscent of cartoons in which a balloon over a character's head reveals what the individual is thinking or saying. *Boy Reading Adventure Story* shows a boy envisioning himself as an armor-clad hero of medieval times riding away with a beautiful damsel.[74] The narrative suggested by Rockwell's picture is different from the plot of the book the boy reads. The real subject is not an adventure recounted in fiction, but rather the power of the written word to excite the imagination and transport the child to a distant land and time.[75] "It's a painting celebrating literature, the magic that happens when

22

—And Daniel Boone Comes to Life on the Underwood Portable
Underwood typewriter advertisement, 1923. Oil on canvas, 36 × 28 in. Collection of Steven Spielberg

23

Daniel Boone, Pioneer Scout
Boys' Life, July 1914

you read a story, and the story comes alive for you," observed Lucas. When working on *Star Wars,* he said, he realized that "there needs to be a kind of film that expresses the mythological realities of life—the deeper psychological movements of the way we conduct our lives that are evident in fairy tales."[76] Elsewhere he remarked that, instead of doing a "socially relevant film" after *American Graffiti,* "I realized there was another relevance that is even more important—dreams and fantasies . . . that you could still sit and dream about exotic lands and strange creatures. Once I got into *Star Wars,* it struck me that we had lost all that—a whole generation was growing up without fairy tales. You just don't get them any more, and that's the best stuff in the world—adventures in far-off lands. It's fun."[77]

Boy Reading Adventure Story gave Rockwell a chance to pay homage to N. C. Wyeth's cover illustration for *A Boy's King Arthur* and to show off his own skill as a painter by contrasting the elegant, linear style of the imagined scene with the looser, realistic painting technique familiar to his own audiences. The difference between the two images is telling. Flanked by a box of crackers and a drowsy dog, Rockwell's boy sits in the dimensional space of the real world in which shadows define form and depth. The muted pastels and clean linear shapes in the imaginary scene suggest the vast distance between the boy's real life and the farthest reaches of his imagination, although in the dream image Rockwell reinforces the child's self-identification as hero by using realistic colors for his face and including shadows cast by the frame of his glasses.

Rockwell's Boys

By the early 1920s, Rockwell was best known for his images of boys and had developed a cast of characters that connected his pictures with the boy-types of popular stories. One type was the Boy Scout, with his associated qualities of forthrightness, bravery, and penchant for good deeds. Another was the awkward character in *Pardon Me* and *The Wishbone,* who is oblivious to the disinterest of the sophisticated young ladies with whom he is smitten. A third was the freewheeling country boy who spent summers swimming in forbidden ponds and, like the protagonist of Tarkington's *Penrod,* getting into mischief. This Penrod type contrasts with a fourth, the city slicker, who with combed hair and fancy clothes is physically and psychologically ill suited to the outdoor activities of his country cousins.

In 1917, Rockwell created Cousin Reginald, a well-dressed city boy who was constantly the butt of jokes dreamed up by his Penrod-like relatives. Cousin Reginald, who appeared on covers of the *Country Gentleman* from 1917 through 1919, dons water wings as he approaches the pond where the "real" (country) boys swim.[78] (fig. 25) In other images, unlike his ragged, barefoot cousins, he wears shoes to go fishing and looks despondent when school is out for the summer.

The pictures of Cousin Reginald and plump, oblivious kids were designed to amuse the rural readers of the *Country Gentleman.* But they reflect the meanness sometimes inflicted on those who fail to fit in with

24

Boy Reading Adventure Story
The Saturday Evening Post,
November 10, 1923.
Oil on canvas, 30 × 24 in.
Collection of George Lucas

their peers that seems misaligned with Rockwell's usual kindly humor. Nonetheless, they coincided with contemporary theories about child development that cautioned parents not to require perfection of their children. In fiction—*Penrod* is just one of countless examples—minor misbehavior proved that young heroes and heroines had spunk. Kate Douglas Wiggin, author of the 1903 children's novel *Rebecca of Sunnybrook Farm,* for example, wrote, "We must not expect children to be too good....Beware of hothouse virtue."[79] Prominent psychologist G. Stanley Hall proposed that aggressive behavior in children was a healthy and necessary part of growing up. Hall described the years between eight and twelve—the ages of most of the children Rockwell depicted—as a phase in which children, like little savages, atavistically recapitulated the aggressive drives that had allowed prehistoric humans to survive in dangerous environments. Failure to pass through this and other developmental stages, he said, might lead

25

Cousin Reginald Goes Swimming
The Country Gentleman,
September 8, 1917

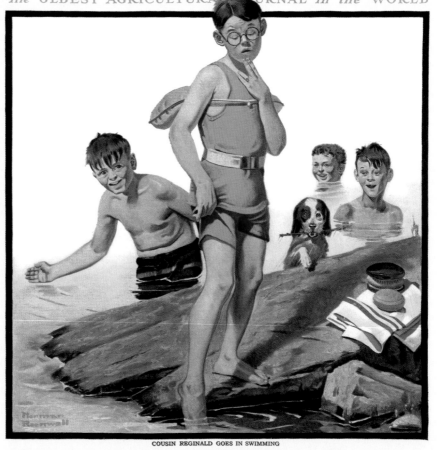

September 8 1917 Five Cents the Copy

The COUNTRY
GENTLEMAN

The OLDEST AGRICULTURAL JOURNAL *in the* WORLD

COUSIN REGINALD GOES IN SWIMMING

In This Issue: DRAINING THE SOUTH OF LABOR

to "retrogression" or "degeneracy."[80] If the behavior of Rockwell's preado-
lescent boys seems particularly transgressive today, in the 1910s and 1920s
it was considered by many as an appropriate path to balanced adulthood.

In other images, however, Rockwell put naughtiness aside and devel-
oped another boy-type, one with a rich imagination and love of learning
who reflects the more complex personalities of the boys in *Boy Reading
Adventure Story* and *Graduation*. (fig. 26) We observe the scene in *Graduation*
from the viewpoint of the boy's classmates. They, too, will receive certifi-
cates from the stack on the teacher's desk, but few will be pinned with the
medals that embellish the youth's chest or enjoy the teacher's mannered
expostulations. The boy has obviously done well in school, but he's neither
beaming with pride nor squirming with embarrassment at being singled
out for his academic prowess. His expression is equivocal as he faces the
class. He is growing and changing—from obedient childhood to the
unknowns of adolescence. The painting is full of clues about his growth.
His sleeves are too short, his knickers don't quite reach his knees, and his
feet are too big. Although he might not yet realize it, he will soon have to
decide what kind of man he will become.

Rockwell cues us to the nature of his choices. The space between the
figures distances the boy from the teacher, who is positioned in Victorian
frock coat, formal collar, and dangling spectacles in front of the Old World
on the map that serves as a backdrop. The boy stands to the left, linked
with the New World and the freedoms associated with contemporary
American life. We see nothing of his hopes or dreams but are struck by
the similarity between the Charlie Chaplin–like positioning of his big brown
shoes and that of the teacher's, a detail that would have been unmistakable
to audiences in 1926 who laughed at the ducklike walk and overly long
footwear characteristic of America's most popular comic movie star.[81]

The round glasses and parted hair of the boy in *Graduation* resemble
Rockwell's caricatures of himself as an adolescent. Like the youth in the
picture, Rockwell had mixed feelings about formal education. He loved
learning but never excelled at academics and abandoned high school to
study art full time; in an early interview he confessed that he was expelled
during his second year of high school for having too much fun.[82] Many
of his images—*Boy Reading Adventure Story* is just one—show boys with
books; their subtext underscores the importance of reading and the
imagination in the life of a youth. These pictures also demonstrate the
increasing sophistication of Rockwell's characterizations. The young
graduate represents a more complex individual than the one-dimensional
Cousin Reginald or the protagonists of *The Wishbone* or *Pardon Me,* and
Rockwell invites speculation not about an episode in a narrative plot,
but about the motivation and development of a multifaceted personality.

The impulse to speculate about a character's personal situation is
particularly strong in *The Apple Peeler.* (fig. 27) An advertisement for Duchess
Trousers, a line of moderately priced men's slacks designed "to fit every
man of every build and for every purpose," the painting appeared in the

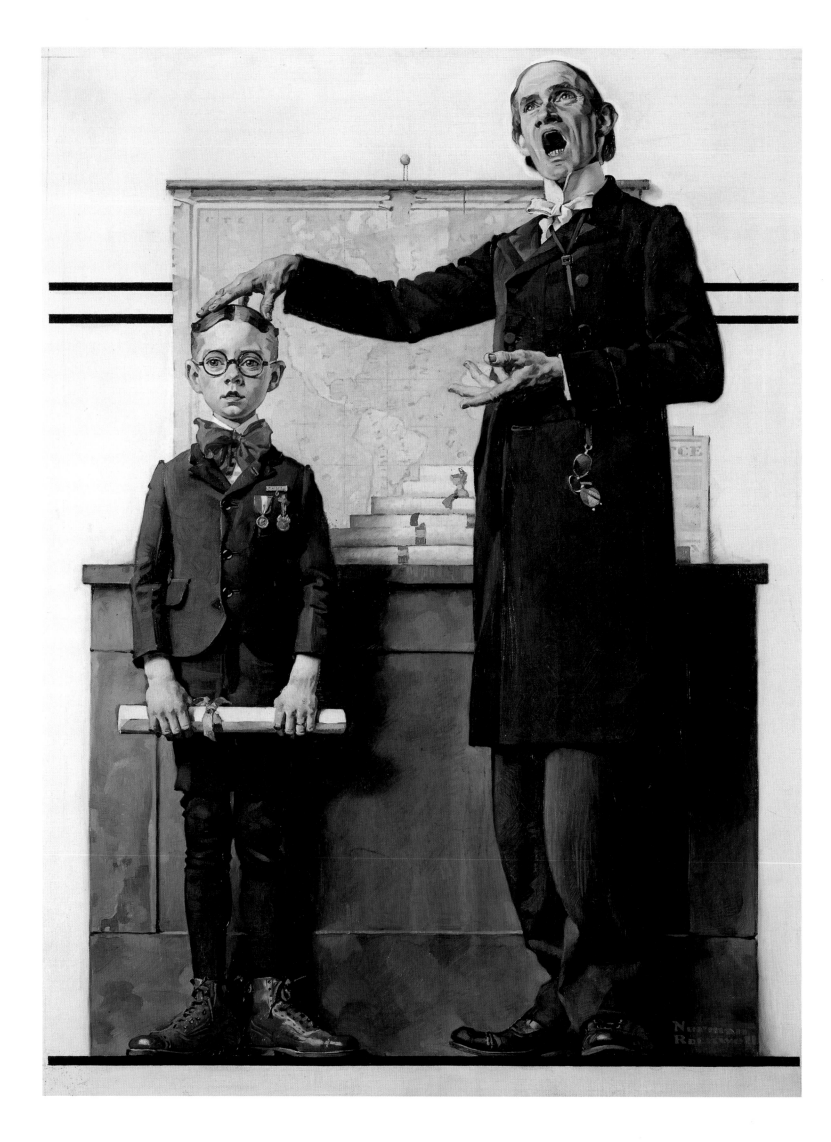

January 8, 1927, issue of the *Saturday Evening Post.* Rockwell created several ads for the trouser firm that appeared in the *American Magazine,* the *Inland Printer,* and *Vanity Fair.* One showed an elderly golfer checking his score; another, a man admiring the fit of his new slacks; a third, an engineer examining a design; and another, a boy in knickers with his dog. Among them, *Apple Peeler* stands out. Neither a sportsman nor a confident professional, the apple peeler is a working-class man who brings his food in a lunch box rather than eat in a restaurant. His brow is furrowed as he carefully peels away the rind, an act that in many households was a wife's responsibility. The tan palette, concentrated expression, and loosely defined space are reminiscent of Thomas Eakins's painting *The Thinker,* which the Metropolitan Museum of Art had purchased in 1917. (fig. 28) The solitary figure may also have been self-referential, echoing Rockwell's sense of dislocation as his marriage to Irene O'Connor was failing. The previous several years had been difficult for Rockwell. Irene's mother, sister, and two brothers came to live with the couple, and by late 1924, Rockwell had relocated to a hotel in the city. Although they subsequently reconciled and moved into an expensive home, their differing expectations of marriage made the prospect of a long-term union increasingly doubtful.

26

Graduation
The Saturday Evening Post,
June 26, 1926.
Oil on canvas, 32 × 25 in.
Collection of George Lucas

Special Characters

Some of Rockwell's models were thrilled when they saw their pictures on the covers of national magazines; others regretted having posed when they became the objects of laughter or derision. Working in New Rochelle, just north of New York City, Rockwell often drew on the corps of professional models who posed in art schools and for the city's many figurative painters. But he also approached acquaintances and neighborhood kids whose faces were particularly well-suited to a developing idea to serve as cast members in his mini-dramas. He was fortunate to find an ideal and willing model for *The Gossips.* (fig. 29) He used only one, James Van Brunt, for all three figures. Rockwell recalled his first meeting with Van Brunt:

I remember it was June and terribly hot. I was working in my underwear and not getting along too well because my brushes were slippery with perspiration. Suddenly the downstairs door banged and I heard someone come up the stairs treading on each step with a loud, deliberate thump.... A tiny old man with a knobby nose, an immense, drooping mustache, and round, heavy-lidded eyes stamped bellicosely into the studio.[83]

Rockwell immediately set to work drawing Van Brunt, who soon appeared on a *Post* cover that showed, in Rockwell's words, a "tramp cooking two sausages (one for himself and one for his dog) on a stick over a fire in a tin can." He used Van Brunt again as an elderly cowboy wearing a Stetson and western clothes and sitting on his saddle listening to music on a gramophone. But after Van Brunt's flowing mustache appeared in two or three covers and a number of ads, Rockwell recalled, "Mr. Lorimer said to me,

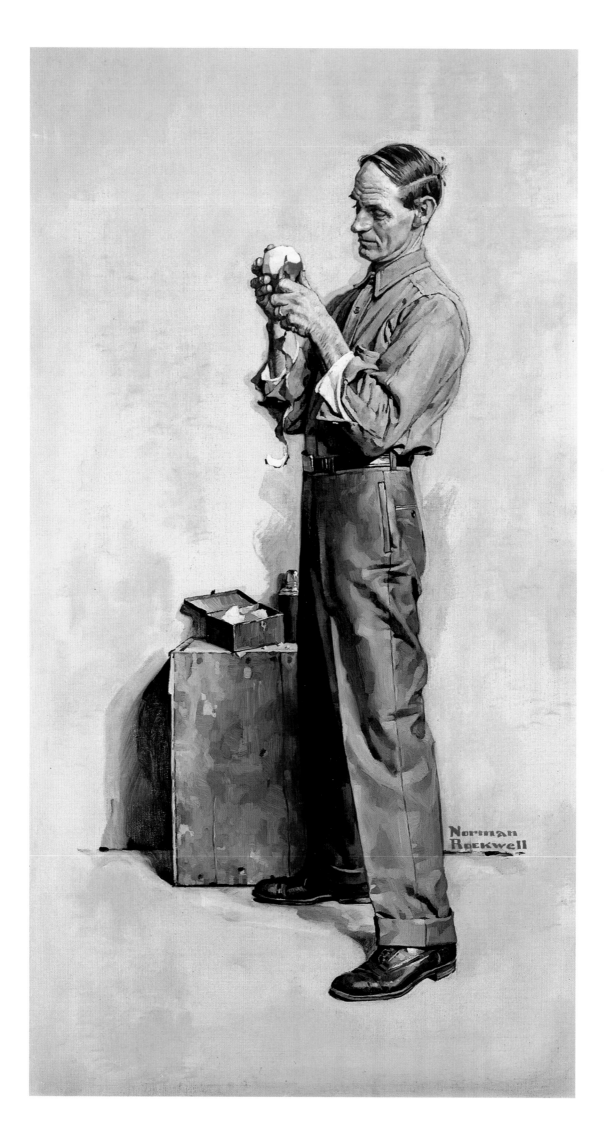

27

The Apple Peeler
Duchess Trousers advertisement,
1927. Oil on canvas, 34 × 18 in.
Collection of George Lucas

28

Thomas Eakins (1844–1916)
**The Thinker: Portrait of
Louis N. Kenton**
1900. Oil on canvas, 82 × 42 in.
The Metropolitan Museum of Art,
John Stewart Kennedy Fund, 1917
(17.172) Image © The Metropolitan
Museum of Art

'I think you're using that man too much. Everybody's beginning to notice it. Maybe you'd better stop for a while. That mustache of his is too identifiable.'"

Rockwell informed Van Brunt of the problem: "If you take off your mustache I can use you again....Otherwise I just can't." Two weeks later Van Brunt visited. If Rockwell would give him ten dollars, he said, he'd shave off his mustache. "It upset me," the artist recollected, "it was like the felling of a great oak or the toppling of a statue which had been for years a monument to man. When I saw the result I was even more upset. Mr. Van Brunt's lower lip stuck out beyond his upper lip by about an inch and was just as identifying as the mustache. But now, of course, I had to use him."

Van Brunt modeled for several more covers, each time with his distinctive mouth concealed by his hand or a prop. "Luckily I'd had an idea on hand for quite some time—three old ladies with their heads together, gossiping—which I had been unable to do because I couldn't find any old ladies who were funny-looking enough." Rockwell was then struck with the solution: he'd use Van Brunt as the model for all three gossiping women. Rockwell confessed, "[I] almost laughed myself into the grave at the way he pranced around the studio in the old maid's costume, lifting the long skirt and curtsying, a flossy little hat tilted rakishly over one eye."

In *The Gossips,* three women in Victorian costume huddle with heads close together. Their silk skirts are sumptuous; the chairs and stool, like their clothing, are holdovers from the nineteenth century. These small details distance the image from Rockwell's audience. A picture of women in contemporary clothing might have offended *Post* readers suspicious that Rockwell was poking fun at small-town American life. The circle enclosing their heads gives focus to the shocked expression of the woman on the right and the knowing report of her talkative friend as she points her thumb in the direction of the offending party. The ridiculous hat worn by the central figure whose back is to the viewer sharpens our understanding that mischief is not only being discussed, but also being made by this small coven of elderly biddies whose faces give them the authority of age and whose clothing suggests their comfortable station in life. Rockwell has softened the motif of embarrassment in front of one's friends and neighbors that appeared in earlier work by showing the perpetrators rather than the object of the gossipy conversation.

The result appealed to audiences young and old. Shortly after the cover's publication Rockwell received a letter from the principal of a school in University City, Missouri, enclosing a short essay that an eleven-year-old had written "of his own accord" based on the *Post* cover of the "three old maids" exchanging bits of gossip.[84]

Hollywood

In 1929 the Rockwells' increasingly unsatisfactory marriage was finally untenable and the couple separated. In January 1930 their divorce became final, prompting Rockwell's former studio mate Clyde Forsythe, now living part of each year near Hollywood, to invite him to come

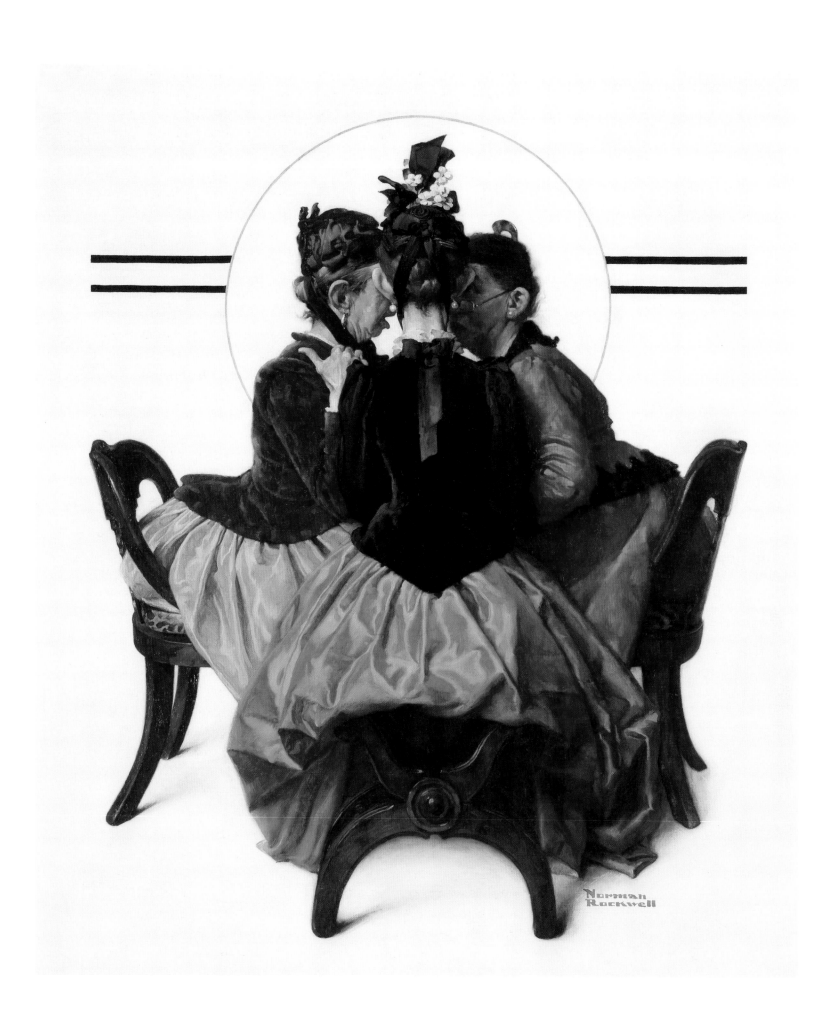

west for a change of scene. Rockwell was excited about the trip. He was an inveterate moviegoer whose main client, the *Saturday Evening Post,* regularly featured articles about technical advances in the industry written by insiders—silent-film producer Mack Sennett among them—and published stories that reflected current debates about censorship, lighting, salary structures, and distribution.[85] Rockwell had dabbled with movie themes in the 1916 picture of a family watching a Chaplin film and again in 1920 in a Paramount Pictures ad showing a father buying movie tickets for his smiling wife and children. He even visited a motion-picture studio in 1923 to get a sense of atmosphere for a story illustration that was never published.[86]

By 1930, movies were big business. The early era of silent films shown in storefront theaters was over, replaced by a network of studio-owned movie palaces where millions of Americans spent their entertainment dollars. Hundreds of Westerns, romances, melodramas, and comedies were produced each year, many with complicated plots made possible by the 1928 introduction of "talkies." Handsome stars, aspiring ingénues, and character actors provided fodder for movie magazines that exposed the professional stories and private lives of Hollywood notables. Even better for Rockwell, Hollywood offered a marvelous array of models: "all the extras, out-of-work actors—cowboys, old geezers, wizened crones, sleek matinee idols, lovely girls, plain girls."[87]

By this time Rockwell was something of a celebrity himself. His magazine covers and advertisements were well known, and his expansive home in New Rochelle had been featured in *Good Housekeeping,* so it is not surprising that he had fairly easy access to the lots of major studios or that his arrival in Los Angeles was noted in the press.[88] The *Los Angeles Times* announced, "Rockwell's character depictions on the *Post* and [*Ladies' Home*] *Journal* from now on are likely to show the Hollywood influence... inasmuch as that is what he came here for. In fact, he very definitely has in mind doing some 'Hollywood' covers showing film characters as he sees them on studio lots and in their more or less native haunts.... 'Both the magazines,' [Rockwell] said, 'will welcome Hollywood depictions.'"[89]

Rockwell had been thinking of doing a *Post* cover for which he needed a "rawboned, glamorous cowboy... dressed in chaps, boots, and spurs having his lips painted by a hard-bitten little makeup man."[90] Forsythe took him to see the publicity director at Paramount studios, who suggested Gary Cooper for the role. The star had just come off his first talkie, the very successful film *The Virginian,* and was about to begin shooting *The Texan* with costar Fay Wray. *The Texan* was an adaptation of O. Henry's famous short story "A Double-Dyed Deceiver," the tale of the Llano Kid (Cooper's role), who kills in self-defense and flees to South America, where he is taken in by a wealthy elderly lady. The plot is full of twists that reveal the manly Llano Kid alternately as con artist and caring friend.

29
——

The Gossips
The Saturday Evening Post,
January 12, 1929.
Oil on canvas, 27 × 22 in.
Collection of Steven Spielberg

When *Gary Cooper as The Texan* graced the *Post*'s cover just three weeks after the movie was released, the public must have enjoyed the irony that cosmetics were being applied to the macho film star. (fig. 30) Rockwell captured the handsome Cooper in profile as a tough-looking makeup artist applies his lipstick. It is a tour de force of western paraphernalia and not-so-subtle double entendre. Cooper sits on an elaborately tooled saddle, dressed in boots, chaps, holstered pistol, quilled vest, and neckerchief with his Stetson beside him. He faces a makeup man who chomps on a cigar. In a consummate picture of role reversal, the manly movie hero is being made up, while the tough guy, with towel on his lap and comb and scissors in his back pocket, sports the tools of femininity.

Light strikes the figures from the right and the front, bathing their forms in a rosy glow that emphasizes the smeary lipstick and rouge stains on the towel and contrasts with the green shadows of the makeup man's white shirt. Drawing on his extensive knowledge of color theory, Rockwell employed complementary colors rather than dramatic shading to create richness and depth in the surface and rendered the minutest details, from the veins on Cooper's hand to the tiny holes in the makeup man's wingtip shoes, with close attention. To ensure that viewers got the connection, the production trunk that serves as a backdrop bears the names of the movie and the director John Cromwell. Steven Spielberg said that Cooper's colorful makeup reminded him of the way actors were made up in the era of silent films. "It was absolutely authentic to the period in which it was painted," Spielberg continued, "and great to see Gary Cooper, a complete and thorough professional, routinely having his makeup applied before getting on his horse to do something utterly heroic."

Although now mostly forgotten, at the time of its release *The Texan* was a critical and popular success. The *Chicago Daily Tribune* gave it four stars as an "extraordinary" movie and declared "Gary Cooper Perfect Again." Westerns like *The Virginian* and *The Texan* that were billed as "expressing the spirit of America" were resurging in the early 1930s.[91] The country needed movies like *The Texan,* just as they needed pictures by Norman Rockwell, to help them escape, even briefly, from discouraging news of the downward-spiraling economy in the early months of the depression.[92]

Flapper Types and Glamour Girls

In Hollywood, Rockwell was surrounded by beautiful and interesting women. Some were stars, others were writers or assistants at the studios he visited, and many were models hoping to be discovered. Rockwell had introduced women as protagonists in the early 1920s; by the mid-1930s female characters routinely had lead roles rather than bit parts in covers that focused on men or boys. He also replaced images of women in conventional domestic settings—mothers watching their sons' first haircuts, courting couples, and young matrons surrounded by housekeeping paraphernalia—with several new feminine types. One was a flapper—

30
—

Gary Cooper as the Texan
The Saturday Evening Post,
May 24, 1930.
Oil on canvas, 35 × 26 in.
Collection of Steven Spielberg

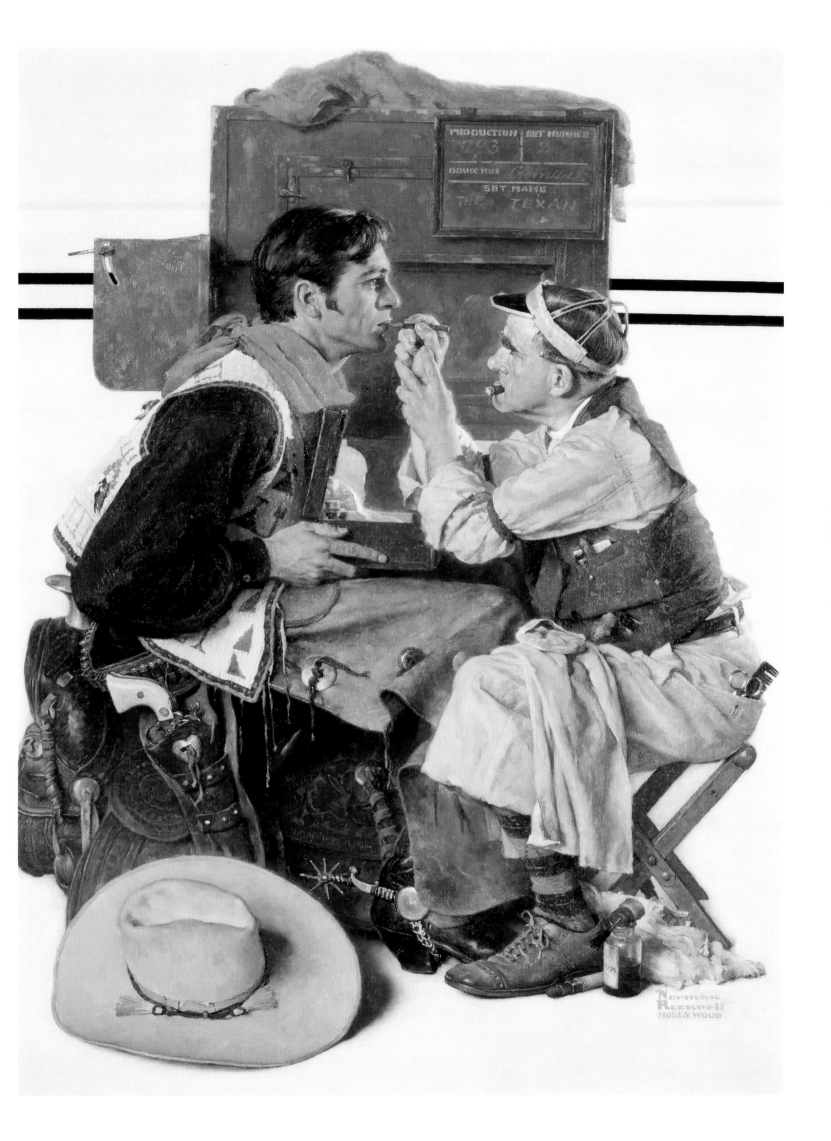

independent, modern, and eager for adventure. Another was the glamour girl, often blonde, always beautiful. Neither is a particularly individualized character. For *Post* readers to identify with them and fantasize about the lifestyles they represented, they had to appear as stereotypes. Rockwell chose models, props, and costumes that made them easily recognizable.

Rockwell redefined the "new woman" character, which had been a stock figure in cartoons and stereoscope viewing cards in the years leading up to passage of the Nineteenth Amendment. He amended the 1920s image of the flapper as a carefree party girl with bobbed hair and slinky dress to emphasize her sense of independence. In a 1928 cover he showed an ambitious young athlete, strenuously striding alongside a male companion. (fig. 31) Although described as "hikers," they are more likely participating in the craze for racewalking competitions, which offered cash prizes for long-distance "heel-toe" races for men and women.[93] The girl's resolute expression reinforces our sense that she is determined to keep up with her masculine friend despite her diminutive size. The picture was followed in the summer by one of a young woman painting outdoors while a country bumpkin peers over her shoulder at the canvas. Neither is a wife or mother, nor are they objects of male attention. Instead, they are individuals pursuing their own interests.

Rockwell's images of active women may have been prompted by an editorial directive from Lorimer. With the depression, the *Post*'s advertising income began to drop and circulation stagnated. The magazine had supported Herbert Hoover in the 1932 presidential election, and throughout the 1930s it maintained an anti–New Deal editorial stance that alienated Roosevelt's many admirers. To reverse the downward trend, Lorimer called on his stable of artists and writers to focus on modern rather than traditional subjects.

Rockwell's decision to feature independent women may also have been inspired by a change in his own life. Forsythe had banked that a trip to Hollywood would pull Rockwell out of his despondency following his divorce, but Forsythe's ulterior motive was to introduce Rockwell to Mary Barstow, an intelligent and active woman who had recently graduated from Stanford University. Initially reluctant, Rockwell joined them for dinner one evening. Within weeks, he and Mary were engaged, and a month later, on April 18, 1930, they married in the garden of her parents' home in Alhambra. (fig. 32) Even though Rockwell had not been in California long, the wedding made the news in Los Angeles.[94]

The young woman in *Couple in Rumble Seat* is a 1930s version of the flapper, who in cartoons and advertisements, and on the covers of the *New Yorker, Smart Set, Vanity Fair,* and other periodicals, was often accompanied by a "gawky boy or squat older man" whose timidity reinforces her carefree personality.[95] (fig. 33) Her bobbed hair is permed, keeping it in place as she leans forward into the wind of the fast-moving car. Her enthusiasm contrasts with the apprehension of her stodgy male companion, who clutches his coat and holds onto his hat in consternation.

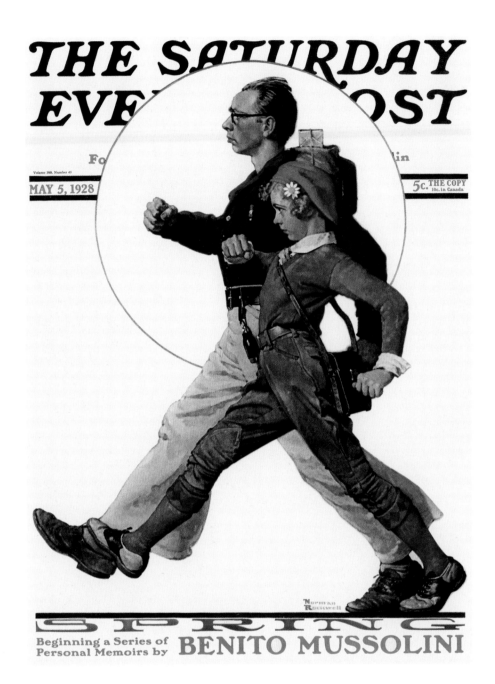

31

Spring: Man and Girl Hiking

The Saturday Evening Post,
May 5, 1928

Couple in Rumble Seat is a simple, almost summary composition in which every element contributes to the sense of streamlined speed. Cars with rumble seats were the ride of choice for the young in the late 1920s and early 1930s, when manufacturers designed automobiles with art deco–like modern lines. They were sporty, exciting, and offered an exhilarating sense of freedom. The car in the painting is a late-model coupe (modeled perhaps after Rockwell's own Apperson Jack Rabbit). The spaniel's ears, the girl's scarf, and the man's tie are blown back by the breeze, which Rockwell indicated with thin horizontal lines brushed across the surface. The couple seems an odd pair. Rockwell has accentuated the flapper stereotype by reversing the traditional roles of well-behaved woman and adventurous man. In her up-to-date sweater and scarf, she is fearless and forward-looking, eager for the experience of wind and speed.

The flapper's younger sister, the tomboy, takes center stage in the 1939 painting *Marble Champion*. (fig. 34) It is a classic image of the battle of the sexes in which a determined-looking girl cleans out two dismayed little boys in a game of marbles. Every detail in the painting compounds the insult. Her bulging bag cannot hold all the marbles she has won, while those of the boys are limp and empty. Even her dress—printed with polka dots the same size as the marbles—conspires to tell the story. With her scuffed brogans and stooped posture she is distinctly unladylike. The characters in *Couple in Rumble Seat* and *Marble Champion* echo roles that were popular fare at the movies in the 1930s. Actress Jean Arthur became typecast as a smart, aggressive female. She played the slick reporter Babe Bennett in Frank Capra's film *Mr. Deeds Goes to Town* (1936), in which Rockwell's friend Gary Cooper played the male lead. Arthur also portrayed a savvy political insider who shows the ropes to a naive and idealistic Scout leader appointed to fill a vacant Senate seat in Capra's *Mr. Smith Goes to Washington* (1939).

Rockwell's glamour girl is a stock 1930s Hollywood blonde who resembled the Jean Harlow character in Capra's film *Platinum Blonde* (1931). Harlow's picture graced the covers of movie magazines and cosmetic ads, and her aquiline features and plucked eyebrows were admired by teenage girls and mooned over by adoring boys.[96] (fig. 35) The young woman in *Woman at Vanity* is the epitome of the glamour-girl type. (fig. 36) Sitting at a frilly dressing table checking her appearance before going out on a date, she is dressed in a variation of a gown by Adrian, the preeminent costume designer for MGM studios, worn by Joan Crawford in the film *Letty Lynton* (1932). The dress was one of the most famous items of apparel of the day. Capitalizing on every woman's desire to be stylishly au courant, Macy's department store sold some half million copies of Adrian's creation in its Cinema Shop.[97] Notes tucked into the frame of the mirror suggest Rockwell's subject has invitations from multiple beaus. We see the scene from the back, behind the little sister in pigtails and pajamas, who watches her older sibling's preparations. As with *Shadow Artist,* Rockwell opted for the viewpoint of the child "audience." He gives no indication of the young girl's reaction, but her curiosity about her sister's preparations is a forerunner of the feminine coming-of-age pictures Rockwell explored extensively in the years that followed.

The Flirts emphasizes the pretensions of the glamour-girl type. (fig. 37) Two truckers ogle a chic young woman who does her best to ignore them as they are stopped at a traffic light that we see reflected in the side-view mirror. The driver pulls petals from a daisy in the age-old "she loves me, she loves me not" refrain, as his companion seems to eyeball another young woman. It is a consummate image of contrasts: between working men in rough clothing and an elegantly dressed young woman, a boxy commercial vehicle and a streamlined convertible, homespun friendliness and aloof disregard. She is linear and fashionable, expensive and well coiffed (begging the question or how she keeps the hat on once she speeds

32

Norman Rockwell and Mary Barstow
Alhambra, California, April 1930.
Bettmann Collection, Corbis

Following pages:

33

Couple in Rumble Seat
The Saturday Evening Post,
July 13, 1935.
Oil on canvas, 21 × 17 ¼ in.
Collection of George Lucas

34

Marble Champion
The Saturday Evening Post,
September 2, 1939.
Oil on canvas, 28 × 22 in.
Collection of George Lucas

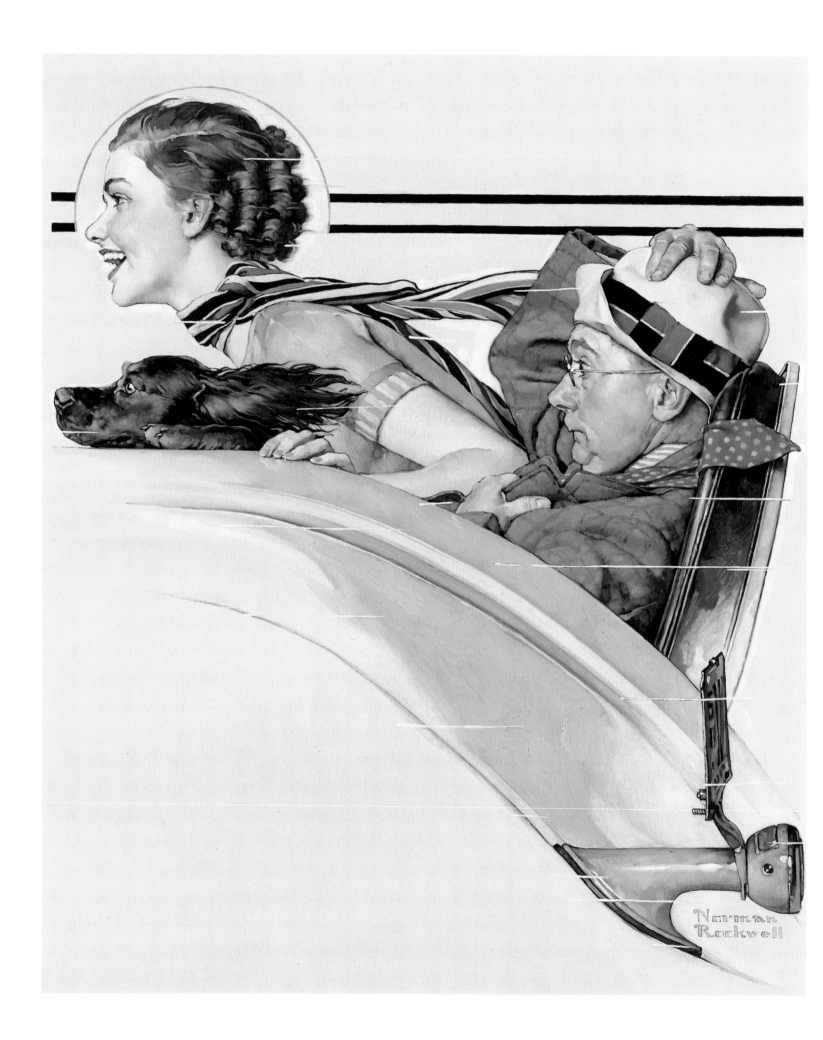

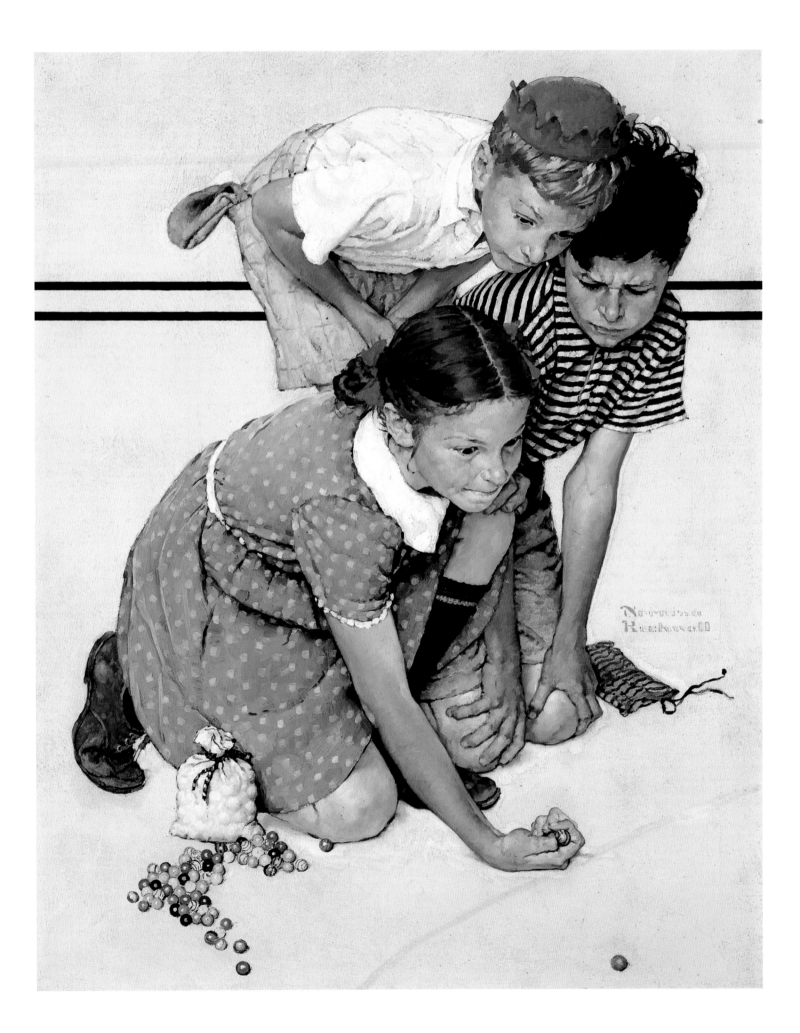

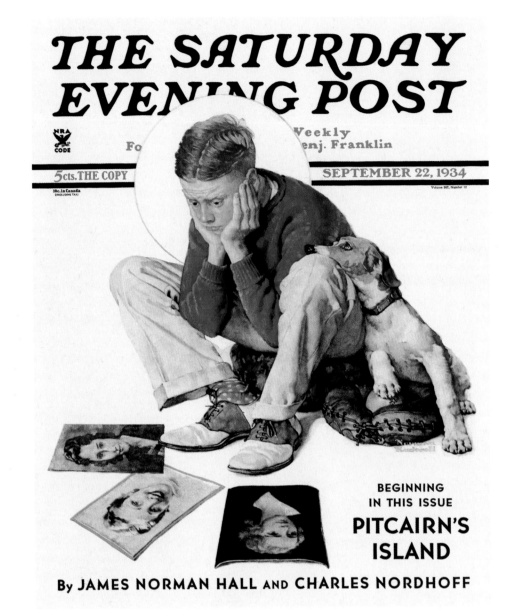

THE SATURDAY EVENING POST

NRA CODE

Fo... Weekly ...enj. Franklin

5cts. THE COPY

10c. in Canada (INCLUDING TAX)

SEPTEMBER 22, 1934

Volume 207, Number 12

BEGINNING
IN THIS ISSUE
PITCAIRN'S
ISLAND

By JAMES NORMAN HALL AND CHARLES NORDHOFF

35

**Boy Gazing at Pictures
of Glamorous Stars**

The Saturday Evening Post,
September 22, 1934

36

Woman at Vanity

The Saturday Evening Post,
October 21, 1933.
Oil on canvas, 32 ¼ × 23 ½.
Collection of George Lucas

away from the traffic light). Their encounter is brief and the social differences between them are obvious, but it's all in good fun. Spielberg, who described her as a "very flashy, Lana Turner type," remarked that the men's glances are "totally innocent, completely moral," and "at the same time, just naughty enough that you know that the guy isn't a total square."

The glamour girl reappears in *Movie Starlet and Reporters,* a classic Hollywood image of a young actress on tour. (fig. 38) The presumed excitement of stardom is replaced by the blasé boredom of an actress holding a welcome bouquet who is surrounded by scruffy journalists eager for the attention she is not prepared to bestow.[98] With camera, radio microphone, and notepad they are ready to capture every word. Absent clues to location, the implied subtext is that this is just one of many stops on a promotional tour in which the starlet hears the same questions and repeats the same trite responses. Rockwell's focus on detail is particularly noticeable in the handling of the reporters' feet and shoes. The newspaperman's are

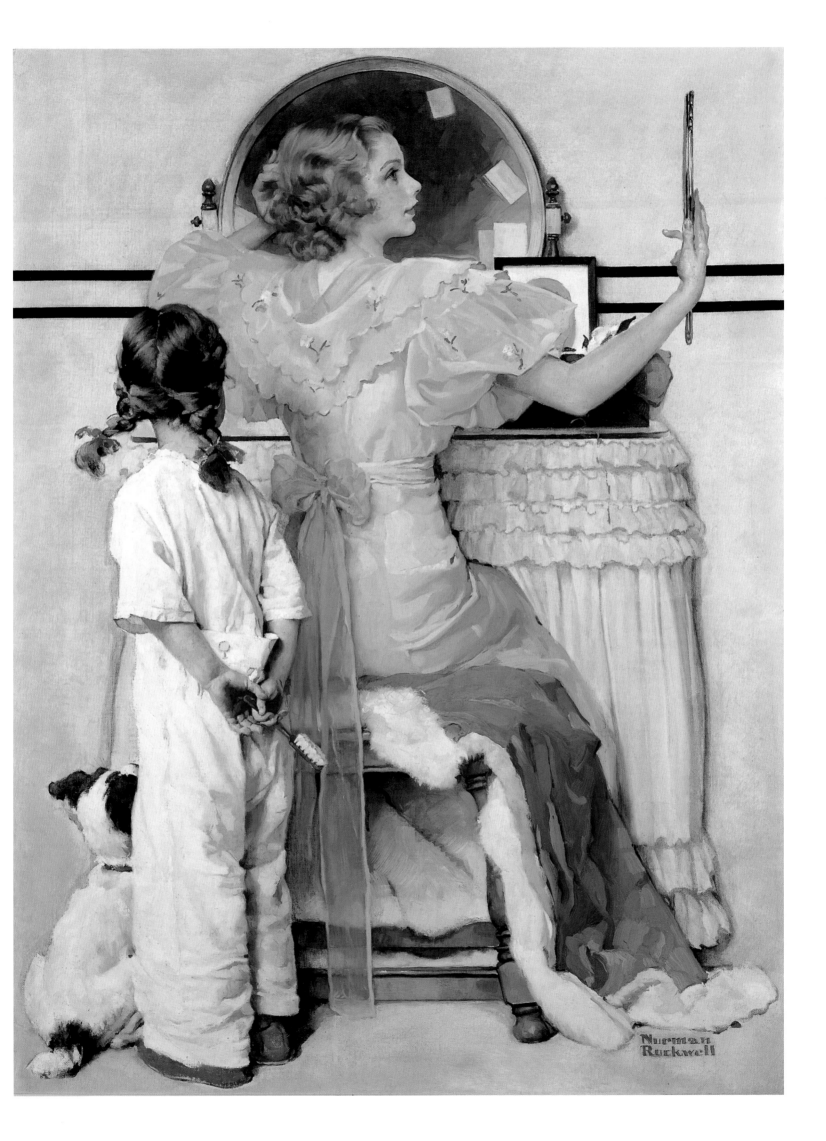

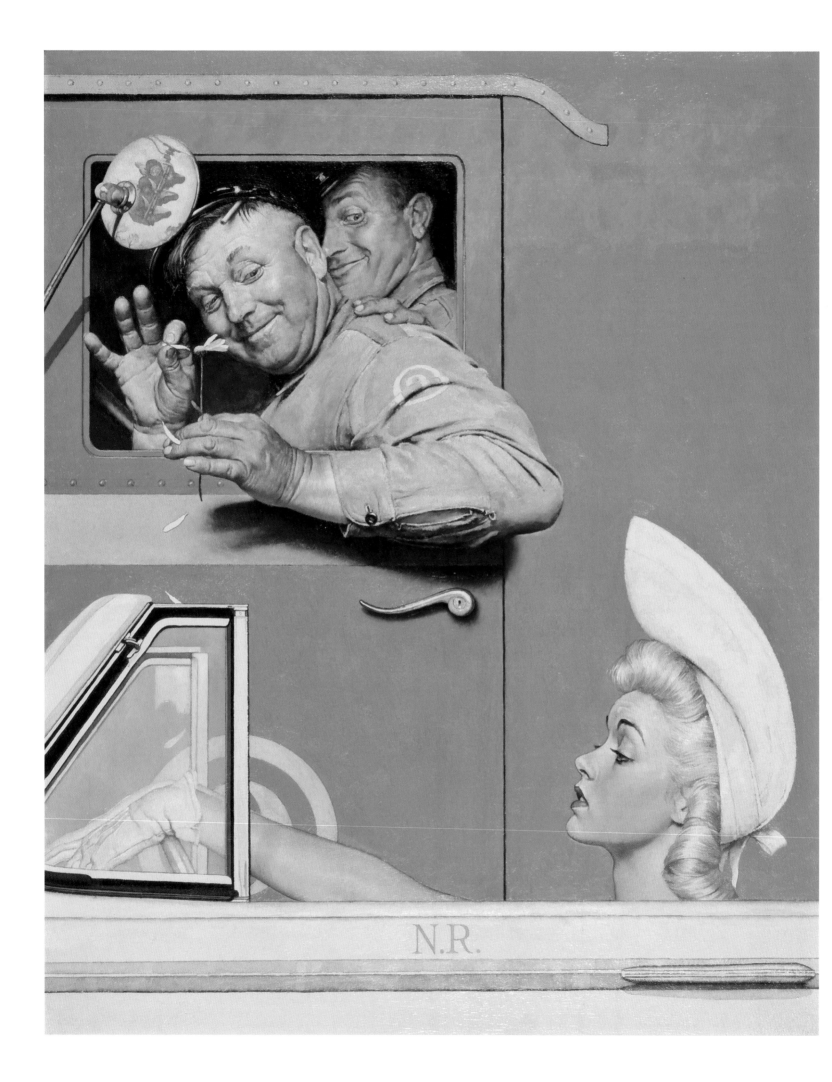

37

The Flirts
The Saturday Evening Post,
July 26, 1941.
Oil on canvas, 34 ¼ × 27 ¼.
Collection of Steven Spielberg

Following pages:

38

Movie Starlet and Reporters
The Saturday Evening Post,
March 7, 1936.
Oil on canvas, 35 × 32 in.
Collection of Steven Spielberg

39

The Convention
The Saturday Evening Post,
May 3, 1941.
Oil on canvas, 43 × 34 in.
Collection of George Lucas

scuffed, and the radio reporter sports spats, although his bedraggled coat attests to aspirations of unachieved success. Fashionably dressed in fur ruff and stylish gray, the actress is an oasis of elegance surrounded by the plainness of real life.

Rockwell's accuracy in capturing the Hollywood type became clear when *Movie Starlet and Reporters* was described as a scene of Jean Harlow being interviewed. Harlow was the quintessential glamour girl, the bombshell who had starred in more than thirty films by the time Rockwell's cover appeared. Although there is some question about who actually posed for *Movie Starlet,* the model may have been twenty-one-year-old Mardee Hoff, the daughter of Guy Hoff, whose illustrations appeared in *Liberty, Collier's, Judge,* and between 1930 and 1935 in the *Post.* Mardee Hoff was a perfect fit for the glamour-girl type. A model for ads and illustrations, she hoped to break into the movies, aided by the recommendations of several notable New York illustrators who suggested to their friends in the film business that they give her a screen test.[99] Rockwell asked her to model shortly after she was selected as having the "most perfect figure in America," an honor she won from a field of 2,600 other contenders in a contest written up in the *New Yorker.*[100] Hoff's name and face were familiar from a photographic portrait published in *Cosmopolitan* magazine in 1935 and ads for Camel cigarettes that appeared in newspapers from Chicago to Los Angeles, but the day Rockwell's *Post* cover hit the newsstands, three movie companies reportedly wired the magazine for her name. Within two weeks Hoff was off to California under contract to Twentieth Century-Fox.[101]

Rockwell was sympathetic to the hordes of actors who flocked to Hollywood to become stars but ended up working in drugstores or sewing shops and were too proud to return home.[102] *Hollywood Dreams,* published in *Ladies' Home Journal* in July 1930, showed what he described as a Mary Pickford look-alike sitting forlornly on a bench in a closed casting office.[103] Many young women, like Mardee Hoff and Terry Walker, another aspiring actress who signed with a major studio after appearing in a Norman Rockwell *Post* cover, took modeling jobs in hopes of being discovered. Newspapers informed aspiring stars that movie scouts studied magazines and newspapers for prospective talent. And it worked, according to the *Chicago Daily Tribune,* which reported that "hundreds of successful film players, including some of the stars, have come out of the modeling business."[104] Actresses Jane Wyman and Norma Shearer modeled for women's clothing and accessory advertisements before being discovered; Henry Fonda posed for ads to augment his meager salary during the early years of his career.

The young hat check girl in *The Convention* may well have been an aspiring actress trying to make ends meet while waiting for a chance at stardom. (fig. 39) She is young and attractive, but with her arms full of coats and hats sporting buttons, she is exhausted and bored, ignored by conventioneers who have dumped their belongings into her arms (and on

her head) and rushed off to meetings. The small stack of tickets coupled with the huge pile she holds invite speculation about how she will ever be able to return the possessions to their rightful owners. As a final insult Rockwell added a smoldering half-smoked cigar—discarded by a man oblivious to the tired young woman who, in high heels and with laden arms, is too encumbered to pick it up.

Painter to the Stars

After their whirlwind courtship and marriage, the Rockwells settled in New Rochelle, where Rockwell had lived for a number of years, but they returned to Los Angeles regularly, especially once they had children, to visit Mary's parents. For Rockwell the trips combined work and pleasure. He could do magazine covers there as easily as at home, and he was increasingly in demand to paint portraits of stars for advertisements put out by the publicity departments of major studios.[105] Rockwell enjoyed the work. Ads were especially lucrative and also easier than *Post* covers, which required coming up with story pictures. Even more, he met interesting people throughout the film industry, and it was exciting to spend time with celebrities, many of whom considered the increasingly famous illustrator to be a celebrity himself.

Rockwell was neither the first nor the only artist to be seduced into work for the movie studios or whose vision was shaped, at least in part, by images seen on the silver screen. John Sloan's fascination with silent films colored both the subjects of his pictures and the way he conceived images.[106] And there were others. Architectural sculptor Lee Lawrie created a figural group based on director Rex Ingram's 1921 film *The Four Horsemen of the Apocalypse,* and Thomas Hart Benton began to develop his regionalist aesthetic in the mid-1910s, when he worked for the Pathé and Fox film companies in New York.[107] Like Rockwell, Benton considered the movies a key element of American culture. *City Activities,* one of nine murals he painted for the New School for Social Research in New York in 1930 and 1931, prominently features moviegoers within the mix of urban life. Benton also used framing devices borrowed from the movies for the internal structure of the series of vignettes that make up the picture.[108] Although his compositional and thematic choices were different from those of Benton, Rockwell, too, borrowed expressive devices (like Charlie Chaplin's famous shoes) and themes that resonated with the subjects of popular movies.

In the late 1930s and 1940s, Twentieth Century-Fox, United Artists, and several other studios hired well-known painters, cartoonists, and illustrators to create promotional materials to bring cachet to their movies. Regionalist art, like Rockwell's, was grounded in images of ordinary life, and Benton, along with his contemporaries John Steuart Curry and Grant Wood, were among the most popular painters of the day. Their appeal was not lost on producer Walter Wanger, who hired Benton, Wood, and several other regionalists both for their brand-name recognition and

because their images resonated with ordinary people all over the country. In 1940 he invited nine to promote the movie *The Long Voyage Home,* the script of which was based on four one-act plays by Eugene O'Neill. Anticipating lukewarm public reaction to a movie with a somber, emotionally difficult theme, Wanger hoped that ads featuring paintings by leading artists would expand the film's popular appeal.[109]

The ploy seemed to work. Artist-illustrators Dean Cornwell, John Falter, Douglass Crockwell, and Constantin Alajálov, familiar for their *Saturday Evening Post* covers, were hired to promote movies, as was Rockwell, who again painted his friend Gary Cooper, this time in the title role of the movie *The Adventures of Marco Polo* (1938) at the behest of Samuel Goldwyn Productions. More movie-star portraits followed. In 1939 Rockwell did a charcoal of Don Ameche in costume that is probably related to Ameche's role in *The Story of Alexander Graham Bell* (1939). In 1942 Rockwell drew the heads of Anne Baxter, Richard Bennett, Dolores Costello, Joseph Cotton, Tim Holt, and Agnes Moorehead—stars of Orson Welles's screen version of the Booth Tarkington novel *The Magnificent Ambersons.* Rockwell painted their likenesses as individual images that advertising directors arranged in varying configurations to accommodate the movie's title and taglines, as well as the names of the director and stars for posters and ads. Although the portraits did not tap into Rockwell's strength as a painter of humorous images of ordinary people, they were accomplished and sensitive renderings of the stars in their various roles and kept him in the Hollywood limelight.[110] In the spring of 1949 the Rockwells arrived in Los Angeles for a five-month stay. They moved into the home of Clara Griffith, one of Mary's friends from Stanford, who was on location with her husband, Gordon, during the filming of *The Thief of Venice.*[111] The Rockwells felt at home there. He painted covers and ads, taught classes at the Otis College of Art and Design, and gave lectures to community groups through the area. He also became a favorite dinner guest of Hedda Hopper, who reported his comings and goings in her syndicated column "Looking at Hollywood."[112] The artist had a prodigious memory for movies, even those he had seen many years earlier, as apparent in Hopper's description of an evening she spent with Rockwell and comedian Harold Lloyd. Rockwell, she recalled, "sat in my living room and went over one entire sequence, bit by bit, in a picture Harold made twenty years ago. Lloyd was in hysterics."[113]

Artist or Illustrator?

The early 1930s was a difficult time for Rockwell. In spite of his marriage and Hollywood adventures, he hit an artistic slump and found himself struggling for ideas. Rarely satisfied, he painted and repainted his pictures, threw them out, and began again. He experimented with illustrator Jay Hambridge's "theory of dynamic symmetry," a system for structuring compositions that Maxfield Parrish and a number of other artists used in the late 1910s and 1920s. Rockwell tried it for a *Post* cover in 1931 that

shows a fireman, boy, and dog racing toward an unseen blaze, their faces and bodies bathed in a warm red glow. But the proportions required for a cover image were ill suited to Hambridge's format, so Rockwell abandoned the approach.[114]

Although Rockwell's sense of humor and love of anecdote were ideally suited to magazine, advertisement, and calendar work, he wondered whether he could succeed as a fine artist. While still a teenage art student, Rockwell and a friend had pledged that they would never succumb to the financial lure of "mere" illustration work. But as his reputation and fees increased, he was loathe to turn down well-paying assignments from commercial publishers. His dilemma was exacerbated by a case of painter's block that plagued him in the early 1930s. Hoping that a change of scene would help, he left with Mary and their five-month-old son, Jarvis, for Paris in February 1932. They stayed for eight months while Rockwell tried to get the magic back. He spent hours studying old masters at the Louvre and wandering the streets with sketchpad in hand.[115] Finally, he wrote, "After months of badly painted, out-of-drawing, lackluster covers, done one after another with a sort of dogged despair, I worked myself out of it." It was a pattern he repeated whenever he found himself blocked. "Each time, as I reached the point where I felt I was finished, at the end of my rope, I've managed to right myself. Always by simply sticking to it, continuing to work though everything seemed hopeless."[116] Hard work and perseverance helped, but looking at paintings by others refreshed his sense of artistic possibility. Drawing on old masters and American painters of the late nineteenth and early twentieth centuries that he saw in Paris, New York, and Philadelphia revitalized both the themes he portrayed and his way of making pictures.[117]

Although *Post* covers with humorous themes continued to pay the bills, some of Rockwell's most memorable images from the 1930s were illustrations for stories in national magazines in which he could explore new compositional approaches and painting techniques. Story illustrations were easier than covers because they gave him a starting point. "Illustration has never been difficult, as compared with *Post* covers," he said. "When painting a *Post* cover I must tell a complete, self-contained story. An illustration is merely a scene from a story. The characters and setting are fully developed by the author."[118] Many, however, were emotionally more complex than the quick-take sight gags and nostalgic images he had been producing for magazine covers. He loved to illustrate stories situated in the nineteenth century, which allowed him to draw from his extensive collection of period props and costumes that were no longer appropriate for *Post* covers with modern themes. He could also get away from the constant pressure to devise visual wisecracks that had instant impact.

Whether prompted by his crisis of confidence or by the adversity experienced by Americans during the depression, many of the commissions were for stories about people overcoming hardship, making difficult

decisions, and showing concern for others that enabled him to paint hopeful pictures with moralizing themes. *Peach Crop,* for example, accompanied a story by Ruth Burr Sanborn in the *American Magazine* in April 1935. (fig. 40) It is a classic tale of "poor but proud" triumphing over selfishness and opportunism. The story opens on an impoverished student who works in a peach orchard to earn tuition for his final year of medical school. He receives a letter from his socialite fiancée announcing that she will visit the friend whose family owns the orchard; he is eager to see his future bride. Although he had once dreamed of becoming a country doctor, after graduation he will instead join her uncle's Park Avenue medical practice—ensuring the social prominence and financial security she considers her due.

He first notices the young woman Rockwell portrays in *Peach Crop* when she injures her hand in the peach-sorting machinery. He bandages it and walks her home to a room filled with antiques and books—Shakespeare, *Canterbury Tales,* and *Paradise Lost,* among them—that she rents in the weathered house of a poverty-stricken sharecropper. She lives frugally, she tells him, to save money for nursing school. As the story unfolds, the sophisticated fiancée arrives in a flashy convertible and snubs the aspiring nurse because her clothes are plain. She also proves insensitive to the suffering of workers who are hurt when fire consumes the peach-packing shed. Tending to the injured, the soon-to-be-doctor and would-be nurse prove a talented pair, and he reconsiders his plan to practice medicine on Park Avenue.

Rockwell's painting shows the moment when the medical student realizes that the injured peach packer is a beautiful young woman. The rude setting and rough clothing establish the strenuous nature of their work, but rather than depict the drama of the fire, the girl's homely lodgings, or the elegant fiancée, Rockwell elected the moment of romantic recognition. In doing so he intimated to readers that love between the two medically inclined protagonists will blossom in the end. Apart from a small drawing of an overturned peach basket, it was the story's only illustration.

Laid out as a double spread across two pages, *Peach Crop* served as a teaser for subscribers to read to the end of the story. The long format for this and several other story illustrations allowed Rockwell to compose horizontal pictures, a welcome change from the vertical configuration of magazine covers. The painting evokes the pathos of Renaissance-era pietà images he would have seen three years earlier, when he frequented the Louvre, and it also bears a striking resemblance to John Vanderlyn's painting *Ariadne Asleep on the Island of Naxos* (1809–14), which was in the collection of the Pennsylvania Academy of the Fine Arts in Philadelphia, near the headquarters of Curtis Publishing. The details of the painting align with the story's narrative, but the art historical resonances of the composition and its movielike panoramic reach reveal the multiple interests and sources that inflected Rockwell's work. Throughout his life he vacillated between feeling satisfied to be a successful illustrator and

Following pages:

40

Peach Crop
The American Magazine, April 1935.
Oil on canvas, 16 × 36 in.
Collection of George Lucas

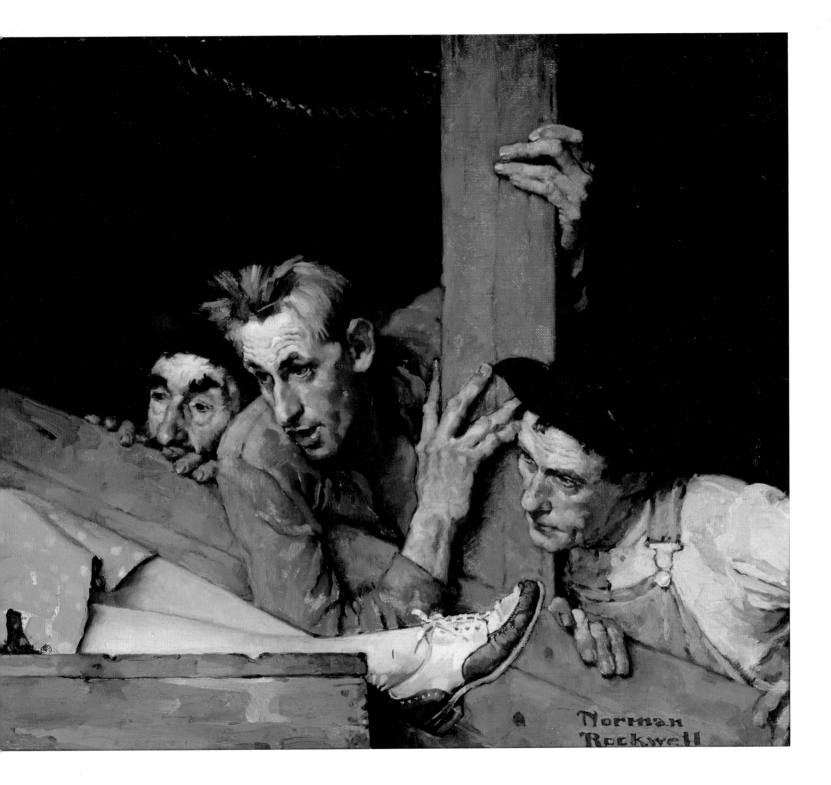

wondering if he could have succeeded as a fine artist. With *Peach Crop,* he fulfills both roles even as he tantalizes readers with the voyeuristic trope in which the body of a sleeping woman is the object of male attention.

A stickler for accuracy and an inveterate researcher, Rockwell traveled to Louisa May Alcott's home in Concord, Massachusetts, to scout the location and setting before beginning illustrations for a biography of the author to be serialized in *Woman's Home Companion* in 1937 and 1938. Alcott, who had died in 1888, was a highly regarded writer whose most famous book, *Little Women,* had become a classic shortly after the first part was published in 1868. The title of the magazine biography, "The Most Beloved American Writer," aptly described the country's ongoing affection for the remarkable Alcott. Katharine Anthony, the author of the magazine article, was also noteworthy. Well known in welfare reform and suffragist circles, Anthony wrote articles for *Survey* and *New Republic* and biographies of Catherine the Great, Queen Elizabeth, and Marie Antoinette in which she explored women's ongoing struggle against predetermined societal roles.[119] This point of view colored her discussion of Alcott and coincided with Rockwell's own interest in the changing roles of women in contemporary life. Anthony emphasized Alcott's dilemma in balancing responsibility to her family—she provided significant financial support for her parents and three sisters—with her need for solitary time to write, and she explored difficulties that Alcott faced as an unmarried woman who wanted to be taken seriously as an author. A biography of Alcott was timely after the success of George Cukor's 1933 movie adaptation of *Little Women.* Starring Katharine Hepburn and Douglass Montgomery, it was championed in the press and nominated for three Academy Awards. It won the 1934 Oscar for Best Screenplay Adaptation.[120]

Rockwell created fourteen illustrations to accompany the biography. Ten were line drawings depicting moments of self-realization in Alcott's life that Anthony described in the article. Four paintings highlighted autobiographical passages in *Little Women* that clued readers to the intersections among the novel, the biography, and the film. The paintings, which were reproduced in full color, also dovetailed with visual details of set and costume in Cukor's production.

The painting for the serial's first installment shows Jo March, the Katharine Hepburn character, protagonist of the novel and surrogate for Alcott, in the act of creation. (fig. 41) She is crafting a narrative that, like many of Rockwell's pictures, is a coming-of-age story about the joys and challenges of growing up. The caption that accompanies it—"The sun lay warmly in the high window, showing Jo seated on the old sofa, writing busily, with her papers spread out upon a trunk before her, while Scrabble, the pet rat, promenaded the beams overhead, accompanied by his oldest son"—is from chapter fourteen of *Little Women.*

Rockwell's canvas is a rich, painterly interior that shows a focused young woman seated on a Victorian sofa with knees drawn up, concentrating on papers she holds in her lap. Light streaming through the window

41

—

"The Most Beloved American Writer"
Woman's Home Companion,
December 1937.
Oil on canvas, 32 × 25 in.
Collection of George Lucas

picks up the shaft of her pen, and her face is a spot of lucidity in the otherwise darkened room. Free from the constraints of proportion and the simplicity required of magazine covers, Rockwell created a subtly modern composition. The insistent horizontal of the rafter and uptilted floor plane transform the attic space into a cocoon of intimacy.

The painting reflects Anthony's description of Alcott's working space: "Louisa's room was on the second floor of Orchard House but she wrote in the attic. One end of the long, bare attic space was partitioned off. Louisa had dragged into it an old sofa and one or two needed articles of furniture. Her esthetic requirements were of the simplest. Oddly enough, however, she liked to dress herself especially for writing in a gown and cap."[121]

The plaid dress Alcott wears in the painting resembles those worn by several of Jo's sisters in the movie, and the small brooch at her neck echoes a similar piece worn by Hepburn in the film's opening scene. Anthony had reported that when Alcott wrote, she wore an academic gown to prevent spilled ink from ruining her dress. In Rockwell's rendition the robe is spread across her lap. Small details like these maintained continuity between Anthony's narrative, Rockwell's painting, and the movie that millions of Americans had seen.

The saga of the March family takes place during the Civil War. Like the real Alcotts, the fictional family falls on hard times. But the messages conveyed—that family is more important than wealth, and happiness comes to those who help the less fortunate—were fit revival subjects in depression-era America.

Rockwell had the chance to tackle two other American classics in 1935, when George Macy, owner of Heritage Press, asked him to illustrate new editions of Mark Twain's *Adventures of Tom Sawyer,* which came out in 1937, and his *Adventures of Huckleberry Finn,* published in 1940. It was an exciting prospect. Some of the country's best-known artists, among them Rockwell's hero Howard Pyle and the famous adventure-story illustrator N. C. Wyeth, had illustrated Mark Twain classics. Rockwell set out for Hannibal, Missouri, hoping that some residue of Twain's hometown remained in the buildings and surrounding landscape. Discovering that Hannibal thrived on sightseers thronging to the sites in which Twain had set both books, Rockwell sketched the town, the author's house, and the cave where Tom and Becky famously got lost. Aiming for authenticity in costuming, he bought weathered straw hats and well-used garments from local residents.[122]

The trip stood him in good stead in 1940, when the *American Magazine* asked him to illustrate "Proud Possessor," and the *Post* requested pictures for "River Pilot." Like *Tom Sawyer* and *Huckleberry Finn,* both are coming-of-age stories in which male protagonists face the first important decisions of their lives.

The image Rockwell created for "Proud Possessor" presents a confrontation between two boys—one black, one white—over a pair of puppies.[123] (fig. 42) Behind their face-off is a narrative about a boy who attempts to

sort out his life after the death of his father. The story rehearses predictable tropes about the emotional bonds between boys and dogs, but rather than being an incidental note, the love of a boy for his pups is the angle around which the plot is constructed. Kiah, the boy holding the dogs, lives with his mother in a once-fine house in rural Mississippi that has fallen into disrepair after the father was gored by a wild boar while hunting. His wife blamed her husband's dog for failing to protect him, so she locks up his rifles and gives the cowardly dog to her housekeeper. The dog bears a litter of pups, two runts of which capture the boy's heart. Rather than drown them, the housekeeper gives them to Kiah but keeps them at her home where her son Pomp expects to be paid for their care. Kiah sacrifices a prized pocketknife and agrees to suffer the humiliation of allowing Pomp to call him a "buss-eyed ape" in front of their friends as payment. To him, the puppies are worth any indignity.

The language of the story is rife with racial stereotyping, and in Rockwell's drawing the ragged clothing of the black boy and the frayed but not yet torn clothing of the white boy emphasize the disparate status accorded by race in the 1930s and 1940s South. The text is full of dramatic passages that offered possibilities for exciting illustrations. But Rockwell ignored them in favor of the moment when Kiah surrenders his pride for the love of his animals. Less predictable than other options, this vignette shows Kiah facing a decision that defines his character as a human being.

Rockwell's drawing, a black and white image, which apart from color is identical to the final painting, is spare—it features just two boys, two dogs, and a stick. Dramatic tension is conveyed via the S-curves of their bodies and the positioning of their hands and feet. Rockwell first photographed his models standing on the ground outside his studio, but he was dissatisfied with the effect. So he had them climb on boxes to compromise their equilibrium. (figs. 43 & 44) Their slightly off-kilter postures impart a sense of urgency to the otherwise simple configuration.

In "River Pilot," a story by Carl D. Lane published in the *Post* on September 21, 1940, twenty-year-old Jem Bates, wearing a new pilot's cap with gold lettering, faces his first test of manhood. He has just earned his credentials as a river pilot and is about to embark. Filled with the hubris of youth, he aims to best the speed record for a paddle wheeler going upriver, proving the worthiness of the old-time craft and, coincidentally, impressing his girl and her river-pilot father. But spring rains have flooded the Connecticut River; when it crests, the swollen, fast-moving current will carry trees, houses, and debris from demolished bridges that could destroy the *River Bird* and those aboard.

Against all advice, Jem heads out, his lone passenger a railroad inspector on board to assess the viability of the paddle wheeler against its rival, the new propeller-driven *Amos Pruitt*. The stakes are high. The winner will receive the lucrative contract to carry express freight. Jem makes the run, sets the speed record, and prepares to depart out for the next stop. But it is a Pyrrhic victory. The skeptical inspector transfers the *River Bird*'s

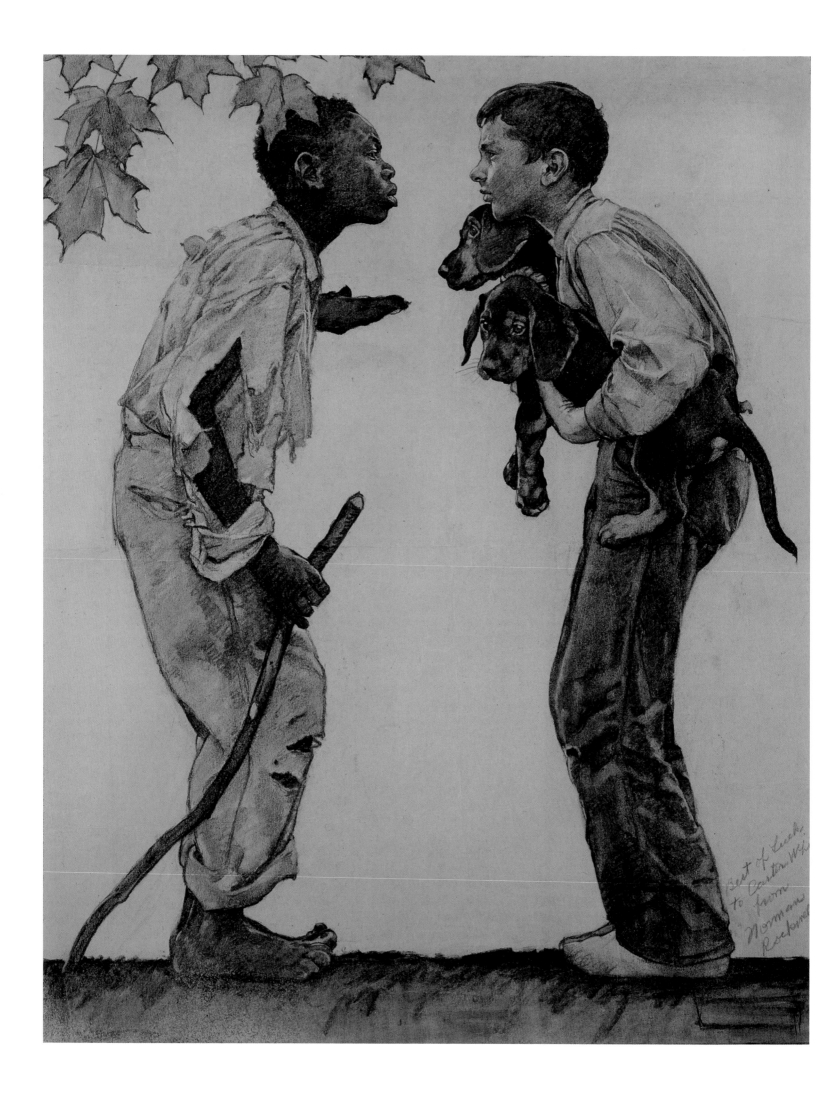

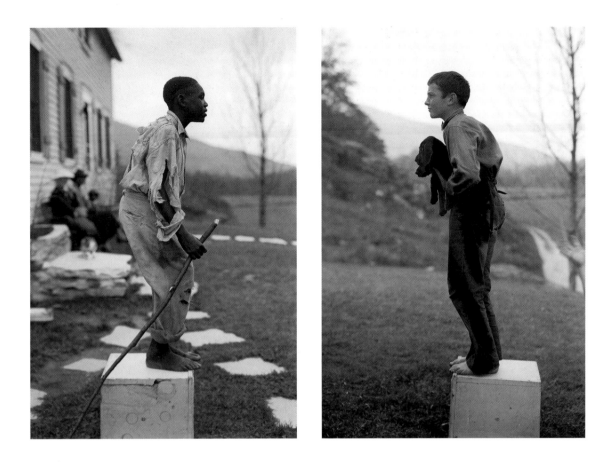

42

Proud Possessor
The American Magazine, May 1940.
Charcoal on paper, 35 × 28 in.
Collection of George Lucas

43, 44

Preliminary photographs for
Proud Possessor
Norman Rockwell Archives,
Norman Rockwell Museum,
Stockbridge, MA

Following pages:

45

River Pilot
The Saturday Evening Post,
September 21, 1940.
Oil on canvas, 44 × 58 in.
Collection of George Lucas

express cargo to the *Amos Pruitt,* eliminating the need for Jem to continue the journey upriver. The arrival of a last-minute package requires him to carry on. He gambles on his knowledge of the river to skirt debris and sandbars and beat the modern vessel to their common destination. On arriving upriver, he discovers that the express packet is addressed to him. It contains a message from his girl, who wanted him to have the chance to prove himself. "River Pilot" is a story of romance and of youthful pride and duty in which tradition triumphs over technology. Paddle wheelers no longer plied the waters of the Connecticut River in 1940, but audiences who rooted for the underdog and were nostalgic for easier, gentler days would have enthusiastically cheered Jem on.

Rockwell made two drawings and the painting, *River Pilot,* to accompany the story. (fig. 45) One drawing shows the *River Bird* dwarfed by the modern *Amos Pruitt*; the other depicts a beautifully dressed young girl standing beside her river-pilot suitor with eyes cast down demurely. For the painting, Rockwell chose Jem's moment of decision before ordering the *River Bird* from the pier. The *Amos Pruitt* is visible through the pilot-house window, but Jem and the helmsman focus on the water ahead. Through his telescope the young pilot scans for debris while the helmsman muscles the wheel. The ship's captain, in stovepipe hat, strains to see what lies ahead; Telfer, the railroad inspector, smokes a small cigar.

Rockwell rendered nuances of light and fabric and the details of wheel and binnacle with careful accuracy, and he deliberately positioned each figure for maximum expressive effect. Their postures indicate their states

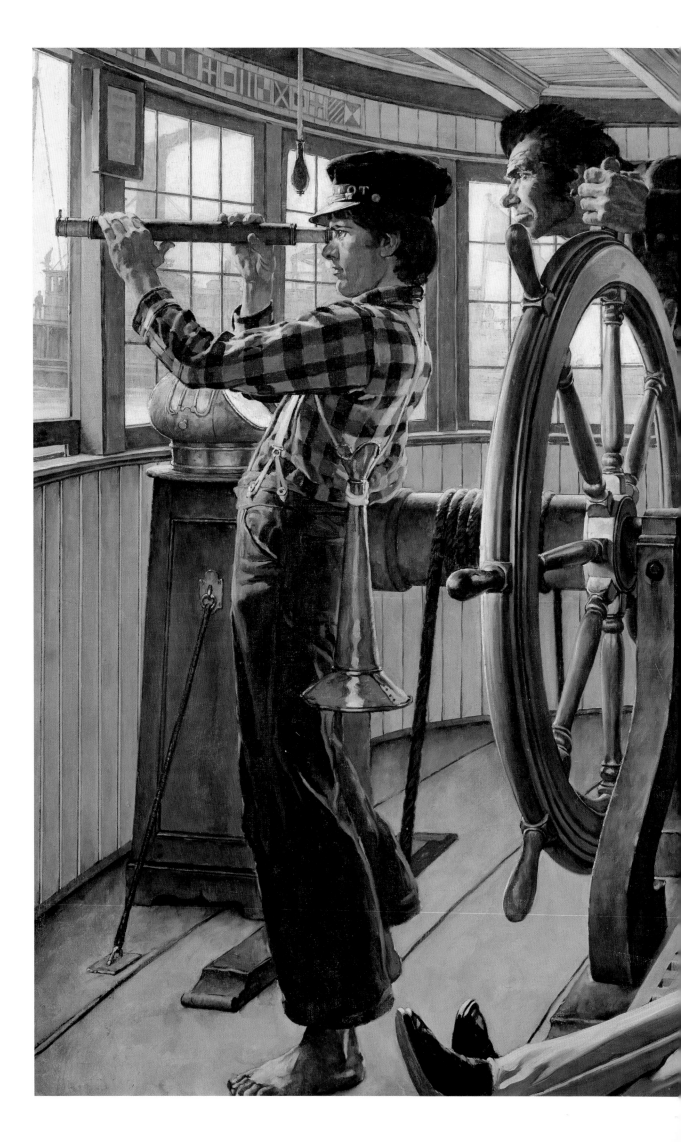

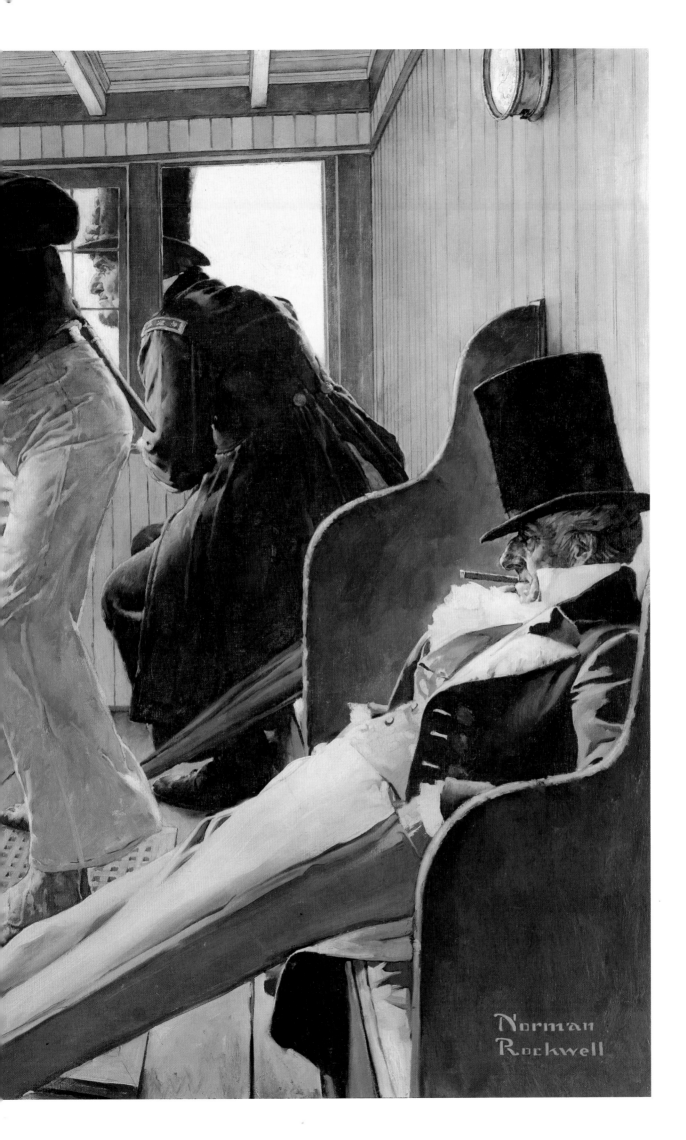

46, 47

Preliminary photographs for
River Pilot
Norman Rockwell Archives,
Norman Rockwell Museum,
Stockbridge, MA

of mind. Jem is relaxed, confident in his role as pilot; the captain is anxious; the dubious Telfer reclines, legs rigidly stretched out as he watches preparations for their departure. Rockwell's preparatory photographs reveal the postural adjustments he required of his models to achieve the sense of tension that pervades the image. To establish Telfer's commanding presence, for example, he combined the body of a younger model with the head of an older man wearing the same clothes. (figs. 46 & 47)

By 1940, when he painted *Proud Possessor* and *River Pilot,* Rockwell routinely used photographs to work out the specifics of his compositions. It enabled him not only to capture a scene quickly, but also to reconfigure the characters' blocking multiple times while his photographer snapped the shutter. He then combined elements from as many as one hundred shots as he worked out the final composition in oil sketches and highly finished drawings before applying paint to canvas. It was an elaborate process, but one that allowed Rockwell to work quickly once he was satisfied with his final conception.

Rockwell's love for the act of painting is apparent in *Let Nothing You Dismay,* which was commissioned for a story of the same title published in the July 1941 issue of *Ladies' Home Journal.*[124] (fig. 48) At four by six feet, it is larger than most of his canvases, and the surface alternates soft passages of painterly brushstrokes with smooth, carefully worked areas. Although we see the faces of three figures, their expressions give no indication of plot. Instead Rockwell has elected an equivocal scene.

Rockwell read the text multiple times to determine the most compelling moment in the narrative. The story, which takes place in 1904, focuses on the love of an ophthalmologist for his tomboyish daughter, the child's chronic indifference to maternal rules, and the affection between the

doctor and his beautiful but very proper wife. In the opening paragraph, the doctor, watching his daughter at play, ponders how to tell a patient that he will lose his eyesight within six months.

The child's mother is concerned about her willful independence. To induce her transgressive daughter to behave, the mother promises that the girl can attend a party if she mends her ways; mom then spends the family food allowance on extravagantly expensive pink hair ribbons and sash so the child will feel pretty in her party dress.

The story jumps to a week later. The ophthalmologist's patient receives the prognosis that he will go blind, and from the determined expression on his face, the doctor fears he will end his life. As they leave the office, doctor and patient see the little girl in her starched party dress and pink hair ribbons, tears sliding down her cheeks. She is desolate. She went to the party only to discover that it had taken place the day before. Her crushing disappointment melts the patient's heart, and he promises her a bicycle to ease her distress. As the story closes, his flinty eyes soften and he begins to laugh. Cheering up the little girl has restored his love of life.

Rockwell painted a comfortable middle-class parlor with patterned carpeting and an elegant Victorian sofa that was modeled on one of his own belongings. Every brushstroke and design element is calculated for optimal effect. The vertically striped wallpaper, the sheen on the sofa's wood trim, and the glint of light on the girl's patent leather shoes reinforce the realism of the scene. The patient's elegant dove-gray attire, gloves, and spats reveal him as a man of means, in contrast with the doctor's ordinary suit and black brogans. The patient's "Oh, no" expression and the doctor's bewilderment at seeing his daughter at home introduce a note of quizzical drama.

The story interweaves a host of emotional motifs: the father's love for his wayward daughter, the challenges faced by parents with recalcitrant children, the value of honesty when confronting life's obstacles, and the importance of small episodes that loom large in the lives of children. Rockwell might have focused on the patient's reception of the bad news, the ophthalmologist's struggle with the prognosis, or a moment in which husband and wife regard their independent child. Instead he portrayed the moment that motivates the story's hope-filled conclusion.

Although the fictional narratives that appeared in *Ladies' Home Journal*, the *American Magazine, Woman's Home Companion, Redbook,* and a host of other women's magazines often took unsuspected twists and turns, they routinely had happy endings. Along the way, many raised issues that readers faced in their own lives. Relationships between parents and their children and the challenges associated with growing up were popular motifs that allowed readers to process their own concerns and affirm the values that guided their day-to-day decisions. Each of these stories is a mini-morality play in which right or good triumphs over misfortune or despair. They reflect the sense of hope and innocence triumphant that shaped films by Capra and other contemporary directors and producers.

Following pages:

48

—

Let Nothing You Dismay
Ladies' Home Journal, July 1941.
Oil on canvas, 33 × 64 in.
Collection of Steven Spielberg

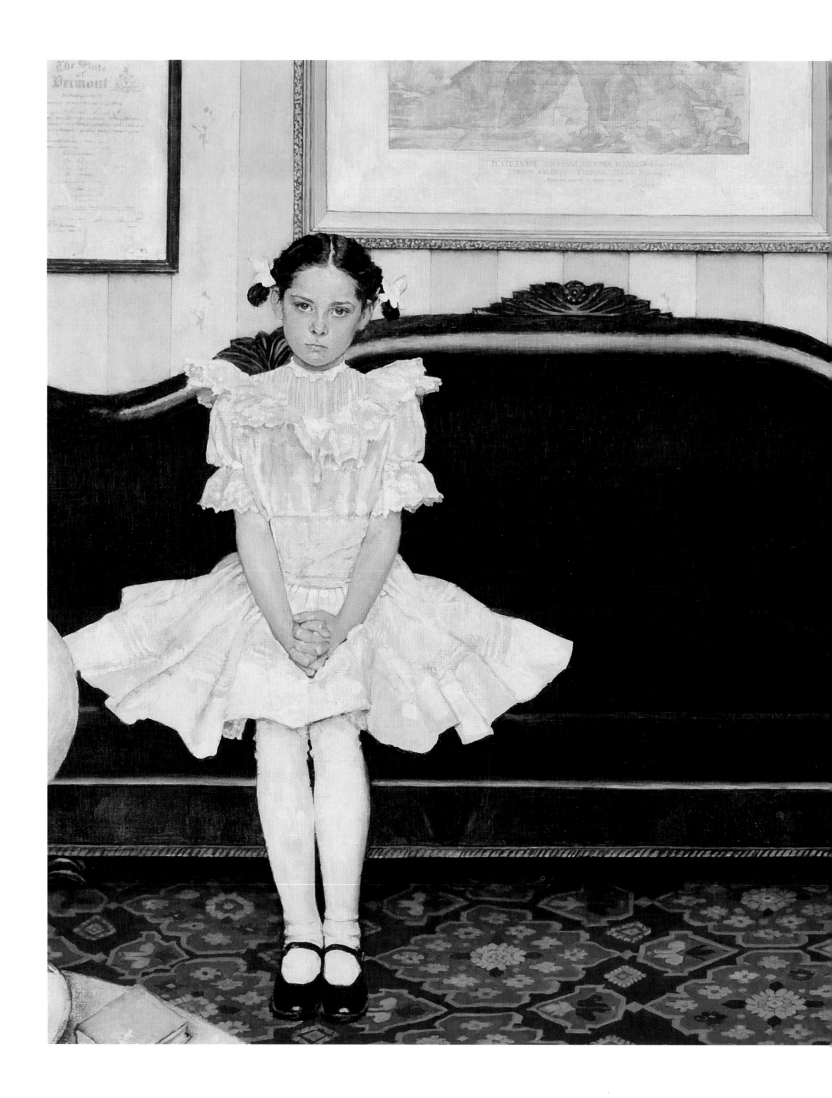

Norman Rockwell

Ordinary Heroes

In the mid-1930s the Rockwells began looking for a summer place where they could retreat with their children from the bustle of life in New Rochelle. They found a farmhouse in Arlington, Vermont. It seemed an idyllic location where the three Rockwell boys could roam freely, play with dogs, swim—live the boyhood life Rockwell dreamed of in his pictures. They moved there permanently in 1937. The change in location, from a suburb of New York City to small-town Vermont signaled a shift in Rockwell's work. In New York, he had often used professional models experienced at holding long poses while he sketched. In Arlington, Rockwell turned to the local community for both images and ideas. Friends, neighbors, and people he met at Grange Hall, the social center of Arlington, became the protagonists of his visual stories. He later said about Arlington, "My pictures grew out of the world around me, the everyday life of my neighbors. I didn't fake things anymore."[125] His new cast of characters represented an expanded vision of America; no longer did he rely primarily on models who fit predetermined stereotypes. Instead, the protagonists of his pictures, like the characters in Frank Capra's hugely successful movies, are individuals whose personal lives, convictions, and foibles represented ordinary people all over the country.

Capra and Rockwell shared a vision about the American everyman, creating characters whose warmth, humility, and humor endeared them to the public. Like Rockwell, Capra recognized that "What interests people most is people," so he built story lines around familiar personality types and the ways they behaved.[126] Although they occasionally stumble, in the end each, like the idealistic protagonist of *Mr. Deeds Goes to Town* (1936), sticks to his convictions in the face of overwhelming pressure. Those who stray, as does political outsider-turned-presidential-candidate Grant Matthews in *State of the Union* (1948), ultimately return to the decent and moral path. The power and reach of their respective media gave illustrator and filmmaker access to a huge American public; both took seriously the challenge and responsibility of sustaining hope during the depression and later, World War II; both located the antidote to hard times in the ordinary American.

Artist and filmmaker were only three years apart in age, although their backgrounds were very different. Rockwell grew up in New York City and its surrounding suburbs, the son of middle-class parents whose families had deep roots in America. Capra was a Sicilian-born immigrant who came to the United States as a child, sold newspapers on the street, worked his way through California Institute of Technology, and earned a degree in chemical engineering before going into movies. Yet both were acutely attuned to a public that believed (or wanted to believe) in fundamental truisms about the goodness of the simple man and the value of the little guy in the great American endeavor. Like Rockwell, Capra acknowledged hard times and tough situations not through reportage, but by revealing ways that ordinary people came to grips with difficult

moments in their lives.[127] Throughout the 1930s Capra's movies played to huge audiences, and his impact was acknowledged in the Oscars—for Best Picture, Best Screenplay, Best Director—that his films were awarded.[128] Many critics applauded his work; others criticized his movies of the 1930s and 1940s—*Mr. Deeds Goes to Town, You Can't Take It with You* (1938), *Mr. Smith Goes to Washington* (1939), and others—as "Capracorn," feel-good pictures that catered to a mass public by repeatedly extolling the virtues of family and homespun wisdom.

Capra's characters faced challenges that often took the form of corruption, greed, or overarching ambition in themselves or others that acknowledge dark side of human behavior. These universal themes played out forty years later in movies by Lucas and Spielberg. *Star Wars (1977), Raiders of the Lost Ark* (1981), *Empire of the Sun* (1987), and other hugely successful films the two have produced or directed since the 1970s resolve conflict according to a rigorous, though sometimes personal, code. They, like Capra and Rockwell before them, construct plots and characters that probe fundamental human values. The connections are not accidental. An episode of Lucas's television series *The Adventures of Young Indiana Jones* (1992–96), for example, is set in Paris, where young Jones encounters artist Norman Rockwell.

There is no evidence that Rockwell ever met Capra, but he was friendly with Fay Wray (Cooper's costar in *The Texan*), whose husband, Robert Riskin, collaborated with Capra on the screenplays for *Platinum Blonde* (1931), *It Happened One Night* (1934), *Mr. Deeds Goes to Town, Meet John Doe* (1941), and others. The parallels between the early development of artist and filmmaker, too, are striking. Capra had begun his movie career as a gag writer for silent films, coming up with amusing visual vignettes— a child using her aunt's cosmetics, a vacuum cleaner sucking the pants off a boy—that had the single-image immediacy of an early Rockwell magazine cover.[129] Capra also acknowledged that he was part of a "'gee whiz' school" of "wide-eyed and breathless" filmmakers who saw the world around them as larger than life. "To some of us, all that meets the eye is larger than life, including life itself. Who can match the wonder of it?"[130] His vision echoes that of the artist-illustrator, whose favorite expressions were "my gosh" and "golly."

Beginning with *Mr. Deeds Goes to Town,* the depression-era story of a tuba-playing naïf from the fictional Mandrake Falls, Vermont, who inherits $20 million from an uncle he never met then gives it away to poverty-stricken farmers, Capra determined that his films "had to say something." He wanted, he maintained, "to integrate ideals and entertainment into a meaningful tale." Making films "about America and its people" was the immigrant's "way of saying, 'Thanks, America.'"[131]

Americans would soon appreciate even more the simple narratives and vicarious emotional experiences that Capra's movies and Rockwell's images provided. In 1941, six months after *Let Nothing You Dismay* was published and shortly after *Meet John Doe* was released, the country was again at war.

World War II and the "Four Freedoms"

On December 29, 1940, almost a year before the Japanese bombed Pearl Harbor, President Roosevelt went on the air to deliver one of his occasional fireside chats. It was a somber address. The Germans had launched a devastating bombing attack on London that day, and large portions of the city were ablaze. He called on "the workmen in the mills, the mines, the factories; the girl behind the counter; the small shop-keeper, the farmer doing his spring plowing, the widows and the old men"—the same Americans celebrated in Rockwell's pictures and Capra's movies—to help America become the "great arsenal of democracy." In his State of the Union address eight days later, Roosevelt spoke again of mobilization. He urged Congress to approve the huge costs the nation would incur in building tanks and arms. To the millions listening on the radio, he spoke of civil liberties and equal opportunity, of the four "essential human freedoms" that are the cornerstones of American democracy.

49
—

Willie Gillis: Food Package
The Saturday Evening Post,
October 4, 1941

50

Willie Gillis: Hometown News
The Saturday Evening Post,
April 11, 1942

Freedom of speech, freedom to worship, freedom from want, and freedom from fear for people all over the world, he said, warranted American commitment and sacrifice.[132]

In September 1940, more than a year before the bombing of Pearl Harbor and several months before Roosevelt's "Four Freedoms" speech, the United States had imposed the first peacetime draft in the country's history; in November the first names had been drawn. Rockwell's response was to invent Willie Gillis, a young draftee who initially appeared on the cover of the *Saturday Evening Post* on October 4, 1941. Like the World War I soldier in *Polley Voos Fransay?*, Willie is the consummate naïf. His ears stick out and he has to roll up the legs of pants that are too long. In the first image—showing young Willie, trailed by a band of seasoned soldiers, carrying a package of food from home (fig. 49)—and ten that followed, Rockwell depicted Willie off duty—asleep in his bed while home on leave, being pampered by attractive young women at the USO, reading the hometown newspaper. (fig. 50) Willie looks much younger than the twenty-one years required for the first round of draftees, but Rockwell otherwise adhered to his usual precise realism. He visited troops stationed at Fort Dix, New Jersey, and bought a complete GI outfit to use in the series.[133] He found his model, Bob Buck, at a dance at the Grange Hall in Arlington.

The public loved the unsophisticated Willie, but Rockwell wanted to do something more, to somehow translate the sweeping abstractions of the Four Freedoms into realities that spoke directly to the lives of ordinary Americans. After the bombing of Pearl Harbor, Roosevelt's Freedoms became a rallying point for the country's fight. Hundreds of newspaper articles and magazine stories referred to the Freedoms, several of which had been reiterated in the Atlantic Charter signed by Roosevelt and British Prime Minister Winston Churchill in the summer of 1941. Although the idea of the Freedoms had caught on with the press, Rockwell remarked, "Nobody I know is reading the proclamation…despite all the fanfare and hullabaloo."[134]

Rockwell told the story of how he came to paint the "Four Freedoms" series many times. He had been talking with Mead Schaeffer, another *Post* illustrator and a close friend who also lived in Arlington, about what they could do to support the war effort. Too old to enlist, they thought they could contribute by creating posters, à la the government's massive World War I propaganda campaign. Rockwell worked up some ideas, including one showing a machine gunner running out of ammunition (published with the caption "Let's give them enough and on time"), but it seemed

inadequate. "I wanted to do something bigger than a war poster, make some statement about why the country was fighting the war."[135] He had read the Four Freedoms proclamation, he said, but the language was "so noble…that it stuck in my throat." So he carried on with life as usual. "I did a *Post* cover and an illustration, went to town meeting, attended a Grange supper, struggling all the while with my idea, or rather, the lack of it." One night, unable to sleep, he had a flash of inspiration. A neighbor, Jim Edgerton, had expressed views in the town meeting that everyone else disagreed with. "But they had let him have his say. No one had shouted him down. My gosh, I thought, that's it. There it is. Freedom of Speech. I'll illustrate the Four Freedoms using my Vermont neighbors as models. I'll express the ideas in simple, everyday scenes. Freedom of Speech—a New England town meeting. Freedom from Want—a Thanksgiving dinner. Take them out of the noble language of the proclamation and put them in terms everybody can understand."[136]

Rockwell roughed out sketches, and in June 1942 he and Schaeffer set out for Washington, where they met up with Orion Winford, head of Brown & Bigelow's creative department, who had government contacts. Rockwell recounted a day spent going from office to office without finding anyone willing or able to commit to producing the proposed ideas as posters.[137] On his way home he stopped off in Philadelphia to see Ben Hibbs, the new editor of the *Post.*

Hibbs was thrilled with the "Four Freedoms" proposals and asked Rockwell to drop everything and work them up into paintings. They dovetailed perfectly with the editorial viewpoint he announced when he took the magazine's helm three months earlier. He reversed the isolationist stance of the previous two editors (Lorimer and his successor, Wesley Stout) and immediately assigned correspondents to cover the war for the magazine. Hibbs knew Middle America; he had grown up in Pretty Prairie, Kansas, a town with a population of just four hundred, and like Rockwell and Capra, believed deeply in the intelligence and moral character of the American people. In June, just after Rockwell's ill-fated trip to Washington, Hibbs published an editorial in which he professed his faith in the public and explained his "credo" for the *Post*'s wartime coverage:

We shall try always to keep a note of sound hopefulness in the *Post*. These are grim days, and I am keenly aware that the problems which confront the American people are staggering; yet I am not one of those who believe that civilization is on its way to collapse. I have profound faith in the capacity and the guts of the American people to work and fight their way through these dark years and emerge with a way of life that is still fine and American.[138]

A week after the statement appeared in print, Jim Yater of the *Post* editorial staff wrote to Rockwell saying, "The editors now plan to run [the "Four Freedoms"] in four consecutive issues. They visualize a double page spread in which one of your Four Freedoms appears in full color bleed on

the right hand side. On the left hand side an essay written by some very prominent person best fitted to write on that particular Freedom as an accompanying interesting feature. People all the way from Franklin Roosevelt himself on down are being suggested as possible essayists."[139]

Rockwell spent the next six months working on the series. For an artist who routinely completed six to ten *Post* covers a year in addition to illustrations for stories and advertisements, the "Four Freedoms" proved difficult. He chose Carl Hess, owner of a local gas station, to be the model for the first one, *Freedom of Speech,* but he struggled with the composition, completing several versions before he arrived at the final image. Each adaptation portrays a man addressing his neighbors in a public forum, but they vary in spatial configuration and viewpoint.

An early concept showed a standing man looking up at an unseen individual who presides over the assembly. (fig. 51) Around him are seated adults of various ages, some well dressed, others in working clothes. Several lean forward to listen attentively; a man in a dark suit just behind the speaker looks skeptical; another seems about to fall asleep sitting up. Several hold blue booklets, programs of some sort, though the nature of the meeting and the contents of the booklet are not specified. It is a compelling picture of a dynamic community, but Rockwell was not completely satisfied with the result, so he started over, repainting the scene with a slightly tighter focus and reducing the space between figures. Steven Spielberg appreciates the sketchiness of the painting. "It's not often," he remarked, "that Rockwell would change a study and go in an entirely different direction." Many of Rockwell's studies, he observed, are "indistinguishable from the final painting, but this one was truly a study. It's got texture, and it's just a little bit blurry, as often the lines of our own personal freedoms have been made to seem blurry over the last decade, at least."

Still not satisfied, Rockwell altered the composition significantly for the final version. He further tightened the focus on the speaker, turned him to face left, and dropped the perspective so that the viewer of the painting is part of the audience rather than an official looking down on the assembly from a dais. (fig. 52) Instead of framing the speaker with a sea of faces, he positioned him in front of a blackboard, as if to situate the discussion within the familiar space of an American schoolroom. Gone is the exasperated man in the black suit; gone are the unconvinced expressions of the listeners. Alert townspeople focus on the standing man who has tucked his booklet into the pocket of his leather jacket. On the bench in front of him, a gentleman holds a copy, cover out, showing just enough text so that we can read it is the annual report of a town in Vermont, the name of which is cut off by the lower edge of the image. We see the response to the speaker's words in the faces of those attending the meeting. In a nod to economic inclusiveness, Rockwell altered the man's clothes. The blue shirt from the study is now plaid; his trousers are a darker shade of tan; and the hues of the sleeves and waistband of his

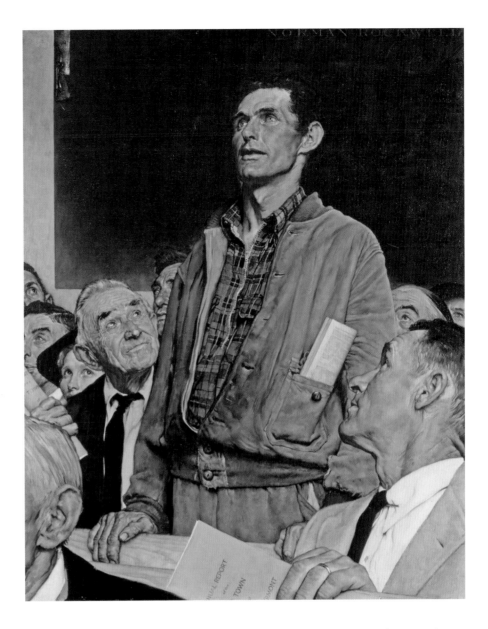

jacket have changed. We internalize these details almost without notice, but they are key to understanding the scene. The meeting includes everyone, the town's working people as well as men in suits whose wrinkled shirts suggest a long day at the office. Although fewer figures are in the final composition, they are closer together than in the earlier versions, crowded into the room to suggest that the night's agenda includes topics of business important to the town.

Having finished *Freedom of Speech,* Rockwell turned to the other three canvases. *Freedom from Want* and *Freedom from Fear* went well, although he went through various concepts and configurations to express *Freedom to Worship.* In mood and scene, each is very different from the others. *Freedom from Want* shows members of a family crowded around a dinner table as a grandmother figure places an impossibly large turkey onto an already full table. (fig. 53) *Freedom to Worship*, which bears the legend "Each According to the Dictates of his Own Conscience," presents profiles of individuals who wear or hold emblems of faith. (fig. 54)

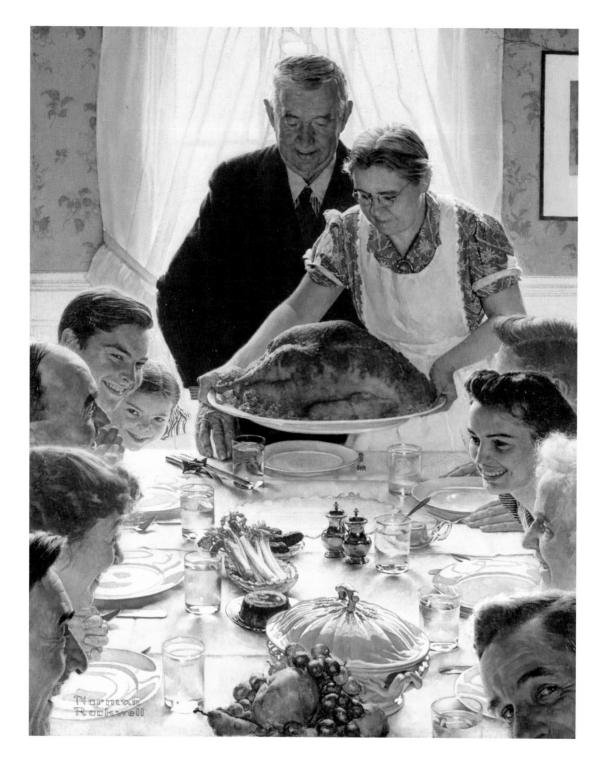

53

Freedom from Want

The Saturday Evening Post,
March 6, 1943.
Oil on canvas, 47 ¾ × 35 ½ in.
Collection of The Norman Rockwell
Museum at Stockbridge, Norman
Rockwell Art Collection Trust

The most personal of the paintings is *Freedom from Fear,* in which a couple looks down on their sleeping children. (fig. 55) The mother arranges the covers as the father, holding reading glasses and a newspaper, looks on. The peaceful scene is belied by the newspaper headlines. Only two words—"Bombings" and "Horror"—are legible. They are terrifying reminders of the devastation German bombs wreaked on the city of London during the Christmas Blitz of 1940, the day Roosevelt delivered his fireside chat telling Americans of the need to mobilize. With his typical bent for accuracy and to bring the message home, Rockwell had asked the newspaper

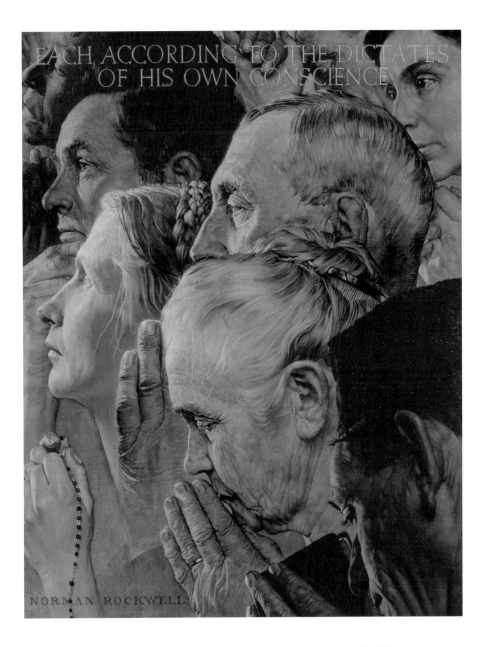

54

Freedom to Worship

The Saturday Evening Post,
February 27, 1943.
Oil on canvas, 46 × 35 ½ in.
Collection of The Norman Rockwell
Museum at Stockbridge, Norman
Rockwell Art Collection Trust

in nearby Bennington, Vermont, to mock up a front page for him to copy. The masthead, which reads just "Bennington," locates the scene in small-town America.

Of all the "Four Freedoms," *Freedom from Fear* is probably the least well known, except by Steven Spielberg. He recalled the first time he saw the image in his father's "very, very thick pile of *Saturday Evening Posts*":

I remember having a sense that when the mother and father both come into the children's bedroom to tuck in the boy, they must really love him. It must be a solidly happy family, a family unit, that hasn't been shattered by divorce or illness. That has always been the American dream, the great concept of the American unit, the American family. The fact that they are both there in the room, and the father's holding a newspaper with bad news about the war overseas—they're looking at the boy, thinking, if the war keeps going, in a few more years he could be drafted or enlist, and also

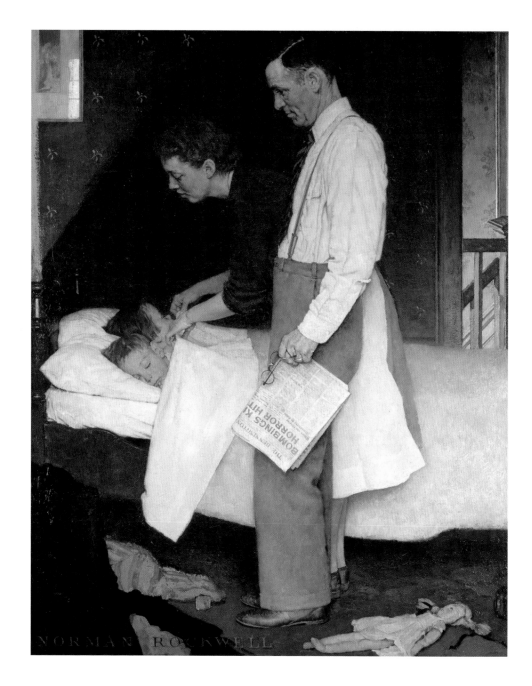

55

Freedom from Fear

The Saturday Evening Post,
March 13, 1943.
Oil on canvas, 45 ¾ × 35 ½ in.
Collection of The Norman Rockwell
Museum at Stockbridge, Norman
Rockwell Art Collection Trust

thinking that we are here, living in freedom and at this moment our child is safe because our country is protecting all of us. But they're not smiling; they're not flaunting that freedom. They're very solemn, and very respectful of it.

Spielberg restaged this scene at the beginning of his film *Empire of the Sun* (1987). (fig. 56) The movie traces the loss of innocence of a privileged young English boy who becomes separated from his parents during the Japanese invasion of Shanghai, where his father is a prosperous businessman. One night, shortly before war tears the family apart, the parents tuck in their sleeping child. As in Rockwell's *Freedom from Fear,* the mother and father stand solemnly over the bed. It was, in Spielberg's words, "a foreshadowing that this will be the last time they're together for many years." Separated from his family, the boy is captured. As he moves from one internment

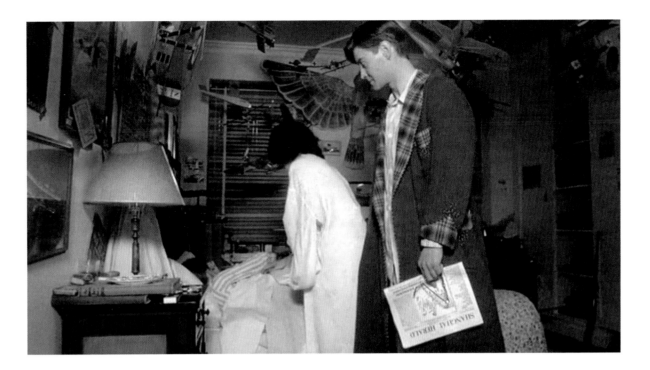

56

Empire of the Sun
Film still
Courtesy Steven Spielberg

camp to another, learning to survive on his own, he carries with him an image of *Freedom from Fear* torn from the pages of a magazine. Rockwell's picture of parental love sustains him through loss and loneliness.

America's Artist

Finally finished, in January 1943, Rockwell sent the paintings off to the *Post*, which published one each week beginning with the February 20, 1943, issue. Throughout the previous fall, while Rockwell was painting, Hibbs and the public relations staff at the *Post* had been busy generating the most ambitious advertising campaign the *Post* had ever launched. The first gambit was to sell Rockwell as America's artist. A week before *Freedom of Speech* appeared in print, the magazine placed ads in newspapers around the country headlined "What Kind of a Man Is Norman Rockwell?" For the "full story" of the artist who had delighted *Post* readers for twenty-five years, audiences were invited to read the "intimate life story of America's best-loved 'Cover Man.'" A long and engaging account, the biography was punctuated with photographs of Rockwell in his studio, with his wife and sons, and with the citizens of Arlington who served as his models. A selection of Rockwell's most popular *Post* covers was featured as were reproductions of the "Four Freedoms" as posters. With the publication of *Freedom of Speech* and each subsequent image, the *Post* invited the public to write in for copies "suitable for framing." Radio stations across the country broadcast interviews with Rockwell, and in March the Office of War Information's Free World Theater aired a dramatization about the freedoms with an all-star Hollywood cast presented by the Hollywood Writers' Mobilization.[140] President Roosevelt sent a congratulatory letter, as did Treasury Secretary Henry Morgenthau, Jr., who announced a new "Four Freedoms" war bond drive.[141] These images, and the *Post*'s elaborate

campaign, confirmed Rockwell's reputation as "America's Artist." His ability to encapsulate patriotism and pride in America's traditions spoke to the whole country.

From the beginning *Freedom of Speech* resonated with people everywhere, not because they lived in places governed by town meetings, but because the scene was common wherever Americans gathered to discuss the business of their communities. One such man, Paul L. Brandt of Carlisle, Pennsylvania, wrote Rockwell:

I've come downstairs, Mr. Rockwell, in a middle of the night moment of wakefulness, to have another session with your "Freedom of Speech." My tools, you see, are screwdrivers and pliers and springhooks—not words. But somehow it is born in upon me, I must try to tell you what you have done for us all.

You are exactly right. There is just enough in that canvas for your purpose, but I can feel and see the parts of the room that lie beyond your boundaries—we're all there, the deep sincerity of purpose that blacks out personal inhibitions and timidity, the old chappie is there who speaks out at every meeting, the chap who relishes the taste of five syllable words and the decorative rhetoric; yes, and in another corner is the old lady who is always called upon to express her sentiments, apropos or not, but the feather on her hat, bedraggled with many a sun and rain, bobs giddily and emphatically just the same; and there are the youngsters, too, striving mightily to order their thoughts and praying for whatever it is that gives quiet to the knees and the fluent tongue. Yes, and thank God, the old heads, the level heads in which there is no longer heat or malice or personal ambition. We look again. There can be no doubt. This meeting, this precious gift of Free Speech—we're getting somewhere!

Thank you, Mr. Rockwell, for your reassurance![142]

Many of the people Mr. Brandt described are not in Rockwell's picture. No children are in the painting, nor is there an old lady with a feather in her hat. The people Brandt talked about came from his own life. Rockwell has evoked them through the setting and the people of Arlington, Vermont.[143]

When the *Post,* working with the U.S. Treasury Department, launched a national tour of the paintings as the centerpiece for Secretary Morgenthau's war-bond drive, results far exceeded expectations. The exhibition opened at the Hecht Company department store in Washington on April 27, 1943, before touring the country. In addition to the "Four Freedoms" paintings, the exhibition included "thousands of *Saturday Evening Post* original pictures and hundreds of manuscripts by well known authors."[144] Supreme Court Associate Justice William O. Douglas gave opening remarks, and distinguished guests were featured in daily programs. Popular *Post* humorist Irvin S. Cobb spoke, Dale Carnegie was featured, and the entire Washington Senators baseball team plus star players from the Washington Redskins football franchise made an appearance. One day was set aside to honor

the country of China; another celebrated the "Valiant People of Great Britain." Children submitted essays to a contest on what freedom meant to them, and buyers of war bonds, each of whom received small reproductions of the "Four Freedoms" paintings, could register to win one of 141 original *Post* drawings, paintings, and manuscripts at the conclusion of the exhibition. In Washington, Philadelphia, New York, Denver, Boston, Chicago, Los Angeles, and other cities large and small throughout the country, crowds flocked to see the paintings and buy bonds. By the time the exhibition concluded in May 1944, a year after its Washington premier, more than $132 million worth of bonds had been sold. Although the principal of a New York investment house bought $10 million in bonds, most of the money came from ordinary Americans, individuals with small pocketbooks and large hearts.[145] Rockwell had done it. His paintings had sparked a vision of individual and collective freedom that unified Americans in a moral cause.

The impact of Rockwell's paintings was equaled only by Frank Capra's series of films called "Why We Fight." Like Rockwell, Capra wanted to contribute to the war effort. He was sworn in as an officer in the U.S. Army Signal Corps on December 8, 1941, and reported for duty two months later. Over the next four years he created a series of seven hour-long films at the behest of Army Chief of Staff General George C. Marshall, who charged him with producing documentary films that would tell American soldiers and sailors why they were fighting.[146] The medium of film would allow all to see the same story and hear the same words. Capra faced a challenge similar to Rockwell's in trying to find the means to translate abstract patriotic ideas into concrete terms. Capra's answer was to use enemy newsreel footage to demonstrate the virulent threat of Nazi and Japanese aggression. Once complete, the seven-film series "Why We Fight" was shown to troops in the United States and around the world, and, although not part of the original plan, millions of civilians saw the movies in neighborhood theaters throughout the country. Despite having worked in different media, Rockwell and Capra shared a moral and patriotic mission that helped Americans understand the reasons behind the sacrifices they were asked to make. Rockwell told us what we were fighting for; Capra, what we were fighting to overcome.

The "Four Freedoms" were, and are, the most famous images Rockwell painted during the war years, but their success did not exempt him from his ongoing work for the *Post* and other clients. Most images were war related, though many, like the multitasking *Liberty Girl*, used Rockwell's characteristic humor. (fig. 57) He loved, he said, to paint scenes set on trains and came up with the idea for *Little Girl Observing Lovers on a Train* when he himself was on a trip from New York to Vermont.[147] (fig. 58)

57

Liberty Girl
The Saturday Evening Post,
September 4, 1943

58

Little Girl Observing Lovers on a Train
The Saturday Evening Post,
August 12, 1944.
Charcoal on paper, 33 × 28 in.
Collection of George Lucas

59, 60

Preliminary photographs for
Little Girl Observing Lovers on a Train
Norman Rockwell Archives,
Norman Rockwell Museum,
Stockbridge, MA

It shows an incident that Americans might have observed anywhere in the country in 1944, when trains were packed with soldiers, sailors, airmen, and marines coming home on leave or traveling to embarkation points, accompanied by lovers, friends, or family members.

It is a charming, yet slightly unnerving picture, at least from the perspective of the couple being observed, even though they seem oblivious to the little girl peering over the seat in front of them. Totally involved with each other, they have turned a double seat on a crowded train into a private universe invaded only by the child's gaze. All we see of the lovers are the backs of their heads and their legs and feet, but the visual story has multiple subplots. One focuses on the intimacy between the airman and his wife or girlfriend, another on the little girl herself, who is probably nine or ten years old and has not yet admitted to herself that she will ever be interested in boys.[148] She seems fascinated, and slightly repelled, by the romantic scene playing out in the space behind her. Still another motif is the intrusion of reality in the form of the ticket taker, whose right hand and arm are just visible at the artwork's right edge. Rockwell took pains with every detail of set and costuming, from the partly closed window shade that curtains off the couple's space, to the insignia on the airman's overcoat and the overseas cap on his lap. The blue and gold piping on the folded cap (visible in the finished painting, though not in the black-and-white drawing) indicates that he is an officer, the patch on his coat that he is in the U.S. Army Air Forces. Dangling from the overhead rack are an accurately rendered M-1936 OD canvas field bag (commonly called a musette bag) with suspenders and an M-1923 cartridge belt.[149] Rockwell had to be precise; mistakes with details such as these would have undermined the scene's credibility for the *Post*'s military readers. The details also universalize the moment—erasing rank-based differences between the central army officer and the enlisted sailors who cuddle in seats ahead and behind.

The set, too, is accurate. At Rockwell's request the Rutland Railroad obligingly parked a train car on a siding in Arlington for two days so he could get the interior photographs he needed.[150] One, a relatively long view of the car, shows the little girl peering over the seat at Rockwell—we see the back of his head in the lower right corner—who holds up a rectangle of white cardboard to reflect light evenly on the child's face. (fig. 59) Other photographs reveal that Rockwell moved a pair of train seats into the studio, where he experimented with alternative poses. (fig. 60) As with *Freedom of Speech,* he reoriented the angle to show the couple from the right rather than the left. Cardboard reflects light on the couple's legs and feet, emphasizing the contrast between her small, fashionable shoes (she probably saved coupons for months to buy the stylish footwear since shoes were rationed at the time) and his much larger combat boots. Rockwell posed her foot crossed over his; it is a minor detail, but this small act of physical closeness reinforces their emotional intimacy.

Little Girl Observing Lovers reveals another aspect of Rockwell's working method. When he wanted to make alterations to a drawing that was otherwise complete, he pasted fresh paper over the area to be changed and redrew the part he found unsatisfactory. This practice is visible in the paper patch that traces an arc from the airman's right shoulder through the middle of his head across to the left edge of the drawing, and in cross-hatched pencil strokes and slight variations in the tone of the added paper. Rockwell finished drawings to this degree in an effort to make painting the finished canvas as straightforward as possible. Even so, he often struggled with the final version, rejecting, reworking, and, in the case of *Saying Grace* (1951), throwing the canvas out into the snow when overcome by frustration.[151]

On taking over editorship of the *Post* in March 1942, Ben Hibbs had modernized the look and contents of the magazine by increasing the ratio of factual articles and significantly altering the masthead design and cover format. A year earlier his predecessor, Wesley Stout, had eliminated the double horizontal line that separated the cover image from the magazine's name, a style that had been in place since 1902. Hibbs went much farther. He did away with the italicized font and reduced the words "The Saturday Evening" to small type and placed them in the upper left corner above the word "Post," which appeared in large block letters. The new format made room for a complex composition to occupy an entire cover, although when the editorial staff wanted to advertise special content, a monochromatic band was often added across the top to serve as the backdrop for the text, as with *Little Girl Observing Lovers.*

Coming Home

Following the surrender of German and Japanese forces, newspapers and magazines were filled with stories about men who woke up screaming from nightmares that brought back the reality of bursting shells and dying friends. The syndrome, now called post-traumatic stress disorder, touched many thousands of lives. Director William Wyler tackled the subject head-on in *The Best Years of Our Lives* (1946), a story of three servicemen returning to the same hometown. It is unlikely that the men would have crossed paths in their prewar lives. The oldest is a bank executive; before the war he was a prominent member of the community who lived in a spacious, well-appointed home with his wife and children and belonged to a country club. Despite his social status, in the army he had been a sergeant, not an officer. Another, whose hands and lower arms have been replaced by metal prosthetics, is an earnest, hardworking young man who had planned to marry his childhood sweetheart after the war. He comes home believing that his hopes for a normal life as a husband and father have been dashed by the loss of his limbs, and he hates the pity he sees in the eyes of his family. The third, a soda jerk, had served as an officer, leading men into battle. Conflict arises when family members and former employers cannot reconcile the troubled men who have returned with the people they once knew. As a result, in Wyler's story, the bank executive

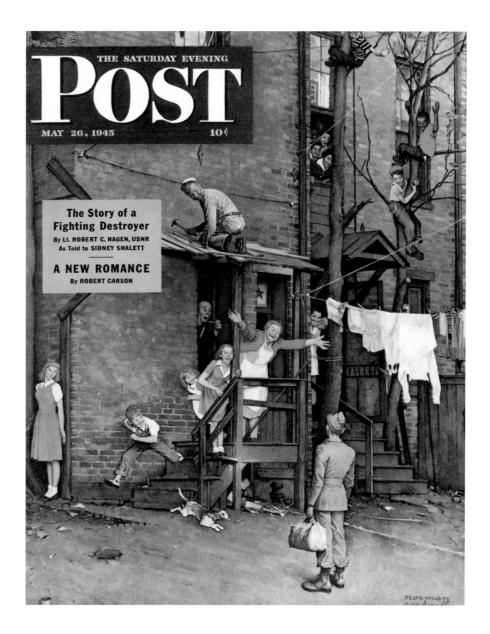

61

The Homecoming

The Saturday Evening Post,
May 26, 1945

succumbs to alcoholism; the man who lost hope along with his hands rejects the affections of his fiancée; and the third, the officer, is unable to reestablish his relationship with his fun-loving wife, who fails to understand that her husband is no longer the carefree man she married. Theirs were all-too-familiar stories.

The *Post* published Rockwell's first homecoming picture in May 1945, a month after Germany surrendered. The man who had mobilized the country's emotions to the cause of war now helped bring the soldiers home by alerting families that their loved ones might have difficulty readjusting to civilian life. In *The Homecoming* we see a young soldier from the back, as he stands, suitcase in hand, looking at a tenement stoop filled with excited family members whose outstretched arms welcome him home.[152] (fig. 61) The soldier, standing still and apart, seems overwhelmed as he faces the world he left behind. Here and in *Homecoming Marine,* which appeared that October, two months after Japanese forces surrendered, Rockwell, like Wyler, acknowledged the psychological trauma of

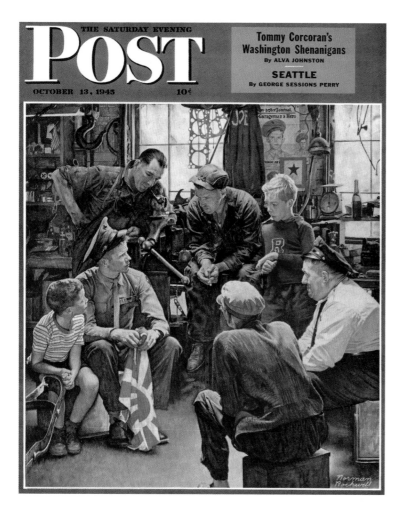

62

Homecoming Marine
The Saturday Evening Post,
October 13, 1945

63

Back to Civvies
The Saturday Evening Post,
December 15, 1945.
Oil on canvas, 39 × 30 in.
Collection of Steven Spielberg

war and the challenges faced by returning soldiers as they attempted to put combat behind them and return to the normalcy of their previous lives. (fig. 62) The marine who has come home holds a tattered Japanese flag. He sits in a neighborhood garage surrounded by friends eager to hear his story. Pinned to the wall above their heads is a tearsheet from a newspaper bearing the young marine's picture and the words "Garageman a Hero." With the character's furrowed brow and distressed expression, Rockwell hints at the horror and loss he feels. He may be a hero to the people in his community, but many years will pass before the war begins to fade from memory. The homecoming images are among the most emotionally complex paintings of Rockwell's career; each actor, from those in starring roles to the "extras" on the sidelines, is key to understanding the complicated expectations and preconceptions faced by returning servicemen.

Hibbs's reconfigured cover format allowed Rockwell to contextualize his pictures with a depth not previously possible. He was able, for example, to tell us considerably more about the economic circumstances of the soldier in *The Homecoming* than in the original Willie Gillis pictures, which showed simple vignettes. He loaded this and other pictures with props that prompt the viewer's preconceptions about particular kinds of places—the backyard of a tenement complex in 1945, for example, or the elegant modernism of an upscale executive office in the 1960 canvas *Window Washer*.

Everyone was changed by the war's end, but not all showed emotional scars. Unlike Rockwell's portrayals of ambivalence in the homecoming soldier and the marine gathered with friends in the garage, the artist erased the residue of war from the face of Lt. A. H. Becktoft, a real-life Flying Fortress pilot featured in *Back to Civvies*. (fig. 63) The painting is filled with notations about a young second lieutenant who has returned from the war. The narrow bed, school banner, fishing rod, and baseball bat behind the chair where he has hung his uniform blouse are leftovers from his youth. The banner points to his former status as a student, and we surmise from the profusion of neckties hanging from the mirror and drooping from the half-open drawer that the young man enjoyed an active social life before the war. A poster of a Boeing B-17 Flying Fortress hanging on the wall and a small model of a Martin B-26 Marauder on top of the messy dresser signal a teenage dream of flying and his duties as an Army Air Force pilot. Spielberg, who brought the realities of war to life in *Saving Private Ryan* (1998), observed, "When he went off to war, time stood still. It probably stood still for as long as the hearts of his father and mother

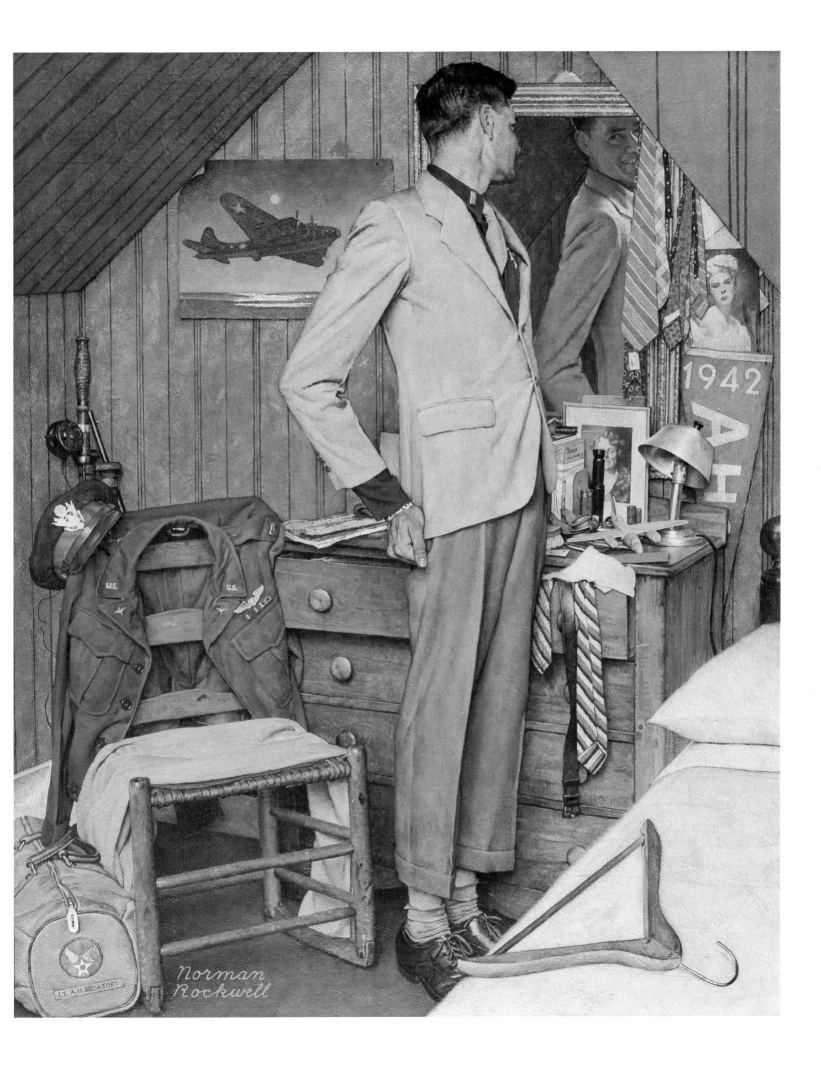

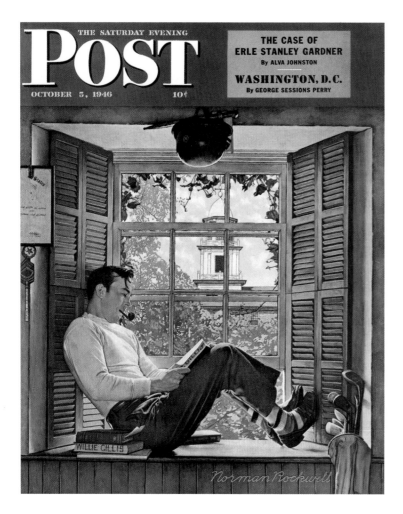

64

Willie Gillis in College

The Saturday Evening Post,
October 5, 1946

stood still, waiting and praying for his safe return. The bedroom represents suspended animation, when young boys go off to war and come back men. In [*Back to Civvies*], he came back from war and he still was a boy. He was just a bigger boy. He's tall, none of the clothes fit, but everything in the room is exactly as he left it."

Rockwell personalized the picture by identifying his subject—his name is on his duffel bag—and traced his military career through the insignia on the bag and his uniform. Lt. Becktoft could be justifiably proud of his record. The wings on the left breast pocket of his blouse are those of a pilot. The blue and yellow ribbon reveals that he was twice awarded the Air Medal (it has a tiny oakleaf cluster), which is given for either an act of heroism or meritorious achievement; the brown and green campaign ribbon with two small oakleaf clusters indicates that he participated in multiple aerial campaigns in Europe, Africa, or the Middle East.

The airplanes tell us more. In a single image, *Back to Civvies*, with its two airplanes, encapsulates the multi-year story of the successful Allied air offensive against the German Luftwaffe. The Flying Fortress reminded viewers that the bomber was used by the Eighth Air Force in England and the Fifteenth Air Force in Italy during Operation Pointblank, an offensive that had been conceived by President Roosevelt and British Prime Minister Winston Churchill when they met in Casablanca in 1943. Pointblank was designed to secure air superiority over the cities, factories, and battlefields of Western Europe in preparation for the Normandy invasion on D-Day, June 6, 1944.[153] The Flying Fortress, Pointblank's primary aerial weapon, was a rugged aircraft, but without long-range fighter support it was susceptible to Luftwaffe attack, so the operation was put on hold until P-51 Mustangs became available in large numbers early in 1944.[154] When Pointblank resumed in the spring of that year, the P-51s effectively protected the Flying Fortresses, shooting down German aircraft, decimating the roster of experienced German pilots, and enabling Allied bombers to strike targets deep in German territory. Rockwell's viewers would also have known that many of the P-51s (bomber crews called them their "little friends") were flown by the black pilots known as Tuskegee Airmen.[155] Thanks to the Flying Fortresses and their "little friends," by D-Day only eighty German aircraft operated on the northern coast of France.[156] The model of the B-26, which was used to bomb rail yards, troop concentrations, and battlefield targets in Europe after the Normandy invasion, encodes the subsequent chapter of the narrative.

Although Becktoft's real Flying Fortress had been shot down over Germany, and he spent months in a prison camp, Rockwell shows us a pleasant-looking man who, in Spielberg's words, "has not been scarred

by war, unlike so many veterans who came back from mortal combat changed forever. He doesn't have that haunted thousand-yard stare." In *Back to Civvies* and in the final Willie Gillis painting, Rockwell shifted the psychological compass of his servicemen from war to peacetime. Lt. Becktoft's calm expression suggests that he has come to grips with his experiences as a pilot, and in fact the real Lt. Becktoft had by this time decided to remain in the air force. Willie's emotional valence has shifted as well. In the last work of the series, which appeared as a *Post* cover in October 1946, Rockwell showed him sitting in the window of a college dormitory room, studying. (fig. 64) He is mature, focused, and calm, a very different man from the carefree youth who had first donned his uniform in the fall of 1941.

On the Road

During the war, foodstuffs and consumer goods had been in short supply. Vegetables, meat, butter, shoes, household appliances, and other commodities were severely restricted so that the country could produce the matériel needed by soldiers fighting abroad. But in the summer of 1945, with the war in Europe over, Americans were ready for a break. Despite warnings from the Office of Defense Transportation against unnecessary civilian train travel as millions of servicemen and women were being redeployed, there was standing room only on New England trains headed to the seaside over the weekend before the Fourth of July, and "New England hotels report[ed] the largest number of bookings in years."[157]

On August 15, 1945, the day after the Japanese surrender, the government announced the end of gasoline rationing. People all over the country pulled into service stations to fill up their tanks; oil companies made extra deliveries in Chicago to avert short-term scarcity caused by the run on gas.[158] The government also lifted the 35-mile-per-hour speed limit but cautioned drivers to "think twice before attempting to increase regular driving speeds in old cars no longer capable of high speed operation." Travel restrictions were also eased to allow people to attend football games, horse races, the 1945 World Series, and other professional and amateur sporting events.[159] In the months after the war ended, the primary constraint on travel by car was the lack of availability of new tires for domestic vehicles. The Office of Price Administration and the War Production Board, two of the government's rationing arms, continued to issue tire certificates according to occupational priorities. Doctors, dentists, nurses, ministers, and utility companies took precedence; farmers, construction workers, teachers, and social workers came next. Ordinary citizens continued to make do with patched and worn-out tires. (fig. 65)

Even before the German surrender, American automakers predicted that new cars would soon begin rolling off the assembly lines, and the War Production Board promised that "neither materials nor manpower should be obstacles to the speedy production of cars after VE-day." Within months automobiles, refrigerators, washing machines, vacuum

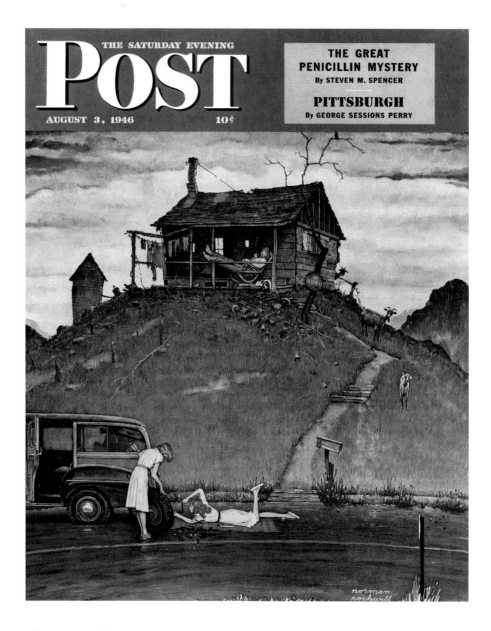

65

Fixing a Flat

The Saturday Evening Post,
August 3, 1946

cleaners, and lawnmowers, unavailable for several years, began flooding the consumer market.[160]

Americans were ready. *Fortune* magazine reported that at the end of the war 25.8 million cars were registered in the United States, although, as a result of the depression and war, at least half were more than ten years old. In the five years that followed, between 1946 and 1950, Americans bought more than 21 million automobiles.[161] With newfound mobility they headed for the mountains, seashore, and lakes on long-awaited vacations. Magazines and newspapers were filled with articles recommending national parks and thousands of lakes and streams with campsites across the country as ideal vacation spots. Some offered advice on what to do with pets while the family was away. Curtis Publishing, the *Post*'s parent company, launched *Holiday* magazine. Travel agencies that helped plan routes reported that people were vacationing for longer periods than before the war because some 35 million Americans now received the relatively new benefit of paid vacation time.[162]

Rockwell capitalized on the craze for travel. His earlier pictures of children going to or returning from summer camp alone gave way to the family outing in *Going and Coming.* The composition presented new pictorial problems because it involved crafting two pictures for a single cover that featured the same models, "yet changing their expressions and their moods completely."[163] After determining the concept, and with dozens of photographs in hand, Rockwell drew the full-scale composition in charcoal but found he needed to make changes before transferring it to color to ensure that readers would realize that it was a "before and after" picture—the same family starting out for a day at the lake and returning after dark. (fig. 66) Rockwell had used this participatory approach previously in several April Fool's Day covers in which he inserted inappropriate elements that challenged viewers to find visual malapropisms and in *Liberty Girl* (see p. 115), in which the girl, according to the *Post,* carried equipment related to thirty-one wartime occupations.[164]

The cast of characters remains the same in the drawing and the painting. In the front seat are father, mother, and a little girl. Behind them are a girl, a boy, and a dog; in the backseat younger children sit beside a stern-faced grandmother. The family boat, "Skippy," is tied to the roof of the car, and a folding chair dangles from the door handle. In the upper panel of both drawing and painting, the older boy and spaniel hang eagerly out of the window; the girl blows bubblegum, and the little brother makes faces at the occupants of a passing vehicle. In the contrasting "coming home" scene, the troops are tired. The father hunches over the steering wheel, the harried mother sleeps against the door, and the eyes of the young brother are glazed with fatigue. Even the dog pants wearily. Only the grandmother seems not to have changed, although she holds a leafy souvenir of the day's outing.

After completing the drawing, Rockwell significantly altered the composition in the final work. (fig. 67) He simplified and clarified before declaring it finished. In the charcoal version of the return scene, for example, we see the excited boy of the morning from the back. To ensure that *Post* readers would realize it was the same child, Rockwell turned him around in the finished picture to reveal his face. The hoods of nearby cars are apparent in both versions, but the couple in a rumble seat in the lower right corner of the drawing has been replaced by the curved trunk of a passing car, and the rear end of a station wagon that appears at the upper left of the drawing is gone. He also changed the view through the car windows, adding a street lamp and a lighted window to reinforce the lateness of their return.

Rockwell situated the scene in the postwar cultural moment by concocting an image linked to the availability of gas and tires that allowed families to take road trips for purposes of leisure. He also contrasted the rectangular windows of the family's old car—a holdover from the 1930s—with the sleek lines of new vehicles in the adjacent lane. Although a small, almost subliminal detail, it would have clued *Post* readers to the family's middle-class status in the postwar economic boom.

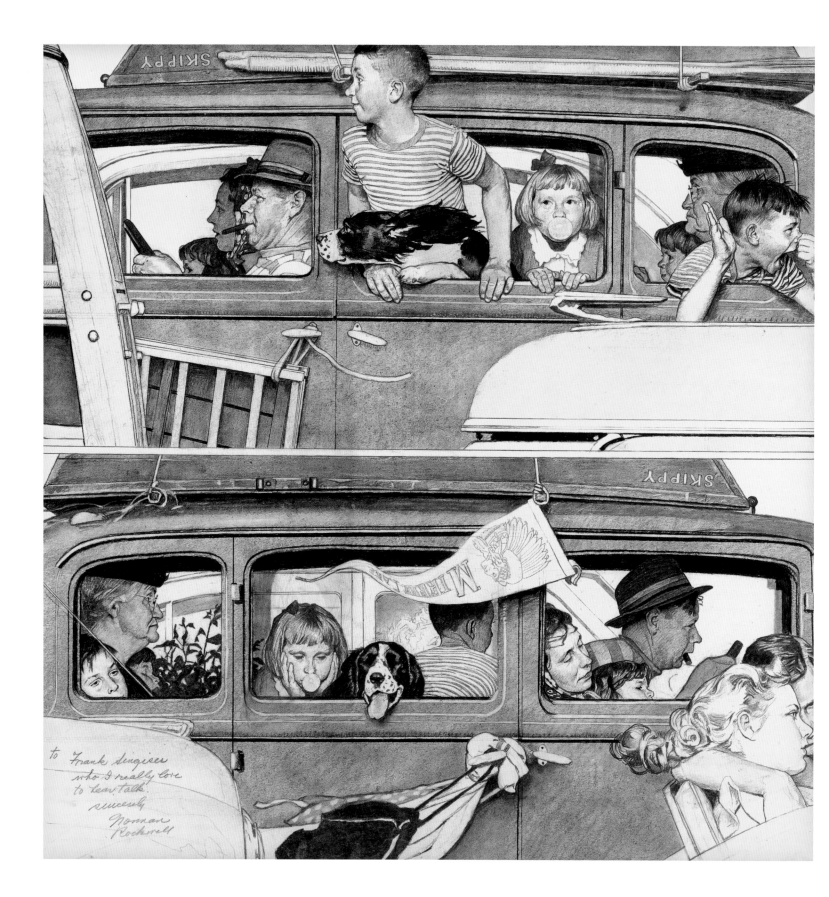

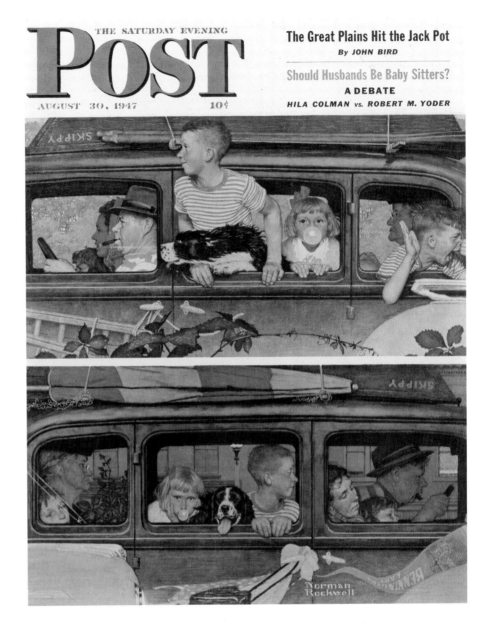

66

Going and Coming

The Saturday Evening Post,
August 30, 1947. Charcoal and
pencil on paper, 28 × 26 ¾ in.
Collection of George Lucas

67

Going and Coming

The Saturday Evening Post,
August 30, 1947

With one successful travel-related cover behind him, Rockwell was
receptive when the Chrysler Corporation asked him to do advertising
images for its Plymouth division. He had worked for companies and ad
agencies since the early days of his career, but during the 1930s and 1940s
he had rarely accepted commissions due to the pressures of *Post* work and
deadlines for book and story illustrations. Advertising commissions picked
up in the 1950s, when corporations recognized that his images were espe-
cially appropriate for lifestyle advertising that associated a product with
an activity or experience rather than providing specific information about
the goods being sold. *"Merry Christmas, Grandma...We Came in Our New
Plymouth!"* is a lifestyle ad—togetherness, affection, happiness, and love
of parents for children are the picture's core messages—but the size of the
family crowded together in the foyer of the house subliminally suggests
that they came in a roomy, comfortable vehicle. (fig. 68) The excitement
of children at Christmas and their delight at visiting their grandparents

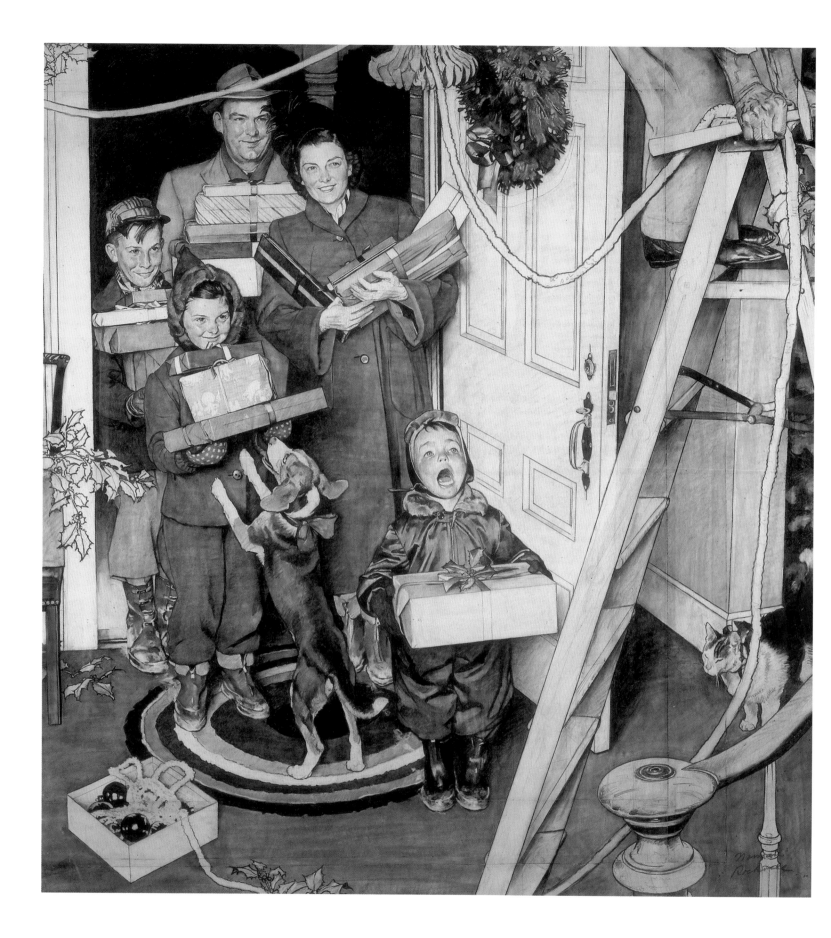

68

**"Merry Christmas, Grandma...
We Came in Our New Plymouth!"**
Plymouth advertisement, *Life,*
December 25, 1950. Charcoal
and crayon on paper, 53 × 48 in.
Collection of George Lucas

69

**"Merry Christmas, Grandma...
We Came in Our New Plymouth!"**
Plymouth advertisement, *Life,*
December 25, 1950.
Oil on canvas, 53 × 48 in.
Collection of Ted Slavin

complement a subtext of prosperity. Family members wear nice clothes
and carry beautifully wrapped presents. Plymouths were affordable
family cars but not flashy, like the convertible in *The Flirts,* or exciting,
like the speeding roadster in *Couple in Rumble Seat.*

As with *Going and Coming,* Rockwell worked out the composition
using drawings and photographs before arriving at the final version.
The "camera angle" in this candid shot of the family at the door is located
halfway up a staircase (the newel post is visible in the lower right corner).
In the drawing, someone, presumably Grandpa, stands precariously
atop a ladder, finishing up the decorations. The dangling garland and box
of ornaments spilling out on the floor suggest that the family has arrived
early. Rockwell may have inserted this element to indicate the efficient
speediness of the Plymouth, but he must have realized, as *Post* readers
certainly would have, that chaos would result when the family descends
on the disorderly space of the entryway, so in the painted version,
Rockwell removed the clutter, Grandpa and his ladder, and the cat that
appear in the drawing. (fig. 69)

"Merry Christmas, Grandma" says nothing about the Plymouth. It could
as easily have been an ad for another brand of family automobile, a
department store, a travel agency, or any number of other products. Only
the caption alerts readers that the family has bought a new Plymouth.

Rockwell's skill at depicting warmth and friendliness made him an ideal candidate for the Christmas 1950 Plymouth ad campaign. A picture by Rockwell, especially after the success of the "Four Freedoms," represented an endorsement much like *Good Housekeeping* magazine's Seal of Approval. The name Rockwell appended to a product signified wholesome, quintessentially American values. Homey, gently humorous images by this nationally famous illustrator from small-town Vermont were understood to mirror a middle-class vision of the American dream.[165]

Throughout the 1940s and 1950s, Rockwell's images helped people process cultural change that affected them on a personal as well as societal level. His was the normative world of middle-class values spawned in the Puritan ethic of the seventeenth and eighteenth centuries that by the middle of the twentieth century had come to represent mainstream American life. For literate, middlebrow audiences, Rockwell's pictures offered ways to resolve the pressures and anxieties of contemporary life, ideas that were addressed photographically in *Life* and *Look* and through articles by leading writers in the *Post* and other text-based publications. The depression and war years had been eras of self-denial, and many Americans continued to resist the desire for consumer goods that flooded the marketplace after prosperity had returned in the 1950s. A picture like *Merry Christmas, Grandma,* painted by Mr. Middle America, allowed viewers to rationalize the desire for a new car, for example, with the sense of family connectedness that came from spending Christmas with loved ones.

Rockwell was certainly not alone in crafting a visual paradigm that translated semiconscious anxieties and questions of relative values, but the power of his imagination and his central place in visual culture made possible by the huge exposure his images enjoyed in the *Post* gave him unique entrée to the emotional life of American society. His impact was often more powerful, in fact, than that of writers or social commentators simply because his pictures were immediate and clear. A quick glimpse at a Rockwell picture was enough to have an effect on the viewer that remained long after the nuances of more highly developed written arguments were forgotten.

A Broader America

The war had muddled conventional class divisions. In Wyler's *Best Years of Our Lives,* a banker is a sergeant; and a soda jerk, a lieutenant. In Spielberg's *Saving Private Ryan,* a high school English teacher becomes a leader of men. During the 1920s and 1930s, Rockwell had pictured piano tuners, bookkeepers, seafarers, an old cowboy listening to a gramophone, a lonely train-ticket seller, and other people who worked outside office settings, but the images were generally nostalgic or, as in *The Flirts,* sight gags in which the punch line relied on rather than erased class distinctions. During the war, however, Rockwell extended his range to pay emotional respect to working-class individuals and families. In a touching scene of a smiling, grimy-faced coal miner who proudly wears a pin bearing two

blue stars (indicating family members serving in the military), and *The Homecoming,* Rockwell revealed his new appreciation for the contributions made by Americans of all incomes.

With his iconic *Rosie the Riveter,* Rockwell had celebrated women who joined the workforce during the war.[166] *Liberty Girl* and other images of the 1930s and 1940s depict girls who racewalked, painted, or traveled abroad by themselves, but rarely had he shown women in work environments. *Charwomen in Theater* is a picture of two cleaning women who take a moment to read the playbill of an evening performance in the theater where they are employed. (fig. 70) Its emotional valence, which is very different from that of *The Departing Maid* (see p. 50), demonstrates a heightened empathy that characterized Rockwell's story illustrations of the 1930s and the emotionally complex paintings of the war years. It also connects Rockwell's pictures of the 1940s with those of Ashcan artist John Sloan. Like Sloan, whose *Scrubwomen, Astor Library* shows three women pausing in their labor to exchange a friendly word, Rockwell depicts a moment of shared intimacy between two older women who work after hours in a place they are not apt to frequent in the course of their own lives. (fig. 71) As Lucas observed, "It's more to them than just a job. They're interested in the place they work. You can imagine them sneaking up and watching shows, watching rehearsals. You can imagine them being proud that they work in the theater, even though all they do is push a broom."

Rockwell achieved the sense of empathy through the picture's remarkable details. The women's striped uniforms and aprons reinforce their servile role; the wrinkles and pouches on their faces and necks and graying hair reveal their need to work long after most middle-income employees have retired. The mop handles, scrub brush, and bucket define their specific jobs, but the women's faces reveal the powerful emotions the theater can evoke regardless of social class or occupation. The drawing is a tour de force of textures, reflections, and specificity. The scene is washed with the quiet light that permeates a theater after a performance has ended. Rockwell rendered the velvet seats, some open, some folded up, with the hatching of soft charcoal. The women's hands touch as they share a single playbill, although other copies lie on the seat in front of them. Wrapped up in the story, they are oblivious to the ring the bucket might leave on the plush cushion of the theater seat. The women are there to clean up the mess left behind by others; they are welcome only after the elegant have long departed. Like so many other Rockwell images, the poignant narrative of *Charwomen in Theater* is implied as much by absence as presence; here the subjects' unsophisticated clothing contrasts with a lacy handkerchief someone has left behind.

Rockwell rarely spoke of the emotional impact of his work. When asked where he got the idea for *Charwomen,* he said, "It just came to me. I think I have always wanted to paint a charwoman or some similar type of worker—the poor little drudge who has to tidy up after more fortunate

70

Charwomen in Theater
The Saturday Evening Post,
April 6, 1946.
Charcoal on paper, 40 × 31 ¼ in.
Collection of George Lucas

71

John Sloan
Scrubwomen, Astor Library
1910–11. Oil on canvas, 32 × 26 ¼ in.
Munson-Williams-Proctor Arts
Institute, Museum of Art, Utica,
New York

Following pages:

72

Little Orphan at the Train
Good Housekeeping, May 1951.
Oil on canvas, 32 × 68 in.
Collection of Steven Spielberg

people have had a good time. I've been interested in the hotel maid, for instance, who has to lay out her ladyship's gown; in reality the maid may be more of a lady."[167] When Kenneth Stuart, the *Post's* art editor, okayed the "idea sketch," Rockwell went to the Majestic Theater in New York, where the musical *Carousel* was playing. He took measurements and sketched while his photographer snapped pictures, then returned to Arlington and convinced two respectable but some-what reluctant neighbors to pose, promising that they were "only acting" as charwomen and that "no one would think the worse of them for it."[168]

Rockwell wanted his models to think of themselves as actors, and he included a section called "acting and directing" in his book *Rockwell on Rockwell: How I Make a Picture,* in which he compared the artist's role with that of a motion picture director. To show models what he was looking for, he wrote, he explained the pic-ture's narrative and acted out the role he wanted each one to play.[169] It was an effective strategy. As Lucas remarked, "With Rockwell every person is a character, which we do in movies a lot. We have to make sure that the extras and everybody that's on the screen has a personality, a life. They aren't just nameless, faceless drones that walk through the shot."

Rockwell again explored empathy and love in his illustration for a story in *Good Housekeeping* called "Good Boy" by Mary McSherry.[170] (fig. 72) The commission, which combined ingredients of boyhood and family affection, gave him a chance to do another horizontal painting and, as in *Let Nothing You Dismay,* to use compositional space to create dramatic tension. The story is told as a first-person narrative in the voice of an old man who listens to a Ph.D. sociologist argue that adoption should be based on scien-tific research rather than emotion to ensure that parents and children are well matched. As a five-year-old, the man had been the youngest child on a foundling train.[171] When the orphanage where he lived burned down, the nuns who ran it headed out by rail with eighty-seven orphans, hoping to find homes for them in cities throughout the Midwest. As a little boy, the man had been timid and small, and he looked like a ragamuffin after three days' travel. The opening paragraphs describe townspeople crowding the platform of a small-town railroad station to catch a glimpse of the orphans. Several farmers select husky boys to adopt.

A middle-aged woman with a shopping basket sees a young boy in the arms of a nun. Her face fills with hope and longing, and she is stunned when she hears the child's name—Patsy, short for Patrick. There is no time to consult with her husband; the train is about to pull out. The other children are on board again, waiting for yet another station where another round of prospective parents will look them over. Her decision is made in

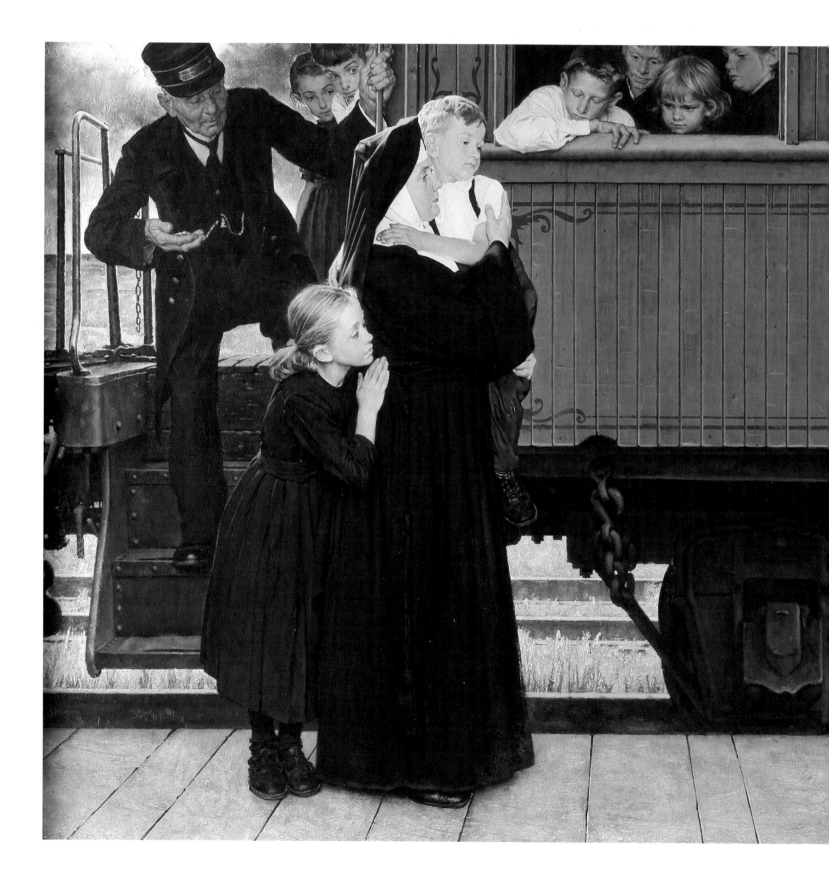

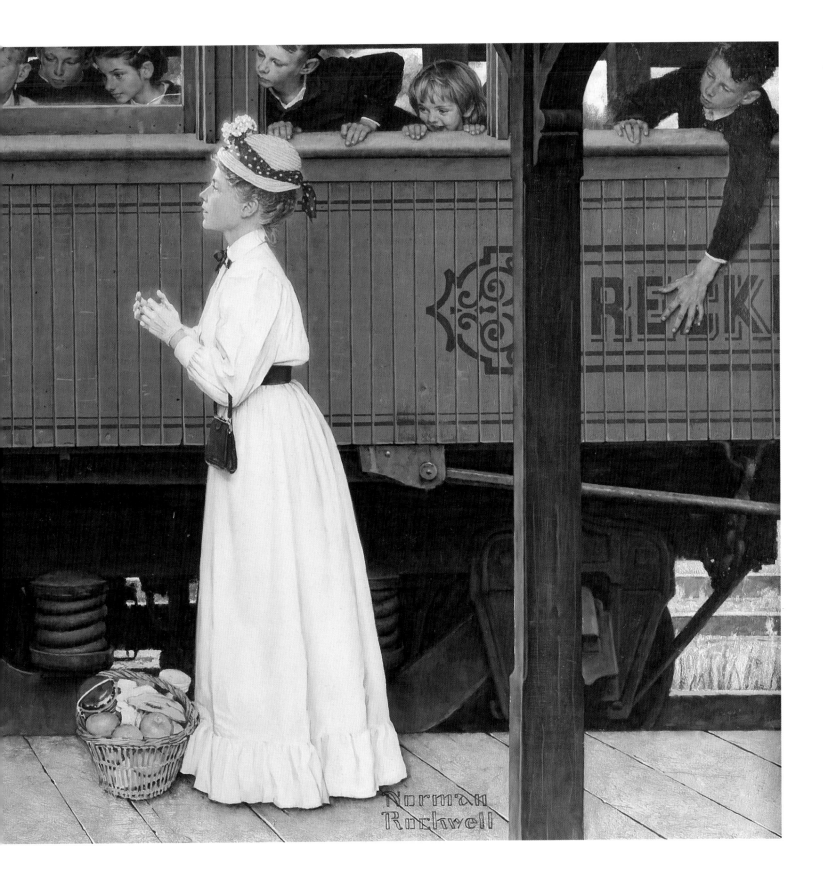

an instant; she opens her arms and takes the child home to a room filled with boy things the child has only dreamed of. The story is about the love of the mother for her new son, who, we understand, shares the name of a son she has lost; her husband's initial emotional distance; and his ultimate acceptance of the small, weakly child as part of the family.

Rockwell may have identified with the tale of a scrawny little boy with big ears when he first read the story and appreciated the bond between mother and child, a closeness he felt he had missed in his own childhood because his mother was often ill. The painting is filled with tension and anticipation. He chose the moment when the yearning mother first sees the child. Occupying different quadrants of the painting, they are separated by a void filled by the powerful wheels of the long green rail car that will take the children to their next destination. Spielberg, who is an adoptive parent himself, noted "the hesitancy of the adoptive mom, the delicacy of her body position, the distance between her and the child. That is the drama and the pathos and the passion of the story."

Rockwell explored physical and emotional closeness between parent and child again in *Forsaken,* a drawing he donated to the *New York Times* for its "New York's One Hundred Neediest Cases" appeal in December 1952. The program, which continues to the present day, was launched in December 1912 to generate support for the few charitable organizations that attempted to address rampant poverty and illness in New York City. Working with several social-service organizations, the *Times* identified one hundred individuals and families and printed short descriptions explaining the reasons for their need. Within three days the paper had received almost a thousand letters from people as far away as Massachusetts who wanted to help.[172] Ten years later, the paper began calling upon painters, cartoonists, and illustrators to donate work to the program, and in the 1930s, Rockwell began contributing empathetic drawings of the homeless and hungry to support the cause.

Rockwell took the same care in creating *Forsaken* that he lavished on his commissioned work. (fig. 73) It is a beautiful portrait drawing; the wrinkles on the man's face, the veins in his hand, and his careworn expression describe a man unwilling to share his troubles with the vulnerable child. She looks at him with trusting eyes, and the touch of her hand on his face clinches the physical and emotional dependence she feels for her protector. It is apparent from a photograph that remains in Rockwell's archive that the drawing accurately portrays the models, but the emotional power of the image goes far beyond capturing their likenesses.

The drawing may well reflect Rockwell's concerns about emotional disruption within his own family. He traveled frequently from Arlington to Stockbridge, Massachusetts, some seventy miles away, where Mary was undergoing treatment for depression and alcoholism. In 1953 the family moved to Stockbridge so he and the boys would be close to their mother. The strain her illness put on the family may explain the depth of sadness he expressed in *Forsaken.*

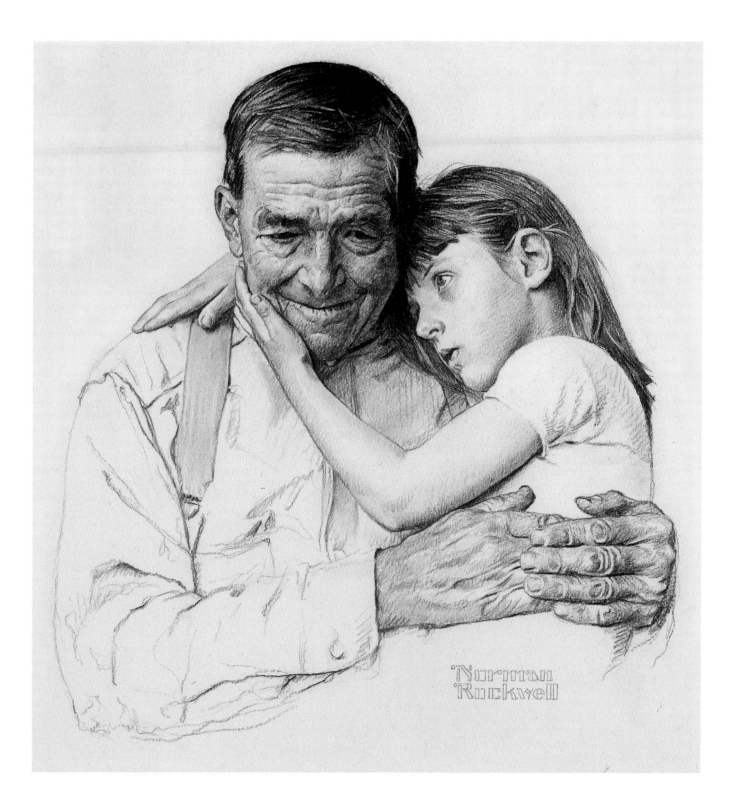

73

Forsaken

The New York Times, December 7, 1952.
Charcoal on paper, 19 × 16 ½ in.
Collection of George Lucas

Human affection also pervades the story Rockwell tells in *Happy Birthday Miss Jones*. (fig. 74) His previous pictures of schoolrooms often pitted students, mostly mischievous boys, against teachers who imposed discipline that cramped their freedom. The "real" boys of Rockwell's early magazine covers fished, played baseball, and made fun of city-slicker kids who dressed well and liked school, but that Penrod type had long since disappeared from Rockwell's repertoire. The children in *Happy Birthday*

Miss Jones fit a 1950s model rather than the earlier bad-boy mold. The girls and boys sitting with backs straight are exemplary students, with one exception—the little boy in the second row with an eraser on his head. We guess that he is the one who scribbled "Happy Birthday Jonesy" on the blackboard. Other details determine the timing of the scene. Miss Jones has just come in—she holds her hat and coat. Partially crushed pieces of chalk on the floor suggest the children's haste as they rushed to take their seats when she arrived.

These hints of what came before reflect a visual strategy Rockwell had used since his early years as a cover artist to extend the temporal potential of individual images. He did not just paint pictures; he told stories that implied preceding and subsequent moments in time.[173] "Every picture is either the middle or the end of a story. You can also see the beginning even though it's not there," Lucas remarked. "You can see all the missing parts, and, of course, in filmmaking we strive for that. We strive to get images that convey visually a lot of information without spending a lot of time at it. Rockwell was a master of that, of telling a story in one frame." This approach required the active participation of the viewer to mentally construct the rest of Rockwell's stories. The device was not lost on *Post* editors. Accompanying the painting, which appeared on the March 17, 1956, issue, was a "cover note" that explained the image:

Children must learn to multiply this by that and come out correct usually, else what's the use of growing up into a world full of income-tax blanks? But education is vexation. Often Miss Jones gets so weary of trying to hammer data into little craniums that she yearns to be shipwrecked on a desert isle; and often the little craniums get so weary of Miss Jones, period. Then one day, surprise! Over the cold, emotionless number work on the blackboard are scrawled words warm with sentiment. Tomorrow the acutely quiet posture of the scholars will have deteriorated into normal squirms, and the teacher's smile will have deteriorated, period. But right now Norman Rockwell has captured a moment when Miss Jones knows she loves those kids, and the kids know they love Jonesy.[174]

Rockwell met Anne Braman, the model for Miss Jones, at her husband's family's store in Stockbridge. Braman reminded Rockwell of his favorite teacher, and he asked her to pose. He requested that she wear tailored clothes, so she came in a white blouse, skirt, and belt she thought would be appropriate for a schoolroom scene. Rockwell concurred but asked her to borrow his wife's shoes to complete the effect of a spinster schoolmarm who devotes her life to her children.[175] Rockwell assembled Mrs. Braman and a group of students in a room at the Stockbridge grammar school in December 1955.

As in many of his postwar pictures, the poignancy of *Happy Birthday Miss Jones* was personal. Rockwell intended the painting to be a tribute to his eighth-grade teacher, Miss Julia M. Smith, who had encouraged

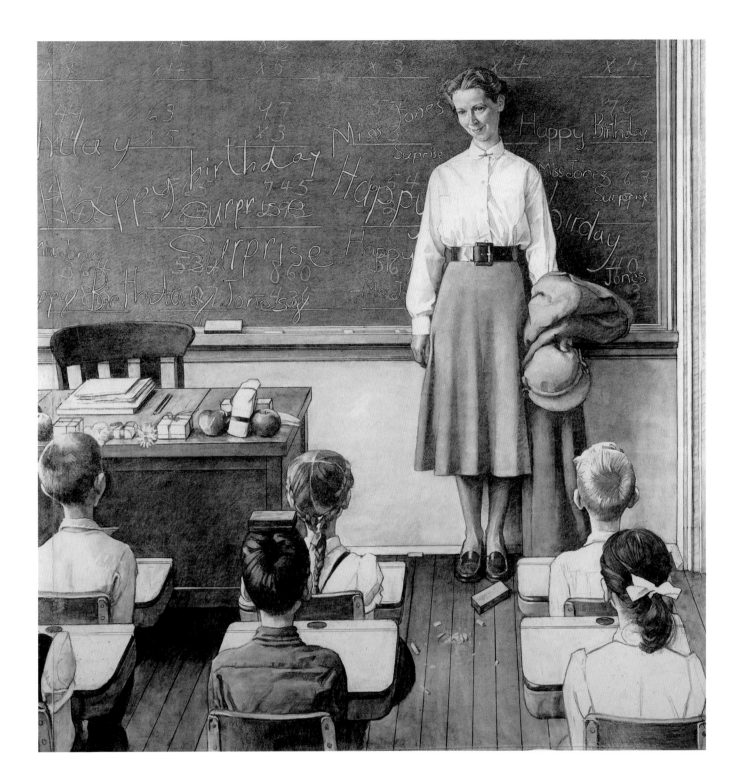

74

Happy Birthday Miss Jones
The Saturday Evening Post,
March 17, 1956.
Pencil on joined paper, 45 × 43 in.
Collection of George Lucas

him to draw, he said, and "taught me what little I know about geography, arithmetic, grammar, et cetera." He thought of her many years later when he received a letter from her caregiver, who wrote that although almost blind, Miss Smith asked friends to describe Rockwell's covers each time they appeared in the *Post,* and she reminisced about drawings he had done on the blackboard as a child. "That letter and others which followed," Rockwell remarked, "brought back my school days. I recalled how devoted and kind Miss Smith had been. Then I thought of how hardworking and

underpaid schoolteachers were. And after I'd mulled all this over for a while I decided to do a *Post* cover of a schoolteacher—sort of a tribute to Miss Smith and all the other school teachers."[176]

Rockwell located the viewpoint in the back of the room; the only face we see is that of Miss Jones. George Lucas, who owns the drawing, said, "You see the kids' faces through her reaction to them." Steven Spielberg, owner of the painting, observed, "The teacher, Miss Jones, has a sweetness about her. You know just by looking into her face that she loves every single student in that classroom, including the class clown with the eraser balanced on his head. You feel the warmth in that classroom, and you feel that this is the best birthday gift anybody has ever given her. The acknowledgment of her existence as a human being almost brings tears to her eyes."

The highly finished drawing and the painting are almost, but not quite, identical. (fig. 75) The viewpoint, positions, and clothing of the children, even the expression on Miss Jones's face translate from drawing to cover. But with his usual preference for clarifying and simplifying, he eliminated papers from the desk in the painted version, and he rearranged the apples, flowers, and wrapped boxes—gifts from the children. He also added an American flag at the top center of the composition and reconfigured the blackboard markings. Several preliminary photographs of the setting show the blackboard washed clean; in others "Happy Birthday" and "surprise" (misspelled) are lettered in chalk. Neatly written math problems cover the board in yet another. For the drawing and finished painting, Rockwell combined these markings. The arithmetic problems are still there, covered over with multiple birthday greetings, among them the affectionate if slightly impertinent, "Happy Birthday Jonesy." All the words are correctly spelled. The parents of Rockwell's younger fans would undoubtedly have objected to any errors in orthography. As he had done in the study for *Freedom of Speech,* he reconfigured the backdrop for maximum narrative impact.

The message of the painting is both personal and universal. Several weeks after its publication, the *Post* printed the following letter signed by Laura R. Jones, Atlanta, Georgia:

I know just how Norman Rockwell's Miss Jones felt as she walked down the hall toward her classroom. This was a birthday she'd like to skip. She was wondering if she ought to try something else maybe—some job that paid more or wasn't so wearing. Maybe she was in a rut. Then she walked into the room.

Some days can be stored in the memory as guards against the darker times. I wish the children's faces could be seen—the eager, excited looks, the unselfish delight at the wonderful surprise.

Miss Jones knows she is where she belongs. After that day things aren't quite the same, and the feeling of warmth makes it much easier to stuff that data into small eager craniums.

I know, because it all happened to the undersigned Miss Jones, too. I even had a cake with "We Love Miss Jones" written on it.[177]

75

Happy Birthday Miss Jones
The Saturday Evening Post,
March 17, 1956.
Oil on canvas, 45 ¼ × 43 ½ in.
Collection of Steven Spielberg

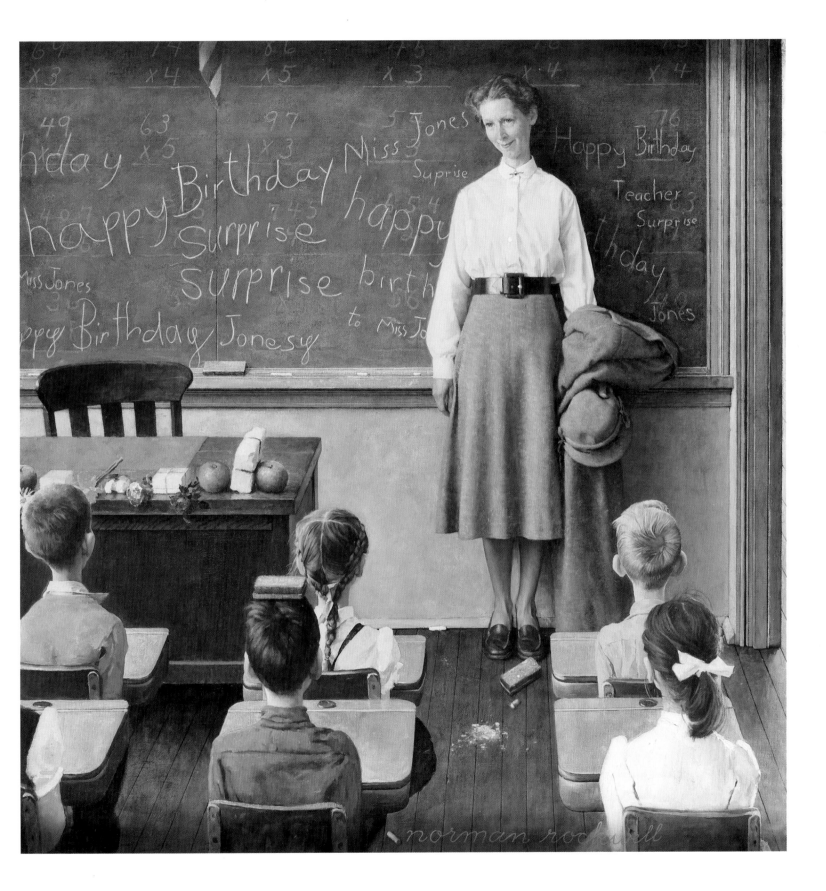

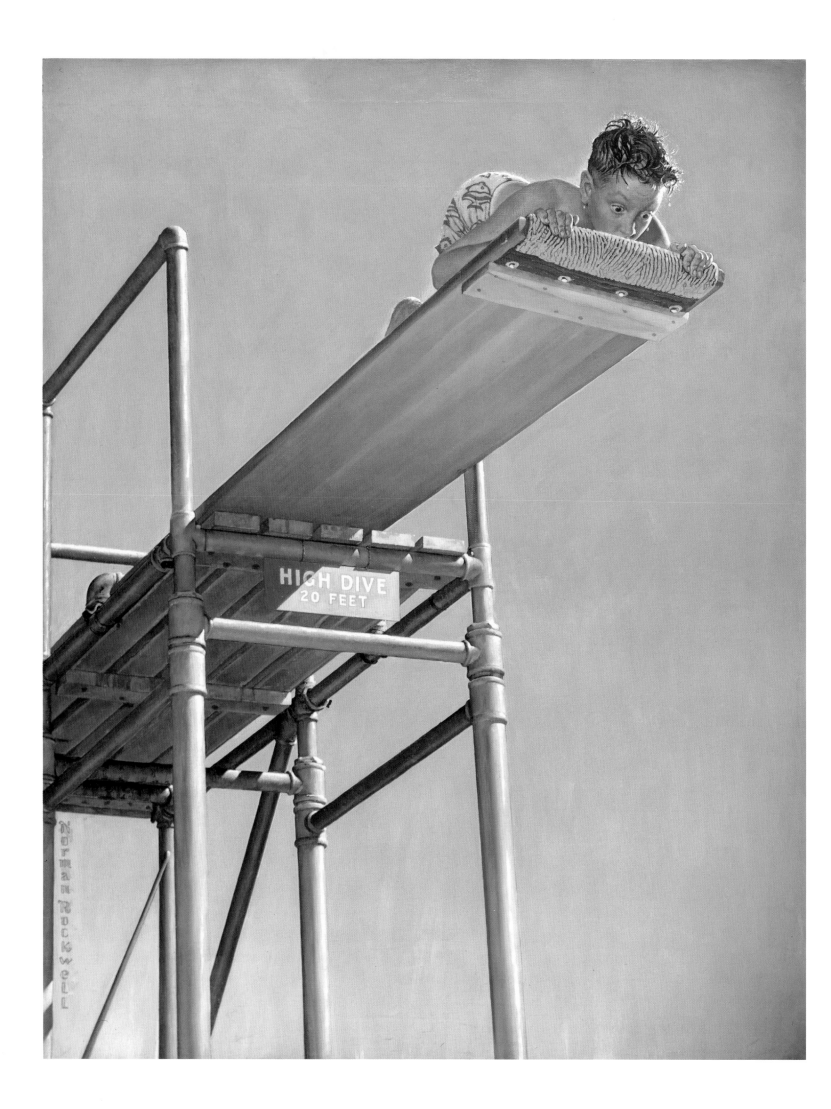

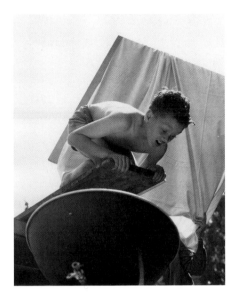

76

Boy on High Dive
The Saturday Evening Post,
August 16, 1947.
Oil on canvas, 35 × 27 in.
Collection of Steven Spielberg

77

Peter Rockwell posing for
Boy on High Dive
Norman Rockwell Archives,
Norman Rockwell Museum,
Stockbridge, MA

78

V. V. Stockton
Preliminary photograph for
Boy on High Dive
Norman Rockwell Archives,
Norman Rockwell Museum,
Stockbridge, MA

79

Peter Rockwell posing for
Boy on High Dive
Norman Rockwell Archives,
Norman Rockwell Museum,
Stockbridge, MA

Growing Up, Growing Old

Rockwell's youngest son, Peter, remembered the day he posed for *Boy on High Dive.* (fig. 76) His father, he reported, "always said a good model had to be able to raise his eyebrows halfway up his forehead to look surprised. I could never get my eyebrows up that far. Except for that terrible time when I had to crawl out on the end of a board he had rigged up to extend from the studio balcony. Remember that magazine cover of the frightened kid out on the end of a diving board, the boy with the eyebrows all the way up to his forehead? Well, that was me, and I was scared stiff."[178]

In November 1947, after the cover had appeared on the *Post,* the magazine reported that the idea had initially come to Rockwell during a trip to California. He had posed his son in a makeshift set five or six feet off the ground. Mary Rockwell and artist friends Clyde Forsythe and Mead Schaeffer watched as the artist directed the scene and experimented with lighting, while photographer V. V. Stockton took pictures. Afterward, Forsythe found a swimming pool with a cooperative caretaker who put up the diving board Rockwell used in the final composition.[179] (figs. 77 & 78) Rockwell brought the photographs back to the East Coast to complete the picture. He lugged his easel to the balcony of his studio, cranked it as high as it would go, and hoisted Peter onto a plank hanging over the two-story space to generate the real-life sense of terror on the boy's face.[180] (fig. 79)

Boy on High Dive is a strikingly dramatic scene that shows Rockwell pushing the boundaries of his own way of making pictures. In his early images he had used conventional straight-on views. Models stood or sat at eye level as the viewer looked on, sometimes as off-camera observers, sometimes as an implied part of the audience (as in *Shadow Artist, Graduation,* and *Happy Birthday Miss Jones*). He began adjusting that point of view in the early 1920s, and in the mid-1940s he experimented with elevated viewpoints. For a 1944 cover showing a crowded train station at Christmas, he prevailed upon the stationmaster, who allowed Rockwell and

his photographer to take pictures from a ladder high above the platform. In *The Charwomen,* we also see the figures from above, observing their quiet intimacy in the theater without ourselves being seen. In *Boy on High Dive* as with the charwomen, the viewer's location is illogical; it is difficult to imagine a circumstance that would allow us to look up at the boy on the diving board from a vantage point midway between the ground and his perch twenty feet above. Instead we see the child as though through the lens of a movie camera that has zoomed in for a close-up.

Boy on High Dive is compositionally more daring than anything Rockwell had ever done. More than in any other painting from his long career, the perspective contributes as much to the tension of the picture as does the child's emphatically raised eyebrows. The simple geometry of the struc-ture is a distinctly modernist reminder of Rockwell's trip to Paris in the early 1930s when he flirted, in his view unsuccessfully, with semiabstract design—a subject he would revisit in 1962 in *The Connoisseur.* Photographs from Rockwell's archive, one of which is torn from having been taped to his easel, reveal the combination of props and sets that resulted in the final scene of *Boy on High Dive.* As with *Little Girl Observing Lovers on a Train,* Rockwell assembled elements from multiple sketches and photo-graphs taken at different times and in different places, then recombined them for maximum impact.[181] It was a more complex process than work-ing from sets that could be captured in a single photograph or sketch, but it allowed him to adjust the viewpoint and the poses of his actors for greater nuance and dramatic effect.

Boy on High Dive is a scene that could have been observed (or exper-ienced) at any of thousands of municipal parks across the United States beginning in the 1920s, when pools began to replace "the old swimming hole," and especially after 1934, when the federal government began building pools as part of the public works programs that constructed roads, bridges, as well as the Grand Coulee Dam in Washington State and those in the Tennessee Valley.[182] Although the subject of Rockwell's painting was appealing to children who reached the top of a high dive only to be too afraid to either jump or climb down (and to parents who looked on with alarm as their children made the ascent), the image goes beyond the specifics of a kid screwing up his courage to leap or parents watching with bated breath. It is a picture of all the challenges faced and the fears overcome that mark a child's road to adulthood and define one's sense of self. The painting hangs in Steven Spielberg's office at Amblin Entertainment. He explained why it holds so much meaning for him: "We're all on diving boards, hundreds of times during our lives. Taking the plunge or pulling back from the abyss… is something that we must face…. For me, that painting represents every motion picture just before I commit to directing it—just that one moment, before I say 'yes, I'm going to direct that movie.'" Before making *Schindler's List,* he continued, "I lived on that diving board for eleven years before I eventually took the plunge. That painting spoke to me the second I saw it…. [And when I was able to buy it,] I said

not only is that going in my collection, but it's going in my office so I can look at it every day of my life."

Here, and in other paintings of the 1950s, Rockwell replaced the errant Penrods of his early years with images of children as emotionally complex individuals who seek rather than shun responsibility, reflecting, perhaps, the greater understanding of child behavior that came with being the father of teenage sons as well as the child-centric focus of the American family that played out in the new medium of television.

Rockwell was fascinated with television; he predicted the impact it would have on traditional life and values in a 1949 *Post* cover that showed the installation of a TV antenna atop the peaked gable of a Victorian house. And he was right. In 1950, 4.4 million families owned television sets; by 1956 the number had skyrocketed to almost 35 million, and a new genre of programming—the family sitcom—emerged.[183] *The Adventures of Ozzie and Harriet* (1952–66), *Father Knows Best* (1954–60), *Leave It to Beaver* (1957–63), *The Donna Reed Show* (1957–66), *My Three Sons* (1960–72), and other family-oriented TV fare presented humor within the structure of an idealized middle-class family: dad went to work, mom ran the household, and the kids had adventures that shaped the flow of family life. Programs focused on the roles the characters played as members of a family, and plots often revolved around minor conflicts and misunderstandings posed by the adventures of the children and were resolved within the family framework.[184]

The emphasis on American children was also reflected in the explosion of television programs aimed at young audiences. Beginning with *The Howdy Doody Show,* which debuted in 1947, a host of programs—variety shows like *Captain Kangaroo* (1955–84) and *Mickey Mouse Club* (1955–59), as well as adventure stories like *Sky King* (1951–59), *Lassie* (1954–73), and *My Friend Flicka* (1956–57)—were presented from the perspective of their youthful protagonists rather than from the viewpoint of adults. Although most shows contained subliminal moral messages—the importance of apologies, empathy for others—they were aimed at children and middle-class parents responsive to their offsprings' requests for Wonder Bread, particular brands of breakfast cereals, or other products offered by program sponsors. By the early 1950s the new medium joined the movies as a rich source for Rockwell's images.

Throughout Rockwell's work, dogs were the devoted companions of their boy owners. Girls were generally shown with pet cats. The animals represented preadolescent childhood as they patiently observed and sometimes participated in their owners' pranks.[185] *Boy in Veterinarian's Office*—which Lucas describes as an example of Rockwell's ability to give us "little bits of our culture, just captured, like a snapshot"—shows a kid from the 1950s generation who feels the discomfort of his pet. (fig. 80) He has wrapped a handkerchief around the ears of his ailing black-and-white mutt and sits in the waiting room of a vet's office along with several adults who hold pedigreed animals. The child is forlorn, oblivious to the

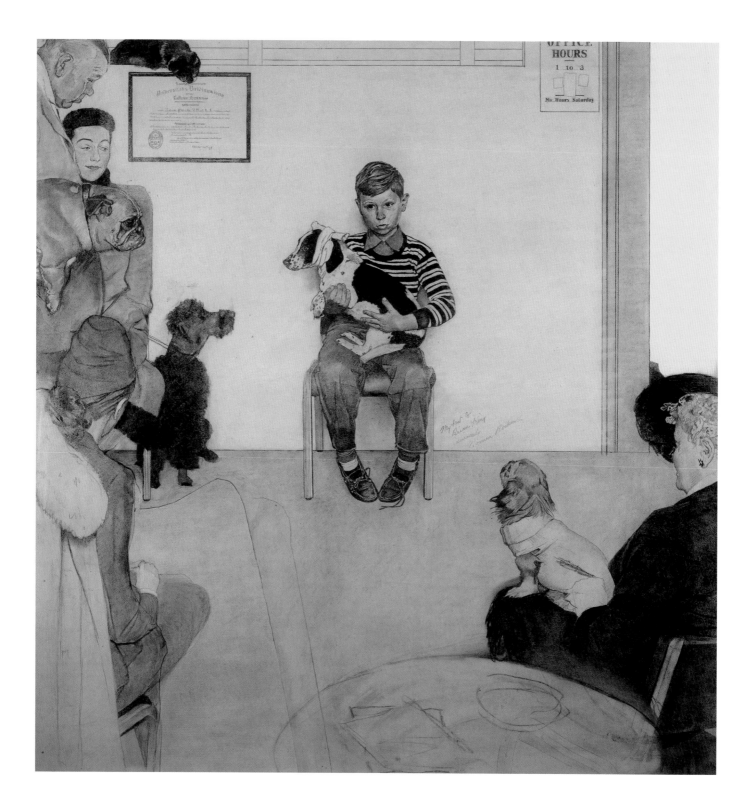

Boy in Veterinarian's Office

The Saturday Evening Post,
March 29, 1952. Charcoal
and pencil on paper, 40 ½ × 38 in.
Collection of George Lucas

pom-pommed poodle that sympathetically observes his sick animal and to the bulldog that bears a remarkable resemblance to older man who holds it.

The picture picks up on the dramatic expansion in veterinary medicine in the late 1940s and early 1950s. Seven new schools of veterinary medicine were established early in the decade to handle the growing demand for pet care following the development of a new rabies vaccine in 1950. (The Humane Society of the United States was founded in 1954.)

Although coincident with the growth of the field, Rockwell's drawing is less about veterinary medicine than about a child who, with no parent in sight, assumes responsibility for the well-being of another creature. The boy's concern for his dog reflects his growing maturity.

In spite of his interest in complex kids, Rockwell never failed to seize an opportunity when an amusing vignette came his way. One day in the mid-1950s, while working on a series of advertisements for the Crest toothpaste advertising campaign "Look, Mom, No Cavities!," the daughter of a friend came into the studio to model. When she smiled, he discovered she was missing her front teeth. It was easy, he said, to paint in the teeth required by the ad, but the episode gave him the idea for a *Post* cover that would be published at the beginning of the 1957 school year.[186] *The Checkup* shows three little girls against an all-white background. (fig. 81) The image is simple; there was no need for an elaborate or detailed set. As the *Post* explained the cover to readers:

One day after school three young ladies met in Norman Rockwell's studio to pose for a painting that called for charming smiles. And one of them, rendering her mouth ajar, proudly revealed a startling discrepancy in her charm department. "When I was eating, it wobbled right out," she glowed. "Gee, isn't that a scrumptious big hole?" One girl gave the chasm a grave, clinical examination and maybe she'll grow up to be a dentist, but the third lass, smitten with jealousy, uttered not a word of praise. So Rockwell was smitten with the first cover idea that ever walked spontaneously into his studio, which, considering his approximately 300 *Post* covers, was long overdue.[187]

Losing teeth and the excitement of waiting for the tooth fairy to leave money under the pillow mark a cherished moment of growing up. An appreciation for the rituals of childhood attracted George Lucas to Rockwell's *Post* covers even as a boy. *The Runaway,* Lucas said, shows a boy "with his little pack of worldly belongings sitting at a soda fountain next to a police officer. It's amusing; it's a part of American rituals of children's need to break away....I tend toward the more anthropological side of art, so I'm very interested in what it says about us and our culture and about how young people express themselves when they're trying to become independent, even before they reach the teenage years....I like images that record those kinds of events. For whatever reason, it's an emotional piece for me." (fig. 82)

Senses of ritual and nostalgia link *The Runaway* with Lucas's first box-office hit, *American Graffiti* (1973). It, too, is a coming-of-age story, which Lucas described in a 1974 interview. It is "about teenagers moving forward and making decisions about what they want to do in life. But it's also about the fact that you can't live in the past....Things can't stay the same. You have to accept change." *American Graffiti* takes place in a single night before best friends Steve and Curt are scheduled to leave for college. They attend a high school dance, cruise Main Street, and confront members of

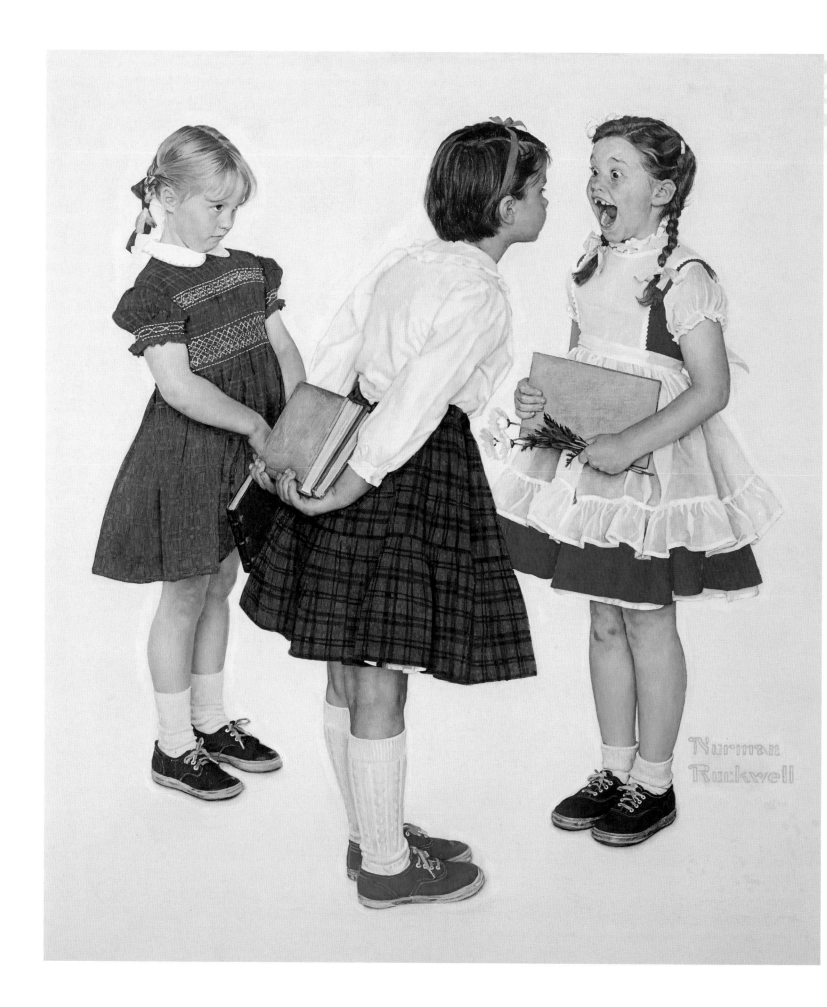

the tough local gang. Steve clings to his girlfriend; Curt chases an elusive beauty in a convertible. *American Graffiti* pits the comfort of the familiar against the lure of adventure, of breaking away. In the final scene, Steve is unwilling to make the leap. He stands with family and friends, waving goodbye to Curt as he boards the Magic Carpet airline. As Lucas explained, "*Graffiti* is partially a nostalgia film, partly a film about teenagers, and partly a film about the future."[188]

Like the little boy in *The Runaway,* Rockwell had run away from home when his family lived in Mamaroneck, a suburb of New York City. He said he "mooned around the shore, kicking stones and watching the whitecaps on Long Island Sound. Pretty soon it began to get dark and a cold wind sprang up and moaned in the trees. So I went home."[189] This boyhood adventure may have been the specific prompt for *The Runaway,* but Rockwell may have been reminded of it by episodes of *The Donna Reed Show* and *Father Knows Best* and the film *East of Eden* (1955).[190] Rockwell's *Runaway* is an innocent scene of a boy who has stuffed a few valuable possessions into a cloth bundle, tied it to a stick, and ventured out on his own. The policeman who found the wayward child respects the youth's dignity, so rather than take him directly home, he has invited the boy for a bite at the local diner. Boy and policeman appear to have conversational rapport. They talk with each other as the short-order cook leans forward to listen with a knowing half-smile.

Having come up with the idea for the picture, Rockwell made several adjustments to establish the companionable interaction between the officer and the child. State trooper Dick Clemens posed for the policeman; Ed Lock sat for the boy. Rockwell initially set the scene at a Howard Johnson's in Pittsfield, Massachusetts, but changed it "to a rural lunchroom," he said, "because I wanted to convey the idea that the kid had got well out of town before being apprehended." Since only the body language of the figures defines the trusting relationship between the runaway and the policeman, Rockwell experimented with the positioning of the arms of these two principal figures. One photograph shows Clemens in his uniform jacket holding his left arm close to his body. (fig. 83) In another he has removed the jacket and rests his left palm on the counter, a pose that conveys a sense of authority rather than relaxed friendliness. (fig. 84) In a third, Clemens's elbow extends outward from his body, reinforcing the tilt of his shoulders as he leans slightly toward the child. (fig. 85) Rockwell also choreographed the position of Lock's arms and moved his jacket from the adjacent stool to his lap. Still not fully satisfied, he replaced the original model for the counterman with a "jaded, worldly type," who he thought would appear "more understanding" than someone younger.[191]

Once he settled on the final configuration, Rockwell made the finished drawing that guided his brush as he painted the canvas. Unlike the process for *Going and Coming,* in which he made major changes between the drawing and finished version, he made only minor adjustments in *The Runaway*—to the still life of coffeepots, sugar dispenser, and cups at the

81

The Checkup
The Saturday Evening Post,
September 7, 1957.
Oil on canvas, 29 × 27 in.
Collection of George Lucas

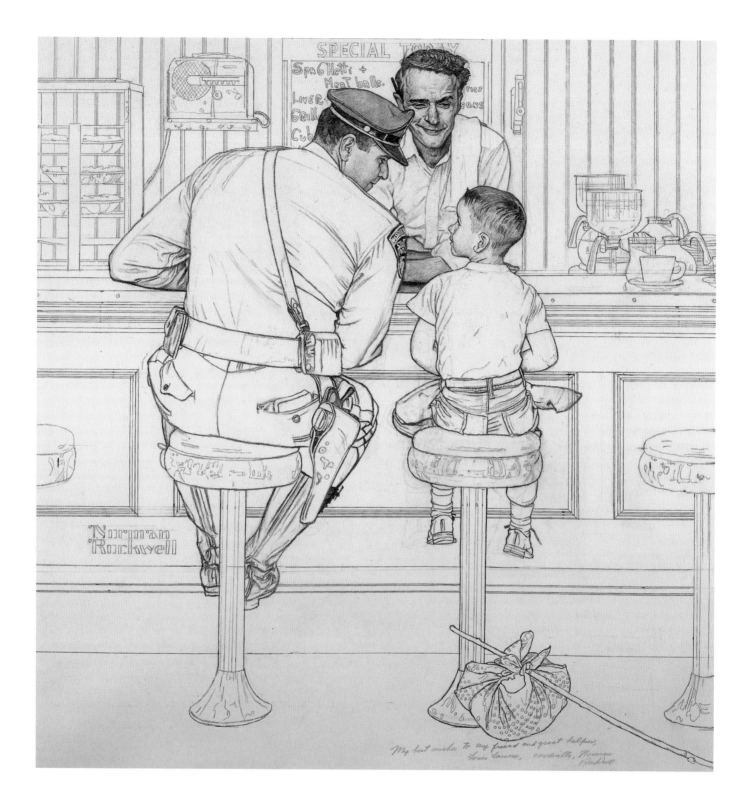

The Runaway

The Saturday Evening Post,
September 20, 1958.
Pencil on paper, 32 × 28 in.
Collection of George Lucas

right. In the painted version he removed one of the coffeepots to simplify the space at the right and give greater emphasis to the center figural group. Despite their differences in age and life experience, the three figures share a bond of understanding associated with the rituals of growing up. Implicit in the characterizations of the men are the options the child will face in the future. Will he choose as his role model the friendly policeman, or the jaded counterman with the cigarette behind his ear?[192]

83, 84, 85

Preliminary photographs for
The Runaway
Norman Rockwell Archives,
Norman Rockwell Museum,
Stockbridge, MA

In 1948, Rockwell proposed a calendar series featuring images of the four seasons of the year to Brown & Bigelow, the company that produced his Boy Scout calendars. With the seasonal calendars, he returned to themes about the passage of time that had occupied him during his early years at the *Post*. In revisiting the motif in the late 1940s and 1950s, Rockwell approached the idea not from the perspective of a twenty-something but as a man in his fifties. The conception was Rockwell's own. He wanted, he said, "to mirror the average person... leading our kind of life during each of the four seasons of the year," adding, "I prefer painting either the very old or the very young because they remain strictly them-selves; neither type wants to pretty up."[193]

Rockwell's Four Seasons images were printed annually from 1948 through 1964. Each featured a picture printed above the three months associated with a particular season. It was lucrative for the artist and less demanding than magazine covers, ads, or even stories. Rockwell chose lighthearted, relatively simple topics and used the same characters for all four images each year. He loved doing them:

Spring, Summer, Fall, Winter—I've no favorite. To me all the garbs of nature are wonderful and beautiful and each season has its own precious personal recollections, nostalgic memories of little everyday incidents out of the past that grow in importance with the passing of time.... These simple scenes represent to me some of the glory and wonder of nature, a little of the joy and happiness of freedom, and a whole lot of the just plain goodness of living.[194]

Boys sledding, ice skating, or relaxing with their dogs; old men playing checkers; couples (young and old) courting; and, beginning in 1961, boys interacting with their fathers—some of the subjects were touching or

sentimental, while others highlighted the foibles associated with growing old. In *Grandpa and Me: Raking Leaves,* the fall image for the 1948 calendar, a grandfather approaching the winter years of his life gazes at migrating geese as his grandson, nearing adolescence, carefully sets fire to a pile of leaves. (fig. 86) Change—in terms of seasons and life—is the point of the picture, which may have had personal overtones for a man whose first child would soon leave for college. The circumstances of Rockwell's life—his childhood, his children, his marriage to an accomplished woman, even his struggle to find subjects for his pictures—were fair game as subjects.

The series for 1951 featured four boys. In the winter, they argue over a basketball game; spring finds them in baseball uniforms holding oversized gloves; they play golf in the summer and football in the fall. Each image is amusing, but the boys' personalities emerge most effectively in *Golf.* (fig. 87) Here Rockwell caricatured the clothing and facial expressions of the boys. Each is an identifiable character—two are confident, comfortable with their sporting abilities; one is small with a goofy grin; and the fourth is a self-portrait of a youthful Rockwell with ears that stick out and round glasses. The pants on the boy holding the golf bag at the left are too big, likely hand-me-downs from an older sibling; the sleeveless T-shirt on the young Rockwell emphasizes his skinny arms and scrawny chest. Rockwell casts himself as the butt of the joke. To the amusement of his fellow golfers, he has just missed an easy putt. The adult Rockwell had taken up golf in the 1920s but said he enjoyed the clothing more than the game. He went to Brooks Brothers to buy a golfing outfit that showed off his "lightly muscled" legs and wore his cap at a "jaunty angle." When photographs showed the Duke of Windsor had begun sporting knickers that reached almost to his ankles, Rockwell and friends replaced their out-of-fashion attire with the aristocratic new style.[195] Such biographical details underscore Rockwell's self-effacing humor evident in *Golf.*

Fathers and sons were the subject of the 1961 calendar series in which a father serves as role model and mentor, teaching his eager son to ski, fish, and hunt. Their relationship mimics the pattern that played out in *Father Knows Best* and other sitcoms of the day. It was so successful that Rockwell repeated the idea the following year using the same father and son figures but altering their roles. In "Boy and Father" of 1962, the boy is a year older and wiser. Rather than learning fatherly lessons about masculine pastimes, the winter 1962 boy watches his dad puzzle over the boy's homework. (fig. 88) In the spring, the two argue over a baseball call. (fig. 89) The father no longer represents unquestioned authority; he points to a rule book as he argues with his irritated offspring.

One of the most amusing Four Seasons calendars appeared in 1957. Titled "Tender Years," it features the relationship between an elderly husband and wife. For the spring picture, *Treating a Cold,* the wife patiently

Grandpa and Me: Raking Leaves
Four Seasons Calendar, 1948.
Oil on canvas, 18 ½ × 18 in.
Collection of George Lucas

administers a dose of medicine to her quilt-wrapped husband, who sits
with his feet in a pan of hot water. In the summer image, *Mowing the
Lawn,* she brings him a refreshing beverage only to find him dozing beside
a push lawnmower. In the autumn he looks with dismay at a union suit
full of moth holes she has just pulled from a trunk. Each is a witty and
endearing commentary on the foibles of aging. But the key image of the
series is the first, *New Calendar,* in which the portly husband, having just
tacked up a new wall calendar, happily ogles a pinup cutie in a cowgirl

87

Golf

Four Seasons Calendar, 1951.
Oil and pencil on canvas, 13 ½ × 12 in.
Collection of George Lucas

outfit sitting astride the saddle of a wooden "horse." (fig. 90) His wife, who needs reading glasses for her knitting, watches in mused annoyance. The cat that brushes her skirt is a frequent emblem of femininity in Rockwell's art, but one more often associated with pretty young girls than with wrinkled, white-haired women. Here Rockwell, now in his sixties, reminds us that no matter how old, we never lose the gendered feelings we learned as children and adolescents. He described the series in 1957:

In a world that puts such importance on the pursuit of youth, it is good to consider, occasionally, the charms—and the comforts—of maturity....My pictures show two people who, after living together for many years, have reached the stage of sympathy and compatibility for which all of us strive. They know their weaknesses and their strengths. They are comfortable and secure in their relationships with each other. And while Mother presumably takes Father's strong points for granted, she's still trying tolerantly to keep him on the straight and narrow when signs of frailty appear.

Paintings like these are fun to do. While they are humorous, they are also human, and the subtle touch of forbearance evident in each of them is something all of us can learn.[196]

Rockwell was sixty-one when *Mermaid* appeared on the cover of the August 20, 1955, issue of the *Post*. (fig. 91) It was the first nude he had ever done for publication. Letters poured in from fans who were alternately amused and shocked. An elderly woman in New Jersey described the cover as "especially delicious."[197] A man from Three Rivers, Michigan, asked "What bait is best? Where are the best fishin' holes (or grounds)? What about a license? Do they keep well, or spoil readily? And what about fishing regulations (limit, etc.)?" The editors responded: "Bait of your choice, no license required, no limit, open season. If you catch any let us know." Another writer reported that Rockwell had made an "egregious technical error" by showing the mermaid with the tail of a fish, when all serious marine biologists knew that "the species *(aquahomo sapiens)* to which mermaids belong is warm-blooded and mammalian, in contradistinction to fishes, which are neither." Another wrote, "Do not like lobsters, but think mermaids O.K." Another, "Your mermaid cover is delightful. I would love my husband to catch one if only he also would go and trap a faun for me."[198] One, who signed himself "Perpetual Secretary" of the "Lake Michigan Society for the Prevention of Cruelty to Mermaids," suggested that, unlike Rockwell's dreamy-eyed "aquahomo sapiens," an authentic mermaid would not have looked so happy unless the lobsterman were a "little younger."[199] Not everyone was equally entertained. The editors recapped reactions several weeks later: "The vote on Rockwell's cover at press time was: In Poor Taste, 11; Obscene, 21; Not Obscene, 245."[200]

Rockwell had begun working on *Mermaid* more than six months before its publication. He had spoken to L. J. Hart, the manager of the Gloucester, Massachusetts, Chamber of Commerce, who obligingly scouted the fishing piers for appropriate models, and in April 1955 sent photographs of Walter Marchant, described by Hart as an eighty-two-year-old lobster fisherman who had been working the pots since he was seven. Because the curved pots in contemporary use were ill suited as mermaid traps, Marchant constructed an old-style boxy model that better fit Rockwell's purposes and used worn materials to ensure the pot looked weathered with age. By mid-May, the lobster trap had been delivered and Marchant was back home in Gloucester after a trip to Stockbridge to pose.

Following pages:

88
—

Homework
Four Seasons Calendar, 1962.
Oil on canvas, 18 × 16 in.
Collection of George Lucas

89
—

Baseball Dispute
Four Seasons Calendar, 1962.
Oil on canvas, 18 × 16 in.
Collection of George Lucas

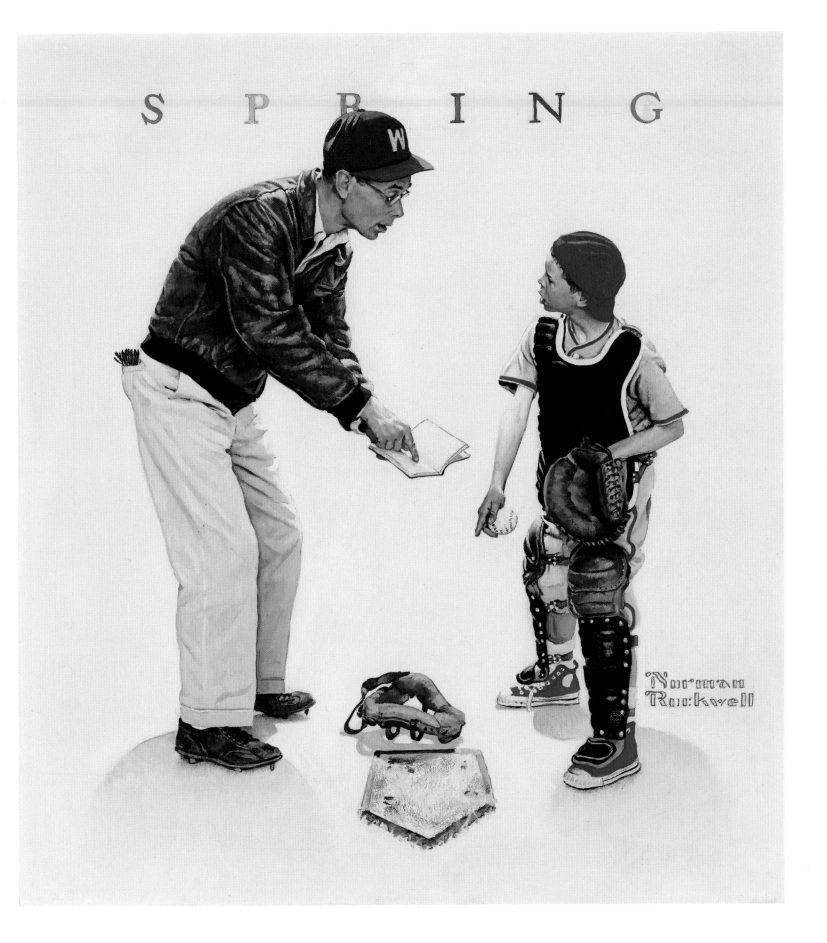

norman rockwell

Preceding pages:

90
—

New Calendar
Four Seasons Calendar, 1957.
Oil on canvas, 18 × 18 in.
Collection of Steven Spielberg

91
—

Mermaid
The Saturday Evening Post,
August 20, 1955.
Oil on canvas, 45 × 36 in.
Collection of Steven Spielberg

Unwilling to ask a neighbor to model in the nude, Rockwell had hired a professional from New York for the mermaid and bought a twelve-pound pollack at the Berkshire Fish Company to copy the tail.[201] He later recalled, "I posed [the nude model] in front of my big studio window because of the light.… I happened to go over to the window and look out. The drug store was just across the street and it was just filled with fellows looking up at my studio window. So I decided to give the fellows a treat and I kept that mermaid posing there a long time."[202]

Rockwell reported that the idea for *Mermaid* had been prompted by recollections of an early trip to Provincetown, but like so many other artworks, it connected with pervasive fantasies about mermaids in contemporary culture. In the 1940s a photograph of a tableau of mermaids and a fisherman at the National Fisherman's International convention was distributed by the Associated Press to newspapers around the country, and beginning in 1952 every American who opened a can of Chicken of the Sea tuna fish saw the mermaid the company adopted as its logo that year (and which appears on labels even today). Spielberg observed that the mermaid is atypical of Rockwell's themes and speculated that Rockwell may have seen a science-fiction film, a couple of fantasy films, or "maybe he loved that old William Powell film called *Mr. Peabody and the Mermaid*."

The parallels between *Mermaid* and the 1948 movie are intriguing. *Mr. Peabody and the Mermaid* was a romantic comedy that starred a middle-aged William Powell and nineteen-year-old Ann Blyth as the mermaid he named Lenore. Mr. Peabody had traveled with his wife from Boston to the Caribbean for a winter vacation. Preoccupied by his approaching fiftieth birthday, Mr. Peabody hears music coming from across the water. He then heads out in a catboat to find the source of the haunting melody. He catches a beautiful mermaid, whose obvious affection eliminates concern that approaching old age is sapping his masculine appeal. The parallels between the movie and Rockwell's conception are striking, especially in the age discrepancy between Mr. Peabody and Lenore.

Contemporary Life

When Ben Hibbs took over as editor of the *Post* in 1942, he changed the cover format, modernized type styles, and expanded content to feature articles about Hollywood personalities, popular bandleaders, and famous sports figures to give readers a more diverse bill of fare.[203] In the 1950s he also introduced coverage about charged social issues. Virgil Blossom, school superintendent in Little Rock, Arkansas, wrote a story on the 1956 integration crisis there, and the *Post* serialized the controversial novel *The Ugly American* (1958) by Eugene Burdick and William Lederer. Hibbs's selections were smart. "During a period in the 1950s," Hibbs reported, "there was never a week [when] we didn't have three [serialized] *Post* books on the [*New York Times* best-seller] list, and sometimes as many as five."[204] In 1957, when he launched "Adventures of the Mind," a series of

articles by America's leading scientists and scholars to keep the magazine from slipping too far to the "lighter side," sixteen book publishers bid for hardcover rights.[205] Hibbs's ideas were well received, and circulation figures steadily climbed.[206]

Rockwell's covers of the 1950s reflect Hibbs's desire for a topical magazine. In *The Rookie,* he captured one of the country's most famous and controversial baseball players. (fig. 92) Baseball images had been popular fare for cover artists since the early years of the twentieth century, but for *The Rookie,* Rockwell went to great effort to feature real, recognizable ballplayers. He decided to do the painting nine months or more before the image was published, in March 1957, just as spring training for the 1957 baseball season got under way. He arranged for photographs of the interior of the clubhouse at the Boston Red Sox facility in Sarasota, Florida, and convinced team officials to send four members of their starting lineup to Stockbridge to pose in the summer of 1956.[207]

The stellar group included pitcher Frank Sullivan, shown seated on the bench tying his shoes; right fielder Jackie Jensen behind him wearing number 8; catcher Sammy White, who relaxes in the left foreground; and second baseman Billy Goodman, covering his mouth with his hand at the right edge of the composition. The figure standing at the left edge is John J. Anonymous, representing, Rockwell said, all the young men who tried out for the Red Sox and waited years to be called.[208] Star hitter Ted Williams stands in the center, staring down the rookie. (Williams was unable or unwilling to make the trip, so Sullivan substituted for his body; Rockwell drew the head from photographs.)

Williams was an old-timer when the cover appeared. He had started his major league career with the Red Sox in 1939 as a raw-boned youngster with a competitive spirit and a mean swing. By 1941 he was batting over .400, and in 1942 he won the "triple crown" with a batting average of .356, thirty-six home runs, and 137 RBIs for the season.[209] Almost from the beginning the outspoken Williams provided fodder for the press. He battled with sports writers who criticized his performance and snubbed fans who booed his missteps on and off the field. But by the mid-1950s his military service was also well known. He had trained as a pilot in World War II (he was about to ship out to the Pacific when the Japanese surrendered) and flew thirty-nine missions with the First Marine Air Wing when he was recalled to active duty during the Korean conflict in 1953. Williams was as vocal about U.S. involvement in Korea as he had been with sports writers, and after a bout of pneumonia that left him with an inner ear problem, he was released by the marines in the summer of 1953, in time to sign a contract for the remainder of the season. In 1954 his life story was published in the *Saturday Evening Post.* In the series, titled "This Is My Last Year," he announced he was planning to retire, although he subsequently changed his mind.[210]

By the summer of 1956, when Rockwell began working on *The Rookie,* Williams was at both his best and his worst. He hit his four hundredth

career home run in July, but confrontations with sports writers and fans made headlines constantly. This attitude may account for Rockwell's showing him aggressively assessing the rookie, although ironically, Williams was known for encouraging young players, especially those who were as awkward and unsophisticated as he had been as a San Diego high school player who hoped to break into the big leagues.

Unlike Rockwell's joking baseball pictures—of boys playing pickup ball or disappointed umpires calling a game for rain—the face-off between a youngster (a Pittsfield, Vermont, high school player named Sherman Safford posed for the rookie) and a veteran player—pits youth against experience. The kid is gangly and eager. His white socks, cheap suitcase, and big hands mark him as a naive newcomer with potential. The expression on Williams's face suggests that the thirty-eight-year-old slugger was not yet ready to welcome a challenger.

Having planned for the cover, Rockwell could not be sure it would be used because rumors of Williams's retirement again circulated throughout the fall of 1956. Not until he appeared on the *Today* show in December did Williams announce that he would return for the 1957 season. Reaction to the cover was mixed when it appeared in early March. A reader from Montana called it "a disgrace to Organized Baseball." His complaint did not hinge on the portrayal of Williams or the depiction of the locker room (in the finished painting Rockwell omitted the trash and cigarette butts that appear on the floor in the drawing). "Not since years ago," the letter writer declared, "did a rookie come into a major-league dressing room in such an appearance or stature." However, another fan applauded: "Your March 2 cover by Norman Rockwell should give him an honorable mention in baseball's Hall of Fame."[211]

The Rookie was a topical picture with recognizable people that spoke to sports fans all over the country. Unlike Rockwell's images of Lindbergh in the 1920s, which cast the young flyer as a national hero, or of Daniel Boone, George Washington, Abraham Lincoln, and other legendary icons of the American past whose likenesses evoked greatness, Williams is shown as a tough, uncompromising man whose quixotic persona and well-known behavioral flaws are clear. Although Rockwell had painted portraits of movie stars and presidential candidates, never before had he portrayed a celebrity in such equivocal terms.

Elect Casey was also topical when it came out on November 8, 1958. It is a rare instance in which an apparently final drawing suggests a different story than the narrative of the finished painting, possibly because Rockwell expected it to appear shortly before, rather than immediately after, the election that year. The drawing for *Elect Casey* shows a candidate exhausted at the end of his campaign as his supporters file out the door. (fig. 93) Casey slumps in a chair, his expression noticeably divergent from that of the smiling figure on the poster behind him. Campaign signs calling him the "People's Choice" litter the floor, signaling the end of a long campaign, the results of which are yet to be determined. In the finished

The Rookie

The Saturday Evening Post,
March 2, 1957. Charcoal
on joined paper, 40 ¼ × 38 ½ in.
Collection of George Lucas

painting, the scene shifts to the moment after Casey learns he is defini-
tively not the choice of the people. (fig. 94) He has lost, we are told by the
scrap of paper on the floor, by a margin of almost six to one (33,127 to
5,784) and is stunned by the magnitude of his defeat. In shifting the timing,
Rockwell altered the number and demeanor of the supporters, adding an
older man in a black overcoat—possibly a local politico—who looks back
in disgust. We have no way of knowing which office Casey had hoped

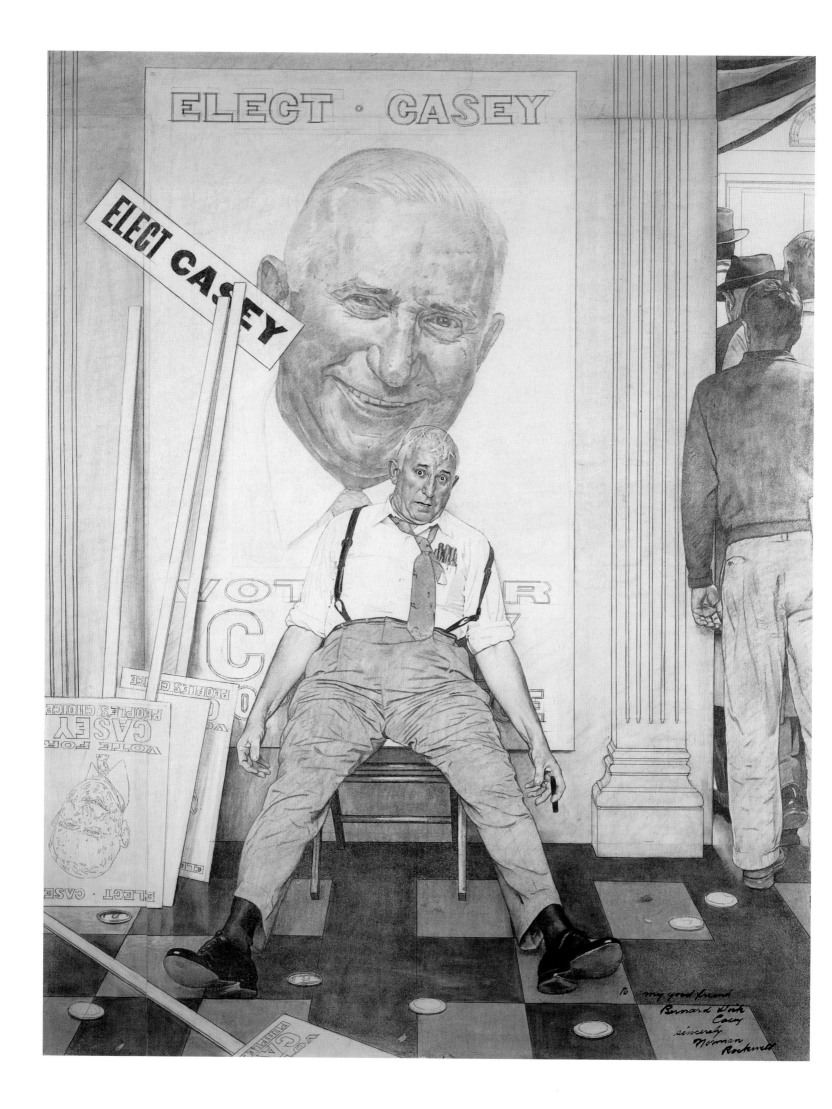

93

Elect Casey
The Saturday Evening Post,
November 8, 1958. Charcoal and
pencil on joined paper, 58 ¼ × 45 ½ in.
Collection of George Lucas

94

Elect Casey
The Saturday Evening Post,
November 8, 1958

to win, but the scene is one that plays out in communities all over the country on election night; for every contested position, someone wins and someone loses. *Elect Casey* is both a depiction of disappointed hopes and a reminder that the electoral process involves choice—a basic tenet of American democracy.

Rockwell had painted election-based images before. His *Political Argument* of 1920, shows a well-dressed couple seated back to back, the Democratic and Republican logos on the wall behind them indicating their opposing political persuasions. Rockwell reprised the motif in 1948 with *Breakfast Table Political Argument,* a picture of a couple arguing; she holds a publication with a large image of Harry Truman, while her husband points to a newspaper featuring Thomas Dewey (see p. 217). Neither seems to notice their toddler crying on the floor. Four years later, Rockwell would paint his first portrait of Dwight D. Eisenhower, for an October *Post* cover appearing a month before the November 1952 presidential election. In 1956, his portraits of candidates Adlai E. Stevenson and Eisenhower were

featured on sequential issues in October. But not until *Elect Casey* did he present the emotional impact of an election on an individual candidate.[212] The painting demonstrates that Rockwell had come a long way from the unquestioned patriotism of the Boy Scout and Lindbergh pictures. It is a statement about the complex nature of American democracy and negotiation among multiple points of view.

Sex in the office was a hot-button topic in the 1950s and 1960s, when postwar prosperity and changing attitudes about women's roles in the workplace shifted from earlier family-centric norms. Flirtations played out in office settings, where millions of unattached young women launched independent careers or sought well-heeled husbands. It was the subject of the television comedy *Private Secretary,* which aired on CBS from 1953 to 1957. In her role as private secretary to a handsome talent agent (played by Don Porter), actress Ann Sothern (who won three Best Actress Emmys for the role) constantly promoted and interfered in the romantic life of her boss.[213] Rockwell had painted the fantasies of working people for more than thirty years. A man sneaking out of the office to play golf, an aging accountant dreaming of adventure, and a salesman who sheds his clothes to take a dip in a swimming hole were commentaries on the employee's desire to escape humdrum routine.[214] *Window Washer* offers a different sort of narrative. (fig. 95) The scene is set high in a midtown Manhattan office tower. Through the soapy window, approximations of the Empire State and Chrysler buildings, two of the city's most prominent landmarks, loom large. The red-headed female protagonist is not, like the charwomen of 1946, in a service position; she is secretary to an important man whose office looks out over the skyline and is furnished in the latest style, complete with potted palm. The executive is a dapper man with thinning hair who wears a flower in his lapel but no wedding ring. The secretary sits demurely, as Spielberg noted, "with that characteristic straight back that Rockwell loved when painting women." Her arms are positioned modestly by her side, and her high heels catch the rung of her chair. But her skirt length reveals her knees, and the neck of her dress is unbuttoned.

As in *The Flirts,* the social distance between the blue-collar window washer and the well-dressed young woman is the obvious joke. He is having a little fun winking at the pretty girl as she works. But the visual pun has multiple punch lines: the momentary lapse of the secretary's attention as she takes dictation, the busy executive's obliviousness to the window washer's presence, and his lack of awareness that his assistant is distracted from her steno pad. *The Window Washer* is also a picture about looking. The office is observed from the back by the window washer and from the front by the unseen viewer of the painting (us). The wink directed at the young woman acknowledges that we, too, are complicit in this intrusion into a private office.

The spatial organization of the painting resembles the set of a television sitcom. The figures occupy separate planes that are sequential in depth, but the framing window links the two men. Rockwell loaded the

95

Window Washer

The Saturday Evening Post,
September 17, 1960.
Oil on canvas, 45 × 42 in.
Collection of Steven Spielberg

picture with sexual innuendo by locating the window washer's bucket and middle torso near the center of the composition, and by the connections implied by the adjacency of the skyscrapers and the men.[215] The city's tallest building is associated with the virile younger man, the less prominent one paired with the middle-aged executive. Coupled with the secretary's unbuttoned neckline, these quasi-subliminal cues invited *Post* readers to speculate on masculinity and flirtation in the workplace. Although *Post*

editors did not report reader reaction to the pairing of men and buildings, several letter-writers reacted to the insinuation. A woman from Chicago commented, "The girl on the cover is anything but 'a very prim girl' indeed. Is Mr. Rockwell (and/or the *Post*) advocating these low necklines for wear in a business office? For shame on you both." Another remarked, "From experience I'm willing to bet the stuffed shirt behind the desk is a bigger wolf than the winking window washer! You'd be surprised the zip those old guys have when it comes to marathon runs around an office. Actually, who could resist…a dish dressed like the one on your cover. She ought to either sew buttons on her sweater or at least wink back. I would—that fellow's kinda cute!"[216] Although at the time the best-known painting of an office, Edward Hopper's *Office at Night* (1940) may not have been familiar to the general public, Rockwell was certainly aware of Hopper's sexually charged image of a secretary and her boss in a dramatically lit office.[217]

One of the most controversial subjects that Rockwell undertook in the late 1950s is *The Jury,* which appeared on cover of the Valentine's Day issue of the *Post* in 1959. (fig. 96) It is a loaded image that allowed readers to chuckle at the idea of an attractive young woman confronted by her male peers on a jury panel. Rockwell provided no information about the nature of the trial—whether civil or criminal, significant or inconsequential. But it is much more provocative than earlier battle-of-the-sexes pictures. Beyond the amusing first impression, Rockwell addressed deep-seated attitudes regarding women's ability to reason, their capability to assess guilt or innocence based on evidence rather than emotion, and the meaning of the right to trial by a jury of one's peers within the American legal system—issues that were the subject of debate throughout the 1950s and 1960s. Most particularly it poses the questions of integrity and the courage of one's convictions in the face of overwhelming pressure.

Rockwell determined the palette and spatial configuration in a color sketch in which the positioning of figures in the left half of the image unbalances the composition and establishes an unsettling tone that reinforces the narrative of the final painting. (fig. 97) He then worked hard to perfect the nuances of facial expression and body language. His photographer took dozens of pictures, and he made sketch after sketch. For this cover, as for others, selecting the right models was important. "I tell the story through the characters," he said. The people represented in the painting, he continued, "are a pretty good cross-section of the people of Stockbridge. There are a couple of ringers—the man with the mustache standing beside the sleeping juryman is Bob Brooks, an art director in a New York advertising agency; the lady in a man's world is his wife."[218] As he worked to stage the scene, Rockwell repeatedly directed his models to adjust position and asked several to change clothes, so the picture would represent a range of types and income levels. The result of this exacting process is the climax of the dramatic scene.

Women had served on juries in Utah and the Wyoming territory in the late nineteenth century, but in 1959 three states—Mississippi, Alabama,

and South Carolina—still prohibited women from serving on juries in state courts, even though passage of the Nineteenth Amendment in 1920 permitted them to vote. Massachusetts, where Rockwell lived, had enacted legislation in 1950 making women eligible for jury service but with the proviso that they be excused from hearing cases of rape and child abuse if they believed they would be "embarrassed" by the testimony of witnesses or jury deliberations.[219] At the time Rockwell painted *The Jury,* eighteen states still imposed restrictions on women's jury service.[220] News accounts of impending trials routinely reported the ratio of men to women on newly impaneled juries.[221]

Attorneys and judges argued the issue. Some claimed that women jurors were more skeptical than men in injury suits; a judge who spoke anonymously remarked that "women are never reliable."[222] Others claimed that women brought idealism to the process: they were "uncomplicated in determining right and wrong, good or evil, justice and oppression" and "uncompromising in their principles [and] sincere in purpose."[223]

Jury trials, individual holdouts, and women's roles were also highlighted in television and film in the late 1950s. Greer Garson starred in an episode of the popular series *Telephone Time* that aired in September 1957, in which Garson's character campaigns for women to be selected as jurors in a murder trial.[224] Without women, the killer would go free because all available male jurors were either his friends or too fearful to vote for conviction. The most revealing connection between Rockwell's painting and contemporary popular culture lies in the parallels it shares with the movie *Twelve Angry Men* (1957). In the film, Henry Fonda stars as the holdout on a jury that, except for his dissenting vote, will impose the death sentence on a young Hispanic man charged with killing his father. Each of the other jurors votes to convict—some for personal reasons, some out of prejudice against nonwhite Americans, some because they simply wanted to escape the heat of the jury room and go to a baseball game. One by one, as the Fonda character poses reasonable questions about the value of the evidence presented, the other jurors acquiesce to his arguments. The final ballot results in a unanimous verdict of not guilty. As in *Twelve Angry Men,* the jury deliberation portrayed in Rockwell's canvas has been lengthy. Cigarette butts and crumpled ballots litter the floor of the smoke-filled room, but the holdout remains unswayed, despite the psychological pressure imposed by her fellow jurors.

Rockwell gave *Post* subscribers a sneak preview of the cover. It was on his easel when Edward R. Murrow's team filmed him for the February 6, 1959, broadcast of *Person to Person,* a live program of interviews with national and international figures whose professional and private lives fascinated the American public. Rockwell was in stellar company when he was selected to appear. He shared the night's billing with Cuba's new leader, Fidel Castro. The previous year, Murrow had featured actors Ann Sothern, Ginger Rogers, Dean Martin, and Gina Lollobrigida; defense attorney Edward Bennett Williams; opera diva Maria Callas; baseball legend

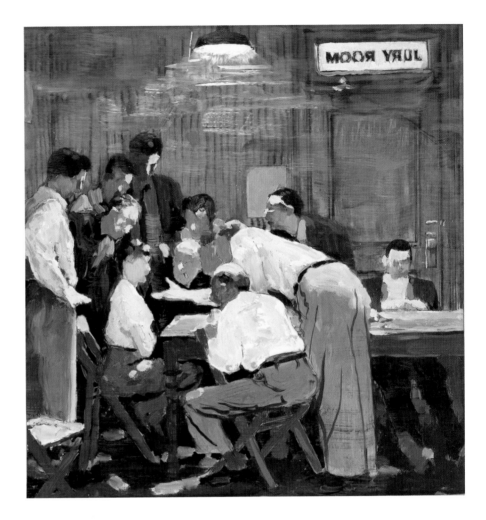

96

The Jury
The Saturday Evening Post,
February 14, 1959.
Oil on canvas, 46 ¼ × 44 in.
Collection of Steven Spielberg

97

The Jury
The Saturday Evening Post,
February 14, 1959.
Oil on paper, 10 × 9 ½ in.
Collection of Steven Spielberg

Roy Campanella; and others. The segment on Rockwell featured the artist
at home with his son, Tom, with whom he was working on his memoirs,
Tom's wife, and Mary, who spoke in the supportive voice that had charac-
terized their relationship since they first met in the spring of 1930. It was
to be her last public appearance by his side. Her sudden death in August
ended their almost thirty-year marriage.

Constructing a Persona

An aw-shucks quality permeates *My Adventures as an Illustrator,* the auto-
biography of four-hundred-plus pages that Rockwell was working on with
Tom at the time of the *Person to Person* interview. The book, and excerpts
that appeared in nine sequential issues of the *Post* beginning in February
1960, confirm the image constructed many years earlier by the magazine's
public relations department of Rockwell as a modest, friendly everyman
with a gentle sense of humor who painted human foibles and familiar
episodes in twentieth-century life. The excerpts were liberally illustrated
with photographs of Rockwell at home, sketching in the studio, posing
models, and mugging for the camera, all humorously captioned to
emphasize the self-deprecating tone of the text. In many respects the
self-effacing image was accurate; it reflected the impressions of friends,
business associates, neighbors, and models who reported that even at

the height of his success, Rockwell was self-conscious about his ability to concoct images that would please the public (and his employers) year after year.

Rockwell painted *Triple Self-Portrait* for the issue that featured the first installment of the autobiography. (fig. 98) The amusing and seemingly straightforward picture is presented from the vantage point of a visitor who looks in on an artist examining himself in a mirror and capturing his likeness on canvas. The background is blank; no indication is given of interior architecture, and Rockwell has included few props. Matches to ignite the pipe, a few paintbrushes, and a tube of pigment—tools of his trade—litter the floor. Reproductions of self-portraits by other artists are pinned to the canvas, and a wastebasket holds the artist's dirty rag. A glass of Coca-Cola sits precariously on an open art book, and a helmet is placed prominently on top of the easel. Rockwell gives no further clues to his artistic identity. Yet these details are enough to validate the artistic persona that Americans had come to associate with their favorite illustrator.

As readers would learn when they read the autobiography, Rockwell had bought the French fireman's helmet as an antique during a trip to Paris in the early 1930s only to discover later that it was not antique at all. The wisp of smoke emerging from the trash is an allusion to the 1943 fire that destroyed his Arlington, Vermont, studio, the result of his own carelessness in discarding still-smoldering ashes from his pipe. The mirror frame with eagle and American crest (according to former Norman Rockwell Museum curator Linda Szekely Pero, his own mirror had no such features) adds a patriotic note, reminding longtime fans that he had been in the navy during World War I and had created the "Four Freedoms" paintings.[225] The eagle and crest also call to mind the values of integrity, self-sacrifice, and service that characterize the American ethic as well as the Boy Scout creed.

The self-portraits of Albrecht Dürer, Rembrandt, Pablo Picasso, and Vincent van Gogh tacked to the right edge of the canvas and the sketches of his own head and hand at the left send additional messages. These artist self-portraits not only reveal Rockwell's knowledge of art history, but also cue us to his long-standing internal debate about the place of illustration within the hierarchy of the arts. They also allude to his youthful pledge never to succumb to the financial lure of illustration, a promise he abandoned before he turned twenty.

Triple Self-Portrait is a statement of multiple selves and a tacit admission that the images Rockwell had composed for almost fifty years were constructed realities, as is the image on the easel that looks younger than the "true" image of the sixty-six-year-old painter whose face is reflected in the mirror. We cannot see his eyes, only the reflection of light on his glasses. It is a striking reminder that we perceive only what the artist wishes to reveal.

Rockwell organized the composition to suggest the humility with which he faced a canvas. According to his son, Peter, Rockwell sat in a Windsor chair, not on a stool, to paint. His lower vantage point in *Triple Self-Portrait*

98

Triple Self-Portrait
The Saturday Evening Post, February 13, 1960. Charcoal and pencil on board, 44 × 34 ½ in. Collection of Steven Spielberg

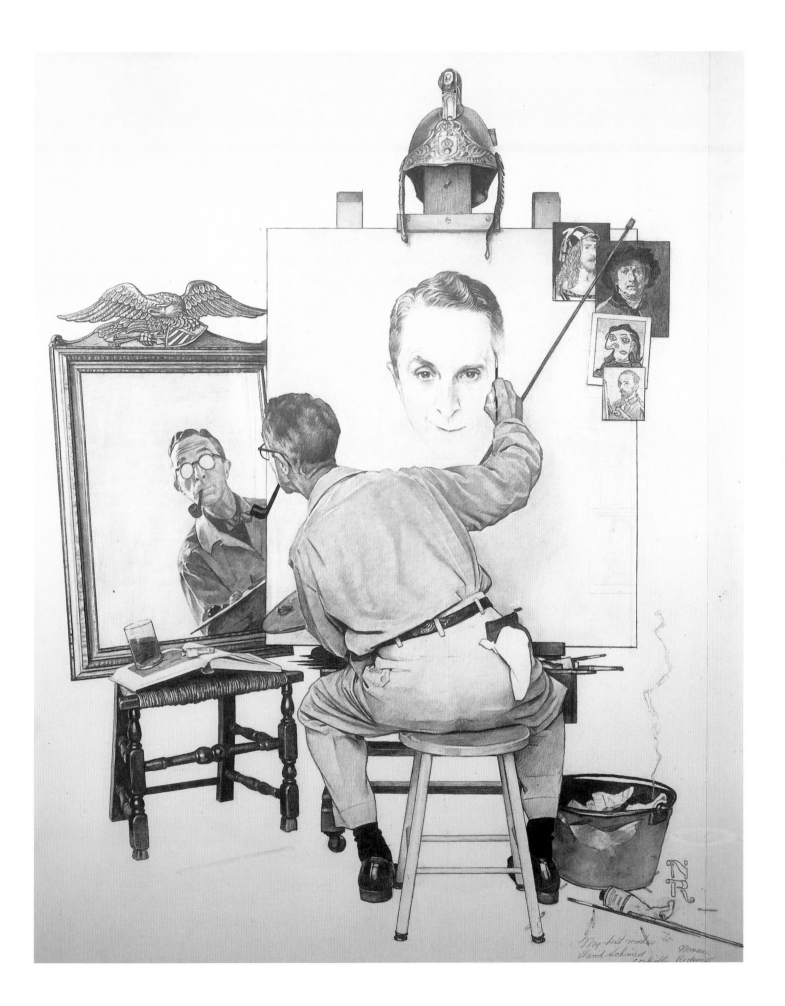

literally reduces the stature of the artist as he sits before the easel.[226] The drinking glass carelessly placed on a book, the few items of work-related debris on the floor, and the paint-smeared palette he holds suggest that painting is a casual affair, even though Rockwell was well known for the obsessive neatness of his working environment and the precision with which he rendered study after study in completing the final versions of his paintings. These details fuel the witting construction of the humble artist.

The portrait on the easel shows a different Rockwell—a jaunty, urbane man who moved easily in the multimillion-dollar worlds of magazine publishing and advertising. Both the humble and the urbane views of the artist are true, as is a third that is more psychologically revealing. Absent the props, models, and other paraphernalia with which Rockwell surrounded himself in the studio, *Triple Self-Portrait* is ultimately a picture of an artist who must rely only on himself. In the final analysis, he faces his canvas alone.

The *Post* propagated the humble nature of Rockwell's personality in a note announcing the first installment of the autobiography. At publication time editors informed readers that Rockwell was nervous about the book's reception. When it came out, he said, "I think I'll go hide in a cave."[227] He was right to worry. A review in the *Nation,* a magazine aimed at intellectuals, took Rockwell to task for what it characterized as the mindlessness and empty sentimentality of his life's work.[228] Others were more enthusiastic. President Eisenhower sent a congratulatory letter, and a reader from Fordingbridge, England, remarked, "Although Rockwell may humbly call himself an illustrator, he has the qualities of the great old masters. But he'll have to be dead three hundred years before the 'critics' realize it." A man from Taos, New Mexico, wrote, "Hardly anything could be more appropriate in these days of Khrushchev, cold war, civil rights battles and other uproar than your fine series on Norman Rockwell." Mabel F. Graham, of Asheville, North Carolina, said, "His talent far exceeds the mere portrayal of people and scenes. His technique becomes a medium of communication through which significant messages can be received. Old-fashioned? As old-fashioned as love, pride, hope, disappointment, and other emotions of the human heart."[229]

Decline of the *Post*

As Rockwell was reexamining himself and his life in *My Adventures as an Illustrator* and *Triple Self-Portrait,* he was concerned about his future at the *Post.* The magazine's profits had dropped precipitously in 1958, and rumors began to circulate that Curtis Publishing might be sold.[230] At the time the firm was huge. Trees grown on company-owned land supplied pulp for the company's paper mills, and a Curtis plant in Sharon Hill, near Philadelphia, printed the *Post, Ladies' Home Journal,* and the other Curtis magazines. But with the advent of *Life* and *Look* in the 1930s and the coming of television in the early 1950s, competition for advertising revenues became fierce, and the creative management practices of other

publishing firms, which diversified into broadcast media, threatened the *Post*'s market position with mainstream, middle-class audiences. Curtis executives were slow to recognize that the huge audience reach of the new medium of television would significantly siphon off advertising dollars. The company expanded, but it did so within the familiar realm of the printed page, and even there its record was mixed. In 1946 and 1947, the corporation experimented with a *Life-Look* type of photographic magazine but abandoned the idea before publication. *Holiday* magazine, which was launched in 1946, began making money around 1950, but a 1954 television guide lasted only eight months, and a 1955 magazine for brides was sold after a year.[231]

Within his purview at the *Post,* Hibbs remained committed to presenting contemporary issues, and the magazine's circulation steadily climbed. From 1954 to 1960, when rumors about the possible sale of Curtis proliferated, *Post* circulation rose from just over 4.5 million to around 6.3 million, and advertising revenues increased by about 30 percent, although the number of pages devoted to ads declined. According to Hibbs, approximately 40 percent of sales were newsstand purchases rather than subscriptions, which indicated to him that audiences liked the publication.[232] Nonetheless, corporate revenues continued their downward spiral.

The discrepancy between circulation figures, reports indicating audience satisfaction, increased advertising revenues, and declining profits was the result of multiple factors. By printing magazines in a centralized plant on the East Coast, distribution costs were higher for Curtis magazines and especially the *Post,* which came out weekly, than for other publications. They also took longer to reach intended audiences than did *Life, Look,* and others that were printed regionally. Ironically, as advertising rates linked to circulation figures increased, the smaller manufacturers that had been the *Post*'s advertising base could no longer afford the cost and so switched to less-expensive venues like *Business Week* and *U.S. News and World Report.*[233] Larger advertisers, among them the automobile companies, which could afford to place ads in print media, devoted larger and larger portions of their budgets to television programming, which reached huge numbers of people. Even photographic magazines like *Look* and *Life,* which could be read quickly and passed along, claimed larger audiences than did text-based publications such as the *Post.* Demographics—age and income of readers—played a part as well. But the "heavy" in the equation was the powerful role that advertising agencies played. The agencies were responsible for recommending venues for their clients' ads. According to Hibbs, from the mid-1950s onward Madison Avenue agencies constantly pressured him to replace Rockwell's "old-fashioned" covers with more contemporary images.[234]

Hibbs had planned to retire at the end of 1961, so he declined to participate when Curtis management determined to update the look and contents of the magazine that year. On September 16, 1961, after much ballyhoo, the "new *Post*" appeared. The format was a mishmash of typefaces and

design elements that failed to impress Madison Avenue and alienated long-time readers.[235] One wrote in, "Please change it back. There are hundreds of 'new,' 'shiny,' perky tabloid-type magazines on the newsstand—but only one *Post.* Would you put fingernail polish on the Statue of Liberty?" Another remarked, "If you are trying to confuse your readers, you have done it. Norman Rockwell and Hazel [a long-running *Post* cartoon] are the only old-time friends I found."[236]

The *Post* was in turmoil. Hibbs's successor stayed only three months, and senior management positions at Curtis changed frequently over the next several years. Rockwell was right to be worried about the future of the magazine and his own role as a leading cover artist.

Rockwell painted *The Connoisseur* for a January 1962 cover during this upheaval. (fig. 99) It is one of his most provocative pictures. Unlike *The Art Critic,* a cover published in 1955, which shows a young male art student gazing at the jewelry adorning the bosom of a buxom woman in a would-be Rubens portrait, the connoisseur in this image stands silently before an erstwhile drip painting by Jackson Pollock just looking, studying the surface of a canvas on which paint has been poured and spattered.[237] Above his right shoulder, an unmistakable red "JP" alerts the viewer to the painting's presumed author. The gentleman's gray suit, gloves, and umbrella mark him as a cultured "Old World" viewer; the gallery guide he holds reveals him as a knowledgeable devotee of art.

The *Post*'s editors surmised that Rockwell's version of Jackson Pollock did not match reader prejudices about what "real" art looked like, so they presented the picture as a joke about modern art: "Is that prosperous-looking art collector about to reach for his checkbook to buy a prizewinning work titled 'The Insubstance of Infinity'? Or is he simply imagining his teen-aged daughter calling it 'Strictly from Blobsville'?" They also reported that when Rockwell got tired of dripping paint himself, he invited the man painting his studio windows to spill a can of white paint onto the canvas from his perch on a ladder, a message signaling that the touch of the artist's hand in creating an artwork, a concept central to abstract expressionism, was meaningless in "real" art.[238]

Letters to the editor validated their supposition. Although one reader remarked that Rockwell had made a "creditable excursion into modern art," another queried, "How can a man of Rockwell's ability waste as much as a second's look at such junk! The word 'art' has been discounted as much as Uncle Sam's dollar in applying the word to such stuff." A third quipped, "No wonder the gentleman is studying the painting in an apparently bewildered manner—it is obviously hanging upside down."[239]

Modern art aficionados would have found much to question in Rockwell's ersatz Pollock. The colors are too bright, the composition is square rather than the usual rectangular format of most of Pollock's large paintings, and the presence of the red "JP" is distinctly un-Pollock-like. But, as he had done forty years earlier in *Boy Reading Adventure Story,* Rockwell creditably re-created the style of another artist alongside

99

The Connoisseur
The Saturday Evening Post,
January 13, 1962. Oil on canvas
mounted on board, 37 ¾ × 31 ½ in.
Collection of Steven Spielberg

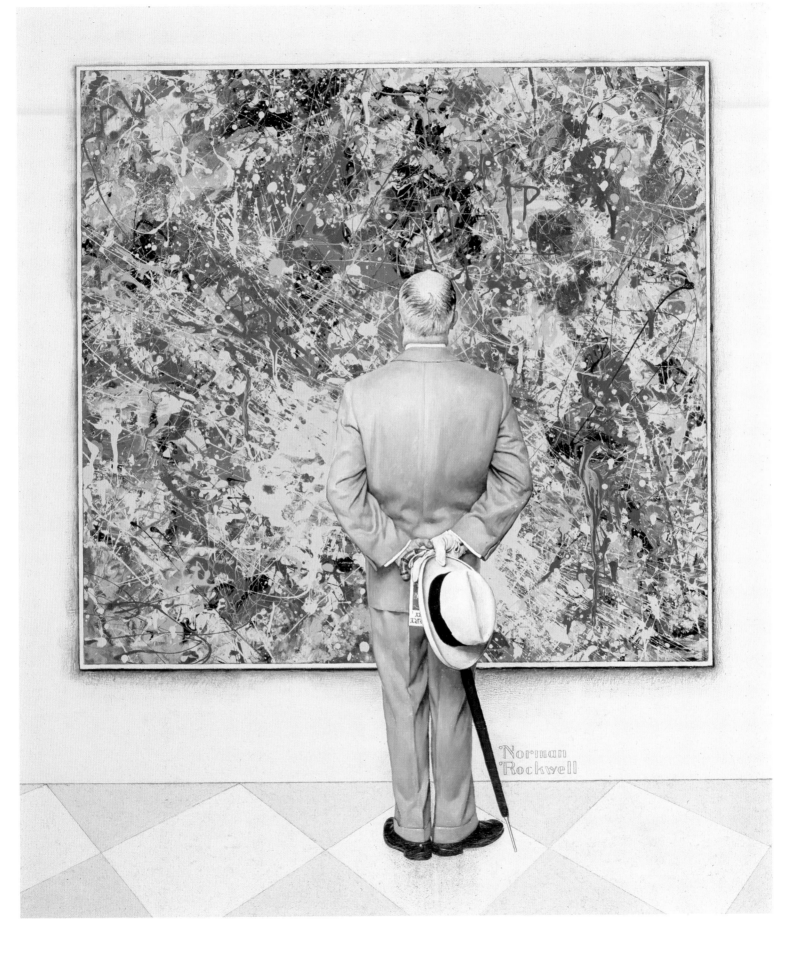

100

Harry Bliss
Paint by Pixels
The New Yorker, April 30, 2007

his own. In doing so he highlighted the debate about realism and abstraction that had been going on since the Armory Show in 1913.

If painted ten years earlier, or 1952, *The Connoisseur* would have made no sense. The debate over abstract expressionism—whether by Pollock, Willem de Kooning, Franz Kline, or their stylistic contemporaries—was still insular within the art world, *Life* magazine's article "Jackson Pollock: Is He the Greatest Living American Painter?" of 1949 notwithstanding. By the late 1950s, however, contemporary abstraction, and especially abstract expressionism, was not only widely accepted as a viable modernist endeavor, but was also considered an important style that demonstrated U.S. preeminence in international cultural affairs. A government-sponsored exhibition featuring seventeen leading abstract expressionist painters had toured in 1958 and 1959 to Basel, Milan, Berlin, Amsterdam, Brussels, Paris, and London to rave reviews, and in the spring of 1958, *Time* magazine reported that prices for individual works in the style of the new abstraction surpassed the annual incomes of most middle-class Americans.[240] Ironically, the message of *The Connoisseur* would also have made little sense had it been painted a year or two later than 1962. By the spring of 1963, pop art had become the new art fad. Andy Warhol soup cans, Roy Lichtenstein's cartoonlike fighter planes, and nudes by Tom Wesselmann supplanted abstract expressionism as the most talked-about topics in the art press.

The elegant connoisseur's posture and the depiction of the scene from behind, the vantage point of the *Post* reader, invites the kind of serious viewing that, as Wanda Corn points out, abstract artists had long hoped for.[241] In spite of attacks against realism in general and his own work in particular by art critics supportive of abstract expressionism, Rockwell intimates in *The Connoisseur* that abstract expressionism can repay the effort of looking. In *Triple Self-Portrait,* he had aligned Van Gogh, Picasso, Dürer, and Rembrandt, suggesting neither hierarchy nor judgment about the validity of old master versus avant-garde. Each had equal value when tacked to his canvas. The respectful posture of the man contemplating the "Pollock" in *The Connoisseur* suggests that Rockwell was prepared to admit Pollock into his personal canon of masters. It is tempting to speculate that the figure of the connoisseur is a dual metaphor—for Rockwell himself, whose work was disparaged by admen for not being sufficiently modern, or perhaps for the late George Horace Lorimer, the elegant collector of antiques and folk art who had set the *Post* on its original path in 1898, as he contemplated the impact of modernity and technological change on his beloved magazine.

As he had with so many paintings during a career that by 1962 had spanned fifty years, Rockwell struck a chord with *The Connoisseur* that remains relevant today. Noted illustrator and cartoonist Harry Bliss reprised the picture in part on the cover of the April 30, 2007, issue of the *New Yorker,* which shows a young couple standing in front of what is presumably a Jackson Pollock canvas, but they ignore the painting and look instead at its image on the screen of a digital camera. (fig. 100) The joke seems obvious—the heroic scale associated with Pollock has been reduced to a tiny camera image. But for those who know *The Connoisseur,* Bliss's cover goes a step further. The painting they observe is not a Pollock at all, but rather a re-creation of Rockwell's Pollock with the red "JP" partly hidden by the letters of the magazine's name.

It is tempting to speculate that the older male figures here and in *Elect Casey* and even in *The New Calendar* are surrogates for Rockwell as he negotiated the changing circumstances of his own life and faced an uncertain future. In them, as in *The Rookie, The Jury,* and other images from the 1950s, protagonists stand alone in stories that play out in real-world terms.

New Beginnings

In 1963, Rockwell's long-standing relationship with the *Saturday Evening Post* came to an end. He completed a series of portraits for the magazine that year, but his storytelling vignettes of American life—even when updated to reflect contemporary fashion and relevant issues—were no longer viable as editors and Curtis executives scrambled to save the financially distressed magazine.

The *Post* had never been Rockwell's sole means of support; he had always worked under contract and, when time allowed, painted covers and story pictures for other magazines. He also had developed a large advertising clientele and worked with a number of ad agencies. During the 1950s he focused much of his effort on advertising—baby food for Swift and smiling children for Crest toothpaste—and he made a trip around the world for Pan American airlines. He also drew Christmas images for Hallmark Cards and continued creating the highly popular Boy Scout images as well as his own Four Seasons calendars for Brown & Bigelow.

In 1963, at the age of sixty-nine, Rockwell joined forces with *Look,* the photojournalistic competitor of *Life,* which began publication in 1937. In its early years, crime stories and celebrity features gave *Look* a reputation for sensationalism (the New Republic derided it as a "morgue and dime museum on paper").[242] But by the 1960s, *Look*'s coverage of current events was timely and thoughtful. A low-cost biweekly, *Look* printed articles by distinguished figures in American politics and letters alongside guaranteed-to-please features on movie stars, baseball heroes, and fashion. Ernest Hemingway contributed, as did Marshall McLuhan and Norman Mailer. In 1965, Sargent Shriver wrote about the War on Poverty, and in 1964, Roger Helsman, former assistant secretary of state in the

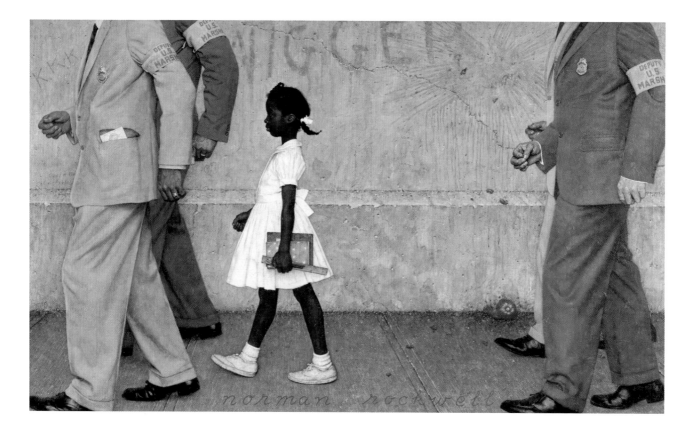

101

The Problem We All Live With
Look, January 14, 1964.
Oil on canvas, 36 × 58 in.
Collection of The Norman Rockwell
Museum at Stockbridge

102

A Time for Greatness
Look, July 14, 1964.
Oil on canvas, 41 × 33 in.
Collection of Steven Spielberg

Kennedy administration, told the inside story of the Cuban missile crisis, which had brought the nation to the brink of war with the Soviet Union two years earlier.[243]

The first Rockwell painting published in *Look* was *The Problem We All Live With,* a tough civil-rights image that appeared in the January 14, 1964, issue that addresses the impact of court-imposed racial integration in the American South. (fig. 101) It is an emotionally charged reference to the moment when little Ruby Bridges walked to school accompanied by burly U.S. marshals. Behind her is a wall on which the crimson spatters of a thrown tomato combine with the scrawled word "Nigger." It is, as Spielberg observed, the most violent image Rockwell ever painted.

Rockwell followed this controversial work with *A Time for Greatness,* which was published in *Look* on July 14, 1964, to coincide with the Democratic National Convention in Atlantic City. (fig. 102) *A Time for Greatness* was reproduced not as an illustration for an article, but rather as a stand-alone memorial. Appearing just eight months after John F. Kennedy's assassination in Dallas, the picture occupied the right side of a two-page spread. The caption read:

1960 was the year when the Democrats produced a unique candidate. John F. Kennedy was young, wealthy, vigorous, articulate, Irish and Roman Catholic. Not all his attributes and advantages would have been acceptable in the early generations of his party. Norman Rockwell's painting recalls the night of his nomination. He spoke only briefly. "All of us . . ." he said, "are united . . . in our devotion to this country." He served two years, ten months and two days.[244]

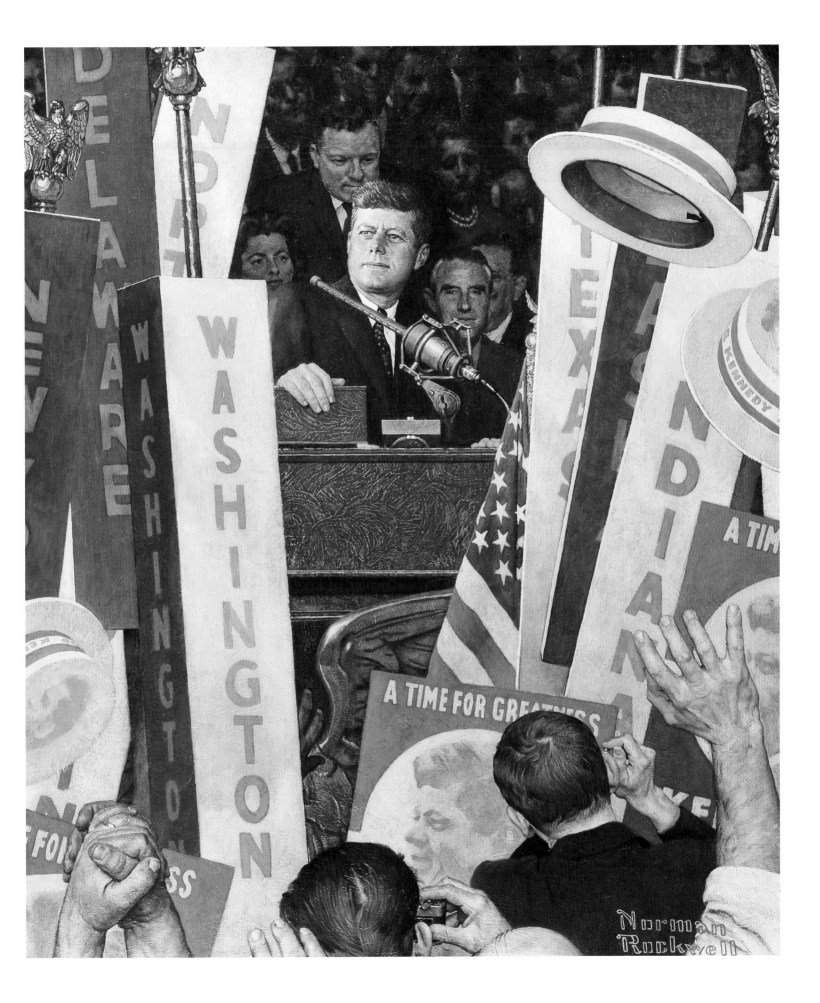

Rockwell had met Kennedy in 1960, when he traveled to Hyannis Port, Massachusetts, to make sketches for a *Post* commission for portraits of the presidential candidates that year. After two sessions, Rockwell got the result he hoped for: "His expression was just what I wanted—serious with a certain dignity, but relaxed and pleasant, not hard."[245] The bust-length portrait was featured on the cover of the *Post* on October 29, 1960, followed a week later by Rockwell's portrait of Richard Nixon.[246]

A Time for Greatness takes as its title one of Kennedy's campaign slogans. For the image, Rockwell chose not the steady-eyed, solemn man of the 1960 *Post* cover, but rather a visionary Kennedy, who gazes outward, beyond the melee on the convention-hall floor. Convention hats sail skyward, and state banners frame political luminaries behind the podium. It is an image of promise and possibility, a statement of the optimism of a nation that assembles quadrennially to exercise the most sacred tenet of democracy—the election of its governing officials. *A Time for Greatness* was a compelling comment on both the promise and the tragic possibilities that America's leaders face, a note reinforced by the likeness of Abraham Lincoln on the crowns of the convention hats. *Look* could have requested a different kind of image—voters at the polls, for example, or a portrait of President Lyndon B. Johnson, the Democratic Party's nominee in the 1964 election. But *Look* and Rockwell opted to reaffirm the sense of hope that had swept the country with the election of the charismatic JFK.

In the seven years that followed, Rockwell painted other controversial subjects. *Southern Justice,* which accompanied an article in June 1965 by Charles Morgan, Jr., shows Michael Schwerner and James Chaney, two civil rights workers who were murdered in Mississippi a year earlier. *New Kids in the Neighborhood* deals with black families moving into white suburban enclaves. Rockwell addressed tensions in the Middle East in 1970 with *Uneasy Christmas in the Birthplace of Peace.* He also painted images of progress. *The Longest Step, Man on the Moon,* and *Apollo and Beyond* celebrated successes of the U.S. space program; images of Peace Corps volunteers in Ethiopia, India, and Colombia spoke to the efforts of young Americans to bring technical advances to the less fortunate of the world. In these late works, Rockwell is no longer just a storyteller; he is a reporter of contemporary events that shape world culture. His shift in focus, from narratives based on the lives of individuals and communities to events that played out on the world stage may have been prompted by his marriage in 1961 to Molly Punderson, a teacher and activist from Stockbridge whom he had met in a poetry class. (fig. 103)

After parting ways with the *Post,* Rockwell also began working for *McCall's,* which billed itself as the "First Magazine for Women." With a circulation of more than eight million issues a month, its reach was even larger than that of the *Post.* However, as a woman's magazine, in content and audience *McCall's* more closely resembled the *Ladies' Home Journal* than either *Look* or the *Post* did. McCall's carried ads for

103

**Norman Rockwell and
Molly Punderson Rockwell**
Stockbridge, Massachusetts,
May 1976
AP/Wide World Photos

cosmetics, prepared foods, perfume, "gifts for him," home appliances, laundry soap—articles designed to stimulate a woman's urge to shop. If Rockwell's *Little Girl Looking Downstairs at Christmas Party,* on the *McCall's* December 1964 cover, is thematically less challenging than the work he was doing for *Look,* it demonstrates Rockwell's continued interest in children and family life. (fig. 104) It also serves as a conceptual parallel to the child in his 1933 painting *Woman at Vanity.* The little girl, who looks like a slightly younger version of the child in the earlier canvas, has crept from her bed to observe the excitement of her parents' Christmas party.

For *Little Girl Looking Downstairs,* Rockwell posed the child at the top of the stairs in his own home, assembled a group of friends and neighbors downstairs, and blocked out color sketches to confirm the composition. George Lucas, who owns one of the rough oil sketches, loves what Rockwell's sketches reveal about the artist's thinking process. Lucas likes the abstract quality of *Little Girl Looking Downstairs,* which he describes as an "idea of the colors and how everything is going to fit together" that conveys the emotions of the scene. "There's no ambiguity about it. It's an impressionistic piece, but very, very specific." Rockwell's "over-the-shoulder point of views," he said, "put the viewer in the frame, which is what we do in movies.... You are seeing what [the little girl] is seeing.... It informs the viewer about whose vision this is." As in *Shadow Artist, Graduation,* and *Happy Birthday Miss Jones*, we take on the persona as well as the viewpoint of a child; Rockwell emotionally transports us to a moment of childhood that erases subsequent experience.

Rockwell tightened the focus, filled in details of hairstyles, put facial expressions on the partygoers, and added a Christmas wreath and a rag doll before declaring the painting ready for publication. Lucas loves the spontaneity of the rough oil sketch: "It's almost an abstract painting." The impressionistic mass of heads in the sketch more effectively conveys the exciting clamor of the happy group at holiday time than does the more elaborate detail of the finished painting. Nevertheless, it was an ideal picture for *McCall's* "Big Surprise" Christmas issue of 1964.

As an artist associated with family values, Rockwell was also in demand to do advertising images for companies that catered to mainstream America. Sears Roebuck, Skippy, Amway, and many other firms paid well to associate the Rockwell name with their products. In 1966 the Top Value stamp company commissioned Rockwell to provide a cover image for the firm's annual gift catalogue.

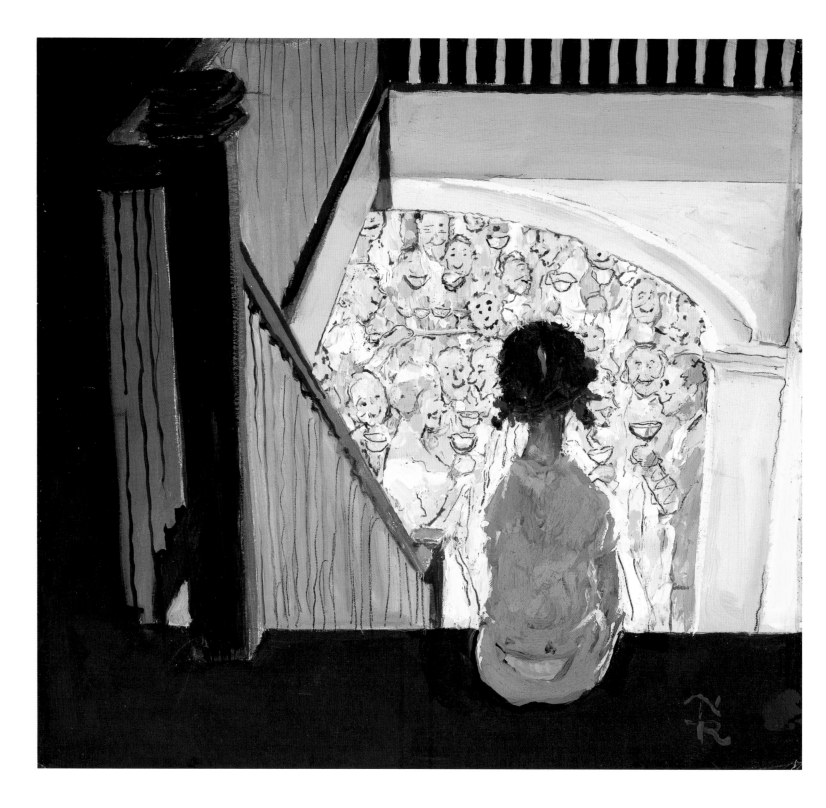

104

**Little Girl Looking Downstairs
at Christmas Party**

McCall's, December 1964.
Oil on board, 10 × 10 ½ in.
Collection of George Lucas

Trading stamps, which were a fixture of consumer life well into the middle of the century, have long since been eclipsed by frequent-buyer programs in today's marketplace, but the idea behind them is essentially the same: to induce customers to keep coming back and to encourage them to spend just a little more so they can receive a premium. Introduced in the late 1890s, trading stamps became a way of life in the 1930s and flourished throughout the 1960s and early 1970s, when an economic downturn

forced retailers to discontinue offering them. In the 1950s and 1960s, when Rockwell was a household name, grocery stores, beauty salons, gas stations, and other retailers purchased stamps from a variety of firms—Top Value and S&H Green Stamps were two of the largest—and gave them to customers in numbers proportionate to money spent in their establishments. Although amounts varied, shoppers typically received ten stamps for each dollar spent, then pasted them into booklets that they redeemed for gifts, appliances, clothing, sporting goods, home furnishings, or personal items. Children and adults pored through catalogues to select premiums and often saved for months or even years to acquire expensive items like televisions or lawn mowers.

First Trip to the Beauty Shop is one of eight Rockwell paintings that appeared as covers of Top Value trading-stamp catalogues. One showed newlyweds in an almost empty home perusing a Top Value Stamp catalogue; another depicted a little girl trying on a new hat; a third showed a girl and boy returning from a date to encounter her parents, the father pointing to the late hour on the clock he holds. As with *"Merry Christmas, Grandma... We Came in Our New Plymouth!,"* Rockwell elected not to show the products people could "purchase," but rather the thrill of the experiences that came to those who collected lots of stamps.

First Trip to the Beauty Shop resurrects and transforms the 1918 cover of a mother sniffling as her little boy's long locks are shorn (see p. 46). In *First Trip,* mother and daughter are excited about the professional cut and style that symbolize the child's growth into girlhood. Here as elsewhere, Rockwell tightened the focus between the almost-final drawing and the finished painting. The drawing shows six heads: the mother's, the daughter's and her reflection, the hair stylist with her mirror image, and the portrait of Jacqueline Kennedy on the magazine the child holds in her lap. (fig. 105) It is an active picture in which the eye moves among multiple focal points and background patterns. For the final version, however, Rockwell zoomed in even further to emphasize the expression on the child's face as she regards herself in the mirror and the mother's pleasure at her daughter's delight. (fig. 106)

Rockwell returned to this coming-of-age motif in *Can't Wait,* one of the last Boy Scout calendars he designed. He initially thought he would paint a picture of several Boy Scouts playing in a band and called a friend to see if her son might pose. When she informed him that her son was not a Scout and had no uniform—Stockbridge had no troop in 1972—he asked her to borrow one.[247] When ten-year-old Hank Bergmans arrived at the studio dressed in the uniform of a much larger boy, Rockwell seized on the idea of showing a Cub Scout who tries on his older brother's uniform and practices a salute while his little dog looks on. (fig. 107) The result pleased Hank. (fig. 108) It is a beguiling picture, and one that brings Rockwell's career full circle, back to the theme of childhood anticipation, of boy and dog, and the simplicity, innocence, and hope of youth.

Following pages:

105

First Trip to the Beauty Shop
Top Value trading stamp catalogue, 1972. Pencil on joined paper, 35 × 32 in. Collection of George Lucas

106

First Trip to the Beauty Shop
Top Value trading stamp catalogue, 1972. Oil on canvas, 30 × 27 in. Collection of George Lucas

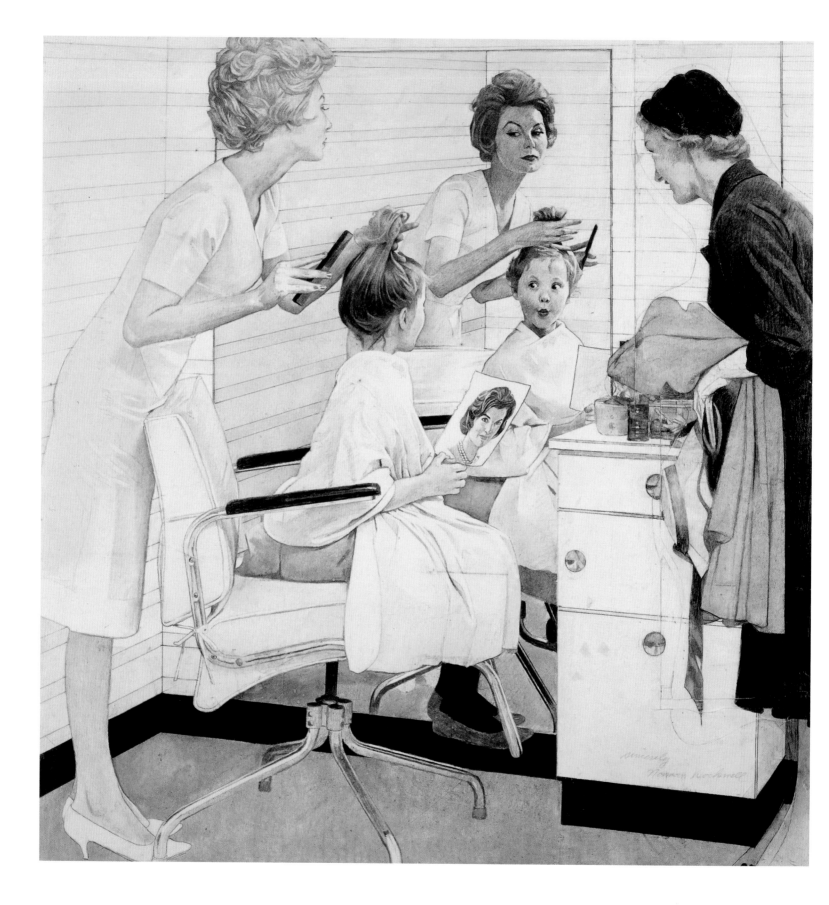

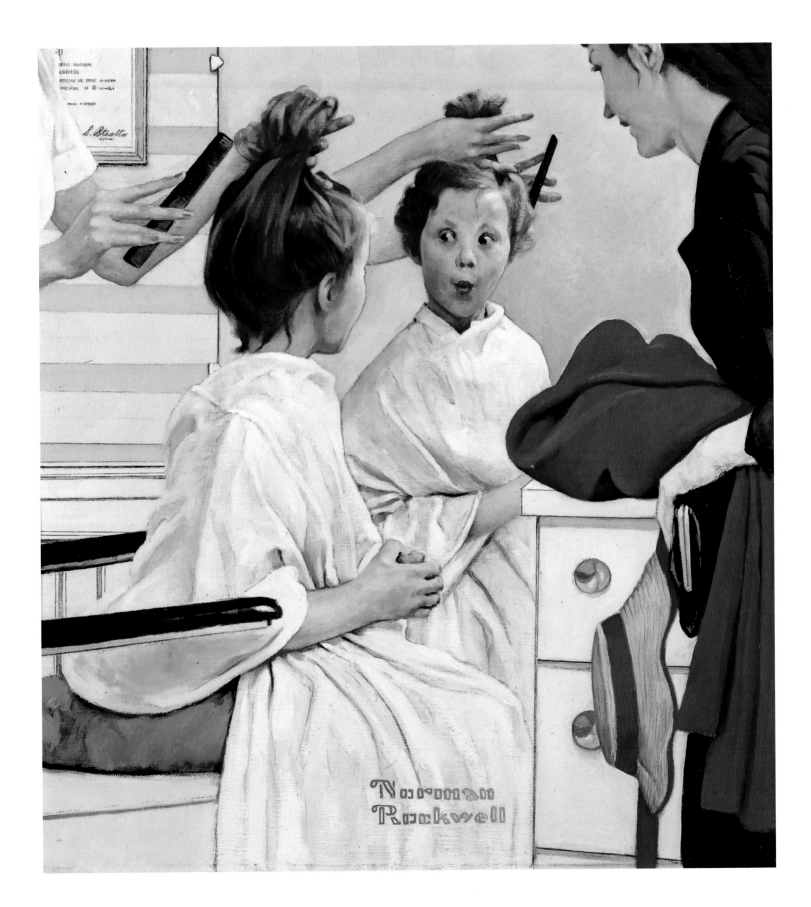

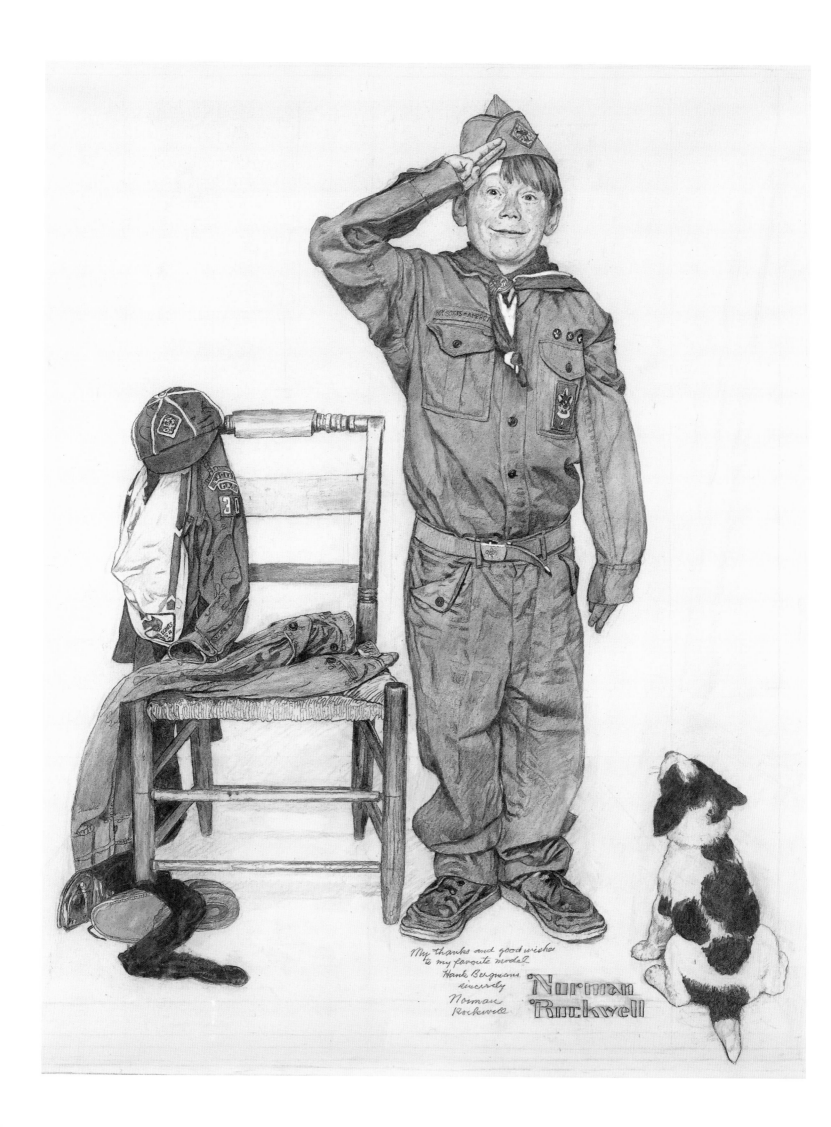

My thanks and good wishes
to my favorite model
Hank Bergmans
sincerely
Norman
Rockwell

Norman Rockwell

107

Can't Wait
Boy Scouts of America Calendar, 1972.
Charcoal on paper, 39 × 31 ½ in.
Collection of George Lucas

108

Rockwell with model Hank Bergmans
examining the painting
Can't Wait
about 1970. Norman Rockwell
Archives, Norman Rockwell Museum,
Stockbridge, MA

A Star Is Born

After the flurry of movie-star portraits in the late 1930s and 1940s, Rockwell's
connection with the studios that had commissioned ads from him tapered
off. Not until 1960 did he make another star portrait—this time of Jerry
Lewis for his role in Paramount's *Cinderfella.*

In February 1965, Rockwell received a call from producer Martin Rackin,
asking if Rockwell would come to Hollywood to paint publicity pictures of
the stars for his remake of John Ford's 1939 film *Stagecoach.* Rockwell was
pleased. He had liked the original movie and looked forward to working
with the cast, which included Ann-Margret, Mike Connors, and Bing Crosby.
By late June, Rockwell was hard at work in Hollywood. He spent time on the
set watching the actors perform; between scenes, they posed for sketches
and photographs in his studio. He was working with Connors one day when
Rackin dropped in. Rackin was intrigued that Rockwell was teaching card
tricks to Connors, who played a gambler in the film, and asked Rockwell
if he would take the role of a card player. Although Rockwell claimed that

he had never acted before, he was a born performer, as apparent from his re-creation of a scene from a Harold Lloyd movie in Hedda Hopper's living room twenty-five years earlier.

For *Stagecoach,* Rockwell agreed to play the character Busted Flush, a "mangy old gambler in cowboy costume, with a bad-guy black hat and high-heeled boots that hurt his feet." (fig. 109) He said he would have done it just for fun, although union rules prevented him from speaking and required Rackin to pay him as an extra. For Rockwell, it was a personal culmination. He had developed plots, cast characters, costumed models, arranged props, and lighted sets all his life. In 1966, when *Stagecoach* was released, *Look* featured an article about his role, and Rockwell could finally add "silent film star" to his list of lifetime credits.[248]

Epilogue

In 1977, when Rockwell was eighty-three, the *Post* celebrated his life with the publication of the *Saturday Evening Post Norman Rockwell Book.* The book was aimed at a general family audience. With Rockwell cover illustrations, it included affirming stories by James Thurber, Steven Vincent Benét, and other major men and women of letters, along with recipes for homespun cuisine like Vermont Red Flannel Hash and Plymouth Succotash. Although Rockwell had not worked for the *Post* for more than a decade, his name and pictures were indelibly linked with the vision the magazine had crafted of a changing America. From his early years under Lorimer's editorship through Hibbs's modernizing efforts in the 1940s and 1950s, Rockwell had told stories Americans wanted, and sometimes needed, to hear. He reminded them that ordinary people going about their daily lives were America. Their hopes and dreams, their memories and fantasies, their wishful constructions and moments of anxiety are the American dream. To borrow words from Steven Spielberg and George Lucas, Rockwell's view of the "pride and self-worth" of America helped make people "whole again."[249]

109

Norman Rockwell as "Busted Flush"

in the movie *Stagecoach,* 1966. Norman Rockwell Archives, Norman Rockwell Museum, Stockbridge, MA

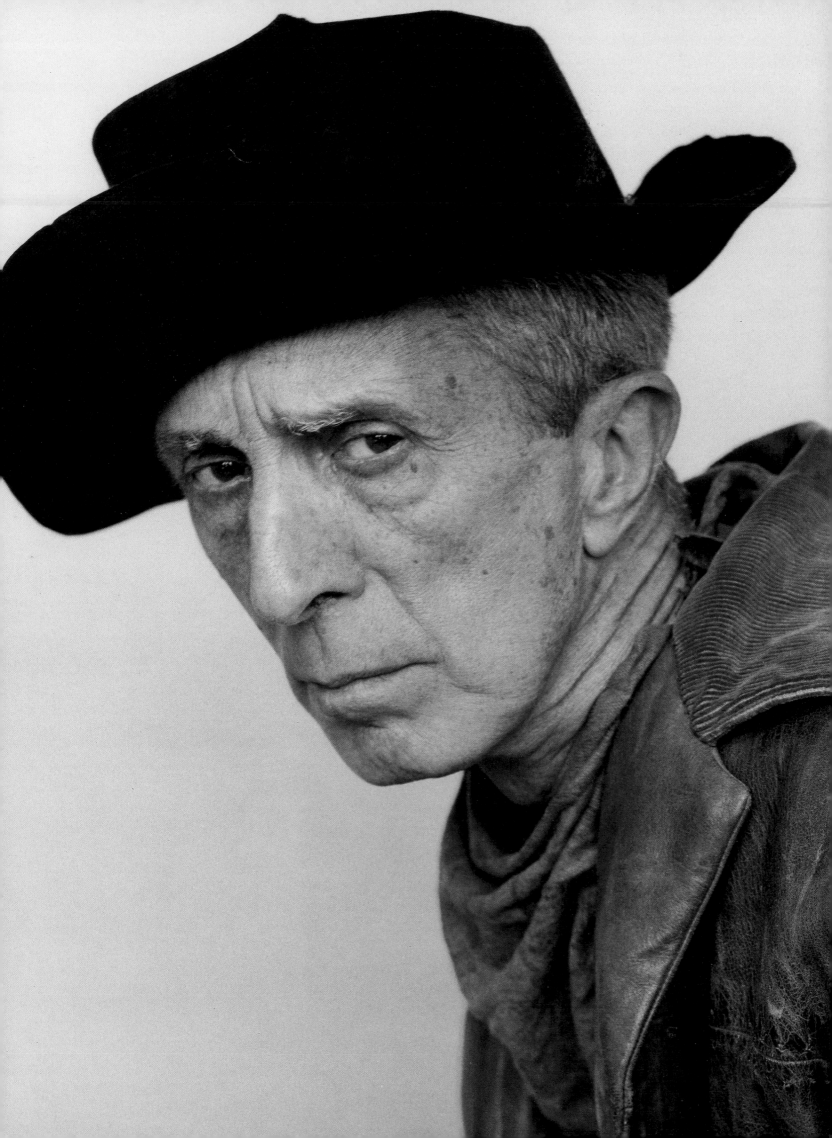

1 Unless otherwise cited, this statement by George Lucas and others that follow were made during an interview with Laurent Bouzereau and Virginia Mecklenburg at Skywalker Ranch on September 12, 2008.

2 See, for example, William Graebner, "Norman Rockwell and American Mass Culture: The Crisis of Representation in the Great Depression," *Prospects* 22 (1997): 323–56.

3 Rockwell acknowledged that he kept up with current issues to mine subjects for his work. See Norman Rockwell, as told to Tom Rockwell, *Norman Rockwell: My Adventures as an Illustrator* (Stockbridge, MA: Norman Rockwell Museum in assoc. with Abrams, 1994), 201.

4 William Hillcourt, *Norman Rockwell's World of Scouting* (New York: Abrams, 1977), 60–61.

5 Hellmut Wohl, "A Master of His Craft: Reflections on Norman Rockwell," *Bostonia* (July–Aug. 1991): 26.

6 Corry Kanzenberg, curator of archival collections at the Norman Rockwell Museum, reports that few documents remain that reveal the specifics of Rockwell's art school attendance. He studied at the Chase School on Wednesdays and Saturdays during his sophomore year of high school (1909–10) and subsequently attended the National Academy of Design for a short period. Records at the Art Students League indicate that he took courses there from sometime in 1911 through at least February 1912. Corry Kanzenberg e-mail to Ann Wagner, June 26, 2009.

7 Hillcourt, *Rockwell's World of Scouting,* 49. Details noted about Rockwell's work for *Boys' Life* and the *Boy Scout's Hike Book* can be found in this volume, pages 45 to 54.

8 N. Rockwell, *My Adventures,* 73.

9 Quoted in Stephen J. Dubner, "Steven the Good," *New York Times Magazine,* Feb. 14, 1999, SM38.

10 For listings and images of Rockwell's work, see Laurie Norton Moffatt, *Norman Rockwell: A Definitive Catalogue,* 2 vols. (Stockbridge, MA: Norman Rockwell Museum, 1986). Moffatt's *Definitive Catalogue* is the single most invaluable source on Rockwell's art. The catalogue is crucial for any serious study of Rockwell's work, and the narrative provides the most informative and accurate account of his work for various clients.

11 For a history of scouting, see David I. Macleod, *Building Character in the American Boy: The Boy Scouts, YMCA, and Their Forerunners, 1870–1920* (Madison: University of Wisconsin Press, 1983), and Carolyn Ditte Wagner, *The Boy Scouts of America: A Model and a Mirror of American Society,* Ph.D. diss., Johns Hopkins University, 1978 (Ann Arbor, MI: University Microfilms, 1979).

12 Among the books Rockwell illustrated are Gabrielle E. Jackson, *The Maid of Middies' Haven* (1912); C. H. Claudy, *"Tell Me Why Stories" about Mother Nature* (1912); Elmer Russell Gregor, *The Red Arrow: An Indian Tale* (1915); Sinclair Lewis, *The Trail of the Hawk* (1915); Ralph Henry Barbour, *The Secret Play* (1915) and *The Lucky Seventh* (1915); and others, including William Heyliger's, *Don Strong of the Wolf Patrol,* which was serialized in *Boys' Life* from May 1915 through March 1916 and published in book form in 1916. See Moffatt, *Definitive Catalogue,* 2:831–960 for a listing of Rockwell's book illustrations.

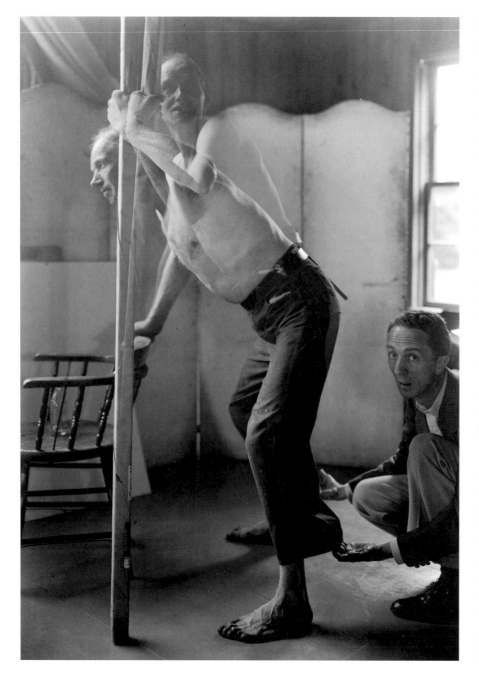

Quotation from Ted Pratt, "A Visit with Norman Rockwell," *Chesterfieldian,* July 3, 1920, 151 (available from Norman Rockwell: Collected Articles, 1914–present, Norman Rockwell Archives, Norman Rockwell Museum, Stockbridge, MA).

13 Because he was traveling in Europe at the time, Rockwell produced no Scout calendars for 1928 and 1930. After the 1926 calendar, Brown & Bigelow began paying Rockwell for the Boy Scout calendar art and donating the artworks to the Scouts. The paintings are now owned by the National Scouting Museum in Irving, Texas. See Moffatt, *Definitive Catalogue,* 1:270.

14 Hillcourt, *Rockwell's World of Scouting,* 96. The calendars continued to be popular for the fifty years that Rockwell contributed images. According to Moffatt, *Definitive Catalogue,* 1:270, in 1947, Rockwell's Boy Scout calendars were best-sellers, second to those that showed "'wholesome American girls and landscapes.'" For background on Brown & Bigelow, see Mark Gabor, *Art of the Calenda*r (New York: Crown, 1976), 8, 10.

15 Unless otherwise cited, this statement by Steven Spielberg and others that follow were made during an interview with Laurent Bouzereau at the Amblin Entertainment offices on August 6, 2008.

16 The image was also used as the cover for the *Boy Scout Handbook for Boys* from 1929 through 1940. See Hillcourt, *Rockwell's World of Scouting,* 95. For the story of Lindbergh and his famous flight, see Dominick A. Pisano and F. Robert van der Linden, *Charles Lindbergh and the Spirit of St. Louis* (Washington, DC: National Air and Space Museum in assoc. with Abrams, 2002).

17 "Lloyd's Refuses Risk on Lindbergh's Chances," *New York Times,* May 21, 1927, 6. There was good reason for risk to be on everyone's mind. In April, Noel Davis, head of the U.S. Navy's reserve flying program, and Stanton Wooster were killed when the plane Davis hoped to fly across the ocean crashed. Just two weeks before Lindy's flight, French World War I ace Charles Eugéne Nungesser and copilot François Coli had taken off from Paris headed for New York, but after a reported sighting over Ireland, they were never heard from again.

18 "Lindbergh Scion of Viking Forbears," *New York Times,* May 21, 1927, 6.

19 "Lindbergh Is Noted for Practical Jokes," *New York Times,* May 21, 1927, 6. The image of Lindbergh portrayed in the press emphasized his sporting physique and clean living. There were few hints of the darker side of his personality or his later association with fascism.

20 "Paris Flight Brings Tears, Joy to Mother," *Chicago Daily Tribune,* May 22, 1927, 1.

21 See "Former Mail Pilot's Dash," *Chicago Daily Tribune,* May 21, 1927, 2; "Ship Alters Course to Seek Lindbergh," *New York Times,* May 21, 1927, 3; and Henry Wales, "France Lights Up Airways as Guide for Yank," *Chicago Daily Tribune,* May 21, 1927, 3.

22 See Edwin L. James, "Crowd Roars Thunderous Welcome," *New York Times,* May 22, 1927, 1, and "City Vast Gallery of 'Lindy' Pictures," *New York Times,* June 14, 1927, 9. Developers even rented vacant floors of buildings to eager spectators for $500 for the day. See "Vantage Points Bring High Prices," *New York Times,* June 12, 1927, 10.

23 See Alva Johnston, "St. Louis Roars Welcome to Lindbergh for Seven Miles; Bombards Him with Roses," *New York Times,* June 19, 1927, 1.

24 Hillcourt, *Rockwell's World of Scouting,* 99–102.

25 N. Rockwell, *My Adventures,* 201.

26 For a history of the *Ladies' Home Journal,* the *Saturday Evening Post,* and other popular magazines, see Frank Luther Mott, *A History of American Magazines,* vol. 4, 1885–1905 (Cambridge, MA: Harvard University Press, 1957). The story of the *Journal* appears on 4:536–55; the history of the *Saturday Evening Post* on 4:671–716. John Tebbel, in *George Horace Lorimer and The Saturday Evening Post: The Biography of a Great Editor* (Garden City, NY: Doubleday, 1948), 7–18, also traces the history of Lorimer's tenure at the *Post* and described the lineage that allowed the publisher to attribute its beginnings with Benjamin Franklin. The three leading magazines at the end of the nineteenth century were *Harper's, Scribner's,* and *Atlantic Monthly,* which printed articles aimed at highly educated audiences. See Tebbel, 18–19.

27 Much of the history and interpretation of *Post* editorial policy summarized here is drawn from Jan Cohn, *Creating America: George Horace Lorimer and the* Saturday Evening Post (Pittsburgh: University of Pittsburgh Press, 1989).

28 "The *Post*'s Plans for 1900," *Saturday Evening Post,* Dec. 30, 1899, 574–75.

29 Quoted in Cohn, *Creating America,* 28.

30 Grover Cleveland, "The Serene Duck Hunter," *Saturday Evening Post,* April 26, 1902, 1–2; Herbert E. Hamblin, "The Fire Fighters," Aug. 31, 1901; Frank Norris, "The Pit: A Romance of Chicago," serialized from Sept. 20, 1902, through July 18, 1903; Jack London, "The Call of the Wild," serialized from June 20 through July 18, 1903.

31 Cohn, *Creating America,* 11, 33–35.

32 Ibid., 46.

33 Ibid., 65–79.

34 Ibid., 69.

35 Ibid., 71.

36 Ibid., 76.

37 Ibid., 79, 81.

38 See, for example, *Saturday Evening Post* covers by Sarah Stilwell-Weber, Dec. 25, 1909, and J. C. Leyendecker, Nov. 12, 1910.

39 These covers were, respectively, by Harry J. Soulen (Aug. 17, 1912), Charles A. MacLellan (Sept. 7, 1912 and Oct. 18, 1913), and John A. Coughlin (April 24, 1915).

40 N. Rockwell, *My Adventures,* 108–9.

41 Ibid., 107. Rockwell repeated this story many times throughout his life.

42 The MacLellan cover was for the Aug. 2, 1913, issue of the *Post.*

43 *The Circus Barker* appeared on the *Post* cover for June 3, 1916, and *Redhead Loves Hatty Perkins* on Sept. 16, 1916. Another Rockwell cover, *Gramps at the Plate,* appeared on Aug. 5, 1916.

44 For a brilliant discussion of the impact of the movies on Sloan's visual strategies, see Katherine Manthorne, "John Sloan's Moving-Picture Eye," *American Art* 18, no. 2 (Summer 2004): 80–95. Edwin S. Porter's 1905 film, *Life of an American Policeman,* which presents scenes of an average patrolman—at home with his wife and family, helping a lost child, chasing a wealthy motorist, trying to apprehend a burglar—is a conceptual prototype for several of Rockwell's later cover images. *A Day in the Life of a Little Girl* and *A Day in the Life of a Little Boy,* like Porter's film, present glimpses into the escapades of children on a summer day.

45 An undated sketch in Rockwell's archive, in fact, bears a striking resemblance to the Bellows painting *Cliff Dwellers,* 1913 (Los Angeles County Museum of Art).

46 Charles J. Maland, *Chaplin and American Culture: The Evolution of a Star Image* (Princeton, NJ: Princeton University Press, 1989) discusses Chaplin and the huge impact he had on American audiences.

47 Sloan, too, visually remarked the salacious content of early films and nickelodeon programs in his 1905 etching *Fun, One Cent* (Smithsonian American Art Museum) in which several adolescent girls in a penny arcade giggle as they peek at "Girls in Their Night Gowns, Spicy" and "Those Naughty Girls." Although clumsy and amusing from today's perspective, shorts like *Trapeze Disrobing Act* (1901), *The Way to Sell Corsets* (1904), *The Shocking Stockings* (1915), and other films offered women's undressed bodies as objects of visual consumption, making the movies inappropriate fare for children and families.

48 See "Food, Fuel, and Supply Bodies Snarl Shipping," *Chicago Daily Tribune*, Dec. 1, 1917, 3.

49 Under the direction of George Creel, an investigative reporter who had worked for the *Kansas City World*, the *Denver Post*, and several other newspapers, the Committee on Public Information enlisted the print media, radio, and movies to broadcast its message. Pamphlets warned Americans to be on the lookout for German spies, and the press published fabricated stories about German soldiers bayoneting babies. One of Creel's most effective strategies was organizing the "Four-Minute Men," thousands of grassroots volunteers who made concise, prowar speeches at community meetings and in movie theaters across the country. A number of well-known *Post* cover artists participated, among them Charles Livingston Bull, who used the American eagle as a symbol of U.S. might; James A. Coughlin; Neysa McMein; and Clarence Underwood. See Robert H. Zieger, *America's Great War: World War I and the American Experience* (New York: Rowman & Littlefield, 2000), 78–80, and James Aulich, *War Posters: Weapons of Mass Communication* (New York: Thames & Hudson, 2007), 54. The Library of Congress Web site illustrates some nineteen hundred World War I posters produced in Australia, Canada, France, Germany, Great Britain, and the United States. To search or browse go to http://memory.loc.gov/pp/wwiposquery.html.

50 N. Rockwell, *My Adventures*, 114.

51 Such covers for *Life* include *The Lord Loveth a Cheerful Giver*, Nov. 8, 1917; *Polley Voos Fransay?*, Nov. 17, 1917; *Soldiers Singing (Over There)*, Jan. 31, 1918; *An American Missionary*, April 18, 1918; *Her Adopted Son*, May 30, 1918; *If Mother Could Only See Me Now*, June 13, 1918; *So This Is Berlin*, Sept. 26, 1918; *Little Mother*, Nov. 7 1918; *Are We Downhearted?*, Nov. 28, 1918; *My Mother*, Dec. 19, 1918; *Goodbye Little French Mother*, Mar. 13, 1919; and *Carrying On*, July 1, 1920.

52 For Rockwell's personal account of his military service see *My Adventures*, 113–31. Although Rockwell reported that he joined the navy in 1917, copies of his military records in the Norman Rockwell Museum Archives indicate that he enlisted on July 31, 1918, and was discharged on November 19, 1918. I am grateful to Corry Kanzenberg for supplying this information and to Stephanie Plunkett, deputy director and chief curator of the Norman Rockwell Museum, who further explained that although initially exempted from the draft, Rockwell later felt guilty about staying home and so decided to enlist. He performed his duties adequately, Plunkett reports, but his independent mind chafed at military regulations, and Rockwell soon realized that he was not well suited to navy life. Stephanie Plunkett, e-mail to the author, July 20, 2009. In contrast to Rockwell's account of digging out tree stumps, his biographer Laura Claridge, said Rockwell "pulled guard duty and burial squad." Laura Claridge, *Norman Rockwell: A Life* (New York: Random House, 2001), 148.

53 N. Rockwell, *My Adventures*, 126.

54 Rockwell acknowledged the declaration of war in a picture that shows an older man in a Civil War uniform, standing beside a young woman and a Boy Scout, who salutes (*Saluting the Flag, Saturday Evening Post*, May 12, 1917). The clown picture appeared on the *Post* cover May 18, 1918; the boy getting a haircut, on Aug. 10, 1918; and the little girl with the Red Cross collection box, on Sept. 21, 1918. The soldier with the picture of his mother appeared on the cover of *Life*, Dec. 19, 1918.

55 For example, a 1917 cover for the *Country Gentleman* showed a boy doing a headstand while his dog and a pretty girl look on, another depicted a girl climbing high in a tree, and several others portrayed awkward moments in boy-girl relationships.

56 He used a similar party scene for *The Party Favor*, the April 26, 1919, cover of the *Post*, although for that image, the girl and boy are more appropriately matched. In an illustration for "Pompadour Days" (*Ladies' Home Journal*, Oct. 1921, 17), a boy sneaks a kiss.

57 *The Departing Maid* appeared on the cover of the *Saturday Evening Post*, March 27, 1920, and *Political Argument* was on the cover Oct. 9, 1920.

58 Moffatt, *Definitive Catalogue*, 1:365–71.

59 See for example, Franklin Fyles, "Hero of New Play a Toy Maker Who Refuses to Make Teddy Bears," *Washington Post*, Dec. 1, 1907, A4, and "Music and The Stage," *Los Angeles Times*, Jan. 6, 1908, 17.

60 German woodcarving centers were famous throughout the United States and Europe for the beauty and quality of wood-carved objects for children, but by the early twentieth century German peasants whose families had made toys for centuries were hard-pressed to compete with the volume, type, and lower price of machine-made products. Of real concern was the disappearance of a family-based cottage industry in which parents fashioned toys from wood, grandmothers and children painted them, and designs were handed down over multiple generations. See "Poor German Toy Makers," *Boston Daily Globe*, Jan. 3, 1904, 44; "The Workshops that 'Made in Germany' Toys Come From," *Chicago Daily Tribune*, Dec. 20, 1908, F8; and "Ingenuity of the Toy Maker," *Christian Science Monitor*, May 11, 1912, 21.

61 See "How Modern Toys Reflect the Progress of the Times," *Chicago Daily Tribune*, Dec. 20, 1908, F2, and "Americans Invent Wonderful Toys," *New York Times*, Dec. 6, 1908, 7.

62 Bassett Staines, "Some Matters of Especial Interest to the Women; Old Santa's Many Yankee Shops," *Los Angeles Times*, Dec. 31, 1905, VII7. For a fascinating discussion of the history and sociology of toys, see Gary Cross, *Kids' Stuff: Toys and the Changing World of American Childhood* (Cambridge, MA: Harvard University Press, 1997).

63 "The Workshops That 'Made in Germany' Toys Come From," *Chicago Daily Tribune*, Dec. 20, 1908, F8.

64 During the Christmas season of 1915, after the New York mayor's workshop for the unemployed closed down, an enterprising woman, Miss Christine S. Foster, solicited funds from wealthy friends and charitable organizations to open a workshop in New York that put unemployed, mostly elderly, men to work carving wooden toys that were sold in borrowed storefront space on Fifth Avenue. Foster arranged housing and provided meals for a group that included, among others, "several boatmen of different kinds, a pilot, a captain, ... a tailor, a jeweler, a pastry maker, a bricklayer, a clerk, and a salesman." The enterprise supported needy men and boosted the hand-crafted toy trade. See "Jobless Old Men Become Christmas Toy Makers," *New York Times*, Dec. 12, 1915, SM11.

65 See "Artist Toy Makers of America," *Boston Daily Globe*, Dec. 24, 1911, SM5.

66 "Santa Claus Toy Maker," *Boston Daily Globe*, Dec. 22, 1918, 47. Holmes was especially known for whirligigs in which the arms of an Indian figure seated in a canoe "revolve to the least puff of wind."

67 This motif continued to resonate in the decades to follow. Tex Avery adapted "The Elves and the Shoemaker" for his 1950 MGM animated short *The Peachy Cobbler,* for example, and a 1956 cartoon with Elmer Fudd, *Yankee Dood It,* is based on this fairy tale. See http://en.wikipedia.org/wiki/Elves_and_the_Shoemaker.

68 Cited in Bennard B. Perlman, *The Golden Age of Illustration: F. R. Gruger and His Circle* (Westport, CT: North Light, 1978), 119.

69 John Filson's book *The Discovery, Settlement and Present State of Kentucke* (1784), which had been translated into French and German, made Boone famous in Europe as well as the United States in the eighteenth century. Lord Byron included lines about the frontiersman in his poem "Don Juan" (1822). In 1890 a "historic drama" called *On the Trail, Daniel Boone the Pioneer,* opened in Atlanta (see "It Was Children's Day," *Atlanta Constitution,* Feb. 12, 1890, 7, and "'Daniel Boone' Tonight," *Atlanta Constitution,* Feb. 14, 1890, 4). Boone's capture by Indians at Blue Licks was noted in the *Boston Daily Globe*'s "Daily Lesson in History" in 1901, on the 123rd anniversary of the event. In 1915 the "Boone Trail" through North

Carolina, Tennessee, Kentucky, and Virginia was completed; a monument to Boone was unveiled by the Daughters of the American Revolution at Cumberland Gap; and Boone was elected to the New York University Hall of Fame. See *Boston Daily Globe,* Feb. 7, 1901, 8; "Boone's Trail Now Well Marked," *New York Times,* Aug. 1, 1915; and "Daniel Boone Gets into Hall of Fame," *New York Times,* Oct. 7, 1915, 7. Several books on Boone were published, including John S. C. Abbott's *Daniel Boone: The Pioneer of Kentucky.* See Pathfinder, "Young Americans: The Trail of the Boy Scouts," *Chicago Daily Tribune,* Nov. 14, 1915, B13.

70 Boone's rifle went on display in Wisconsin in 1919. See "The Rifle That Boone Carried," *Los Angeles Times,* Aug. 31, 1919, VII1. See also "Current News via the Camera: Striking Costumes Displayed at the Mardi Gras Ball Given by the Washington Riding and Hunt Club," *Washington Post,* March 4, 1917, SM1. The quotation is from "Daniel Boone Pioneer," *Los Angeles Times,* Dec. 24, 1922, III, 30—a review of Stewart Edward White's book *Daniel Boone, Wilderness Scout* (Doubleday, Page, 1922) for the Boy Scouts. Tales about his exploits were recounted in dime novels and books for boys throughout the nineteenth and early twentieth centuries, although the accuracy of the accounts diminished almost proportionally as Boone's fame grew. See John Mack Faragher, *Daniel Boone: The Life and Legend of an American Pioneer* (New York: Holt, 1992), 323–24, cited in Wikipedia, "Daniel Boone." Accessed March 13, 2009.

71 In the twentieth century, Boone was a staple of Boy Scout lore and a figure associated with the group's founding. In 1910, when the Boy Scouts of America was chartered, it was a union of three separate boys' organizations: Ernest Thompson Seton's Woodcraft Indians, Daniel C. Beard's Society of the Sons of Daniel Boone, and the Boy Scouts, founded by Robert Baden-Powell in England. See Robert W. Peterson, *The Boy Scouts: An American Adventure* (New York: American Heritage, 1984), 20–32.

72 Boone's preferred clothes—a fringed hunting shirt, leggings, and moccasins—had been captured in a full-length portrait by Chester Harding that reached mass audiences through an engraving by James Otto Lewis. Both images correctly showed Boone with a beaver hat, but when an actor hired to sell the engravings donned a coonskin cap for a minstrel show called "The Hunters of Kentucky," he inadvertently launched the association between Boone and the cap that would live on. See Daniel Boone Homestead, "History of Daniel Boone," http://www.danielboonehomestead.org/history.htm. Accessed March 13, 2009.

73 See "Will Play in 'Daniel Boone,'" *Los Angeles Times,* March 10, 1923, 18; "Splendid Films on Tap Today for Children," *Atlanta Constitution,* Oct. 6, 1923, 16.

74 *Post* cover artists had occasionally used ovals to frame bust-length images of women, and Leyendecker had selected an orange circle as the backdrop against which a kid chows down on his Thanksgiving turkey (*Saturday Evening Post,* Nov. 12, 1910) and used it again later, behind an image of a soldier in full kit holding up a steaming mug (*Saturday Evening Post,* Dec. 8, 1917). Charles Livingston Bull had chosen an orange circle as a large "moon" that set off an owl (*Saturday Evening Post,* Sept. 18, 1915). Before the 1920s, however, the circle had served as a compositional device rather than part of the story line of a picture. Rockwell, for example, encircles the heads of the man and woman in *Ouiji Board* (*Saturday Evening Post,* May 1, 1920) to suggest intimacy between the protagonists. He first used it as part of the story line, that is, with additional illustration inside the circle, for a *Post* cover (Dec. 4, 1920) showing Santa thinking of the little children eagerly awaiting his arrival. It also appears on a cover called *Adventure* (June 7, 1924), in which an elderly clerk dreams of the sea. Rockwell used the panorama motif in a painting much like *—And Daniel Boone Comes to Life,* in *Ethan Allen and His Green Mountain Boys,* an ad for Dixon Ticonderoga pencils that was published in *Liberty* magazine on Sept. 13, 1930.

75 Rockwell reprised this theme in *Land of Enchantment,* a mural he designed for the children's section of the New Rochelle public library in 1934 and which was reproduced in the *Post* in December of that year. See pp. 218–19.

76 Quoted in Kerry O'Quinn, "The George Lucas Saga," in *George Lucas Interviews,* ed. Sally Kline, 116 (Jackson: University of Mississippi Press, 1999). The interview was originally published in *Starlog,* in three installments July–Sept., 1981.

77 Quoted in Stephen Zito, "George Lucas Goes Far Out," in Kline, *George Lucas Interviews,* 53 (originally published in *American Film,* April 1977, 8–13).

78 For images of the *Country Gentleman* covers, see Moffatt, *Definitive Catalogue,* 1:15–28.

79 Quoted in David I. Macleod, *The Age of the Child: Children in America, 1890–1920* (New York: Twayne in assoc. with Prentice Hall, 1998), 23. *Rebecca of Sunnybrook Farm* was made into a movie starring Shirley Temple in 1938.

80 Ibid., 24–25.

81 Rockwell revisited the graduate motif for the June 6, 1959, cover of the *Post* in which a worried young man holding a diploma and wearing a cap and gown is seen against a newspaper page with partly visible headlines, some of which read "Officials to Seek Help for Job Woes," "Khrushchev Warns West of War Danger," and "Thugs Beat Two Men Due to Testify Today Against Union Pickets."

82 "Who's Who," *The* [New Rochelle] *Tattler,* March 1914, 15.

83 This quotation and those that follow are, respectively, from N. Rockwell, *My Adventures,* 202, 203, 208 (three quotations), 209 (two quotations).

84 V. Carl Ilgen, principal, Pershing School, University City Public Schools, Missouri, to Norman Rockwell, Oct. 28, 1929, Fan Correspondence [1929], Norman Rockwell Archives, Norman Rockwell Museum, Stockbridge, MA.

85 See, for example, the following articles in the *Saturday Evening Post*: Mack Sennett, "Movie Star Stories," Sept. 16, 1916, 41; Will Payne, "From the Movies to the Photoplay," June 26, 1915, 23; Rob Wagner, "Ready! Action! Camera! Go!" Jan. 20, 1917, 11, and Jan. 27, 1917, 12; Rob Wagner, "Making the Films Safe for Provincialism," Nov. 15, 1919, 22; Floyd W. Parsons, "Everybody's Business: The Movies' Business Side," March 26, 1921, 26, 29; and Harry Leon Wilson, "Merton of the Movies," a ten-part *Post* serial that ran weekly from Feb. 4, 1922 (p. 3) through April 8, 1922 (p. 24).

86 In 1919 he repeated the motif of the 1916 image with a few changes for *Literary Digest.* He also talked about the silent film called *Sentimental Tommy,* which was released in 1921. See Katherine E. Fitzpatrick, "Interviews: Norman Rockwell," *Purple and White* (New Rochelle High School paper), Dec. 1923, 14–15 (available from Norman Rockwell: Collected Articles, 1914–present, Norman Rockwell Archives). The studio visit is recorded in "Draws Boys and Not Girls," *Boston Daily Globe,* Aug. 5, 1923, 70.

87 N. Rockwell, *My Adventures,* 262.

88 See Ruth Boyle, "A House with Real Charm," *Good Housekeeping,* Feb. 1929, 48–49, 172.

89 "Rockwell May Decide to Remain," *Los Angeles Times,* Feb. 11, 1930, A1.

90 N. Rockwell, *My Adventures,* 263.

91 Mac Tinée, "'The Texan' Draws Four Stars; It's O. Henry's," *Chicago Daily Tribune,* May 9, 1930, 35; Elena Boland, "Westerns Stage a Comeback," *Los Angeles Times,* May 4, 1930, B11.

92 In 1948, almost twenty years after painting *Gary Cooper as the Texan,* Rockwell received a letter from John McCallum, the model for the makeup man, asking if Rockwell could use him again. He had become ill, his leg had been amputated, and although he did not yet have full use of his new artificial leg, he offered to pose sitting in a chair. "Expression," he said, "is what I want to give you." John McCallum to Norman Rockwell, Dec. 16, 1948, Norman Rockwell Archives, General Records, Norman Rockwell Museum, Stockbridge, MA.

93 See "Cross-Country Walk Planned," *Los Angeles Times,* April 29, 1927, B1; and "Walking Race Important: Western Public Being Educated to Appreciate Scientific Pedestrian Event," *Los Angeles Times,* June 13, 1927, B4.

94 "Norman Rockwell, Noted Artist, Divorced in Reno," *Chicago Daily Tribune,* Jan. 14, 1930, 1; "Artist Takes Alhambra Bride," *Los Angeles Times,* April 18, 1930, A5.

95 Carolyn Kitch, *The Girl on the Magazine Cover: The Origins of Visual Stereotypes in American Mass Media* (Chapel Hill: University of North Carolina Press, 2001), 121, provides this characterization of the flapper type.

96 Rockwell painted *Boy Gazing at Pictures of Glamorous Stars* for the Sept. 22, 1934, cover of the *Post,* and twenty years later, *Girl at Mirror* (March 6, 1954). He turned the tables in *Girls Looking at Movie Star's Photo,* a picture of young women gazing admiringly at a handsome hero, which appeared as a *Post* cover on Feb. 19, 1938.

97 Annette Tapert, *The Power of Glamour: The Women Who Defined the Magic of Stardom* (New York: Crown, 1998), 52–53. I am very grateful to Amy Henderson, senior historian at the National Portrait Gallery, for pointing out this source for the gown in *Woman at Vanity.*

98 Steven Spielberg interprets her expression not as haughty but as "zoned out." He suggests she has entered a Zen-like state to escape the claustrophobia of being surrounded by paparazzi and is working hard not to break their cameras or snap their pencils in half.

99 Tebbel, *George Horace Lorimer,* 116.

100 Russell Maloney, "The Talk of the Town: 'Perfect 34'," *New Yorker,* Jan. 11, 1936, 9.

101 Tebbel, *George Horace Lorimer,* 116. For ads featuring Hoff, see "Get a Lift with a Camel!" *Los Angeles Times,* March 5, 1935, 12; and "Camel's Costlier Tobaccos Never Get on Your Nerves!" *Chicago Daily Tribune,* March 11, 1935, 8. Photographs of Hoff appeared in the new pictorial *Life,* Oct. 21, 1940, cover, 27.

102 N. Rockwell, *My Adventures,* 262–63.

103 *Ladies' Home Journal,* July 1930, 7.

104 Rosalind Shaffer, "The Movies Go for Models," *Chicago Daily Tribune,* Nov. 7, 1937, H1, H4.

105 By the mid-1910s, Rockwell customarily used facial expression as a key element in crafting his visual narratives. Except for the portraits he drew while in the navy in 1918 and occasional images of friends and family members, he painted few portraits for publication before the late 1930s. His remarkable skill at capturing nuanced likeness became apparent, however, in a series of ads commissioned in 1936 for a Schenly Cream of Kentucky whisky promotional campaign that continued into the 1940s. For images of the whisky ads, see Moffatt, *Definitive Catalogue,* 1:520–36.

106 Manthorne, "John Sloan's Moving-Picture Eye."

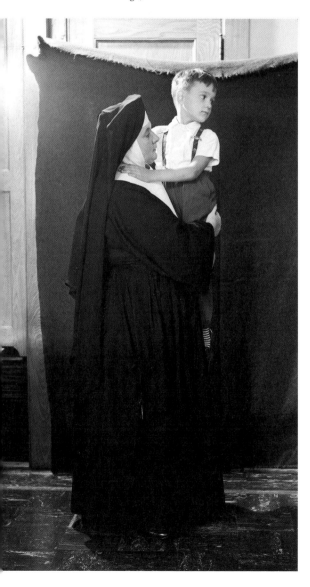

107 Erika Lee Doss, *Regionalists in Hollywood: Painting, Film, and Patronage,* 1925–1945, Ph.D. diss., University of Minnesota, 1983 (Ann Arbor, MI: University Microfilms, 1985), 49. Doss's dissertation is an important and provocative study of the influence of film and Hollywood on Thomas Hart Benton and other regionalists, and, conversely, of the impact of the artists on King Vidor and other Hollywood luminaries who collected regionalist art.

108 Doss, *Regionalists in Hollywood,* 41–43, cites Robert Manvell, who in 1948 used "pattern of action" to describe a "mobile composition within the bounding lines of a frame" (p. 41).

109 Ibid., viii.

110 In 1944, an enormous (82 × 42 ft.) version of Rockwell's poster for Fox's *Song of Bernadette* (1943) covered the front of the Rivoli Theater in New York when the movie opened. "Art and Advertising Certainly Do Mix," *Exhibitor,* Feb. 5, 1947. Thomas M. Pryor, "Short 'Takes' on the Film Scene," *New York Times,* March 12, 1944, X3.

111 "Who's Who in the Hills: Norman Rockwell, Celebrated Magazine Artist Tells Story Behind Covers," *Canyon Crier* (Hollywood, CA), April 28, 1949, 1, 6.

112 In 1945, Hedda Hopper reported additional star portraits by Rockwell: images of Gary Cooper and Loretta Young for ads for the comedy Western *Along Came Jones* (1945), and of Barry Fitzgerald, who played an elderly priest in *Going My Way* (1944), for a magazine cover. See Hedda Hopper, "Looking at Hollywood," *Chicago Daily Tribune,* Feb. 22, 1945, 16; and Hedda Hopper, "Looking at Hollywood," *Chicago Daily Tribune,* Feb. 16, 1945, 18. For the 1946 movie adaptation of W. Somerset Maugham's novel *The Razor's Edge,* Rockwell limned a full-length portrait of Tyrone Power, shown surrounded by disembodied heads of five other cast members. See "Ty Power's Portrait Keys 'Razor' Ads," *Motion Picture Daily,* Nov. 14, 1946.

113 Hedda Hopper, "Looking at Hollywood," *Chicago Daily Tribune,* March 17, 1949, 22. Back home in Arlington, Vermont, Rockwell's neighbors were thrilled when Twentieth Century-Fox actress Linda Darnell, star of *My Darling Clementine* (1946), *Forever Amber* (1947), and *Unfaithfully Yours* (1948) came to town in late 1948 for three days to study painting with Rockwell. Tucked in among articles on new voting machines and Girl Scout activities was an item in the *Bennington Evening Banner* announcing her arrival. The folks in Arlington were doubly pleased when pictures of Rockwell and his star pupil at work in the studio were featured in *Parade,* the Sunday supplement inserted into newspapers around the country,

the following February. Roy A. Sullivan, "Linda Darnell to Study Art Under Eye of Rockwell," *Bennington Evening Banner* (Bennington, VT), Nov. 4, 1948, 1, 5; "Linda Darnell, Artist," *Parade, Rocky Mountain News Sunday Magazine,* Feb. 6, 1949; and "Pretty as a Picture," *Motion Picture,* May 1949, 30–31.

114 N. Rockwell, *My Adventures,* 265–69.

115 For a fascinating extended discussion of the months the Rockwells spent in Paris based on letters Mrs. Rockwell sent to family, see Laura Claridge, *Norman Rockwell, A Life,* 232–44.

116 N. Rockwell, *My Adventures,* 270.

117 Rockwell borrowed Michelangelo's Isaiah figure in the Sistine Chapel for his World War II image *Rosie the Riveter.* An August 1930 *Post* cover, *The Breakfast Table,* showing a husband reading a newspaper and ignoring his wife parallels William McGregor Paxton's 1911 painting *The Breakfast.*

118 N. Rockwell, *My Adventures,* 270.

119 Anthony's 1914 book *Mothers Who Must Earn* was published by the prestigious Russell Sage Foundation, and by 1916, articles she wrote on women's issues and the poverty among European immigrants in New York appeared in *Survey* magazine and the *New Republic.* For an extended discussion of Anthony's life and beliefs, see Alden Waitt, "Katharine Anthony: Feminist Biographer with the 'Warmth of an Advocate,'" *Frontiers: A Journal of Women's Studies* 10, no. 1 (1988): 72–77.

120 *Little Women* was nominated for the 1933 Academdy Awards for Best Picture, and George Cukor was nominated for Best Director. Producers Merian C. Cooper, Kenneth Macgowan, and David O. Selznick won the Photoplay Medal of Honor in 1933, and Katharine Hepburn won the Golden Medal at the Venice Film Festival the following year. See Internet Movie Database (IMDB), "Awards for Little Women," at www.imdb.com/title/tt0024264/awards. Accessed March 30, 2009.

121 Katharine Anthony, "The Most Beloved American Writer," *Woman's Home Companion,* Dec. 1937, 102.

122 N. Rockwell, *My Adventures,* 274–79.

123 The image accompanied a story of the same title ("Proud Possessor") by James Street, in *American Magazine,* May 1940, 50–52, 62–68.

124 Augusta Tucker, "Let Nothing You Dismay," *Ladies' Home Journal,* July 1941, 18–19, 61–62, 64–65.

125 N. Rockwell, *My Adventures,* 328.

126 Frank Capra, *The Name Above the Title* (New York: Macmillan, 1971), 30.

127 See Vito Zagarrio, "It Is (Not) a Wonderful Life: For a Counter-reading of Frank Capra," in *Frank Capra: Authorship and the Studio System,* ed. Robert Sklar and Vito Zagarrio, 64–94 (Philadelphia: Temple University Press, 1998).

128 *It Happened One Night* (1934) won Academy Awards for Best Picture, Best Director, Best Actor in a Leading Role (Clark Gable), Best Actress in a Leading Role (Claudette Colbert), and Best Writing (Adapted Screenplay) for Robert Riskin's adaptation of Samuel Hopkins Adams's story "Night Bus." *Mr. Deeds Goes to Town* (1936) won an Oscar for Best Director; *You Can't Take It with You* (1938) was awarded Oscars for Best Picture and Best Director; *Mr. Smith Goes to Washington* (1939) received an award for Best Writing, Original Story (screenplay by Lewis R. Foster).

129 Capra, *The Name,* 38, 39.

130 Ibid., 138.

131 Ibid., 185, 240.

132 Roosevelt's fireside chat on Dec. 29, 1940, was expected to attract record audiences worldwide. See Harold R. Hinton, "President Works All Day on 'Chat' to Reassure Nation," *New York Times,* Dec. 29, 1940, 1. The texts of the fireside chat and Roosevelt's 1941 State of the Union address can be found on the Library of Congress Web site, www.loc.gov.

133 Susan E. Meyer, *Norman Rockwell's World War II: Impressions from the Homefront* (San Antonio, TX: USAA Foundation, 1991), 12.

134 Quoted in Stuart Murray and James McCabe, *Norman Rockwell's Four Freedoms: Images that Inspire a Nation* (Stockbridge, MA: Berkshire House in assoc. with the Norman Rockwell Museum, 1993), 8.

135 N. Rockwell, *My Adventures,* 312, 313.

136 Ibid., 313.

137 According to Rockwell's account in *My Adventures* (313–14), he met with indifference, even hostility, from government officials. However, Winford wrote Hibbs in September that Rockwell had been thrilled with conversations they had with the Secretary of War and staff members in the Office of Facts and Figures, the forerunner of the Office of War Information. "The one idea that was mentioned more times," wrote Winford, "was something painted to illustrate the Four Freedoms as brought out in the Atlantic Charter." See Orion Winford to Ben Hibbs, September 3, 1942, Norman Rockwell Archives, General Records, Norman Rockwell Museum, RC.2007.18.

Franklin Roosevelt and Winston Churchill had signed the Atlantic Charter on August 14, 1941, on board a ship off the coast of Newfoundland. Although it is cited along with Roosevelt's speech as the source for the Four Freedoms, only freedom of speech and freedom from fear were enumerated in the document. All four, however, were listed in the first Proclamation of the United Nations on January 1, 1942.

The Four Freedoms overlapped, but were not identical with, the freedoms guaranteed in the Bill of Rights, which includes freedoms of assembly and of the press but not freedom from want or from fear. See Lester C. Olson, "Portraits in Praise of a People: A Rhetorical Analysis of Norman Rockwell's Icons in Franklin D. Roosevelt's 'Four Freedoms' Campaign," *Quarterly Journal of Speech* 69 (1983): 20, n. 12. In an essay on the "Four Freedoms" paintings, Maureen Hart Hennessey quotes a letter from Thomas D. Mabry, one of the officials Rockwell met in Washington, dated April 23, 1943. In it, the former staff member of the Museum of Modern Art in New York congratulated Rockwell on the success of the paintings and continued: "I recall last spring, when you

came to see me at the Office of Facts and Figures, I said at that time that one of our most urgent needs and one that was most difficult to fill was a series of posters on the four freedoms." See Maureen Hart Hennessey, "The Four Freedoms," in *Norman Rockwell: Pictures for the American People,* ed. Maureen Hart Hennessey and Anne Knutson, 96 (New York: Abrams in assoc. with the High Museum of Art and the Norman Rockwell Museum, 1999).

What Rockwell reported as a lack of enthusiasm may have been the result of the bureaucratic reorganization in mid-June that created the Office of War Information to coordinate the government's informational campaign of pamphlets, posters, and war-related advertising that had previously been the purview of several unrelated agencies.

138 Ben Hibbs, "Credo," *Saturday Evening Post,* June 20, 1942, 4. For a discussion of Hibbs's early years and career at the *Post,* see Deryl Ray Leaming, *A Biography of Ben Hibbs,* Ph.D. diss., Syracuse University, 1969 (Ann Arbor, MI: University Microfilms, 1969).

139 James Yater to Norman Rockwell, June 26, 1942, Norman Rockwell Archives, General Records, Norman Rockwell Museum, RC.2007.18.

140 "Full Color Reproductions of Norman Rockwell's Paintings of the Four Freedoms Now Available," *Saturday Evening Post,* March 13, 1943, 10; "Keeping *Post*ed," *Saturday Evening Post,* March 6, 1943, 4.

141 "Keeping *Post*ed," *Saturday Evening Post,* March 20, 1943, 4.

142 Paul L. Brandt to Norman Rockwell, quoted in Murray and McCabe, *Rockwell's Four Freedoms,* 67.

143 Christopher Finch presents a different interpretation of *Freedom of Speech*: "Unfortunately, Rockwell has painted him with his eyes lifted as though to heaven and with an expression which might be appropriate to a saint, but which seems to bear little relationship to the worldly affairs that are presumably before the meeting. The people surrounding the young worker—including middle-aged and elderly business-executive types—gaze up at him with looks that are so laden with admiration as to seem unreal. The overall effect is to patronize both the young man and those who surround him…. As it is, we feel we are looking at the dramatization of a slogan." Christopher Finch, *Norman Rockwell's America* (New York: Abrams, 1975), 168.

144 "Four Freedoms War Bond Show to Have Hecht Store Preview," *Washington Post,* April 23, 1943, 5.

145 Scott Faron to Norman Rockwell, June 11, 1943, and A. J. Gallager to Norman Rockwell, April 6, 1944, Norman Rockwell Archives, General Records, Norman Rockwell Museum, RC.2007.18.

146 Capra, *The Name,* 311–12.

147 The painting appeared on the cover of *Saturday Evening Post* on Aug. 12, 1944. For a compelling discussion of *Little Girl Observing Lovers on a Train,* see Karal Ann Marling, "Norman Rockwell Soldier on Leave (1944)," in *Seeing America: Painting and Sculpture from the Collection of the Memorial Art Gallery of the University of Rochester,* ed. Marjorie B. Searl, 265–67 (Rochester, NY: University of Rochester Press, 2006).

148 On February 21, 1945, Rockwell wrote to a fourteen-year-old girl who asked about the expression on the little girl's face. Rockwell's response was as follows, "I should think her expression was a combination of wonderment, very great interest, and pleasure in having found something to amuse her on the dreary night journey." Reproduced in http://findarticles.com/p/articles/mi_m1189/is_3_280/ai_n25429574?tag+content;coll. Accessed Feb. 9, 2009.

149 My thanks to James P. McNally and Kaleb Dissinger of the United States Army Heritage and Education Center, Carlisle, PA, for identifying uniform details, accessories, and insignia for both *Little Girl Observing Lovers on a Train* and *Back to Civvies.*

150 Norman Rockwell, *Rockwell on Rockwell: How I Make a Picture* (New York: Watson-Guptill in cooperation with Famous Artists School, 1979), 38.

151 My thanks to Stephanie Plunkett for this information about *Saying Grace.*

152 See Alexander Nemerov, "Coming Home in 1945: Reading Robert Frost and Norman Rockwell," *American Art* 18, no. 2 (Summer 2004): 59–79.

153 With Operation Pointblank, Roosevelt and Churchill determined to effect "the progressive destruction and dislocation of the German military, industrial and economic system[s]" and to undermine the morale of the German people. See Arthur Travers Harris and Sebastian Cox, *Despatch on War Operations: 23rd February, 1942, to 8th May, 1945* (Portland, OR: Frank Cass, 1995), 196.

154 For further information, see http://en.wikipedia.org/wiki/P-51_Mustang#Operational_history. Accessed April 21, 2009.

155 Brig. Gen. George E. McCord, a B-24 pilot based in Italy and the author's father, remembered the P-51s with affection and gratitude many years after his own bullet-ridden plane safely returned to base with its P-51 escort.

156 See Wikipedia, "Operation Pointblank," http://en.wikipedia.org/wiki/Operation_Pointblank#Pointblank_operations. Accessed April 20, 2009.

157 "Big Rise in Holiday Travel Under Way," *Christian Science Monitor,* July 2, 1945, 1.

158 See "Long Gone Cry of 'Fill 'er Up' Is Heard Again," *Chicago Daily Tribune,* Aug. 16, 1945, 3. Rationing was also lifted, in addition to gasoline, on fuel oil and oil stoves, and "blue point" canned fruits and vegetables, although ration controls on meats, fats, oils, butter, and sugar remained in effect. See also Jay Walz, "Ample Supplies Assured in Freeing 'Gas,' Fuel Oil," *New York Times,* Aug. 16, 1945, 1. The dramatic reduction in military use freed up wool and cotton, and the shoe industry immediately began retooling for an onslaught of orders for civilian shoes, which had also been rationed

during the war. For people who did not live through the shortages and restrictions, it is hard to imagine how extensive wartime military need affected life on the home front. During the war, increases in wages and salaries had been restricted, and sales, excess profits, and excise taxes had been imposed, leading to the need to reorganize overall tax structure after the war. See William H. Stringer, "Home Front Hails Quick End to Bans," *Christian Science Monitor,* Aug. 18, 1945, 1. With the need for high-octane aviation fuel drastically reduced, the quality of gas available for civilian use also increased. See "Prewar Quality Gas on Way and Cars Will Sing Not Ping," *Christian Science Monitor,* Aug. 16, 1945, 7.

159 Quoted in Stringer, "Home Front Hails Quick End to Bans," *Christian Science Monitor,* Aug. 18, 1945, 1. The wartime restriction on the number of people allowed at a single business convention (maximum 50) was raised (to maximum 150), but a ban on group tourism remained in effect.

160 "Auto Industry Predicts New Cars This Year," *Los Angeles Times,* April 29, 1945, 1.

161 Cited in "Redesigning the American Car: Conversion and Back Again," in Victor Bondi, ed., *American Decades,* vol. 5, 1940–1949 (Detroit: Gale Research, 1995), 189–90. By 1955, 52 million cars were on the nation's roads, almost double the number *Fortune* magazine had reported ten years earlier, and many of them were new. "The Car Culture" in Richard Layman, ed., *American Decades,* vol. 6, 1950–59 (Detroit: Gale Research, 1994), 266.

162 Samuel Wallace, "Vacation Horizon Moves Back but Stays in North America," *Chicago Daily Tribune,* June 8, 1947, C1.

163 N. Rockwell, *Rockwell on Rockwell,* 129.

164 *Liberty Girl* appeared on the cover of the Sept. 4, 1943, issue of the *Post.* See also Meyer, *Rockwell's World War II,* 44.

165 After the success of the "Four Freedoms" made his name a household word, Rockwell began doing product endorsements. See, for example, "Eleven Ounces of Youth," an ad for Aqua Velva aftershave, *New York Times,* Dec. 11, 1949, SM20.

programs to replace institutional orphanages. New York City's foster care program began in 1949. In 1950 the Minnesota state social welfare division placed newspaper advertisements for homes for orphan children. Throughout the late 1940s and early 1950s, when "Good Boy" appeared in *Good Housekeeping,* newspaper articles reported on the need for foster homes and adoptive families for American children and orphans left homeless during World War II and by civil wars in Greece and China. Newspapers were filled with stories and photographs of international orphans being met by their adoptive parents on arriving in the United States. Programs were also set up whereby Americans could provide monthly financial support for children abroad. The problem was so widespread that the American Legion began collecting toys to be distributed to Belgian orphans. See "American Experience: The Orphan Trains," http://www.pbs.org/wgbh/amex/orphan/, accessed April 23, 2009, for a summary of the PBS American Experience documentary on orphan trains; Connie DiPasquale, "A History of the Orphan Trains," http://www.kancoll.org/articles/orphans/or_hist.htm, accessed April 23, 2009; "Want Ads Used to Place Orphans," *Los Angeles Times,* Jan. 13, 1950, 10; "Five Hundred Foster Homes Are Sought by City," *New York Times,* Jan. 25, 1950, 37; "'Foster Parents' Plan Reports Growing Need of War Orphans," *Christian Science Monitor,* Jan. 6, 1950, 4; "Belgian Children to Get Twenty-Five Thousand Toys from U.S.," *Chicago Daily Tribune,* April 7, 1951, 10. For a compelling history of orphan trains, see Marilyn Irvin Holt, *The Orphan Trains: Placing Out in America* (Lincoln: University of Nebraska Press, 1992).

172 "Santa Claus, Please Take Notice! Here Are New York's One Hundred Neediest Cases," *New York Times,* Dec. 15, 1912, SM1, and "Quick Response for 'One Hundred Neediest Cases,'" *New York Times,* Dec. 18, 1912, 7. A photograph of Rockwell's drawing appeared in the *New York Times,* Dec. 7, 1952, X1.

173 Manthorne, "John Sloan's Moving-Picture Eye," 84–85, discusses the temporal dimension of several of Sloan's etchings.

174 "The Cover," *Saturday Evening Post,* March 17, 1956, 3.

175 See Allison Adato, "The People in the Pictures," *Life,* July 1993, 91. See also Bill Ryan, "Rockwell's Real People," *Saturday Evening Post,* Jan.–Feb. 1984, 96.

176 Rockwell, *My Adventures,* 43.

177 "Letters: Surprise!" *Saturday Evening Post,* April 21, 1956, 4.

166 *Rosie the Riveter* appeared on the cover of the May 29, 1943, *Saturday Evening Post.*

167 Quoted in Arthur L. Guptill, Norman *Rockwell, Illustrator,* 3rd ed. (New York: Watson-Guptill, 1970), 53.

168 Ibid., 55; and S. Lane Faison, Kenneth Stuart, and Thomas S. Buechner, *The Norman Rockwell Album* (Garden City, NY: Doubleday, 1961), 46.

169 N. Rockwell, *Rockwell on Rockwell,* 91–92.

170 Mary McSherry, "Good Boy," *Good Housekeeping,* May 1951, 54–57, 232–45.

171 The Children's Aid Society was established in 1853 by Charles Loring Brace, a young minister who went to New York for seminary study and was horrified by the numbers of children living in the streets. Between 1854 and 1929, the Society sent more than one-hundred thousand children via orphan trains to rural areas. Handbills and newspaper advertisements alerted communities in advance of a train's arrival so prospective parents could plan to meet and inspect children. In 1869, the Sisters of Charity of St. Vincent de Paul founded the Catholic Charities of New York, which also sent children by train to adoptive parents. Although processes and requirements differed, both organizations worked to place children in suitable American families. By 1930, with the depression, fewer families were able to take on additional children, and legislation made transporting children across the country by train more difficult. Several states began foster care

178 Peter Rockwell with Shari Steiner, "My Father, Norman Rockwell," *Ladies' Home Journal,* Nov. 1972, 88.

179 "Keeping *Posted*," *Saturday Evening Post,* Nov. 1, 1947, 10.

180 Susan E. Meyer, *Norman Rockwell's People* (New York: Abrams, 1981), 177.

181 Rockwell remarked later that he thought he had made a mistake in posing Peter in his studio. "It would have been much better," he said, "if I had posed the boy on the actual springboard,"—not, however, because the scene would have been more realistic, but because "You just can't simulate the effect of real sunlight—or at least I can't." N. Rockwell, *Rockwell on Rockwell,* 106.

182 Jeff Wiltse, *Contested Waters: A Social History of Swimming Pools in America* (Chapel Hill: University of North Carolina Press, 2007), 88. After the war, when aluminum was available again, traditional wood diving boards were replaced by the springier metal, which propelled divers higher and required that pools be deeper. See Thomas A. P. van Leeuwen, *The Springboard in the Pond: An Intimate History of the Swimming Pool* (Cambridge, MA: MIT Press, 1998), 187.

183 These figures are reported respectively by Ella Taylor, *Prime-Time Families: Television Culture in Postwar America* (Berkeley: University of California Press, 1989), 20; and Nina C. Leibman, *Living Room Lectures: The Fifties Family in Film and Television* (Austin: University of Texas Press), 3. Taylor's and Leibman's excellent studies are part of a considerable body of literature that exists on television and families in the 1950s. Also of interest are Jay Fultz, *In Search of Donna Reed* (Iowa City: University of Iowa Press, 1998); Marsha F. Cassidy, "Sob Stories, Merriment, and Surprises: The 1950s Audience Participation Show on Network Television and Women's Daytime Reception," in *Feminist Television Criticism, A Reader,* 2nd ed., Charlotte Brunsdon and Lynn Spigel, eds. (Berkshire, England: Open University Press, 2008); and Mary Beth Haralovich, "Sitcoms and Suburbs: Positioning the 1950s Homemaker," *Quarterly Review of Film and Video* 11: 61–83. The sitcom had been a staple of radio for almost two decades before television. *Father Knows Best, Ozzie and Harriet, Meet the Goldbergs,* and others were built around family relationships and episodes of daily life. Television, however, codified visual information about family structure, home appearance, and roles "typical" of the middle-class suburban family.

184 Leibman, *Living Room Lectures,* 24.

185 For the June 19, 1920, cover of *Saturday Evening Post,* Rockwell represented growing up by showing an annoyed boy at a girl's front door sending his dog away.

186 N. Rockwell, *Rockwell Album,* 158.

187 "The Cover," *Saturday Evening Post,* Sept. 7, 1957, 3.

188 Quoted in Larry Sturhahn, "The Filming of *American Graffiti,*" in Kline, ed., *George Lucas Interviews,* 22. The interview was originally published in *Filmmakers Newsletter* (March 1974): 19–27.

189 N. Rockwell, *Rockwell Album,* 166. Quoted in Linda Szekely Pero, *American Chronicles: The Art of Norman Rockwell* (Stockbridge, MA: Norman Rockwell Museum, 2007), 177.

190 Leibman, *Living Room Lectures,* 1.

191 N. Rockwell, *Rockwell Album,* 166.

192 There's no suggestion in Rockwell's image of contemporary legal and socio-logical concerns over runaway children, yet they were significant. In *Youth in Danger: A Forthright Report by the Former Chairman of the Senate Subcommittee on Juvenile Delinquency* (New York: Harcourt Brace, 1956), Robert C. Hendrickson and Fred J. Cook summarized testimony documenting that the problem of runaway children in the United States had reached what the *Chicago Daily Tribune* called "staggering proportions." According to the article, more than 200,000 boys and girls ran away from home each year, many of them headed for California, where authorities would annually "fill from six to nine trains with runaway youth for return to their homes east, north, and south." See Virgil W. Peterson's review of *Youth in Danger,* "Runaway Children: A Problem of Staggering Proportions," *Chicago Daily Tribune,* May 13, 1956, B2. Art critic Dave Hickey imagined the runaway ten years later, in 1968: "He is standing by a highway with his backpack, thumbing a ride to San Francisco. Or he is bleeding and battered on the streets of Chicago, having encountered an altogether different sort of policeman." See Hickey, "The Kids Are All Right: After the Prom," in Hennessey and Knutson, *Pictures for the American People,* 128.

193 Norman Rockwell, as told to Nanette Kutner, "They Live in Our Town," *American Weekly,* August 1953, 10. Each year the images were published in *American Magazine* before the calendars were commercially distributed. For reproductions of all the Four Seasons calendar images, see Moffatt, *Definitive Catalogue,* 1:302–38.

194 Gabor, *Art of the Calendar,* 70.

195 N. Rockwell, *My Adventures,* 232.

196 Quoted in Wright Morris, "Norman Rockwell's America," *Atlantic Monthly,* Dec. 1957, 135.

197 Meta Shirrefs to Norman Rockwell, Sept. 18, 1955, Fan Correspondence [1955], Norman Rockwell Archives.

198 These letters appeared in "Letters," *Saturday Evening Post,* Sept. 24, 1955, 4, 6.

199 P. L. Forstall to Norman Rockwell, Aug. 16, 1955, Fan Correspondence [1955], Norman Rockwell Archives.

200 "Letters," *Saturday Evening Post,* Oct. 22, 1955, 4.

201 "Rockwell Nets Mermaid for First Cover Nude," *Berkshire Eagle,* Aug. 20, 1955 (available from Norman Rockwell: Collected Articles, 1914–present, Norman Rockwell Archives).

202 Quoted in Camilla Snyder, "The Yankee Artist Everybody Knows," *Los Angeles Herald-Examiner,* Nov. 15, 1970, E8 (available from Norman Rockwell: Collected Articles, 1914–present, Norman Rockwell Archives).

203 Leaming, *Ben Hibbs,* 109.

204 Quoted in Leaming, *Ben Hibbs,* 147, which cites Joseph C. Goulden, *The Curtis Caper* (New York: G. P. Putnam's Sons, 1965), 90.

205 Goulden, *Curtis Caper,* 62–63.

206 Leaming, *Ben Hibbs,* 180–81, reports that circulation figures grew from 4,590,607 in 1954 to 6,301,789 in 1960.

207 Sam Allis, "Sullivan Captures Rockwell Moment," *Boston Globe,* May 13, 2005, see http://www.boston.com/sports/articles/2005/05/13/sullivan_captures_Rockwell_moment/.

208 "The Cover," *Saturday Evening Post,* March 2, 1957, 3.

209 Glenn Stout, *Ted Williams: A Portrait in Words and Pictures,* ed. Dick Johnson (New York: Walker, 1991), 73.

210 Ted Williams, as told to Joe Reichler and Joe Trimble, "This Is My Last Year: Part 1," *Saturday Evening Post,* April 10, 1954, 17–19, 90–94; "Part 2," *Saturday Evening Post,* April 17, 1954, 42, 24–25, 147–50; "Part 3," *Saturday Evening Post,* April 24, 1954, 31, 155–58.

211 "Letters: Big Moment," *Saturday Evening Post,* April 13, 1957, 6.

212 Finch, *Rockwell's America,* 172.

213 The set for the program was a state-of-the-art 1950s executive office. See http://en.wikipedia.org/wiki/Private_Secretary_(TV_series). Accessed Oct. 22, 2009.

214 These pictures appeared, respectively, on the covers of the *Post* on Sept. 20, 1919; June 7, 1924; and Aug. 11, 1945.

215 For an in-depth discussion of Rockwell's construction of masculinity, see Eric Segal, "Norman Rockwell and the Fashioning of American Masculinity," *Art Bulletin* 78, no. 4 (December 1996), 633–46.

216 "Letters: Cute as Her Buttons," *Saturday Evening Post,* Oct. 22, 1960, 4.

217 For a discussion of paintings showing office interiors, see Gail Levin, "The Office Image in the Visual Arts," *Arts Magazine* 59, no. 1 (September 1984): 98–103.

218 N. Rockwell, *Rockwell Album,* 170.

219 See www.mass.gov/courts/sjc/jury-system-e.html. Accessed on April 27, 2009. For a brief survey of women's jury service, see Valerie P. Hans and Neil Vidmar, *Judging the Jury* (New York: Plenum Press, 1986), 51–53.

220 The eighteen states were Alaska, Arkansas, Florida, Georgia, Idaho, Kansas, Louisiana, Minnesota, Missouri, Nevada, New Hampshire, New York, North Dakota, Rhode Island, Tennessee, Virginia, Washington, and Wisconsin. In 1961, two years after *The Jury Holdout* was painted, the United States Supreme Court upheld a Florida law requiring that women were automatically exempted from jury service unless they registered and volunteered. Doris Weatherford, *Milestones: A Chronology of American Women's History* (New York: Facts on File, 1997), 298; "Rules Women Aren't Vital to Jury Trial," *Chicago Daily Tribune,* Nov. 21, 1961, 3. Not until January 1975, did the Supreme Court overturn its earlier ruling and declare the exclusion of women from jury service to be unconstitutional. See Linda Mathews, "Exclusion of Women as Jurors Overruled," *Los Angeles Times,* Jan. 22, 1975, A7.

221 In 1957 the *New York Times* found the inclusion of three women on the jury of a United States District Court in Alabama for the first time sufficiently newsworthy to report; in 1958, women in South Carolina were actively pressing for the right to serve on juries. "Jury Shift in Alabama," *New York Times,* Nov. 19, 1957, 41; Henry Lesesne, "Women Ask Rights in South Carolina," *Christian Science Monitor,* March 6, 1958, 10.

222 Quoted in "A First for Judge: Woman's Suit Settled, Avoiding Female Jury," *Washington Post and Times Herald,* Jan. 30, 1959, B1.

223 Norma H. Goodhue, "Lancaster Woman Awarded Citation by Junior Chamber," *Los Angeles Times,* June 5, 1957, A7.

224 The title of the episode was "Revenge." It aired nationally on September 10, 1957. A videotape of the program is available at the Library of Congress.

225 Pero, *American Chronicles,* 181.

226 Peter Rockwell, "Some Comments from the Boy in a Dining Car," in Hennessey and Knutson, *Pictures for the American People,* 76–78. Rockwell used the same device of the low stool in caricatures of himself he drew for Arthur L. Guptill's *Norman Rockwell, Illustrator,* originally published in 1946.

227 "Keeping *Posted:* Norman Rockwell Tells His Story," *Saturday Evening Post,* Feb. 13, 1960, 132.

228 Benjamin DeMott, "When We Were Young and Poor," *Nation,* April 2, 1960, 299–300.

229 "Letters: Fan Mail for Norman," *Saturday Evening Post,* March 26, 1960, 4.

230 Leaming, *Ben Hibbs,* 184, 189.

231 Goulden, *Curtis Caper,* 79–80.

232 Ibid., 91; Leaming, *Ben Hibbs,* 161, 180–82.

233 Goulden, *Curtis Caper,* 92.

234 Leaming, *Ben Hibbs,* 181.

235 For a description of the new format, see Leaming, *Ben Hibbs,* 190–91.

236 Quoted in Goulden, *Curtis Caper,* 103.

237 For a fascinating discussion of *The Connoisseur,* see Wanda Corn, "Ways of Seeing," in Hennessey and Knutson, *Pictures for the American People,* 80–93.

238 "The Cover," *Saturday Evening Post,* Jan. 13, 1962, 3.

239 "Letters to the Editor: Rockwell's Modern Art," *Saturday Evening Post,* Feb. 17, 1962, 5.

240 "Boom on Canvas," *Time,* April 7, 1958, 80. A Pollock painting, for example, had sold for $30,000, more than the cost of a house, and at $7,500, a Hans Hofmann canvas was valued at three times the price of a family sedan. See Virginia M. Mecklenburg, *Modern Masters: American Abstraction at Midcentury* (Washington, DC: Smithsonian American Art Museum in association with D. Giles, 2008), 51–52.

241 Wanda Corn, "Ways of Seeing," 93.

242 Quoted in Alan Nourie and Barbara Nourie, eds., *American Mass-Market Magazines* (New York: Greenwood Press, 1990), 228.

243 Sargent Shriver, "How Goes the War on Poverty?" *Look,* July 27, 1965, 30–34; Roger Helsman, "The Cuban Missile Crisis: How Close We Came to War," *Look,* Aug. 25, 1964, 17–21.

244 "1960," *Look,* July 14, 1964, 60.

245 Quoted in Pero, *American Chronicles,* 182.

246 The Kennedy portrait was republished on the cover of the December 14, 1963, memorial issue of the *Post.*

247 Jo Ann Losinger, "Scouting for a Collectible Print," *Portfolio* (newsletter of the Norman Rockwell Museum) 13, no. 1 (Spring 1996): 12.

248 See Chester Morrison, "Norman Rockwell: 'Silent' Film Star," *Look,* March 8, 1966, 40, 44–45. For a diary of the film's shooting, see Muriel Davidson and Janet Rale, "Stagecoach, 'Do It Right Kid: You'll Be Dead If You Don't,'" *Saturday Evening Post,* April 9, 1966, 30–33, 76, 78.

249 Lisa Vincenzi, "A Short Time Ago on a Ranch Not So Far Away," in Kline, *George Lucas Interviews,* 163.

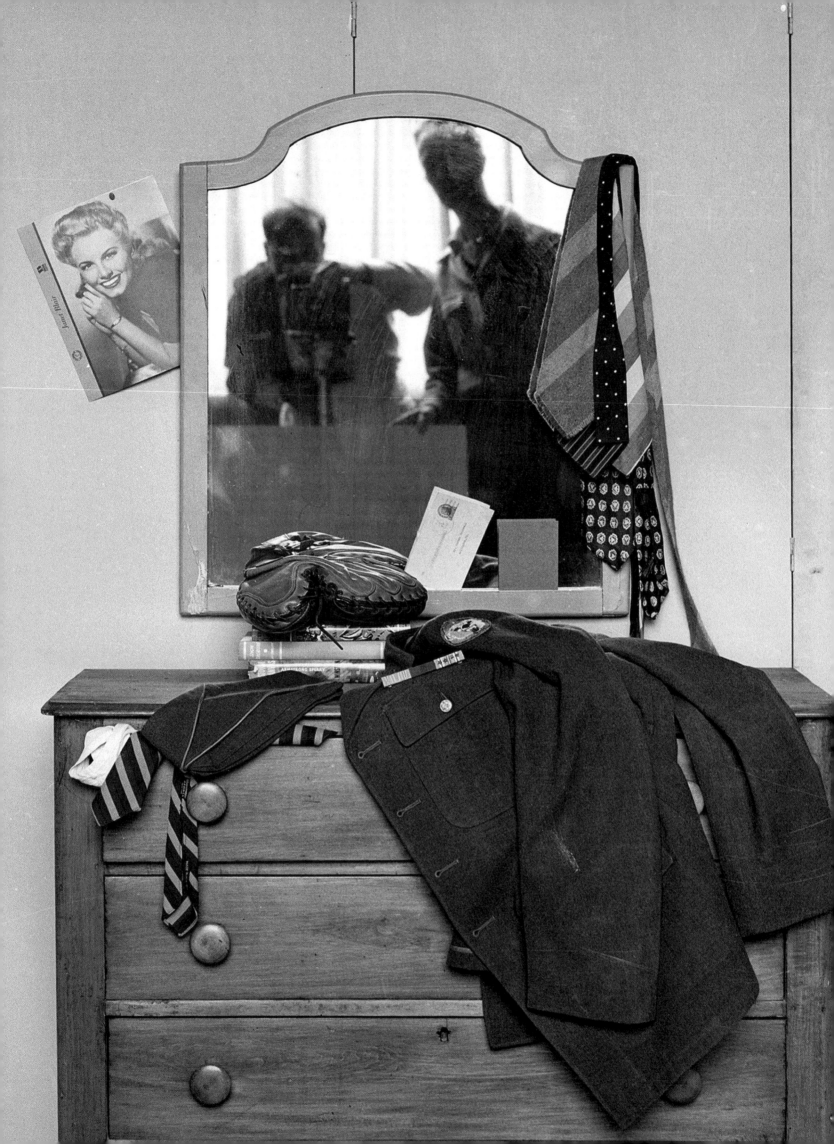

"I'VE ALWAYS BEEN KNOWN AS THE KID WITH THE CAMERA EYE,"
Norman Rockwell once reflected.[1] This admission would seem to stand
as a simple acknowledgment of the painter's much-noted photographic
realism, a talent that served him well as a commercial illustrator—just as
it set him apart from many notable movements of the twentieth-century
art world. But the comment might just as easily point toward an occasion-
ally noted but scarcely explored aspect of Rockwell's approach to his work—
its frequently cinematic conception of story, character, setting, and the
emotional moment. The most potent of Rockwell's pictures convey what
movies do—what the actor James Stewart called "pieces of time"[2]—moments
that present recognizable characters in quickly comprehensible situations
rife with comedy, drama, and the things of life. The images also offer
the viewer ample conjectural backstory—details suggestive of where the
characters come from and their station in life—while conveying a tangible
sense of the cultural mindset from which the pictures sprang. Culminating
the great line of American visual storytellers represented by Winslow
Homer, Howard Pyle, and N. C. Wyeth, Rockwell created privileged moments
through the little prisms he devised. Functioning very much like a drama-
tist, he concerned himself with such everyday experiences as yearning,
surprise, family connections, celebration, excitement, anticipation, hope,
youthful mischief, and grown-up responsibility, thereby seeking a direct
emotional connection with his public that moviemakers aspire to but
most modern painters rarely attempt. Along with that, much like American
movies did from the 1930s through the mid-1960s, Rockwell's art created
an image of the United States that was idealized, optimistic, and partially
blinkered in its presentation of society. And like many enduring examples
of classical studio filmmaking, Rockwell's work conveys universal truths
in a specifically American vernacular.

Todd McCarthy

Norman Rockwell's
Camera Eye

Asked late in his life how he would describe his job as a commercial illustrator, Rockwell replied, "Making pictures from somebody's writing."[3] In practice, someone else came up with the story, and Rockwell supplied the most expressive images he could to visualize the writer's intentions; for the vast majority of film directors, especially during the old studio era, this quotation provides a succinct definition of their own function vis-à-vis maximizing the dramatic values of a screenplay. However, Rockwell went on to explain that he no longer worked as an illustrator. "I do genre. That's spelled g-e-n-r-e."[4] By this, Rockwell meant that he had graduated from the world of commercial illustration to the mantle of fine art, where he dedicated himself, as had so many painters before him, to depicting scenes of everyday life. In the film world, "genre" is a familiar critical term used to describe different sorts of movie categories, such as thrillers, musicals, melo-dramas, Westerns, and so on, and one could say that, even by this definition, Rockwell specialized in certain genres—from slapstick humor to the inspi-rational, from boyish adventure to private moments of contemplation.

For Rockwell every picture tells a story. As an illustrator of advertise-ments, it was his job to grab the reader's attention. Similarly, for his 322 covers for the *Saturday Evening Post,* Rockwell's guiding principles were to create pictures that would catch the eye of people perusing the many offerings at newsstands and to communicate the cover's point within three to four seconds—a challenge of economy and synthesis similar to that which makers of television commercials face all the time. Filmmakers have more time to work with but are increasingly obliged to "hook" the audience within the first few minutes.

One of Rockwell's most astute champions, Christopher Finch, observed, "It is easy to see that, had he not been a gifted artist, Norman Rockwell might well have become a successful writer or director for films or televi-sion. Situation comedy has been one of the most popular genres in both these mediums, and no one has a better knack for inventing comic situa-tions than Rockwell."[5] Although they are hardly the works for which he is best remembered, Rockwell, whose early career as an illustrator coincided with the growth of silent films, made many sketches that are basically sight gags, goofy events, and pranks featuring slightly exaggerated characters in everyday settings that would have been right at home in comedy shorts of the time—fishing expeditions, embarrassing mishaps, borderline banana-peel stuff at times.

The first time Rockwell explicitly referenced the movies in his art was in a *Post* cover of October 14, 1916, called *People in a Theatre Balcony*, which shows a family delighting in watching a Charlie Chaplin comedy (see p. 42). From what could be called this one-reeler phase of his career, Rockwell moved on to more complexly developed, multi-layered pictures in which character, emotion, setting, and cultural and moral dimensions blossomed out of a basic situation, which could be comic or serious.

Rockwell's work shared resonances with the movies not only in their content and outlook, but also in the method of their creation. Thomas

Hoving noted, "Like a movie director, he blocked out the moves of his 'actors' according to a script and 'shot' them for posterity."[6] Once he had an idea for a picture, Rockwell engaged subjects—professional models well into the 1930s, everyday people more often thereafter—to pose for him. He dressed them in costumes and adorned the scene with props from his extensive personal collection. He constantly readjusted the blocking of characters, the number and kind of props, and other elements before eventually removing more often than adding details for simplicity's sake. He sometimes did the equivalent of a location scout, such as when, having agreed to illustrate new editions of *The Adventures of Tom Sawyer* and *Adventures of Huckleberry Finn,* he traveled to Hannibal, Missouri, to inspect the actual locations of Mark Twain's stories.

In preparation for a final work, he made sketches, then drafts, and in some cases initial versions of paintings, changing the compositions, the angles of perspective, or even flipping the images entirely. By the late 1940s, when Rockwell taught a course in advanced illustration at the Famous Artists School, he laid out his method as follows: "Getting the Picture Idea; How to Select Models; The Importance of Detail, Poses and Props; Making the Charcoal Drawing; Making the Color Sketch; The Final Painting."[7] For a film, the job is similar: Finding the Story, Writing the Script, Selecting the Cast, Choosing the Locations, Designing the Sets, Settling on the Look, Preparing the Storyboards, Shooting the Picture.

In 1937, Rockwell began to use a camera to compose his pictures, much as a film director might use a viewfinder, or today a video camera, to help create a shot. For many years, Rockwell also made use of an esoteric bit of equipment called the balopticon, an early-twentieth-century projection machine considered a "missing link" between the old magic lantern and a classroom overhead projector. By inserting a slide or opaque copy of an existing artwork or photograph into the balopticon, one could project the image onto a screen, facilitating its being traced or copied. Pressed about his own reliance on it, Rockwell once allowed, "The balopticon is an evil, inartistic, habit-forming, lazy, and vicious machine! It is also a useful, time-saving, practical, and helpful one. I use one often—and am thoroughly ashamed of it. I hide it whenever I hear people coming."[8] In all events, Rockwell's use of the balopticon and camera in the preparation of his images unquestionably influenced and intensified the photographic realism of his pictures and paintings. This was especially true in his extra-ordinary use of what in cinematography is called "deep focus," in which foreground and background objects possess an equal clarity, producing an effect that is sometimes hyper-realistic. This approach came into vogue in Hollywood in the early 1940s, due especially to the adventurous creativity of cinematographer Gregg Toland on William Wyler's *Little Foxes* and Orson Welles's *Citizen Kane.* Three of Rockwell's most striking uses of deep focus are found in his paintings *Boy in a Dining Car* (1946), *Shuffleton's Barbershop* (1950, fig. 1), and *Saying Grace* (1951), all three of which rank among his greatest works. Occasionally he would employ other cinematic techniques,

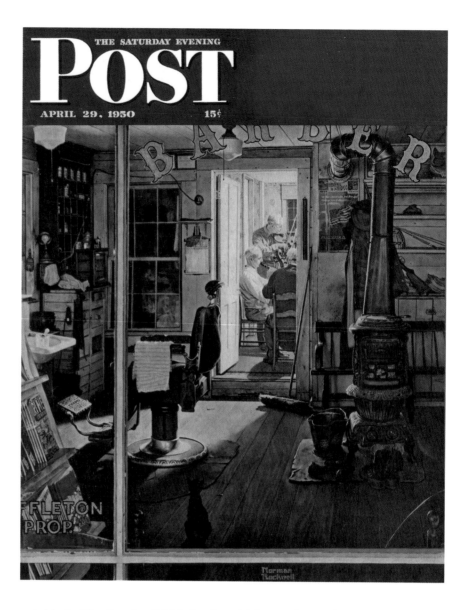

1

Shuffleton's Barbershop
The Saturday Evening Post,
April 29, 1950

notably in *The Gossips* (1948, fig. 2), which consists of fifteen individuals seen in twosomes: the sequence of "frames" conveying the progression of gossip from one person to another correlates precisely with the editing technique of montage.

In the simplest terms, the single trait that links Norman Rockwell, more than most other modern American painters, to filmmakers is his interest in human beings, depicted where they live, work, and play. Abstractions, still lifes, landscapes, starry skies, and empty city streets were not for him. This was a man whose original hero was Charles Dickens and who sought to evoke the human condition with methods similar to those of the English novelist, through vivid portraits of domestic settings, the central use of children, and heightened, often comic, caricature. The other line of temperamental influence comes straight down from Mark Twain, in terms of sense of humor and the view that, as Rockwell confided, "The commonplaces of America are to me the richest subjects in art."[9]

These were affinities shared or, at least, easily accepted by Hollywood producers and directors at the time. Notwithstanding his reputation as

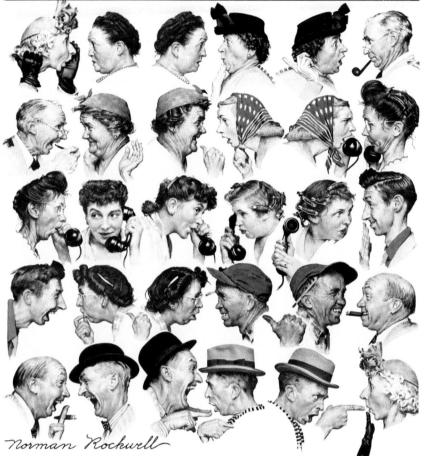

2
—

The Gossips

The Saturday Evening Post,
March 6, 1948

an old-fashioned, rural New Englander, Rockwell enjoyed considerable connections with Hollywood through employment, friendships, portrait subjects, and artistic outlook. He visited Los Angeles periodically, even frequently during the 1930s and 1940s, met and married his second wife there, taught at the Los Angeles County Art Institute (now the Otis College of Art and Design) in 1948 and 1949, and, perhaps unexpectedly for such a thoroughgoing Easterner, liked show people. As his biographer Laura Claridge put it, "Rockwell respected, in a slightly obstinate fashion, the open artificiality of the Hollywood crowd; people here didn't pretend to be something they weren't, since their jobs were all about role playing."[10]

Beginning with the amusing, cliché-tweaking painting of cowboy hero Gary Cooper's face being painted by a makeup man in 1930 (see p. 71), Rockwell painted many a star's portrait. He befriended Walt Disney, who asked the artist to make drawings of his daughters to hang in his office and later visited Rockwell in Vermont. Rockwell also executed everything from illustrations to full advertising campaigns for many major motion pictures, including *The Magnificent Ambersons* (1942), *The Song*

of Bernadette (1943), *The Razor's Edge* (1946), *Old Yeller* (1957), *Cinderfella* (1960), and the remake of *Stagecoach* (1966), in which he played a bit part.

The same year Rockwell produced the humorous *Gary Cooper as the Texan,* he also created an atypically downbeat illustration called *Hollywood Dreams* for a story in the *Ladies' Home Journal.* The picture depicts three people—an old woman; a forlorn, middle-aged ham actor type; and a young blonde with Mary Pickford curls—sitting on a bench in front of a movie casting office window displaying a "closed" sign. In a similarly depressive vein is the June 12, 1937, *Post* cover *Gaiety Dance Team* (fig. 3), which evokes the demise of the vaudeville era by having the couple that comprises the "Dolores & Eddie Gaiety Dance Team" sitting dejectedly, back to back, on a steamer trunk, a copy of *Variety* sticking out of Eddie's coat pocket. These portraits of frustration and unhappiness seem unsatisfactory not only because their glum tone doesn't much suit their maker, but also because they lack a dynamic either of physical action or emotional movement; they reflect stasis rather than actualization of an accomplishment or internal discovery. In contrast, an essentially contemporaneous painting with a similar subject and setting, Edward Hopper's *New York Movie* (1939) shows how little feel Rockwell had for the more subtle nuances of unrealized dreams and thwarted hopes. Hopper's masterpiece shows an alluring blonde movie-palace usher standing to the side of the theater, lost in her thoughts. Her solitariness creates an overwhelming sense of melancholy. Is she wishing she were up on the silver screen, or is she dreaming of a love lost or desired? An ineffable sense of hope unrealized and the mundane settled-for pulsates from this work in heartbreaking ways, even if it ostensibly shows a young woman waiting for the movie to end so she can get off work. It's a comparison to consider when assessing Rockwell's ultimate standing; he could very effectively tug the heartstrings, but he was not inclined to explore the dark rooms of melancholy or delve profoundly into the void.

A lighter, more conventional mood prevails in another of Rockwell's film-related illustrations. In *Two Girls Looking at Movie Star's Photo,* a *Post* cover of February 19, 1938, two young women sitting on a bed moon over a head shot of, it would appear, Robert Taylor. Sixteen years later, Rockwell reworked the same concept into a much more complex and telling picture. *Girl at Mirror* (1954, fig. 4) is a poignant portrait of a girl on the cusp of adolescence having just tried on lipstick (one guesses for the first time) as she ponders her face and future, a fan magazine featuring a photograph of Jane Russell lying in her lap and a toy doll fallen over next to the mirror. The picture is flush with insecurity, wonder, and fear of the unknown as the girl faces the end of childhood and the uncertainties of womanhood and a competitive world.

A rare curio among Rockwell's Hollywood-oriented illustrations is a charcoal and pencil sketch intended for a *Post* cover in September 1960. *Murder Mystery* shows six elegantly garbed individuals staring at the feet of a corpse sticking out past a table. A scene out of an Agatha Christie story, it depicts the surprised faces of Loretta Young, Ethel Barrymore, Richard

Widmark, Linda Darnell, Boris Karloff, and Clifton Webb; Van Johnson plays the victim, and Lassie is tossed in for good measure. It was a four-day job but, in the end, the *Post* didn't feel it was up to Rockwell's customary standards. The artist eventually agreed, regarding it as something of a cheap joke, perhaps even crude.[11]

Large swaths of human experience remained beyond either Rockwell's interest or artistic purview: violence and lurid urbanism were altogether absent, vulgarity as well, and eroticism was permitted very selectively, and then only in a discrete, "sexy librarian" kind of way. Even when depicting a scene with serious or dark overtones, he did it, he admitted, in a nice way. It was as if, unconsciously and born of his own temperament, Rockwell willed upon himself a personal censorship edict, an internalized version of Hollywood's famous Hays Code, which from 1934 to 1966 imposed strict rules as to what could and could not be shown in American movies. According to the production code, devised at the studios' behest by Will H. Hays, all manner of undesirable behavior—"low forms" of sexuality, profanity, nudity, criminal methods, drugs, and making fun of religious

3

Gaiety Dance Team
The Saturday Evening Post,
June 12, 1937

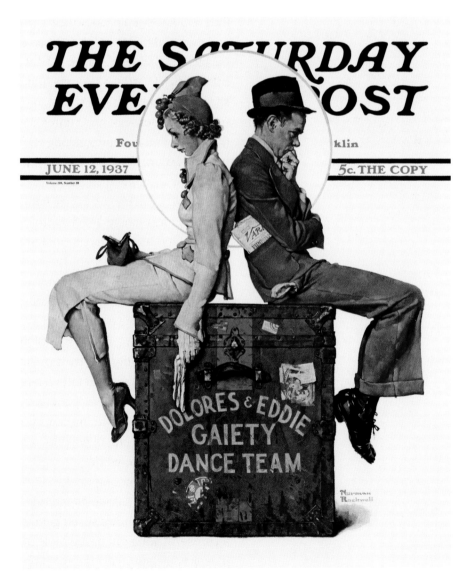

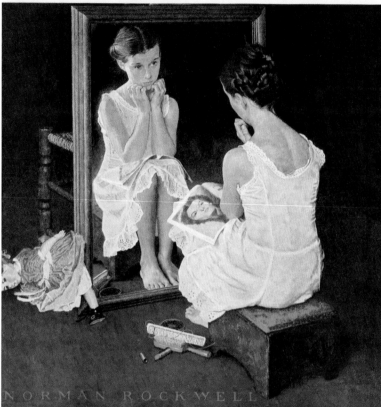

4

Girl at Mirror
The Saturday Evening Post,
March 6, 1954

figures—were forbidden, all under an umbrella, good-taste edict stipulating that "no picture shall be produced that will lower the standards of those who see it." Due to these restrictions, everything from gangsterism to married couples occupying the same bed were absent from American screens for a time. Still, within these rigid boundaries, thus-inclined filmmakers learned the power of suggestion, the inference-laden fade to black, and the trick of tagging a moralistic ending onto an otherwise sordid scenario. Impudent, clever filmmakers such as Billy Wilder, Howard Hawks, and Preston Sturges could so dazzle that the censors were sometimes unable to see what was right in front of their eyes. Wilder built his classics *Double Indemnity* (1944) and *Sunset Boulevard* (1950) around thoroughly unsavory central relationships. Hawks steamed up *To Have and Have Not* (1944) and *The Big Sleep* (1946) with sexual innuendo and double entendres that still seem racy. Sturges avoided the single bed problem by having Joel McCrea and Veronica Lake (disguised as a boy) spend the night in the hay in a freight car in *Sullivan's Travels* (1941) and had the drunken Betty Hutton get pregnant (with sextuplets, no less) by a man she can't remember in *The Miracle of Morgan's Creek* (1944).

An urban aesthete with a unique gift of putting eloquent dialogue into the mouths of lowbrows and tough guys, Sturges, on the basis of his wartime home front comedies *Hail the Conquering Hero* (1944) and *Morgan's Creek,* could be considered Hollywood's anti-Rockwell. Both films star comic actor Eddie Bracken, who, with his doofus personality, elastic face, and over-eager manner, bears more than a passing resemblance to Rockwell's wide-eyed World War II everyman, Willie Gillis. The small-town settings, with their patriotic trappings, front porch dwellers, and pervasive naïveté, would be right at home in Rockwell Country, but Sturges mercilessly sends up their hyperbolic boosterism just as, in the end, he celebrates them. Sturges had no stomach for cant, bunk, and the absence of skepticism, and he cast a dubious eye on the collective wisdom of the populist mob.

Sturges's subversive sophistication provided a comic antidote to one of the most successful directors of the era, Frank Capra, who, without question, was the Hollywood film director whose work most closely aligns with Rockwell's. "I wanted to glorify the average man, not the guy on top," Capra once acknowledged, "just the ordinary guy whose strength I admire."[12] It's a pithy summary that characterizes much of Rockwell's output as well, but there is more to the parallel. Born dirt poor in Sicily in 1897, three years after Rockwell came into the world, Capra embraced his

adoptive country with a fierce pride, convinced that only here was there boundless opportunity for one determined to become self-made. Although Capra didn't write his own screenplays (Robert Riskin was his most frequent writer), his major films were obsessed with the United States—its character, ideals, hopes, flaws, and infinite potential—and were populated by characters who represented distinctive aspects of it. Capra and Sturges vied for top honors in Hollywood for the fulsome use of great character actors. Of course, Hollywood was in the business of making inspirational pictures that promoted, even propagandized, American values. But Capra took this impulse to high levels of conviction and artistry. Capra's belief in the nation's fundamental virtues was so strong that he was not afraid to put his characters' belief in them on an anvil. Time and again, the faith his leading characters have in the essential rightness of their way of life is held to the fire, only to emerge intact, even strengthened in the process.

In *American Madness* (1932), a film made during the worst of the depression and that possesses an astonishing modern relevance, Walter Huston plays a banker who bets everything he has on his belief in the fundamental decency of his customers and, by extension, the average citizen. *Mr. Deeds Goes to Town* (1936) pits a simple New England fellow who inherits $20 million against the big-city leeches who would bleed him of it, especially after he announces his intention to give it away to the nation's "little men" who badly need it. *Mr. Smith Goes to Washington* (1939) is centered on yet another small-town man (whose pet concern back home is the "Boy Rangers") whom the Washington power brokers make and then try to break when their man doesn't play ball. *Meet John Doe* (1941) is the ultimate everyman story in which a bum off the street is cynically promoted as a hero by a newspaper and made the center of a national movement by powerful, crypto-fascist business interests. *It's a Wonderful Life* (1946) both celebrates the virtues of the ordinary man and dares to imagine what might happen to small-town life if mean-spirited business interests were to prevail over common decency. *State of the Union* (1948) illustrates the struggle of a big businessman to maintain his integrity while running for president.

More than is commonly remembered, Capra's films possess a dark underside. Democracy and personal decency will always be threatened, his work continuously reminds, and must be vigilantly safeguarded if we are to remain free. Rapacious profiteers, greedy lawyers, insipient fascists, and other societal despoilers lurk throughout Capra's significant films, which acknowledge these ominous forces far more than Rockwell's pictures ever do. But, according to Capra, the best defense is always the philosophical and legal pillars on which the nation was founded, and the clear, proper thinking of its ordinary citizens, who rise to the occasion when called upon to speak out publicly to proclaim what is right. Capra's heroes are, more often than not, American everymen and women, and it is here that he and Rockwell most importantly intersect. One of Rockwell's most famous works, *Freedom of Speech* (see p. 109), from the 1943 "Four

Freedoms" series, could be a definitive image from almost any of Capra's essential films, as it shows an ordinary man standing at a town meeting to say what's on his mind, with various citizens packed into the frame around him to listen with expectation and respect; the central figure is Mr. Deeds, Mr. Smith, John Doe, and George Bailey rolled into one.

While Capra responded artistically to World War II by supervising the "Why We Fight" documentaries, Rockwell created many pictures depicting the war as experienced on the home front—by workers, kids, parents, and loved ones waiting for the soldiers' return. Along with the "Freedom" quartet, the simplest, most eloquent and moving of these are his various depictions of homecomings. He had worked in this vein at the end of World War I, albeit in a comparatively obvious fashion. But his 1945 World War II series—including *The Homecoming, Homecoming Marine* (see pp. 119, 120), and *Thanksgiving: Mother and Son Peeling Potatoes* (fig. 5)— were all so fleshed out and piercing that they could have been scenes from movies. In their emotional impact, they anticipated the heart-stopping moment when Al Stephenson (played by Fredric March) quietly returns to his family after years at war in William Wyler's Oscar-winning *The Best Years of Our Lives* (1946).

Coincidentally or not, certain Rockwell works mirrored or prefigured some well-known motion pictures. The celebrated breakfast sequence depicting the cooling of the central character's marriage in *Citizen Kane* was partially imagined by Rockwell more than once, in such works as *The Breakfast Table* (1930) and *Breakfast Table Political Argument* (1948, fig. 6), which showed couples at odds over politics, newspapers in hand. *Elect Casey* (1958, see p. 165), centering on the exhausted loser of a local election, reverberates with echoes of John Ford's film of the same year, *The Last Hurrah,* about the final campaign of a Boston mayor. The idea for the recent hit film *Night at the Museum* (2006) could easily have been found in Rockwell's *Lunch Break with a Knight* (1962).

As the United States moved through the 1950s, a period unsatisfactorily generalized as a time of massive conformity, Rockwell's work for a while represented the kind of sanitized image of the country commonly seen on television—in *Father Knows Best* and *Leave It to Beaver*—and widely recycled today. Against his will, Rockwell for years had been forced to abide by a *Post* edict that no blacks other than servants or domestics could appear on the magazine's cover, and the virtually all-white populations in and around his residential towns in rural Vermont and Massachusetts did nothing to point him toward diversity in his models.[13] But with his run at the *Post* nearing an end—his last cover appeared there in 1963—Rockwell found his attention moving toward other publications and new subject matter.

The Problem We All Live With (see p. 180), which was published in *Look* on January 14, 1964, marked a stunning departure from anything Rockwell had ever done for the *Post.* A depiction of a black southern schoolgirl in a proper white dress being escorted along a sidewalk by three U.S. marshals in front of a wall scarred by racial epithets, this expression of overt social

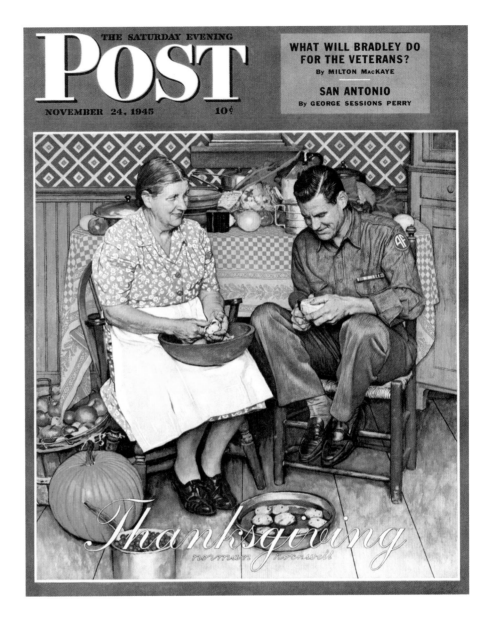

5

**Thanksgiving: Mother and Son
Peeling Potatoes**
The Saturday Evening Post,
November 24, 1945

consciousness seemed like a liberation from the constraints placed upon him at his old home base. *Southern Justice,* painted the following year, is a powerful, atypically edgy and roughhewn evocation of the murder of civil rights workers in the South, while *New Kids in the Neighborhood,* an illustration for *Look* in 1967, shows three white children gawking as a black boy and girl arrive at their new home for the first time, a moving van in the background. Rockwell had always been sensitive to social currents and the winds of history, but while at the *Post* he had never grappled with them in ways that might ruffle the feathers of the magazine's conservative-leaning readership. Now, in his seventies, the old-school, New England traditionalist had become preoccupied by civil rights in a parallel way with Hollywood, which was gradually awakening to topics it had long avoided, specifically racism and integration. Slowly in the 1950s and more noticeably in the 1960s, American movies began featuring black characters in realistic parts other than just as domestics or background figures, and Hollywood started making issue-related pictures on racial themes.

Mostly made by prominent liberal filmmakers, such as Stanley Kramer, Otto Preminger, Richard Brooks, and Martin Ritt, known for making respectable films about significant subjects and powerful enough to push through films others perhaps could not, these films included *The Blackboard Jungle* (1955), about juvenile delinquency in schools; *The Defiant Ones* (1958), a big hit starring Tony Curtis and Sidney Poitier as two escaped prisoners handcuffed together as they elude authorities in the South; *Carmen Jones* (1954), an all-black rendition of Bizet's opera; and two more with Poitier, *In the Heat of the Night* (1967), about a Northern black detective come south to help investigate a murder, and *Guess Who's Coming to Dinner* (1967), an all-star comedy-drama about a white woman bringing a black man home to meet her elderly parents. Then there were the occasional independent, low-budget films, such as *One Potato, Two Potato* (1964), concerning an interracial marriage; *Nothing but a Man* (1964), about black workers in the South; and *Black Like Me* (1964), in which a white reporter passed for black to relate experiences of prejudice.

Serious, sometimes powerful, and often too earnest by half, these films were not radical or incendiary but pushed things about as far as mainstream white audiences were willing to be taken at the time. The same could be said for Rockwell, who knew his public, felt motivated to address certain topics, and impressively stepped outside his previously imposed boundaries to do so.

Just as Rockwell's career was winding down in the 1970s, two young directors, both of them Rockwell fans, emerged on the scene. Steven Spielberg said, "Aside from being an astonishingly good storyteller, Rockwell spoke volumes about a certain kind of American morality."[14] By this, Spielberg would seem to be referring to the traditional, patriotic, decent, small-town virtues expressed in so many ways throughout his artworks—the sorts of traits that, when put to the test by crisis, inspire citizens to rise to the occasion and do the right thing to defeat any threat to their ordinary existence. Consciously or not, Spielberg transferred the Rockwell world of safe, modest-sized towns where kids are free to roam to the more anonymous, nondescript suburbs in which Spielberg grew up, namely bedroom communities in the West. He also introduced the modern and, for him, personal elements of divorce, fractured families, and kids who are to some extent ignored by adults, the better, in some cases, to allow the flowering of an active imagination and fantasy life. Historian Karal Ann Marling advanced the important insight that it is the very Rockwell-like qualities of the communities in Spielberg's films—old-fashioned, stable, unthreatened—"that makes the incursion of Spielberg's alien forces so terrifying;" the "timeless and true" aspects of Rockwell's world mark them, in the filmmaker's hands, as "something always on the verge of destruction."[15] This is emphatically the case, not only in *Jaws,* in which Martha's Vineyard is terrorized by a giant shark, but in his key science-fiction and horror films, *Close Encounters of the Third Kind, E.T.: The Extra-Terrestrial, Poltergeist,* and *War of the Worlds.* In these instances, as well as in many of the major

films he produced but did not direct, including the "Back to the Future" and "Gremlins" series, the communities involved are middle or working class, and children are at the center of the response to the threat.

It can hardly escape notice that the logo for DreamWorks, the company founded by Spielberg, David Geffen, and Jeffrey Katzenberg, bears a pronounced Rockwell feel. The logo depicts a young boy fishing into the clouds from the edge of a crescent moon. Rockwell composed many fishing scenes over the years, but the 1958 charcoal-on-paper sketch *Boy and Dog: Boy Fishing* is a convincingly close match with the DreamWorks insignia.

The throwback, boys' adventure ethos that permeated Lucas and Spielberg's "Indiana Jones" series can be traced directly back to the iconographic images Rockwell created for *Boys' Life* magazine early in his career and for Boy Scout calendars for decades. Simply because the hero was younger and the time period earlier, the scouting connection was even more pronounced in the television series the *Adventures of Young Indiana Jones,* which Lucas supervised without Spielberg.

6

Breakfast Table Political Argument
The Saturday Evening Post,
October 30, 1948

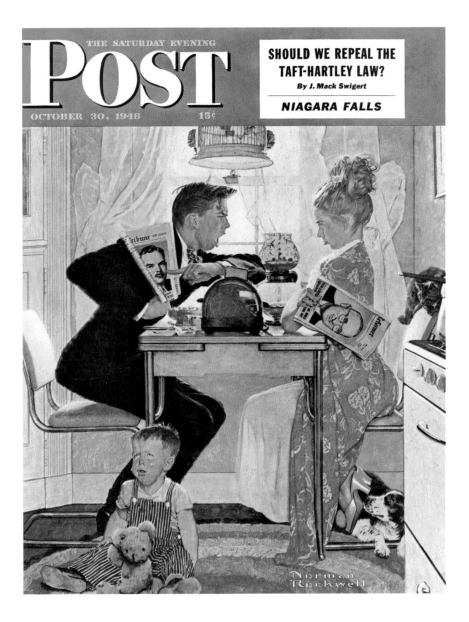

7

The Land of Enchantment
Story illustration for
The Saturday Evening Post,
December 22, 1934

Although the direct link with Rockwell may not be as immediately apparent with Lucas as it is with Spielberg, a case could be made for Lucas's breakthrough picture *American Graffiti* as the last pure, unmediated, non-revisionist "Rockwell film" ever made. Released in 1973, it is set in 1962 in a small California town and both evokes and expresses the sort of "innocent," unthreatening, and uncommodified image of adolescence that had prevailed in the United States up to the early 1960s but was on the cusp of changing. In these decent, fun-seeking, eager high school graduates, particularly those played by Ronny Howard (before he became Ron), Charlie Martin Smith, and Cindy Williams, one could clearly see the same American youth Rockwell had been depicting since early in the century but who were about to become either extinct or retrograde resisters of cultural trends. These kids, living in their cocoon entirely apart from parents and the outside world, are untouched by anything other than their own concerns and remain relatively unassertive members of society. Within two years, the tectonic shift would occur, with teenagers moving center stage for the first time, with the Beatles, Vietnam, drugs, hippies, and protest. It's not so

much a sense of innocence that connects *American Graffiti* with Rockwell, but rather the notion of existing in one's insular world, where what goes on means everything to those involved and nothing at all to anyone else. Looking back at youth often carries a wistful nostalgia for an allegedly simpler time, but with Lucas's film, the feeling is genuine because it's positioned in the immediate calm before the whirlwind. It is set in the very world that, little more than a decade after the film was made, would be idealized as a desirable past in Roert Zemeckis's Spielberg-produced *Back to the Future.*

Since then, of course, Lucas has mostly devoted himself to the cultural phenomenon known as *Star Wars,* and it would be stretch to suggest that the fantastical events that unfold in that world so far, far away bear much relation to the entirely down-to-earth preoccupations of Norman Rockwell. However, the bodies of work produced by George Lucas and Steven Spielberg, far more than those of anyone else since Walt Disney, actually embody the meaning of a Rockwell illustration called *The Land of Enchantment* (fig.7), which he created for the *Saturday Evening Post* in 1934. It shows two kids lying on their stomachs enthusiastically reading while an enormous mural of exotic adventure hovers behind them like a giant movie screen. The picture may specifically evoke the power of the written word to transport the reader to another realm, but, because it is a visual work itself, it potently suggests the elemental appeal of motion pictures that imaginatively convey the viewer to another time and place. Lucas and Spielberg revived this concept of cinema so seriously and successfully that it changed the direction that Hollywood movies took from the mid-1970s onward. For both men, as it was for Norman Rockwell, it's a case of a boyhood-fixed imagination bearing the most wondrous fruit.

1 Norman Rockwell, as told to Tom Rockwell, *Norman Rockwell: My Adventures as an Illustrator* (New York: Abrams, 1988), 293.

2 Peter Bogdanovich, *Pieces of Time: Peter Bogdanovich on the Movies* (New York: Arbor House/Esquire Book, 1973), 140.

3 Karal Ann Marling, *Norman Rockwell* (New York: Abrams in association with the National Museum of American Art, Smithsonian Institution, 1997), 111.

4 Ibid.

5 Christopher Finch, *102 Favorite Paintings by Norman Rockwell* (New York: Crown, 1978), 124.

6 Thomas Hoving, "The Great Art Communicator" in *Norman Rockwell: Pictures for the American People,* ed. Maureen Hart Hennessey and Anne Knutson, 30 (New York: Abrams, 1999).

7 Norman Rockwell, *Rockwell on Rockwell: How I Make a Picture* (New York: Watson-Guptill in cooperation with Famous Artists School, 1979). This book is based on Rockwell's previously unpublished manuscript "How I Make a Picture," developed as part of his affiliation with Famous Artists School. The quotation comes from the chapter headings of this book.

8 Ibid., 117.

9 Norman Rockwell, "Commonplace," *American Magazine,* May 1936, 11. Cited in Laurie Norton Moffatt, "The People's Painter" in *Norman Rockwell: Pictures for the American People,* ed. Maureen Hart Hennessey and Anne Knutson, 24 (New York: Abrams, 1999).

10 Laura Claridge, *Norman Rockwell: A Life* (New York: Random House, 2001), 224.

11 Rockwell, *My Adventures,* 345–47.

12 Joseph McBride, *Frank Capra: The Catastrophe of Success* (New York: Simon & Schuster, 1992), 257–58.

13 Richard Reeves, "Norman Rockwell Is Exactly Like a Norman Rockwell," *New York Times Magazine,* Feb. 28, 1971, 42. Cited in Judy L. Larson and Maureen Hart Hennessey, "Norman Rockwell: A New Viewpoint" in *Norman Rockwell: Pictures for the American People,* ed. Maureen Hart Hennessey and Anne Knutson, 43 (New York: Abrams, 1999).

14 Stephen J. Dubner, "Steven the Good," *New York Times Magazine,* Feb. 14, 1999, SM38.

15 Marling, *Norman Rockwell,* 7–8.

For Further Reading

A dizzying number of books and articles have been published on Norman Rockwell and his art. Some are picture books with brief commentaries; others pair his work with poetry, patriotic songs, even recipes. Some trace specific themes—World War II or Christmas, for example—while others are designed to help children learn their ABCs. Among the publications written for the serious student of Rockwell, Laurie Norton Moffatt's two-volume *Norman Rockwell: A Definitive Catalogue* (1986), which lists all the paintings, drawings, and preliminary studies known at the time of publication, stands out. Karal Ann Marling's *Norman Rockwell* (1997), written for the "Library of American Art" series (Abrams), is a smart and eminently readable monograph that includes a highly useful chronology. Laura Claridge drew on extensive interviews with Rockwell's family, friends, colleagues, and models for her biography *Norman Rockwell: A Life* (2001). And Rockwell told his own story in the anecdotal autobiography *Norman Rockwell: My Adventures as an Illustrator* (1960). Also noteworthy are the exhibition catalogues *American Chronicles: The Art of Norman Rockwell* (2007), which includes a listing of exhibitions in which Rockwell's work has appeared, and *Norman Rockwell: Pictures for the American People* (1999). The archives at the Norman Rockwell Museum in Stockbridge, Massachusetts, holds an extensive collection of newspaper clippings, magazine tear sheets, photographs, and correspondence, as well as Rockwell's personal library, the balopticon he used to project images onto canvas, and copies of many of the radio and television programs in which he appeared.

Books by Norman Rockwell

Rockwell, Norman, as told to Thomas Rockwell. *Norman Rockwell: My Adventures as an Illustrator*. Stockbridge, MA: Norman Rockwell Museum in association with Abrams, 1994.

Rockwell, Norman. *Rockwell on Rockwell: How I Make a Picture*. New York: Watson-Guptill in cooperation with Famous Artists School, 1979.

———. *A Visit with Norman Rockwell and the Saturday Evening Post*. New York: Four S Corp, 1976.

Rockwell, Norman, and Molly Punderson Rockwell. *Willie Was Different: The Tale of an Ugly Thrushling*. New York: Funk & Wagnalls, 1969.

Films about Rockwell

Norman Rockwell: An American Portrait. View Video, Art Series, 2004. DVD.

Norman Rockwell: Painting America. Dir. Elena Mannes. American Masters Production, 1999. DVD.

Norman Rockwell's World ... An American Dream. Dir. Robert Deubel. Narr. Norman Rockwell. Concepts United, 1972. DVD.

Articles and Books about Rockwell

Adato, Allison. "The People in the Pictures." *Life,* July 1993, 83–91.

Alexander, Jack. "Cover Man." *Saturday Evening Post,* Feb. 13, 1943, 16–17, 37, 39, 41.

Beem, Edgar Allen. "A Rockwell Renaissance?" *Artnews* 98, no. 8 (Sept. 1999): 134–37.

Belgrad, Daniel. "The Rockwell Syndrome." *Art in America* 88, no. 4 (April 2000): 61–63, 65, 67.

Bogart, Michele H. "Norman Rockwell, Public Artist." In *The Arts of Democracy: Art, Public Culture, and the State,* edited by Casey Nelson Blake. Washington, DC and Philadelphia: Woodrow Wilson Center Press and University of Pennsylvania Press, 2007.

Brookeman, C. E. "Norman Rockwell and the *Saturday Evening Post:* Advertising, Iconography and Mass Production, 1897–1929." In *Art Apart: Art Institutions and Ideology Across England and North America,* edited by Marcia Pointon. Manchester, UK, and New York: Manchester University Press, 1994.

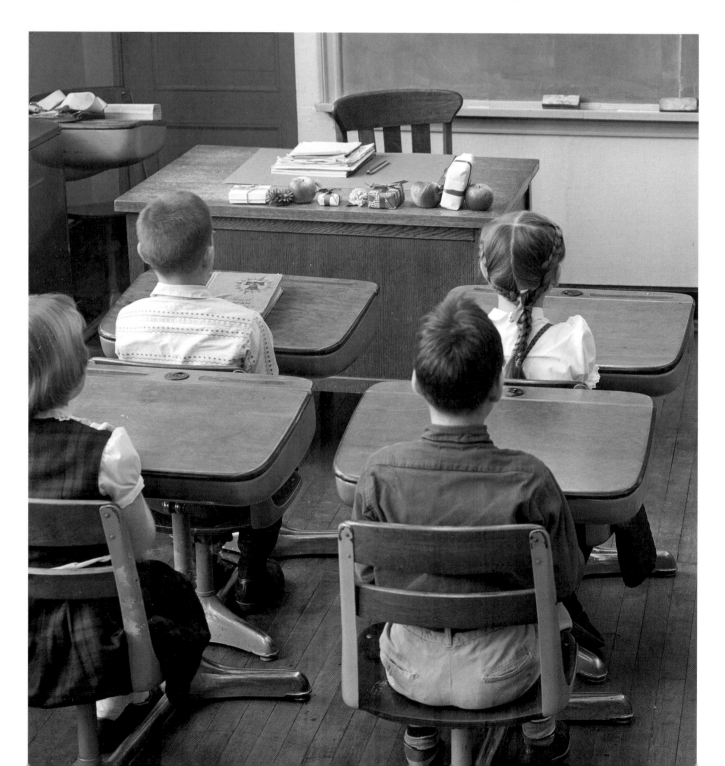

Buechner, Thomas S. *Norman Rockwell, Artist and Illustrator*. New York: Abrams, 1970.

Cave, Damien. "Rockwell Re-Enlisted for a Nation's Darker Mood." *New York Times,* July 9, 2008, http://www.nytimes.com/ 2008/07/09/arts/design/09rock.html.

Ceglio, Clarissa J. "Complicating Simplicity." *American Quarterly* 54, no. 2 (June 2002): 279–306.

Claridge, Laura. *Norman Rockwell: A Life*. New York: Random House, 2001.

Dabakis, Melissa. "Gendered Labor: Norman Rockwell's *Rosie the Riveter* and the Discourses of Wartime Womanhood." In *Gender and American History Since 1890,* edited by Barbara Melosh. New York: Routledge, 1993.

Danto, Arthur C. "Age of Innocence: Norman Rockwell." *Nation,* Jan. 7, 2002, 47–50.

DeMott, Benjamin. "When We Were Young and Poor." Review of *Norman Rockwell: My Adventures as an Illustrator. Nation,* Apr. 2, 1960, 299–300.

De Young, Gregg. "Norman Rockwell and American Attitudes Toward Technology." *Journal of American Culture* 13, no. 1 (March 1990): 95–103.

Ensor, Allison R. "Norman Rockwell Sentimentality: The Rockwell Illustrations for *Tom Sawyer* and *Huckleberry Finn*." In *The Mythologizing of Mark Twain,* edited by Sara deSaussure Davis and Philip D. Beidler. Tuscaloosa, AL: University of Alabama Press, 1984.

Faison, S. Lane, Kenneth Stuart, and Thomas S. Buechner. *The Norman Rockwell Album*. Garden City, NY: Doubleday, 1961.

Finch, Christopher. *Norman Rockwell: 332 Magazine Covers*. New York: Abbeville Press, 1979.

———. *Norman Rockwell's America.* New York: Abrams, 1975.

Forsythe, Clyde. "Norman Rockwell." *Saturday Evening Post*, Dec. 8, 1926, 34.

Goffman, Judy, Davide Faccioli, and Manuel Teatini, eds. *Norman Rockwell.* Milan, Italy: Electa, 1990.

Goodyear, Anne Collins. "On the Threshold of Space: Norman Rockwell's *Longest Step*." In *2001: Building for Space Travel,* edited by John Zukowsky. New York: Abrams in association with the Art Institute of Chicago, 2001.

Graebner, William. "Norman Rockwell and American Mass Culture: The Crisis of Representation in the Great Depression." *Prospects* 22 (1997): 323–56.

Greenhill, Jennifer. "The View from Outside: Rockwell and Race in 1950." *American Art* 21, no. 2 (Summer 2007): 70–95.

Guptill, Arthur L. *Norman Rockwell, Illustrator*. 3rd ed. New York: Watson-Guptill, 1970.

Halpern, Richard. *Norman Rockwell: The Underside of Innocence*. Chicago: University of Chicago Press, 2006.

Hart-Hennessey, Maureen, and Anne Knutson, eds. *Norman Rockwell: Pictures for the American People*. New York: Abrams, 1999.

Hickey, Dave. "America's Vermeer." *Vanity Fair,* Nov. 1999, 172, 174, 177–78, 180.

Hillcourt, William. *Norman Rockwell's World of Scouting*. New York: Abrams, 1977.

Hughes, Robert. "The Rembrandt of Punkin Crick." *Time*, Nov. 20, 1978, 110.

"I Like to Please People." *Time,* June 21, 1943, 41–42.

Jarman, Rufus. "U.S. Artist." *New Yorker,* March 17, 1945, 34–38, 41–42, 44–45.

———. "U.S. Artist–II." *New Yorker,* March 24, 1945, 36–40, 43–44, 46–47.

Kamp, David. "Norman Rockwell's American Dream." *Vanity Fair*, Nov. 2009, 190–205.

Kimmelman, Michael. "Renaissance for a 'Lightweight.'" *New York Times*, Nov. 7, 1999, AR1, 54.

Marling, Karal Ann. *Norman Rockwell.* New York: Abrams in association with the National Museum of American Art, Smithsonian Institution, 1997.

Mendelson, Andrew. "Slice-of-life Moments as Visual 'Truth': Norman Rockwell, Feature Photography, and American Values in Pictorial Journalism." *Journalism History* 29, no. 4 (Winter 2004): 166–78.

Meyer, Susan E. *Norman Rockwell's People.* New York: Abrams, 1981.

———. *Norman Rockwell's World War II: Impressions from the Homefront.* San Antonio: USAA Foundation, 1991.

Moffatt, Laurie Norton. *Norman Rockwell: A Definitive Catalogue*. 2 vols. Stockbridge, MA: Norman Rockwell Museum, 1986.

Morris, Wright. "Norman Rockwell's America." *Atlantic Monthly*, Dec. 1957, 133–36, 138.

Murray, Stuart, and James McCabe. *Norman Rockwell's Four Freedoms: Images that Inspire a Nation*. Stockbridge, MA: Norman Rockwell Museum, 1993.

Nelson, Derek. *The Ads That Won the War.* Osceola, MN: Motorbooks International, 1992.

Nemerov, Alexander. "Coming Home in 1945: Reading Robert Frost and Norman Rockwell." *American Art* 18, no. 2 (Summer 2004): 59–79.

"Norman Rockwell: Painter for America's Millions." *American Artist*, May 1940, 11–16.

Olson, Lester C. "Portraits in Praise of a People: A Rhetorical Analysis of Norman Rockwell's Icons in Franklin D. Roosevelt's 'Four Freedoms' Campaign." *Quarterly Journal of Speech* 69 (1983): 15–24.

Pero, Linda Szekely. *American Chronicles: The Art of Norman Rockwell*. Stockbridge, MA: Norman Rockwell Museum, 2007.

————. "Freedom: Norman Rockwell's Vermont Years." *American Art Review* 15, no. 5 (2003): 152–59, 192.

Plagens, Peter. "Norman Rockwell Revisited: Long Thought to Be a Painter Just for Squares, the Master of Feel-Good Americana Gets a Modern Makeover as His Work Is Shown in Atlanta." *Newsweek*, Nov. 15, 1999, http://www.newsweek.com/id/90208.

Richard, Paul. "Norman Rockwell, American Master—(Seriously!)." *Washington Post*, June 6, 1993, G1, G8–9.

Robertson, Stewart. "He Paints the Town." *Family Circle*, March 6, 1942, 20–21, 26–28.

Rosenblum, Robert. "High Anxiety? Revisiting the 'Bad Art' Issue." *Art Papers Magazine* 24, no. 2 (March–April 2000): 24–25.

Schick, Ron. *Norman Rockwell: Behind the Camera*. Boston: Little, Brown, 2009.

Schjeldahl, Peter. "Fanfares for the Common Man: Norman Rockwell Reconsidered." The Art World. *New Yorker*, Nov. 22, 1999, 190–93, 196.

Segal, Eric. J. "Norman Rockwell and the Fashioning of American Masculinity." *Art Bulletin* 78, no. 4 (Dec. 1997): 633–46, 755.

Stoltz, Donald Robert, Marshall Louis Stoltz, and William F. Earle. *The Advertising World of Norman Rockwell*. New York: Harrison House, 1985.

Stoltz, Donald Robert, and Marshall L. Stoltz. *Norman Rockwell and the Saturday Evening Post*. 2 vols. New York: MJF Books, 1994.

Updike, John. "An Act of Seeing: Looking Back Through the Window of His Magazine Covers to Norman Rockwell's Silver Age." *Art and Antiques*, Dec. 1990, 93–99.

Wallach, Alan. "Norman Rockwell at the Guggenheim." In *Art and Its Publics: Museum Studies at the Millennium*, edited by Andrew McClellan. Malden, MA: Blackwell, 2003.

————. "The Norman Rockwell Museum and the Representation of Social Conflict." In *Seeing High and Low: Representing Social Conflict in American Visual Culture*, edited by Patricia Johnston. Berkeley: University of California Press, 2006.

Walton, Donald. *A Rockwell Portrait: An Intimate Biography*. Kansas City: Sheed, Andrews and McMeel, 1978.

The Saturday Evening Post and American Magazine History

Cohn, Jan. *Covers of the Saturday Evening Post: Seventy Years of Outstanding Illustration from America's Favorite Magazine*. New York: Viking, 1995.

————. *Creating America: George Horace Lorimer and the Saturday Evening Post*. Pittsburgh: University of Pittsburgh Press, 1989.

"Cutback at Curtis: Saturday Evening Post, After a Long and Stormy Search for a New Image, Will Attempt a New Life as a Biweekly." *Wall Street Journal*, Nov. 16, 1964, 4.

Damon-Moore, Helen. *Magazines for the Millions: Gender and Commerce in the* Ladies' Home Journal *and the* Saturday Evening Post, *1880–1910*. Albany: State University of New York Press, 1994.

Doss, Erika, ed. *Looking at* Life *Magazine*. Washington, DC: Smithsonian Institution Press, 2001.

Friedrich, Otto. *Decline and Fall*. New York: Harper & Row, 1970.

Goulden, Joseph C. *The Curtis Caper*. New York: Putnam, 1965.

Kozol, Wendy. Life*'s America: Family and Nation in Postwar Photojournalism*. Philadelphia: Temple University Press, 1994.

Leaming, Deryl Ray. *A Biography of Ben Hibbs*. Ph.D. diss., Syracuse University, 1969. Ann Arbor, MI: University Microfilms, 1969.

Little, Stuart W. "Are Illustrators Obsolete?" *Saturday Review,* July 10, 1971, 40–44.

Meyer, Susan E. *America's Great Illustrators*. New York: Abrams, 1978.

Tebbel, John William. *George Horace Lorimer and the Saturday Evening Post.* Garden City, NY: Doubleday, 1948.

Tebbel, John William, and Mary Ellen Zuckerman. *The Magazine in America, 1741–1990.* New York: Oxford University Press, 1991.

Wood, James Playsted. *The Curtis Magazines.* New York: Ronald Press, 1971.

American Life and Culture

Aulich, James. *War Posters: Weapons of Mass Communication.* New York: Thames & Hudson, 2007.

Cameron, Ardis, ed. *Looking for America: The Visual Production of Nation and People.* Malden, MA: Blackwell, 2005.

Carlson, Allan. *The "American Way": Family and Community in the Shaping of the American Identity.* Wilmington, DE: ISI Books, 2003.

Cassidy, Marsha F. "Sob Stories, Merriment, and Surprises: The 1950s Audience Participation Show on Network Television and Women's Daytime Reception." In *Feminist Television Criticism, A Reader.* 2nd ed. Edited by Charlotte Brunsdon and Lynn Spigel. Berkshire, UK: Open University Press, 2008.

Cobble, Dorothy Sue. *The Other Women's Movement: Workplace Justice and Social Rights in Modern America.* Princeton, NJ: Princeton University Press, 2004.

Cross, Gary. *Kids' Stuff: Toys and the Changing World of American Childhood.* Cambridge, MA: Harvard University Press, 1997.

———. *The Cute and the Cool: Wondrous Innocence and Modern American Children's Culture.* New York: Oxford University Press, 2004.

Frascina, Francis. "*The New York Times,* Norman Rockwell and the New Patriotism." *Journal of Visual Culture* 2, no. 1 (2003): 99–130.

Fultz, Jay. *In Search of Donna Reed.* Iowa City: University of Iowa Press, 1998.

Hans, Valerie P., and Neil Vidmar. *Judging the Jury.* New York: Plenum Press, 1986.

Gabor, Mark. *Art of the Calendar.* New York: Crown, 1976.

Hawes, Joseph M. *Children Between the Wars: American Childhood, 1920–1940.* New York: Twayne in association with Prentice Hall, 1997

Holt, Marilyn Irvin. *The Orphan Trains: Placing Out in America.* Lincoln: University of Nebraska Press, 1992.

Kitch, Carolyn. *The Girl on the Magazine Cover: The Origins of Visual Stereotyping in American Mass Media.* Chapel Hill: University of North Carolina Press, 2001.

Leeuwen, Thomas A. P. van. *The Springboard in the Pond: An Intimate History of the Swimming Pool.* Edited by Helen Searing. Cambridge, MA: MIT Press, 1998.

MacLeod, David I. *The Age of the Child: Children in America, 1890–1920.* New York: Twayne in association with Prentice Hall, 1998.

———. *Building Character in the American Boy: The Boy Scouts, YMCA, and Their Forerunners, 1870–1920.* Madison: University of Wisconsin Press, 1983.

Pisano, Dominick A., and F. Robert van der Linden. *Charles Lindbergh and the Spirit of St. Louis.* Washington, DC: National Air and Space Museum in association with Abrams, 2002.

Rugh, Susan Sessions. *Are We There Yet? The Golden Age of American Family Vacations.* Lawrence: University Press of Kansas, 2008.

West, Elliott. *Growing Up in Twentieth-Century America: A History and Reference Guide.* Westport, CT: Greenwood Press, 1996.

Wiltse, Jeff. *Contested Waters: A Social History of Swimming Pools in America.* Chapel Hill: University of North Carolina Press, 2007.

Movies and Television

Balio, Tino. *Grand Design: Hollywood as a Modern Business Enterprise, 1930–1939*. Vol. 5 of *History of the American Cinema*. Edited by Charles Harpole. New York: Scribner, 1993.

Baxter, John. *Mythmaker: The Life and Work of George Lucas*. New York: Avon Books, 1999.

Bohn, Thomas William. *An Historical and Descriptive Analysis of the "Why We Fight" Series*. New York: Arno Press, 1977.

Capra, Frank. *The Name Above the Title*. New York: Macmillan, 1971.

Chopra-Gant, Mike. *Hollywood Genres and Postwar America: Masculinity, Family and Nation in Popular Movies and Film Noir*. New York: I. B. Tauris, 2006.

Clapp, James A. "Growing Up Urban: The City, the Cinema, and American Youth." *Journal of Popular Culture* 40, no. 4 (Aug. 2007): 601–29.

Crafton, Donald. *The Talkies: American Cinema's Transition to Sound, 1926–1931*. Vol. 4 of *History of the American Cinema*. Edited by Charles Harpole. New York: Scribner, 1997.

Dickinson, Greg. "The *Pleasantville* Effect: Nostalgia and the Visual Framing of (White) Suburbia." *Western Journal of Communication* 70, no. 3 (July 2006): 212–33.

Dixon, Wheeler Winston, ed. *American Cinema of the 1940s: Themes and Variations*. New Brunswick, NJ: Rutgers University Press, 2006.

Doss, Erika Lee. *Regionalists in Hollywood: Painting, Film, and Patronage, 1925–1945*. Ph.D. diss., University of Minnesota, 1983. Ann Arbor, MI: University Microfilms, 1985.

Dubner, Stephen J. "Steven the Good." *New York Times Magazine*, Feb. 14, 1999, SM38–43, 62, 66, 75.

Edwards, Gavin. "The Cult of Darth Vader: George Lucas Takes Us Behind the Mask of the Great Villain in Movie History." *Rolling Stone*, May 19, 2005, http://www.rollingstone.com/news/story/7314866/the_cult_of_darth_vader.

Farber, Stephen. "George Lucas: The Stinky Kid Hits the Big Time." *Film Quarterly* 27, no. 3 (Spring 1974): 2–9.

Goodwin, Christopher. "He's Got the Whole World in his Hands." *New York Times*, June 19, 2005, http://entertainment.timesonline.co.uk/tol/arts_and_entertainment/film/article534416.ece.

Haralovich, Mary Beth. "Sitcoms and Suburbs: Positioning the 1950s Homemaker." *Quarterly Review of Film and Video* 11, no. 1 (1989): 61–83.

Jacobs, Lewis. *The Movies as Medium*. New York: Farrar, Straus and Giroux, 1970.

———. *The Rise of the American Film: A Critical History*. New York: Teachers College Press, Columbia University, 1968.

Kline, Sally, ed. *George Lucas Interviews*. Jackson: University of Mississippi Press, 1999.

Koszarski, Richard. *An Evening's Entertainment: The Age of the Silent Feature Picture, 1915–1928*. Vol. 3 of *History of the American Cinema*. Edited by Charles Harpole. New York: Scribner, 1990.

Leibman, Nina C. *Living Room Lectures: The Fifties Family in Film and Television*. Austin: University of Texas Press, 1995.

Lloyd, Justine, and Lesley Johnson. "The Three Faces of Eve: The Post-war Housewife, Melodrama, and Home." *Feminist Media Studies* 3, no. 1 (2003): 7–25.

Maland, Charles J. *Chaplin and American Culture: The Evolution of a Star Image*. Princeton, NJ: Princeton University Press, 1989.

Manthorne, Katherine. "John Sloan's Moving-Picture Eye." *American Art* 18, no. 2 (Summer 2004): 80–95.

McBride, Joseph. *Steven Spielberg: A Biography.* New York: Simon & Schuster, 1997.

O'Connor, John E., ed. *Image as Artifact: The Historical Analysis of Film and Television.* Malabar, FL: Robert E. Krieger, 1990.

Poague, Leland A. *The Cinema of Frank Capra: An Approach to Film Comedy.* New York: A. S. Barnes, 1975.

Pomerance, Murray. *American Cinema of the 1950s: Themes and Variations.* New Brunswick, NJ: Rutgers University Press, 2005.

Schatz, Thomas. *Boom and Bust: The American Cinema of the 1940s.* Vol. 6 of *History of the American Cinema.* Edited by Charles Harpole. New York: Scribner, 1997.

Sklar, Robert. *Movie-Made America: A Cultural History of American Movies.* New York: Vintage Books, 1975.

Sklar, Robert, and Vito Zagarrio, eds. *Frank Capra: Authorship and the Studio System.* Philadelphia: Temple University Press, 1998.

Taylor, Ella. *Prime-Time Families: Television Culture in Postwar America.* Berkeley: University of California Press, 1989.

Tomasulo, Frank P. "The Gospel According to Spielberg in *E.T.: The Extra-Terrestrial.*" *Quarterly Review of Film and Video* 18, no. 3 (2001): 273–82.

Windolf, Jim. "Keys to the Kingdom." *Vanity Fair*, Feb. 2008, 116–23, 168–69. http://www.vanityfair.com/culture/features/2008/02/indianajones200802.

List of Illustrations

Rockwell rarely, if ever, named or dated his paintings and drawings. As a result many of his images are known by multiple titles. Titles of works on the following list are those used by Moffatt in *Norman Rockwell: A Definitive Catalogue*. Dates of paintings and drawings coincide with year of publication. Dimensions are given in inches with height preceding width.

All images from the *Saturday Evening Post* are available at www.curtispublishing.com.

* indicates artworks included in the exhibition

"Norman Rockwell's Camera Eye"

For Further Reading

Index

Index

Telling Stories

Norman Rockwell from the Collections of
George Lucas and Steven Spielberg

Published in conjunction with an exhibition of the same name,
on view at the Smithsonian American Art Museum, in
Washington, D.C., from July 2, 2010, through January 2, 2011.

Chief of Publications: Theresa J. Slowik
Editor: Tiffany D. Farrell
Designer: Karen Siatras
Production Assistant: Megan C. Krefting
Editorial Support: Jane McAllister
Photo Researcher: Deborah A. Earle

The Smithsonian American Art Museum is home to one of the
largest collections of American art in the world. Its holdings—
more than 41,000 works—tell the story of America through the
visual arts and represent the most inclusive collection of
American art in any museum today. It is the nation's first federal
art collection, predating the 1846 founding of the Smithsonian
Institution. The museum celebrates the exceptional creativity of
the nation's artists, whose insights into history, society, and the
individual reveal the essence of the American experience.

For more information or a catalogue
of publications, write:

Office of Publications
Smithsonian American Art Museum
MRC 970, PO Box 37012
Washington, DC 20013-7012

Visit the museum's Web site at
AmericanArt.si.edu.

 Smithsonian American Art Museum

Typeset in Leawood, Optima, and Gloucester
Extra Condensed and printed on Furioso paper
by Artegrafica in Verona, Italy.

Library of Congress Cataloging-in-Publication Data

Mecklenburg, Virginia M. (Virginia McCord), 1946–
Telling stories : Norman Rockwell from the collections of
George Lucas and Steven Spielberg / Virginia M. Mecklenburg,
Todd McCarthy.
 p. cm.
Includes bibliographical references.

ISBN 978-0-8109-9651-9 (cloth cover : alk. paper)

ISBN 978-0-9790678-5-3 (softcover : alk. paper)

ISBN 978-0-9790678-6-0 (special ed. cloth cover : alk. paper)

1. Rockwell, Norman, 1894–1978—Themes, motives.
2. Lucas, George, 1944– —Art collections.
3. Spielberg, Steven, 1946– —Art collections.
4. Narrative art. I. McCarthy, Todd. II. Smithsonian American
Art Museum. III. Title. IV. Title: Norman Rockwell from the
collections of George Lucas and Steven Spielberg.

N6537.R576M43 2010
759.13—dc22

2010008010

First published in 2010 by Abrams, New York, in association with
the Smithsonian American Art Museum.

THE ART OF BOOKS SINCE 1949

115 West 18th Street
New York, NY 10011
www.abramsbooks.com

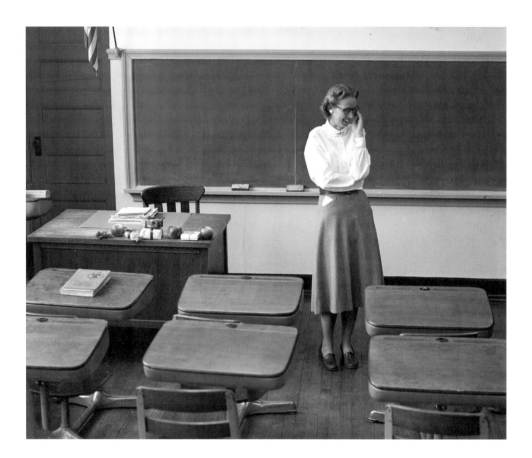